HOLLYWOOD'S
LAST GOLDEN AGE

HOLLYWOOD'S LAST GOLDEN AGE

POLITICS, SOCIETY, AND THE SEVENTIES FILM IN AMERICA

JONATHAN KIRSHNER

Cornell University Press
Ithaca and London

First published 2012 by Cornell University Press
First printing, Cornell Paperbacks, 2012

Printed in the United States of America

Library of Congress Cataloging-in-Publication Data

Kirshner, Jonathan.
 Hollywood's last golden age : politics, society, and the seventies film in America / Jonathan Kirshner.
 p. cm.
 Includes bibliographical references and index.
 ISBN 978-0-8014-5134-8 (cloth : alk. paper)
 ISBN 978-0-8014-7816-1 (pbk. : alk. paper)

 1. Motion pictures—United States—History—20th century. 2. Motion pictures—Social aspects—United States. 3. United States—Social conditions—1960–1980. I. Title.
 PN1993.5.U65K56 2013
 791.430973—dc23 2012016501

Cornell University Press strives to use environmentally responsible suppliers and materials to the fullest extent possible in the publishing of its books. Such materials include vegetable-based, low-VOC inks and acid-free papers that are recycled, totally chlorine-free, or partly composed of nonwood fibers. For further information, visit our website at www.cornellpress.cornell.edu.

Cloth printing 10 9 8 7 6 5 4 3 2 1
Paperback printing 10 9 8 7 6 5 4 3 2 1

For Esty, the one she wanted

CONTENTS

Acknowledgments ix

Prologue 1

1. Before the Flood 4

2. Talkin' 'bout My Generation 23

3. 1968, Nixon, and the Inward Turn 52

4. The Personal Is Political 76

5. Crumbling Cities and Revisionist History 102

6. Privacy, Paranoia, Disillusion, and Betrayal 133

7. White Knights in Existential Despair 166

8. Businessmen Drink My Wine 189

Appendix: 100 Seventies Films of the Last Golden Age 217

Notes 233

Index 261

ACKNOWLEDGMENTS

In working on a book that crosses disciplinary boundaries, my first debt is to my home institution, the Government Department at Cornell University. Among its great strengths is that it has always encouraged faculty to pursue their intellectual interests, wherever they might lead. Many of the ideas in this book were developed over the years in my seminar "The Politics of the Seventies Film," and in various summer courses I taught at Cornell's Adult University. (Ted Lowi also kindly agreed to co-teach a seminar with me on the politics of the 1960s, which he must have known was really my way of taking a course from him.) I have also benefited enormously from the generosity of scholars and friends who commented on various aspects of this work from the perspective of their own areas of expertise. These include Glenn Altschuler, David DeVries, Mark Feeney, Lester Friedman, Heather Hendershot, Michael Jones-Correa, Mary Katzenstein, Fred Logevall, Karl Mueller, and David Simon.

It has also been a pleasure working with Cornell University Press; the commentary, enthusiasm, and close attention to detail of my editor, Michael McGandy, has made this a better book. I am particularly indebted to two anonymous referees for their extremely thoughtful readings and excellent suggestions, and for additional comments, suggestions, and support from other members of the production and editorial team at the Press.

I am especially grateful to the late Arthur Penn, who graciously received me in his home to spend a few hours talking about his film *Night Moves,* and to Lorenzo Semple Jr. and Jennifer Warren for taking the time to talk with me about some of their seventies experiences as well. I also thank Amy Sloper at

the Harvard Film Archive, and Sandra Kisner for help in preparing the manuscript and the appendix.

All of the images in this book I "captured" myself from DVDs; they are not production or publicity stills from the studios. I am grateful to Michael Tolomeo for enhancing the resolution so that they could be reproduced. My use of these images for a scholarly publication falls well within the bounds of the doctrine of "fair use" under U.S. copyright law and follows the practice of the U.S. Society for Cinema and Media Studies.

Special thanks to Matt Evangelista, Jason Frank, Alison McQueen, and Dana Polan for the extraordinary time and effort each put in on close readings, detailed comments, and numerous conversations which were crucial in keeping me alert and on track over the course of writing and revising. Elie and Ari were there as I wrote this book, and I look forward to watching—and talking about—these movies with them. As always, my greatest debt is to Esty, for going to the seventies with me, and bringing me back.

HOLLYWOOD'S
LAST GOLDEN AGE

PROLOGUE

When I was in college, we argued about the movies. One time a post-screening debate about *Chinatown* became particularly heated. It was late enough to cross city streets against the light with little concern for oncoming traffic, and, lost in the heat of the moment, we raised our voices to an extent that was surely inconsiderate. Arguments like these were rarely resolved, but they were not really meant to be. Progress was measured with the acknowledgment that impressive evidence had been introduced, usually in the form of a counterfactual ("If that interpretation were true, how would you account for this shot?"), or by the recognition of a novel perspective ("I hadn't thought of it that way before").

A good argument made fine company. At some point we agreed that you could take the measure of a movie by how long we talked about it afterwards. Not every movie invited such exuberant contestation, but we sought out those that did. Soon enough I found myself gravitating toward American films made in the late 1960s and 1970s, which, more often than not, seemed designed to provoke such conversations. Coincidentally (or so I thought), as a student, and later a professor of politics, I was also irresistibly drawn to the political and social history of the period: Vietnam, the women's movement, race relations, Watergate. And it turned out that at about the same time, rock music was scaling new heights as well. There *was* something happening there.

This book engages what I call the "seventies film" in the context of its times. Although there is a growing literature in film studies on this era, and social scientists continue to explore the remarkably rich and fascinating terrain of the sixties and seventies, often with reference to cultural touchstones,

my goal in this book is to take both the films and the times seriously, and to argue, most fundamentally, for their essential interdependence. Thus I do not introduce films as illustrations of history or politics, but rather I take on close readings of particular films to show that these films—these commercial Hollywood movies—were shaped by, and in dialogue with, the political, social, personal, and philosophical issues of their times.

The "seventies," as redefined here to include the late 1960s and exclude the late 1970s, was a golden age in American film, and it was a revisionist period as well. The traditional conventions of the industry were challenged—the rules and norms that had dictated what stories could be told, and how stories could be told. None of this means, and it is clearly not the case, that all seventies films are "good," or that the movies that came before (and after) are "bad." It is to argue that the decade was an unusually rich period of cinematic achievement, and that it was indeed an "age." That is, it was characterized by a cohort of films that were noticeably different, especially from their predecessors, and can be understood as a distinct and identifiable era, and one that came and went, like a window opening and closing. The era of the seventies film reflected a shift away from the pristine exposition of linear stories with unambiguous moral grounding, and toward self-consciously gritty explorations of complex episodes that challenged the received normative structure of society. Two interrelated factors contributed to this transition: the end of movie censorship, and changes in the industry and American society that had been developing for some time but became obvious and irresistible by the mid-1960s. Ten years later, a different constellation of political, economic, and social factors would foster conditions that were much less hospitable to the seventies film, and its culture withered.

Of course, history does not come in boxes. Nor do events unfold on schedule, or even, necessarily, in proper sequence. In retrospect, observers attempt to impose order on a disorderly past so they can make some sense of it. Untidy episodes are categorized as "false starts," some things happen "before their time," and events that slip beyond the grasp occur as "echoes of the past." Crucial turning points, less obvious to the harried participants who experienced them, are established.

These messy realities complicate the most tractable endeavors, such as cold war history. (When did it start? Was it inevitable? What were the rules? Why did it end?) This is true of film history as well, especially in the way the vagaries of production and release schedules make the "dating" of any particular film tricky. Nevertheless, I argue that envisioned collectively, from 1967 to 1976 a certain type of great American film thrived. Though I call it the seventies film, it has also been called the New Hollywood or the American New Wave, phrases that signified generational change as well as a nod toward the influence and artistic ambitions of the "New" European cinemas of the 1950s and 1960s.

This book on the seventies film, then, is not designed to be a comprehensive survey of the movies (or for that matter of the history and the politics) of the period. The New Hollywood thrived, but there were still plenty of Old Hollywood movies being produced as well. Many big hits—probably most of the very biggest hits, movies like *Airport, Love Story,* and *The Towering Inferno*—are ignored. Some notable genres of the period—disaster films, horror movies, and blaxploitation—are also marginalized. Comedies are underrepresented (*Young Frankenstein,* a movie I love, was released in 1974, but it is not a seventies film). Some of these choices were not easy to make; the great works of outsiders like Stanley Kubrick and John Cassavetes, for example, are not systematically engaged. Other personal favorites, like Alfred Hitchcock and Woody Allen, are mentioned only in passing. (It can be argued that Allen carried the promise of the seventies film into the 1980s and 1990s. Nevertheless, his most important contributions arrived after 1976.)

Hollywood's Last Golden Age is concerned with a certain type of film—the seventies film—born of the era, with recognizable characteristics, and deeply and deliberately enmeshed with the political, social, and cultural concerns of its day. The movies discussed in the pages that follow, taken together, reflect that coherent subculture. In an appendix at the end of the book there is a chronological list (in order of release date in the United States) of one hundred seventies films, along with the principal participants behind and in front of the camera for each entry. The choices reflect the stuffing of the book, but they are also designed to capture and represent the breadth of the era's achievements. Having considered fifty seventies films for the final five slots, and having nominated twenty movies for canonical status, I have no doubt that the list is debatable—in the best sense of the word.

CHAPTER 1

BEFORE THE FLOOD

It was "the decade when the movies mattered."[1] Choices made by fictional characters mattered. How a movie ended *really* mattered. The next film by a noted director was eagerly anticipated because chances were he had something to say. In the precious ten years from 1967 to 1976, a certain type of American film culture thrived, clearly different from what had come before, and once it was gone, well, *out of the blue, and into the black,* just like Neil Young said. Perhaps the puzzle was not that it ended but that it ever happened. Still, for that brief moment it seemed like the inmates were allowed to run free. Soon enough the survivors were brought back to their rooms, in many cases for their own protection. But few would make their best films in captivity.

Great movies have been made throughout film history, and they will continue to be produced in the future. Yet there was something special and meaningful and important about the period 1967 to 1976 for mainstream American movies. It was a moment when a number of extraordinary factors all came together to produce an uncommonly fertile era in American film. The end of censorship, the passing of the old guard of the studio system, and economic and demographic changes in both the industry and its audience created unprecedented uncertainty and a crisis of confidence that afforded an opportunity for a new type of commercial film. At the same time, the content of those new films, especially (but not exclusively) those created by a new generation of filmmakers, could not help but be shaped by the omnipresent social and political upheavals of the era: the civil rights movement, the domestic consequences of the Vietnam War, the sexual revolution, women's liberation, the end of the long postwar economic boom, and the traumatic Shakespearean saga of the Nixon presidency.

The claim that something new and special emerged from Hollywood in the decade from 1967 on is not novel. It is increasingly acknowledged in the community of film scholars and critics. Indeed, it was even recognized by many at the time. Orson Welles, for one, observed Hollywood producers "frantically pandering to youth" because they "cannot pretend they know anything about the market except that it is very young." The result is "very young filmmakers in total control of their own work," which Welles, having been through decades of studio doors slamming in his face, understandably viewed with a hint of mixed emotions. He saw a situation that was "slightly ridiculous, and very hopeful for the future of American films."[2]

Of course, nothing comes from nowhere. The seventies film has its characteristics, its culture, and its concerns, but it would not have been possible without the end of the censorship regime that would otherwise have radically circumscribed its content. The comprehensive censorship of American films from the earliest days of the industry through 1966 was the most consequential determinant of the content of Hollywood movies. As fans of classic movies can attest, in the old days people (well, at least people in the movies) didn't swear, didn't have sex, and didn't even bleed much; these three big and obvious prohibitions obscured a much longer list of taboos regarding the treatment of race, crime, drugs, and sexuality more broadly. The fact that the movies can now be more profane, more violent, and more sexually explicit has come with some costs. Under censorship, the inability to speak frankly encouraged filmmakers to resort to codes and visual devices that were inherently well suited to the medium, developing finesse and at times even virtuosity in subtle techniques of visual storytelling—skills less necessary when anything can be said or shown. And after censorship, freeing sex and violence invites a slippery slope, for the power of the movies to shock and titillate depends, to some extent, on novelty and outrageousness, creating mounting pressure to outdo predecessors each time the bar is raised (or lowered).

Still, the end of censorship was the liberation, even if the reason why is commonly misunderstood. At bottom, censorship is paternalistic, and the result of American censorship, not surprisingly and in fact purposefully, was films suitable for children. And children, more than anything, needed to be taught about the difference between right and wrong, and to trust authority and institutions, and to be assured that good will triumph over evil. What the seventies brought, then, was the possibility of a truly adult cinema, which was not a function of nudity or vulgarity or violence but rather derived from the ability to traffic in that which was previously forbidden, the ultimate taboo: moral ambiguity. In the adult world, and in the world of the seventies film, choices are not always easy and obvious, most people are some combination of good and bad, authorities and institutions are often imperfect and even corrupt, and, finally, the hero doesn't always win.

Censorship and Moral Ambiguity

Hollywood censorship is largely the story of self-censorship as a preemptive tactic, rooted in fear. The industry was afraid of state and local censorship boards, boycotts by private groups (most famously the Catholic Legion of Decency), and the power of the federal government more generally. Censorship tended to peak at those times when the industry felt most vulnerable, in particular during economic downturns, which left the studios less than eager to alienate a shrinking audience or squander scarce resources to put up a fight. Key moments in the twenties, thirties, and forties would define the characteristics of the censorship regimes that followed.

The studios had good reason to fear government censorship. On February 23, 1915, a unanimous Supreme Court ruled that motion pictures did not enjoy constitutional protections regarding freedom of expression. In *Mutual Film Corporation v. Industrial Commission of Ohio,* the Court upheld that states could, in advance, examine and approve (or not) all films intended to be exhibited for profit in the state. The potential implications of censorship by states and localities were real, and enormous. In 1945, for example, during a period of strict Hollywood self-censorship, Fritz Lang's *Scarlet Street* was initially banned in (of all places) New York State, for its flirtations with prostitution and infidelity and its failure to punish the guilty more explicitly. Not until 1952 *(Burstyn v. Wilson)* did the Court place any limitation on states' power in this arena, with an important decision that narrowed the basis on which movies could be censored. Further encroachments on state authority followed, but it was not until the mid-1960s that the legal foundations of local censorship boards were unambiguously crumbling.[3]

Three crises defined the nature and practice of self-censorship. The first, and only episode with some historical charm, was the effort to clean up the industry's image as a den of iniquity. Hollywood's loose morals were associated most famously with the free sexuality of its biggest stars, like Mary Pickford, who divorced her husband to marry Douglas Fairbanks in 1920. But things took a darker turn with the Fatty Arbuckle sex scandal in September 1921, with its salacious rumors (and subsequent sensational trials) surrounding the circumstances that led to the death of a young woman, and with the sordid, unsolved murder of director William Desmond Taylor in February 1922.

These ugly episodes were poorly timed from a business perspective. A month before the Fatty Arbuckle scandal hit, New York State established its movie licensing system, and within a year, censorship bills were introduced in thirty-two states. The moguls, looking for cover, created the Motion Picture Producers and Distributors of America (MPPDA) and hired Will Hays to be its president. He was a casting agent's dream. Hays, lured from President

Harding's cabinet (he had orchestrated the successful Harding campaign), was a conservative Republican, a midwestern teetotaler, and a Protestant church elder—in sum, the opposite of everything that was objectionable about Hollywood. Nominally, Hays had two jobs—externally, to promote the industry and to fight outside censorship; internally, to supervise the self-censorship of the movies. Hays introduced the morals clause into all Hollywood contracts and formed the Committee for Public Relations, the office that established guidelines for content, including a list of "don'ts and be carefuls" in 1927, and the more elaborate production code of 1930. But his energies were directed much more forcefully, and effectively, at fighting local censorship efforts around the nation.[4]

The Great Depression, which coincided with the emergence of sound, created a second and much more profound crisis for Hollywood and contributed to a much more severe period of censorship. (The sound films of the early 1930s are certainly tame by today's standards, but a comparison of the 1931 and 1941 versions of *The Maltese Falcon* provides a fascinating illustration of how dramatically standards were tightened in the interim.) With the collapse of the economy, attendance nosedived. One hundred million Americans went to the movies in the average week in 1930; 40 million fewer did so in 1932. Profits plummeted, and theaters closed. At the same time, and possibly with an eye toward recapturing its flagging audience, the movies of the early sound period trafficked increasingly in sex and violence—most famously in the person of Mae West (who in 1927 served eight days in prison for her role in the Broadway production *Sex*) and with gangster films like *Little Caesar* and *Scarface*.[5]

The relative frankness of some of the pictures of the early sound era attracted unwanted attention as well. In 1932 the Catholic Church appealed to the industry to tone down its content, and in 1933 its efforts became more public and ambitious. A Committee of Bishops was convened, and in April 1934 the Legion of Decency was established. Ten million Catholics signed a pledge not to attend immoral films, and they would be guided in their choices by the Legion's own rating system, which identified movies that were "morally unobjectionable" and others that were "condemned."

Hollywood was quick to react. Within three months of the establishment of the Legion, Hays hired Joseph Breen, a Catholic—and for good measure an anti-Semite as well—to run the Production Code Administration (PCA), the successor to the Committee for Public Relations. The PCA revisited, interpreted, and enforced the production code, which had been written out in 1930. Crucially, the members of the MPPDA (that is, all the major studios) agreed that they would not distribute any film that did not carry the PCA purity seal, and faced a fine of $25,000 if they did. Since at that time the studios owned most of the theaters in the country, in the era of studio dominance the

code would be virtually impossible to circumvent. The studios even agreed to withdraw older films, such as *A Farewell to Arms,* that were deemed offensive. Breen ran the PCA from 1934 to 1954, and did so with an iron fist.[6]

The code was aggressively enforced, with censors demanding specific changes from pre-production scripts all the way through to the finished product. The effect could be comically oppressive—banning words like "tart" and "chippie," and "obscene" phrases like "in your hat," and of course with its exile of married couples into separate beds. It could also be offensive, banning outright "sex perversion or any inference to it" (meaning, for openers, homosexuality) as well as interracial romance. But the first item mentioned in the code was not about sex or violence or vulgarity; rather, it began: *"No picture shall be produced which will lower the moral standards of those who see it. Hence the sympathy of the audience shall never be thrown to the side of crime, wrongdoing, evil, or sin."* The second general principle discussed "correct standards of life," and the third covered respect for "natural or human" law. Taking on the specific category of crime, the code specified that it "shall never be presented in such a way as to throw sympathy with the crime as against law and justice"; the discussion of sex that follows starts with "the sanctity of the institution of marriage and the home" before moving on to rule that adultery and "illicit sex" may not "be explicitly treated or justified, or presented attractively." In sum, the code as written and enforced was first and foremost about imposing a set of strict, strident, and sacrosanct moral standards on the movies.[7]

The effect was immediate. In 1933–34, more than half of Hollywood's output was either condemned by the Legion of Decency or found to be "morally objectionable in part." Two years later over 90 percent of Hollywood's product was deemed "morally unobjectionable"; in 1938, only 5 of 535 movies produced were "condemned" by the Legion. Thus Mae West's line "Men are at their best when women are at their worst" was banished to the cutting room floor. (Years later, audiences would be similarly protected from hearing Ronald Reagan say "razzberry" in *Bedtime for Bonzo.*) And of course crime, or even "immoral" behavior, *never, ever* went unpunished. Shirley Temple replaced Mae West as Hollywood's leading woman, and both sides of the screen were made safe for children. Mission apparently accomplished, in the late 1930s and beyond, the Legion, and Hollywood's censors, turned their attention to protecting American audiences from a more subtle danger—the subversive social or political "message" film. Movies like *Confessions of a Nazi Spy* (1939) and, especially, *The Grapes of Wrath* (1940) were particularly disconcerting for the Legion, which proclaimed that "the move to bring social and realistic messages" was a "wedge for the sly introduction of propaganda materials" that "may be more dangerous to the welfare of souls than indecencies or immoralities."[8]

These issues were put aside as Hollywood enthusiastically turned its energies to supporting the country in the Second World War. But they would soon return with a vengeance. Even in triumph, for the nation as a whole, and in particular for its returning GIs, the war was a sobering experience, and many postwar movies reflected a more serious and downbeat sensibility. *The Best Years of Our Lives* (1946), which dealt with the challenges returning vets faced in readjusting to small-town American life, picked up seven Academy Awards. In 1947 a number of films, all of which conformed to the code, nevertheless suggested a political point of view. *Gentleman's Agreement* and *Crossfire,* for example, each took on anti-Semitism. Even more troubling for some was *Body and Soul,* about a boxer's fall from grace, in which the lure of big money leads the hero astray.

In 1946, 90 million Americans went to the movies each week, one of the best years in Hollywood history. But the audience would never be that big again. In 1950, about 60 million tickets a week were sold, and the audience would continue to dwindle. Nineteen forty-six was also a watershed year in U.S. politics. The November elections swept Republican majorities into the House and Senate for the first time since the Hoover administration, and prominent among these new lawmakers were ambitious young politicians, such as Richard Nixon, who had run on a platform of crusading anticommunism. Nixon waged an aggressive, red-baiting campaign, as he would in his successful Senate bid four years later; in the interim he made his reputation fighting communist subversion as a member of the House Un-American Activities Committee (HUAC). With the transfer of political power in Congress in 1947, that committee was chaired by the combative J. Parnell Thomas, a passionate opponent of the New Deal, who saw in taking on Hollywood an opportunity to challenge liberal politics in society more broadly.

Thomas held congressional hearings in October on "communist infiltration of the motion picture industry," initially with studio heads and other "friendly" witnesses naming names of communists working in the industry. The committee meant business—Nixon had promised that the "red network" would be exposed—and nineteen purported subversives were named in the hearings. Initially the industry rallied to their support. Leading Hollywood liberals, including John Huston, Katharine Hepburn, Billy Wilder, Groucho Marx, and Humphrey Bogart, formed the Committee for the First Amendment and traveled to Washington to show their support. At the same time, Eric Johnston (the former president of the U.S. Chamber of Commerce, who had recently succeeded Will Hays as the head of the MPPDA) stated plainly: "As long as I live, I will never be a party to anything as un-American as a blacklist.... [T]here'll never be a blacklist. We're not going to go totalitarian to please this committee."[9]

But Hollywood's courage, never in great supply, was quickly depleted. Economic distress in the movie business, and possibly even a desire to placate the conservative banking community (which provided crucial financing for the industry), fueled the retreat. In addition, the hearings did not go well, with absurd and at times comical exchanges between the shrill committee members and unfriendly witnesses. After eleven of the nineteen had testified, Thomas unexpectedly suspended the proceedings. One of the eleven witnesses, Bertolt Brecht, fled the country; thus remained the "Hollywood Ten." On November 24, the House voted 346–17 to hold them in contempt of Congress. (All would eventually serve time in prison for this offense.) The following day Johnston emerged from a closed-door meeting in New York with industry executives to issue the "Waldorf Statement," in which the studios condemned the Hollywood Ten and vowed that they would not "knowingly employ" any communists or subversives. Loyalty oaths would be mandatory. Thus the "Hollywood blacklist" was formed.[10]

In the following years, things would only get worse. In February 1950, the then undistinguished Senator Joseph McCarthy of Wisconsin made the speech that signaled a renewed and nationwide effort to root out subversives in American society: "The reason why we find ourselves in a position of impotency is not because our only powerful potential enemy has sent men to invade our shores, but rather because of the traitorous actions of those who have been treated so well by this nation." An opportunistic politician searching for a platform, he had finally struck gold: the hunt for the enemy within. However vile McCarthy was, it is important to keep in mind that he found in 1950s America fertile soil to plant his poisonous seeds. As Jean-Pierre Melville once remarked with regard to his masterpiece *Army of Shadows* (1969), "Don't forget that there were more people who didn't work for the resistance than people who did."[11]

McCarthyism took root in an America traumatized by the appearance of a three-headed monster: in the nine-month period from September 1949 through June 1950, the Soviets got the atomic bomb, years before anyone thought they would; the Chinese communists won the civil war, by the accounting principles of the day reducing the ranks of the "free world" by hundreds of millions; and without warning, communist North Korea invaded the South. The international communist threat suddenly seemed very real and on the march, possibly with the help of enemies from within America. It was in this atmosphere that Congress passed the Internal Security Act over President Truman's veto. The act required the registration of communists and created the Subversive Activities Control Board to investigate suspected subversives.[12] And in 1951 HUAC intensified its efforts to flush out communists in Hollywood.

The human costs of the Hollywood blacklist, and the much broader nationwide effort to expose and purge "subversives" from all walks of society, have been well documented.[13] Some, like Dashiell Hammett, author of *The Maltese Falcon,* went to jail; others, such as Jules Dassin (director of *The Naked City*), fled the country. Many testified before the committee. Sterling Hayden saved his career but never recovered. ("Not often does a man find himself eulogized for having behaved in a manner that he himself despises," he would later write.) Countless more were unable to find work. Less harrowing but more pervasive was the smothering effect that political fear had on the content of the movies. McCarthyism produced the third great wave of Hollywood self-censorship, eliminating from the screen anything that might be understood, or misunderstood, as challenging American values. As Elia Kazan noted in 1952, "Actors are afraid to act, writers are afraid to write, and producers are afraid to produce." Kazan would know. In January 1952 he refused, "as a matter of conscience," to name names before the House committee. But fearing for his career, he returned in April and read sixteen names into the public record.[14]

There were great films made in the 1950s—Huston's *The Asphalt Jungle,* Hitchcock's *Rear Window,* and Welles's *Touch of Evil,* to name a few—but American films of the decade are nevertheless best characterized by their timidity, conformity, and enforcement of the moral certainty of the code. And the Production Code Administration would continue to supervise the censorship of Hollywood's output until its sudden collapse in 1966. It is clear in retrospect, however, that although the shattering of the code marked a sudden, radical transition in the content of the movies, the foundations of the censorship regime had been slowly eroding for some time.

In 1953 Otto Preminger famously released *The Moon Is Blue* without a PCA seal, a film objectionable to the Hays office because of its explicit references to the heroine's virginity. But that virtue was preserved; indeed the spirit if not the letter of the code remained intact. Much more subversive was Preminger's *Anatomy of a Murder* (1959), in which the lawyer played by Jimmy Stewart defends a killer. Technically speaking, justice is served in *Anatomy,* as the murderer is found not guilty in a trial, but the film leaves little doubt as to the character's moral complicity. As Andrew Sarris observed, Preminger saw the "eternal conflict not between right and wrong, but between the right-wrong on one side and the right-wrong on the other." The film was banned in Chicago (a right upheld by the courts as late as 1961), following the logic explained by the city's chief censor: "Children should be allowed to see any movie that plays in Chicago. If a picture is objectionable for a child, then it is objectionable, period."[15]

Preminger and others were willing to push back against the code because in the 1950s the studios were on the ropes. *The Moon Is Blue* was able to reach

theaters in part because of the Supreme Court's 1948 *Paramount* decision, the culmination of an antitrust suit brought by the U.S. government that forced the studios to divest themselves of their theater chains. The rapid growth of television (along with various other factors, including suburbanization, which moved people farther away from downtown theater palaces) was stripping away the mass movie audience, while on another flank, more sophisticated (and unregulated) international "art house" pictures gained in popularity with urban and college audiences. In 1950, weekly attendance fell below 60 million; a full third of the old audience had been lost. By 1960 it was down to 25 million. All of these developments encouraged Hollywood at least to flirt with more daring fare, especially as it assiduously avoided any hint of political content that did not involve flag waving.[16]

The relaxation of informal restrictions on the political content of the movies lagged behind the growing industry tolerance for (relatively) risqué subject matter in films, but the roots of political change are also visible in retrospect. In 1953 Stalin died and the Korean War ended, and in 1954 McCarthyism was exposed during the televised Army-McCarthy hearings; before the year was out, McCarthy had been censured by his Senate colleagues, and he descended into alcoholism and obscurity before meeting an early death from liver disease three years later. Coincidentally, 1954 was also the year Joe Breen stepped down as head of the PCA; his handpicked successor, Geoffrey Shurlock, toed the line, but he was more of a pragmatist than his old boss. And finally, by the end of the decade the blacklist was eroding. In 1958 Vice President Nixon met with Kirk Douglas and referred to the blacklist as an "industry problem." That year Douglas hired Dalton Trumbo, one of the Hollywood Ten, to write *Spartacus* and, more important, put his name on the screen when the film opened in 1960. (Preminger would follow suit with *Exodus*.) Within a few years, politically sophisticated and even daring films like John Frankenheimer's *The Manchurian Candidate* (1962) and Stanley Kubrick's *Dr. Strangelove* (1963) were released, two movies that could not conceivably have been produced as little as five years earlier.[17]

The confluence of factors that had been cumulating for years—declining audiences, the rise of TV, the success of the art house,[18] and the dispersion of authority attendant on the crumbling of the classical studio system—continued to swell, and finally, catching the right break, breached the dikes of censorship. When MPAA head Eric Johnston died suddenly in 1963, Hollywood, after a long search, for the third time settled on a Washington power broker to fill the job. Jack Valenti, special assistant to President Johnson, left the White House and set up shop in New York City, stepping into Will Hays's old shoes on May 16, 1966. The tireless, aw-shucks Valenti shared Hays's gift for public relations, but the Great Society Democrat did not fashion himself as a censor, and his inaugural speech was critical of the production code.[19]

Not being a censor would occupy much of the first two years of Valenti's long tenure at the MPAA. Within weeks of his appointment, Warner Brothers screened for Valenti *Who's Afraid of Virginia Woolf,* Mike Nichols's film of Edward Albee's Tony Award–winning play, which had been ruled "unacceptable" by PCA chief Shurlock. Valenti shepherded the movie—negotiating bits of dialogue line by line ("screw you" would be dropped, "son-of-a-bitch" stayed) through a successful appeal of the ruling. The film was released with a PCA seal and labeled "for mature audiences." Later that year, and released by MGM without a PCA seal, Michelangelo Antonioni's *Blow-Up* set a new benchmark for on-screen nudity. In 1967 several films shattered previously acceptable standards for the portrayal of violence. The code had been breached on all fronts. In its place, Valenti was eager to establish some new form of self-governance that encouraged the responsible expression of artistic ideas while respecting societal standards and providing some control over the exposure of children to potentially objectionable content. In 1968 this was formalized with the introduction of the industry rating system that is largely intact today. Legal struggles over obscenity would continue into the 1970s, but the floodgates of sex, violence, and language were unhinged.[20] Much more important and consequential if less obvious at the time was that by 1967, Hollywood was at long last largely out of the business of imposing a moral vision on its filmmakers or placing limits on the types of stories that could be told.

Freedom to Do What?

By the middle of the 1960s the form had been liberated, and virtually anything was possible. But freedom permitted the New Hollywood; it did not define it. Not surprisingly, the seventies film was a child of the tumultuous politics of the 1960s. Three earthquakes were taking place in the United States in the 1960s, any one of which would have been enough to make for a busy decade: the civil rights movement, the domestic social consequences of the Vietnam War, and the women's liberation movement. Together, sequentially but also overlapping, they shook the foundations of American society.

Twenty-first-century America remains troubled by significant racial problems. Nevertheless, enormous strides have been made over the past fifty years or more, and the 1960s were a time of both progress and upheaval. In 1963 Martin Luther King Jr. led his epochal March on Washington; the Civil Rights Act of 1964 prohibited segregation in public places; the Voting Rights Act of 1965 was designed to dismantle the elaborate official and unofficial obstacles intended to prevent black citizens from voting. (Although the promise of these acts was not promptly fulfilled, consider how things had been. In 1960, only 5 percent of eligible blacks in Mississippi were registered to vote; and

even though basketball superstar Bill Russell was given the key to the city of Marion, Indiana, he still couldn't get served in his hotel dining room.) Racial unrest would characterize the entire decade, often erupting in protracted large-scale violence, most notably in the Watts section of Los Angeles in 1965, Newark in 1967, and everywhere, it seemed, in 1968.[21] The New Hollywood did not, in fact, make lots of movies *about* the civil rights moment or, for that matter, about the Vietnam War. But seventies filmmakers were irretrievably affected by, and in many cases actively participated in, the political controversies surrounding these and other events. Their movies very much reflected the influence of these highly charged and broadly understood—if often unstated— underlying contexts.

Vietnam increasingly dominated domestic politics with a growing intensity that corresponded to the number of American soldiers in the country. Desperate to salvage a losing effort, President Johnson made the fateful decision to introduce ground troops in 1965. Twenty-three thousand Americans were in the field in January; by December there would be 180,000. Like clockwork, additional increments were regularly deemed necessary, at least to stave off defeat. In December 1966 there were 380,000 U.S. troops in Vietnam; by 1968 there were over 500,000, a figure that would have boggled the mind in 1964. Yet they were not enough to secure the political objective for which the troops were nominally introduced in the first place—the establishment of a legitimate, self-sustaining government in South Vietnam. Things came to a head with the Tet Offensive in 1968, a massive coordinated Vietcong assault across the country, including the breach of the U.S. embassy in Saigon. Revisionists emphasize that the offensive was a military failure for the Vietcong, which it certainly was, but that misses the point entirely. Tet mattered because it put to rest the idea that victory was "just around the corner," called attention to the vast gulf between what the U.S. government was saying about the war and what was happening on the ground, and destroyed what was left of the Johnson presidency. Faced with a request for 200,000 additional troops, which would have required mobilizing the reserves, the president commissioned a secret top-level "A–Z reevaluation" of the war effort, which concluded that the end was not in sight and that neither more bombing nor more troops would ensure victory. Johnson pulled out of the 1968 presidential election with a surprise announcement to the nation on March 31.[22]

Before the war was over, the United States had dropped more bomb tonnage on North Vietnam, an impoverished country the size of Wisconsin, than all the bombs dropped during the entire course of World War II. The problem for the United States was that it lost sight of the relationship between the use of force and the achievement of its political goals. This pathology underscored many of the domestic crises associated with the war: the shattering of the cold

war foreign policy consensus; the reassessment of American virtue and exceptionalism; the exacerbation of race, generational, and class conflicts, given the military draft; and, not to be underestimated, the widespread loss of trust in government.

For the seventies film, it was these consequences of the war, more than the war itself, that were formative. One aspect of the war that did directly affect the movies was the way in which it raised the stakes for the visual expression of violence. As noted earlier, the very strict censorship of TV programming nudged Hollywood toward differentiating its product with more daring fare than that which could be broadcast over the public (and regulated) airwaves. But TV did push the envelope in one area—with images from Vietnam on the evening news that brought into millions of American homes a portrayal of violence much more vivid and real than had been permissible in Hollywood films during the censorship era. This put pressure on the movies to offer more realistic expressions of violence: violence that hurt, violence with consequences.

National debates over civil rights and Vietnam occurred on a mass scale and took place in the public sphere. They asked big questions, like "What is America?" The women's movement, in contrast, affected people's most intimate and private relations, inside the home, one at a time. It raised questions that sounded much smaller, like "Who am I?" But it turned out that these questions were enormous and foundational—and once posed, there was no sanctuary from them. And the answers were not always comforting. Describe gender relations of the time to young women today, and they would assume that you were talking about the 1860s, not the 1960s. The large majority even of "good liberals," young radicals, and sophisticated urbanites held assumptions, beliefs, and expectations about women at that time that can only be described as backward. In the early 1960s, women's own dissatisfactions became pronounced. By 1962, only 10 percent of mothers hoped that their daughters would follow the pattern of their lives, reflecting the distress articulated by Betty Friedan in her 1963 best-seller *The Feminine Mystique.* In that same year the report of the Presidential Commission on the Status of Women, initiated by President Kennedy at the urging of Eleanor Roosevelt, spelled out the extent to which women throughout society were systematically discriminated against without legal recourse. Yet when Congressman Howard W. Smith of Virginia introduced a provision to include gender in the Civil Rights Act of 1964, it was widely understood at the time (and debated on the House floor) that Smith, a bitter opponent of the Civil Rights Act, hoped to undermine the legislation by inviting opposition or ridicule.[23] By the end of the decade, however, the women's movement was reshaping the nation, and its signature phrase—"the personal is political"—calling attention to the power structure of private relations, probably had a more profound effect on the content of

the seventies film than did most "big P" Political Issues. This inward turn was anticipated by Bob Dylan. Associated with the civil rights and peace movements, Dylan nevertheless remarkably and explicitly renounced Politics by the end of 1963—but he never stopped writing about politics.

The New Hollywood was forged by these social upheavals, and it was also shaped by its relative youth. This generalization can be overstated, but behind the camera, on the screen, and at the box office, the new prominence of youth was notable. Part of this was sheer demographics, the coming of age of the baby boom generation; part was due to changes in the composition of the dwindling movie audience, discussed earlier. And part was due to continuing struggles and changes in the business. The studios lost a lot of money in the late 1960s, especially on expensive "Old Hollywood" extravaganzas like *Doctor Doolittle* (1967) and *Star!* (1968), which lost tens of millions. These difficulties contributed to the rise of the conglomerates, giant corporations that bought distressed studios and added them as ornaments to their empires. Gulf + Western bought Paramount, Transamerica acquired United Artists, Kinney National scooped up Warner Brothers. But the suits in industry, insurance, and the parking business didn't know much about making movies, and many of them were willing to take a chance, especially an inexpensive chance, on the youth market.[24]

The most important of these chances was proffered by struggling Columbia Pictures, which gave a six-picture deal to BBS Productions (Bert Schneider, Bob Rafelson, and Steve Blauner), with budgets set at a ceiling of $1 million each in exchange for no studio interference in the product. This was the dream of the American New Wave: to make movies that were commercial Hollywood products, to be sure—that is, films that aspired to turn a profit—but that were at the same time serious expressions of a personal cinema. The BBS deal yielded some of the best of the New Hollywood: *Five Easy Pieces, The Last Picture Show,* and *The King of Marvin Gardens.*[25]

Youth mattered, as did the very particular circumstances of younger people in the post–World War II era, a time of unprecedented material comfort and existential insecurity. Each of these two factors defined the context though which questions and problems were posed and understood. The long, unprecedented postwar economic boom was all that those born to the expanding middle class after 1940 had ever known, and it instilled an implicit confidence; relatively few would worry about where their next meal was coming from, or even think to ask the question. Contrast the experience of that generation with that of their parents, who had lived through the deprivations of the Great Depression and then the horrors of total war against fascist states bent on world conquest. The young looked at America—especially suburbanizing, acquisitive America—and saw materialism and complacency as opposed to what their

parents saw: the rewards of a long and difficult struggle, unappreciated by their spoiled and naïve offspring.

From this perch of security and comfort, baby boomers and their older cousins were afforded the opportunity to think about more than getting by, and felt free to interrogate—and often reject—the rituals and rigid dictates of the previous generation. The great economist John Maynard Keynes described a similar opportunity grasped by his cohort in the Bloomsbury artistic community earlier in the century. "We repudiated entirely customary morals, conventions, and traditional wisdom," he wrote. "We spent our time trying to discover precisely what questions we were asking."[26] The artists who came of age in the 1960s were hardly different. As David Bowie told an interviewer, "We were taught that we should question all the established values, all the taboos, and that the one thing we must continually strive for was a sense of self and a sense of expanding our horizons."[27]

Those expanding horizons included, for lack of a better phrase, sex, drugs, and rock and roll, which, as factors that contributed to a distinct generational culture, need to be taken seriously. The mainstreaming of experimentation with, not to mention downright use of, recreational drugs was a significant part of the youth culture of the period. The arrival of one new drug, dispensed more traditionally—the birth control pill—contributed mightily to the sexual revolution and reinforced another heretical idea of the postwar generation: the legitimation of sex outside the expectation of marriage. This development further recast gender relations and provided yet another axis of intergenerational discord. And third but not least, there was the music. Rock exploded on the scene in the 1950s, but its first wave had long since crested: by 1959, Chuck Berry was in jail for violating the notorious Mann Act, Buddy Holly was dead, and Elvis was in the army. But in the mid-1960s, rock was reborn, especially after Dylan, crossing over from folk, convinced the world (and his peers, starting with the Beatles) that rock music could have something to say. For New Hollywood moviemakers, the music was content, not background. "The music was always very close to me," said Martin Scorsese. "I am almost reverent to it."[28]

But material security and social experimentation were joined at the hip with existential insecurity. The baby boom and nuclear war were conceived in the same year, and the Atomic Age had a rough childhood and adolescence. Americans born after 1945 never knew a time unthreatened by the prospect of sudden nuclear annihilation. Trained to duck and cover, directed to fallout shelters, and having endured the Cuban Missile Crisis (during which President Kennedy estimated the odds of nuclear war as one in three), the loss of control they felt was palpable. "Let me die in my footsteps / Before I go down under the ground," the twenty-two-year-old Dylan insisted. At the street level, a different type of insecurity was pervasive in the 1960s for all members of

society: in New York City there were 390 murders in 1960, 653 in 1965, and 1,117 in 1970. Crime more generally rose even faster; robberies soared from 6,579 to 23,539 to 74,102 over the same years. And while most people were not victims of violent crime, the sense of personal vulnerability developed a momentum of its own. No one seemed safe from a sudden, unpredictable burst of violence—cosmic or meaningless. And nobody was. The assassination of President Kennedy was a watershed moment, a metaphor for fallen youth, a marker of lost innocence. "The next morning we all understood we were living in another country," Jules Feiffer wrote. The subsequent political assassinations of the decade were darker still, suggesting deeper social cleavages and precious opportunities foreclosed. "Now that they've taken Dr. King off," Stokely Carmichael offered, "it's time to end this non-violence bullshit."[29]

The night of King's death, Robert Kennedy, against the wishes of local authorities who feared for his safety, delivered the news in lieu of his scheduled campaign rally to a stunned, mostly black audience on the streets of Indianapolis. With a moving short speech that invoked the poet Aeschylus and his feelings about the death of his brother, Kennedy, remarkably, captivated the crowd. "I ask you tonight to return home," he concluded, and "dedicate ourselves . . . to tame the savageness of man and make gentle the life of this world." Scores of American cities erupted in riots that night, but Indianapolis was not one of them. Two months later, of course, Kennedy himself would be assassinated after winning the California Democratic primary.[30] It should come as no surprise that so many of the films from this era of assassination ended with dreams unfulfilled and young lives cut short.

Nixon, Noir, and the New Wave

The end of censorship freed the form; the civil rights movement, the domestic social consequences of the Vietnam War, and women's liberation shook the foundations of political and personal institutions; and changes in the industry produced an opportunity for new filmmakers, representing a shift toward a rambunctious generation empowered by economic plenty but plagued by existential dread. Three more factors would shape the style and content of the movies and give form to the seventies film.

It is almost impossible to overstate the influence that the presidency of Richard Nixon had on the context, or the subtext, of the movies of the era. Scratch any story about power, privacy, or paranoia, not to mention endemic institutional corruption, and Nixon would be revealed just below the surface. The president was, long before assuming office, a polarizing and in many quarters a hated figure, the legacy of his bruising, no-holds-barred campaign tactics

that dated back to the forties and the tenor of his crusading anticommunism in Congress and as Eisenhower's vice president. In 1968 Nixon ran a campaign for president based on the "silent majority," law and order, and the southern strategy. His narrow victory over Hubert Humphrey was a bitter pill for many to swallow, leaving them to wonder what might have been. Eugene McCarthy may have been the candidate of the New Left, but Bobby Kennedy was the candidate of the New Hollywood.[31] Young and idealistic but experienced, tough, and ambitious, Kennedy was both calculating and visionary, eloquently on the right side of the big issues of the day like race and Vietnam, and he had the magnetism of a movie star. With his murder, America went from the promise of Kennedy to the presidency of Nixon, one of the most dramatic "what ifs" in modern American history. An oversimplified story, to be sure, but one that would haunt the seventies film.

Nixon was also a fascinating villain: smart, complex, paranoid, and in the end tragic. His interdependent, cumulative crimes and misdemeanors— the secret bombing of Cambodia in 1969, obsession with enemies and press leaks, overlapping extralegal cobwebs of surveillance, off-the-books financing of covert domestic political operations, obstruction of justice, the Saturday Night Massacre, and the bizarre final days in the bunker—dominated American political culture until his resignation in 1974. Watergate was not about the break-in at Democratic National Headquarters or the (perfectly legal) Oval Office taping system, but rather about what that bungled break-in threatened to expose and what those tapes revealed about all the president's men, and about the president himself. "I never knew a man / could tell so many lies," Neil Young sang in 1974, and there was no doubt to whom he was referring.

The filmmakers of the New Hollywood were influenced by the politics of the times, but they were also, as filmmakers, profoundly influenced by the history of their own craft. One important source of inspiration and affinity was film noir, the dark and fatalistic crime dramas of the 1940s and beyond. These films were made during the heyday of the studio system, yet they were shot in the antithesis of the classical Hollywood studio style, and they pushed the production code to its limits, possibly because they flew under the radar, or because their complex (or convoluted) plots left the censors unsure as to what they had seen. One thing they didn't see, to take *The Maltese Falcon, Double Indemnity,* and *Out of the Past* as iconic examples, was happy endings.

Film noir shares with the seventies film attributes of both style and substance. Filmmakers from both periods sought to portray a grittier and more "realistic" reality than what was presented in the standardized Hollywood formulation. For film noir, as the descriptor implies, this involved the use of darkness to a much greater extent than was associated with the bright, shadowless lighting of the studio system. Films noir were also infused with anxiety over

gender and shaped by an existential angst associated with the hard realities of their time—in particular, witness to the horrors of World War II, the challenges of adjusting to the peacetime economy, and postwar disillusionment (most explicitly in films like John Huston's 1948 film *Key Largo*).

Paul Schrader, initially a critic who would become an important writer and director, called attention to the relationship between the New Hollywood and film noir in a seminal essay on the topic. The renewed interest in noir, he wrote in 1972, "reflects recent trends in American cinema: American movies are again taking a look at the underside of the American character, but compared to such relentlessly cynical films noir as *Kiss Me Deadly* or *Kiss Tomorrow Goodbye,* the new self-hate cinema of *Easy Rider* and *Medium Cool* seems naïve and romantic. As the current political mood hardens, filmgoers and filmmakers will find the film noir of the late forties increasingly attractive."[32]

Film noir, as the term implies, was invented by the French, and in particular by the community of French critics who in the 1950s would create the cauldron of the French New Wave. The *nouvelle vague,* part of a broader European renaissance in film, was a big hit with the American art house crowd by the early 1960s, with celebrated debuts by François Truffaut (*The 400 Blows,* 1959), Jean-Luc Godard (*Breathless,* 1960), and many others. These filmmakers were young, self-consciously critical of the establishment, and eager to make less polished, more personal films. The New Wave had an enormous influence on the seventies film, especially with regard to the latter two points, aspiring to a more intensely personal cinema that was more "realistic" in its presentation than traditional studio-bound productions. This was new and a sharp break from the past. Even the artistic titans of the studio era, figures like Howard Hawks, Billy Wilder, Jimmy Stewart, and Cary Grant, did not see themselves as trafficking in a self-referential or personal cinema. In the late 1990s, when Cameron Crowe (then embarking on *Almost Famous,* a film based on his own life) asked his hero Billy Wilder whether he'd ever thought about making an autobiographical picture, Wilder replied that he always avoided such things, which "would only have been of interest to my mother and father."[33]

Unlike most of his contemporaries, Alfred Hitchcock (who was first taken seriously by French film critics and future New Wave directors like Eric Rohmer and Claude Chabrol) was quick to recognize and admire the new European film culture. In the early 1960s Hitchcock, always innovative and once a boy wonder himself, watched everything he could get his hands on, and was particularly impressed with Antonioni. After screening the enigmatic, unconventional *Blow-Up,* he declared, "These Italian directors are a century ahead of me in terms of technique!" He decided to make his own New Wave film, about a sex murderer, in contemporary style, with location work, natural light, and a young, unknown cast. A complete draft script was developed.

Hitchcock sent the draft to Truffaut, who wrote back with extensive commentary. About forty minutes of test footage for the film, now called *Kaleidoscope,* was shot in 1968.[34] But it didn't sound like a Hitchcock film, and the great director could not secure studio backing for the project. The master would not be permitted to join the American New Wave. Such things would be left to the next generation.

What, then, was the seventies film? One of the pleasures of the period was the toleration for, and even cultivation of, a heterogeneous product and chance taking, so there are no "laws" that define the specifics and limits of the New Hollywood. But there is a collection of attributes that commonly characterize these films in a distinct and identifiable way. First and foremost was the emphasis on moral ambiguity, and it was this that represented, with the end of censorship, the emergence of a true "adult" film—characters faced with morally complex choices, not necessarily between right and wrong, but made by imperfect people trying to find the best alternative from the menu of compromised choices that circumstances have made available to them. Choices you could talk about and debate long after the movie was over. Nazis, by contrast (or the Empire in *Star Wars*), are irretrievably evil and thus dramatically uninteresting. The seventies film set aside the black and white moral fables of childhood and took on the complex grays of grown-up decisions.

Seventies films also tended to be character driven rather than plot driven; indeed "open" endings, that explicitly fail to offer and even resist resolution, were quite common. And when resolutions did occur, evil often triumphed over good—a reflection of what filmmakers thought happened in the "real world," and also a reaction against the happy endings typically imposed on movies by studios in the past, which were seen as condescending to the audience, and just as crass and vulgar as a "happy ending" to a massage.

Seventies films often had a political text, and even more commonly a political subtext, especially with regard to gender, class, race, and the relationship between individuals and (corrupt or flawed) institutions. But of even greater import here was the inward political turn—movies that explored troubled and complex adult relationships with no obvious solutions or clean resolutions, often emphasizing themes of loss, regret, and the erosion of personal privacy. More frank sexuality (admittedly at times vulnerable to the charge of pandering and titillation) was embraced as an important vehicle for exploring characters' challenges and complexity, and acknowledging that sex and gender are inescapable elements of adult relationships.

The seventies film, in its search for a more "realistic" cinema, often had a characteristic visual style, one with a new emphasis on source lighting, location work, and in many ways "worse" picture quality—less pristine and more

often shaky, darker, filtered, or grainy—as well as a willingness to depart from "invisible" editing that seamlessly matched images and adhered to standardized notions of continuity. In sum, with the stories chosen, their content and purpose, the way they were told, and their technical presentation, the seventies film was at odds with the political and technical conventions of the classical Hollywood studio system.

Finally, individual seventies films can also be understood collectively as participating in a broad new Hollywood culture—with filmmakers aspiring to make personally meaningful films that reflected their own convictions, struggles, and visions, and with the anticipation that their movies would be received as such, by serious critics, and by the (then large) segment of the audience that saw cinema as a provocative art with something to say. Seventies films, then, were commercial enterprises, but they were more than entertainment. They were worth fighting about.

The chapters that follow explore the seventies film in the context of its time, taking seriously both the films as important works of art and the political and social context in which those movies are positioned. As noted in the prologue, the movies considered do not reflect a comprehensive overview of the American films produced from 1967 to 1976, but are attended to in a manner designed to emphasize and give shape to the content, coherence, and trajectory of the seventies film as I have defined it here. The chapters proceed in a rough chronological and thematic order, highlighting particular issues and engaging in close readings of selected films.

CHAPTER 2

TALKIN' 'BOUT MY GENERATION

"The employers will love this generation," University of California president Clark Kerr notoriously predicted, anticipating the college students of the 1960s. "They aren't going to press many grievances. They are going to be easy to handle. There aren't going to be any riots."[1] But the baby boomers—the massive demographic bulge produced in the twenty fat years after World War II—would prove to be more than a handful.

The first few years of the decade did not do much to disconfirm Kerr's expectations. A youth culture of clean-cut, well-mannered, buoyant Americana was reflected in early-sixties television, movies, and pop music. But a closer look would reveal two shadows that portended an ominous if repressed unease across the white picket fences of the postwar American dream: the cold war and the struggle for civil rights. The baby boomers as children witnessed the bloody spectacle of racial oppression on TV; they were raised to imagine the possibility of their instant annihilation. Into the 1960s these pressures mounted. In September 1962 President Kennedy sent federal troops to Oxford, Mississippi, to suppress the rioting that followed his order of protection for James Meredith, the first black student to enroll at the University of Mississippi. In October the president announced to a stunned nation his blockade of Cuba in response to the Soviet introduction of missiles there. The world stood on the brink of nuclear war.

Nineteen sixty-three was a watershed year for the emergence of a new generational culture. On August 28 the March on Washington brought the largest demonstration in the history of the capital; Martin Luther King Jr. delivered his "I have a dream" speech. In September the first baby boomers entered

college; before the term was out, President Kennedy was assassinated. A traumatized nation shuffled forward in a stupefied daze, awakened, it seemed, by the arrival of the Beatles a few months later. Over 70 million people—almost 40 percent of the entire population—watched them perform on *The Ed Sullivan Show*. At their first American press conference, the Beatles, sporting rather modest "mop tops," fielded five questions about the length of their hair.

Trouble began brewing on college campuses in 1964, most notably at Berkeley, the flagship campus of the University of California. Politically active students, some returning from a summer of dangerous volunteer work in the South on behalf of the civil rights movement, were astonished to find that the university had banned the information tables they had traditionally set up on the fringe of the campus to support various causes. In protest, some students set up tables in the middle of campus, an action that led to the "indefinite suspension" of eight students, which in turn led to the formation of the Free Speech Movement (FSM). On the afternoon of December 2, following a rousing speech by undergraduate civil rights activist Mario Savio, one thousand students occupied Sproul Hall. At 3AM the police moved in to clear the building, a twelve-hour process that led to 733 arrests, the largest mass arrest in the history of California. The students responded with a general strike. Ultimately they were supported by the faculty, which led finally to the revision of the regulations regarding speech and political activity at the university along the lines that had been demanded by the FSM.[2]

Politics was not the only thing that stoked student dissent on college campuses in the 1960s. There was also the figurative—and, from a legal standpoint, often literal—paternalism of university administrators. *In loco parentis*, a status meaning "in place of the parents," gave college authorities the power to determine those freedoms students would be allowed to enjoy and what punishments they would bear for violating university rules. These prohibitions most notoriously affected social relations, with female students governed by strict curfews, limitations on visits from men, and imaginative regulations like the "three-foot rule" (requiring a couple to keep three of their four feet on the floor at all times) and the "three-book rule" (the width that doors must remain open), designed to preserve the wholesomeness of young women on campus.[3]

Increasingly, students gained more latitude in what they were able to get away with (though Brandeis University *tightened* its dorm visitation policies in 1964). But a more permissive youth culture was not without its critics. Ronald Reagan, running for governor of California in 1966, seized on "the mess at Berkeley" as a key theme in his campaign. On the stump he declared that the leaders of the "so-called" free speech movement should have been "taken by the scruff of the neck and thrown out of the university once and for all." Reagan went on to read from a report of a dance held at the university, featuring

"three rock and roll bands," two movie screens that displayed "the nude torsos of men and women...in suggestive positions and movements," air thick with "the smell of marijuana," and, finally, "indications of other happenings that cannot be mentioned here." He won the election in a landslide.[4]

Reagan was tapping into a larger sociopolitical conflict with an important generational component—and it ran both ways. A new generation "has totally rejected the values of the previous one, a rejection that is completely defensible and understandable," said film director Arthur Penn. "The question we have to ask is: how do we want to live our lives and what values do we want to hold ourselves to?" More superficially, David Newman and Robert Benton (who would go on to write Penn's *Bonnie and Clyde*) fired an early salvo in this defining struggle with a splashy, influential cover story in *Esquire* magazine defining a "New Sentimentality." The pop essay contrasted the vanguard of new thinking with the vestiges of old (and obsolete) values. Out went the Fourth of July, the Rat Pack, and John Wayne; standard bearers of the New Sentimentality included the Beatles, Hitchcock, and Jean-Paul Belmondo.[5]

People of all ages were thinking in generational terms—especially as the first baby boomers entered young adulthood—and they were very much aware of the traits, values, and behaviors that identified them as members of one cohort or another. One attribute that distinguished the sixties generation, as suggested by Newman and Benton's pantheon, was a reverence for serious film culture. The 1960s were, in Phillip Lopate's phrase, "the 'heroic age' of moviegoing." Nineteen sixty-three saw the founding of the New York Film Festival at Lincoln Center—twenty-one films played in ten days at the 2,700-seat Philharmonic Hall. Most shows sold out; most ticketholders were under the age of twenty-five. *Time* magazine ran a cover story on the new "religion of film," flush with young disciples worshiping foreign masters.[6]

As Hollywood shed much of its mainstream audience in the decades following the Second World War, the art houses, which mostly played serious foreign films produced outside the Production Code Authority, grew in both absolute and relative importance. Starting from just a handful after the war, there were around 450 such movie houses by 1960; the greater New York area alone had 150 and was the epicenter of the art film business. In 1959 Ingmar Bergman had five different films screened in the United States, and in the fall of that year the French New Wave crashed on American shores; Louis Malle's *The Lovers,* François Truffaut's *The 400 Blows,* and Claude Chabrol's *Les Cousins* played concurrently in New York City. Jean-Luc Godard's *Breathless* was not far behind. *Time* reported that 80 percent of foreign film buffs were under thirty, and young people were lining up to see the latest Kurosawa, the social realism of the British Angry Young Men, and everything by the Italians, Antonioni, Fellini, and Visconti. Antonioni's *L'Avventura* was enormously

controversial—and fighting about movies was an integral part of the heroic age. Not only was cinema taken seriously, *writing about cinema* was taken seriously as well. Pauline Kael and Andrew Sarris famously traded literary blows over auteur theory, but there were dozens of others who had a piece of the action and participated in these great debates.[7]

Emerging in the 1960s, then, was a generational culture that took its art seriously, and for which positions on film (and music) were attributes that informed one's political identity.

Youth Culture, Cinephilia, and the French New Wave

Of all the new international film movements of the heroic age, none had a greater resonance with—and influence on—the sixties generation than the French New Wave. Fittingly, the phrase *nouvelle vague* was initially coined to refer to a broad generational identity. It first appeared in a series of articles in *L'Express* in 1957, which surveyed the thoughts, habits, and tastes of its younger readers, aged eighteen to thirty. One attribute of this cohort, born between 1928 and 1940, was that they were too young to have been implicated in the traumatic fall of France in 1940 or to have collaborated with the Nazi occupation.[8] As a generation primed to reject its elders, it was a half-step ahead of its American peers. But the phrase soon became identified with a legion of new filmmakers who suddenly seemed to be everywhere in 1959: in February and March, Chabrol's first two films premiered; in May, Truffaut won the best director prize at the Cannes film festival for *The 400 Blows;* Alain Resnais's *Hiroshima, Mon Amour,* screened out of competition, was given a special award. *Breathless* was released in March 1960; the debut efforts of Eric Rohmer and Jacques Rivette and scores of others would soon follow.

The New Wave was young, the New Wave was cinephilic, the New Wave was revolutionary. Each of these three interdependent attributes defined the movement. Godard was twenty-nine when he made *Breathless.* When their first feature films were released, Truffaut was twenty-seven, Chabrol twenty-eight, and Agnès Varda twenty-seven. Louis Malle was twenty-five when he made *The Lovers* and *Elevator to the Gallows,* both with Jeanne Moreau. *The Lovers* caused a sensation with its then-daring expression of sexuality; *Elevator,* steeped in *noir,* featured adulterous outlaw protagonists and an improvised jazz soundtrack by Miles Davis.

This band of outsiders supported one another's efforts. Chabrol, in the first flush of success, provided financial support for the debut films of Rohmer and Rivette; Truffaut's fame after *The 400 Blows* helped Godard secure funding for *Breathless.* Chabrol also collaborated on *Le Coup du Berger,* a short film

directed by the twenty-eight-year-old Rivette and shot in Chabrol's apartment; Truffaut and Godard put in appearances. Rohmer scripted the short *All the Boys Are Called Patrick,* directed by Godard.[9]

Much of the camaraderie of the group came from their shared passion for cinema. Five central figures of this broad movement—Chabrol, Godard, Rivette, Rohmer, and Truffaut—first met in the late 1940s, when they haunted the Cinémathèque Française, run by the passionate and colorful Henri Langlois. As Truffaut later recalled, "The Cinémathèque was really a haven for us then, a refuge, our home, everything." Godard and Rivette once showed up for the 2 PM screening of Orson Welles's *Macbeth;* Godard watched repeated screenings through 10 PM while Rivette stayed on till midnight. Langlois was a godfather of the New Wave, as was the critic André Bazin, who was virtually a surrogate father to Truffaut. In 1951 Bazin co-founded the journal *Cahiers du Cinéma,* and over the next decade his young movie fanatics—the Young Turks—served as prominent voices of the new periodical. The *Cahiers* critics had a distinct enthusiasm for American films, championing Hitchcock, Welles, Howard Hawks, Nicholas Ray, Samuel Fuller, and Fritz Lang. In European cinema, the magazine studied and revered the work of Ingmar Bergman, Max Ophuls, Jean Renoir, and Roberto Rossellini.[10]

From their days as critics, the New Wave figures were hugely controversial. Bazin in the 1940s was an early champion of *Citizen Kane,* which was initially panned in France, and of Alfred Hitchcock, a critical stance that provoked even greater controversy. French intellectuals and the left more generally were deeply suspicious of *Cahiers'* enthusiasm for American cultural products, and the journal's lack of proper respect for French films with a commitment to social causes was coded as "anti-left." Certainly the youthful upstarts instinctively rejected doctrinaire authority, whether from the Communist Party or the Catholic Church. Nevertheless, they were opposed to the Algerian war (Truffaut was banned from appearing on state-owned media after he signed a public petition against it), prescient in their early criticism of the American campaign in Vietnam, and associated with the interrogation and rejection of traditional social norms that occurred in the 1960s. But the political struggle the Young Turks were most interested in took place at and about the movies. "We have won the day," Godard crowed on the heels of the triumph of *The 400 Blows,* "in having it acknowledged in principle that a film by Hitchcock, for example, is as important as a book by Aragon."[11]

Before they revolutionized cinema with their cameras, however, the New Wavers fought a pitched battle with the French film establishment in the pages of *Cahiers.* The journal devoted relatively scant attention to French cinema, and when it did, it championed maverick figures such as Renoir (then in self-imposed exile in Hollywood), his disciple Jacques Becker, Robert Bresson,

and Jean-Pierre Melville. Melville, a passionate cinephile, shot his first film, *The Silence of the Sea* (1949), on a shoestring budget, self-financed outside the French studio system. This was a heroic and inspiring accomplishment in the eyes of the Young Turks, who had nothing but disdain for the industry establishment, which concentrated power and production within a few familiar hands and enforced a rigid hierarchy in which employee-apprentices were expected to make their way slowly and dutifully up through the ranks.[12]

In December 1952, twenty-year-old François Truffaut showed André Bazin the first draft of a long, vituperative essay on the sclerotic state of mainstream French film. He argued that the industry, with its emphasis on safe, prestigious literary adaptations, had resulted in an antiseptic, lifeless cinema with no voice or identity. A system whereby the director served the screenwriter was an important source of this problem; the director, according to Truffaut (and his cohort), must be a movie's *auteur*—the author and source of a film's principal artistic voice and vision. Bazin was more than sympathetic to Truffaut's point of view, but he held back the piece, insisting on rewrites to tone down some of the rhetoric. (Truffaut's youthful contempt for "le cinéma du papa" was among the many barbs that remained in.) The article, "A Certain Tendency of the French Cinema," was finally published in January 1954, alongside a qualifying editorial that hoped to preemptively contain a bitter controversy. It did not.[13]

Truffaut's landmark diatribe was not unrepresentative of the brash, opinionated contributions that each of the Young Turks routinely published in *Cahiers*. But more than academic polemics, these essays accurately anticipated how the New Wave would eventually go about the practice of filmmaking. First with documentaries and short films (two formats that afforded young filmmakers opportunities within the industry), and then in their feature films, a New Wave aesthetic and philosophy is recognizable from those earlier writings.

In general, New Wave filmmakers favored location shooting, with a strong preference for the use of source lighting (or, at a minimum, as little artificial light as possible), even when shooting on the streets at night, which they often did. They encouraged flexibility in changes to auteur-driven scenarios, emphasized more naturalistic styles of acting (often with nonprofessional players), and typically shot with small crews using fast film stocks. Some of these choices may have been reinforced by the exigencies of tight budgets and limited access, but they also reflected the preferences and strengths of the filmmakers, many of whom had experience in making documentaries under similar circumstances.[14]

Each participant in the New Wave had his own distinct style and interests, and there were many more participants beyond the most famous names. (Over 170 French filmmakers made their first films between 1959 and 1963.) Truffaut and Godard rummaged through a bag of dazzling visual tricks; Resnais

shot more classically but experimented with the manipulation of time; Rohmer became known for long takes, a static camera, and lenses that approximated human vision. But underlying this diversity was without doubt a shared and coherent set of cinematic values. Above all, they sought a more "realistic" film. In the words of participant Jean Douchet, most highly valued was "Truth, which was positioned morally above the Good and aesthetically above the Beautiful." Smaller, personal stories were favored over epic or noble themes. And in place of the "tradition of quality" and the "false perfection" of polished studio product was instead motivated experimentation with the possibilities of the form—a search for ways in which ideas could be explored and stories told distinctly through the medium of film. Notably absent from those stories were traditional heroes (youthful outsider protagonists were common). Very rarely did they conclude with a happy ending.[15]

From New Wave to New Hollywood

The French New Wave had an enormous influence on the New Hollywood; the affinity was reflected in the label. And indeed, the early efforts of a youthful cohort of American directors, including Francis Ford Coppola, Brian De Palma, Paul Mazursky, and Martin Scorsese, were quite visibly and unabashedly inspired by the French movement. In fact, even though the "seventies film" did not emerge until 1967, the influence of the New Wave was already evident in some transitional films of the mid-60s.

Two or three years ahead of its time was Arthur Penn's *Mickey One* (1965).[16] More mood than plot, it offered a fractured, expressionistic, allusive story. At the narrative level, a stand-up comedian (Warren Beatty) flees Detroit when he comes to realize that he (like many comedians in the fifties and sixties) is ruinously indebted to and essentially owned by mobsters who run the nightclub circuit. He ekes out an anonymous subsistence existence in Chicago before tentatively returning to comedy, and not without reason lives in fear that the success he finds will expose him to the wrath of the mob. But the Kafkaesque movie is interested in much broader, more existential questions than what will happen to Mickey. For Penn, those questions are "Who owns me?" the unanswered query that sends Beatty running, and, more implicitly, "What have I done that has put me in a state of obligation that confines my freedom of choice?"[17]

As *Time* magazine observed, *Mickey One* also reflected Penn's express desire "to push American movies into areas in which Fellini and Truffaut have moved." As early as 1963 Penn described the French New Wave as "the only movement I really like." As a successful and established film and theater

director, Penn had negotiated a two-picture deal with Columbia that traded very small budgets in exchange for his control over the content. And he took full advantage, embarking on the project that was "extremely meaningful" to him, even though, from the beginning, the studio "hated it."[18]

Mickey One was a failure at the box office, but Penn did succeed in essentially making a French New Wave film in America. Truffaut and Godard visited Penn on location in Chicago (and it was Truffaut who had recommended Alexandra Stewart for the female lead). The movie withholds traditional narrative signposts and leaves uncertain the passage of time; the soundtrack (echoing Malle's approach in *Elevator to the Gallows*) features improvisations by jazz musician Stan Getz. Visually *Mickey One* combines dark nighttime exteriors and stylized compositions with documentary-style street shooting by day. Penn's chief collaborator for this look was the French cinematographer Ghislain Cloquet, who had previously shot films for Resnais, Becker, and Claude Sautet. Cloquet worked on *Mickey One* in between shooting Malle's *The Fire Within* and Bresson's *Au Hasard Balthhazar.*

Penn's subject matter is also, anticipating the New Hollywood, mature and ambitious. Poverty is a recurring motif; Mickey drifts through junkyards, alleys, and flophouses, mixing in with hobos, grifters, and winos. Bosley Crowther, chief film critic of the *New York Times,* did not enjoy sitting through such "grimly realistic" scenes "played in such disagreeable places." Perhaps covering his eyes, Crowther missed Penn's main point. More than anything else, the director saw his film as an allegory for McCarthyism, about a "country paralyzed by fear" and people who feel hounded and "guilty" but are not quite sure why. (Mickey says he is guilty "of not being innocent.")[19] This theme is most apparent in Mickey's relationship with Ed Castle (Hurd Hatfield), the manager of the Chicago nightclub, who is eager to hire him. With his New Age diet, funky modern office, and unwillingness to acknowledge that he is owned by organized crime, Castle can be seen to represent the failure of liberal Hollywood, fearing for its business, to stand up to McCarthyism. Castle is reminded—four times—by his purse-string-holding business partner that he is "responsible" for Mickey. "I happen to work in a field they control...they don't control me," Castle naïvely insists. He does admit, however, that "in the real world you have to be realistic...you have to make certain compromises."

McCarthyism fills in part of the backstory for another important European-influenced film that was transitional toward the New Hollywood—John Frankenheimer's *Seconds* (1966). Although not an element of the movie's text or subtext, it is nevertheless notable that three of the principal players in the film—John Randolph, Will Geer, and Jeff Corey—had been blacklisted in the 1950s for refusing to name names before the House Un-American Activities Committee. Unable to find work, Corey (who also appeared in *Mickey One*)

became a prominent acting teacher; his students included Roger Corman, James Dean, Jack Nicholson, Anthony Perkins, and Robert Towne.

Frankenheimer produced and directed *Seconds* after spending a year in Europe, and he was obviously influenced by the experience. He had always been a thoughtful and imaginative director—*The Manchurian Candidate* (1962) was an ambitious film filled with innovative shots—but *Seconds* was something different; it combined dazzling visual techniques with a dedicated commitment to "realism." Thus while Frankenheimer (working closely with cinematographer James Wong Howe) chose a tricked-up visual style—disorienting wide-angle lenses, numerous, often shaky handheld shots, and bracingly tight close-ups—he also insisted on using real locations and (where possible) source lighting. And so the film opens in the real Grand Central Station and then hops on the real train to Scarsdale, after which Arthur Hamilton (Randolph) arrives at the real train station there and gets into a real car (as opposed to a studio mock-up with rear projection). Frankenheimer went so far as to have Tony Wilson (the "reborn" Hamilton, played by Rock Hudson) live in his actual California home, just as Truffaut featured his own apartment in *The Soft Skin* (1964). These potentially conflicting elements meshed neatly because the visual choices were clearly motivated; as Frankenheimer later explained, the distortion was "terribly important" to show "how society had distorted this man." And the handheld work accurately captured Hamilton/Wilson's disposition, especially at the drunken party (at which Hudson was encouraged to *really* drink), where the anxiety-provoking jittery camera showed the character coming apart and anticipated the terrible secret he was about to learn.[20]

There are no young people in *Seconds,* but the film points to a critique of middle-aged, upper-middle-class affluence that would soon be expressed on college campuses. Arthur Hamilton is a success by the standards of the American Dream. A respected banker with a nice house in the suburbs, a wife, and grown children, he had "fought hard for what he was taught he wanted." But his life (like the lives of his peers) is portrayed as empty, meaningless, and a bit desperate. Lingering in a (real) meatpacking plant (*Mickey One* also features one prominently), *Seconds* suggests that the peddling of flesh is part of capitalist materialism, and also more directly foreshadows the Faustian arrangement that Hamilton will reach with the shady corporation that promises him a new life.

Of course it all goes horribly wrong; wiping the slate clean and trying to start again, even when provided with "what every middle aged man would like to have," is exposed as an impossible fantasy. The opposite of a feel-good movie, *Seconds* ends first in despair and then in horror. Frankenheimer, for whom the film had great personal meaning, emphasizes the former—the lesson that "your experience is what makes you the person you are. If you don't want

to live with it, it's just too bad."[21] But *Seconds* also ends in transgressive horror, as Wilson is murdered by the corporation so it can make use of his body. The film lingers extensively on Rock Hudson's truly disturbing, terrified struggle as he is wheeled to his fate—one that pushes *Seconds* through the withered walls of the crumbling and decrepit production code and into the realm of the seventies film. Frankenheimer was forced to trim some nudity for the American cut of the film, but left untouched were the fates of several featured characters who not just get away with murder but go on with their work.

Seconds, like *Mickey One,* was not a commercial success. Had they been released in 1967, the year that *Blow-Up,* Bergman's *Persona,* and the politically charged *Battle of Algiers* lit up the art houses while *Point Blank, Bonnie and Clyde,* and *The Graduate* met with mainstream success, they would likely have found larger audiences.[22] At that point the New Hollywood had arrived, more and more European-influenced directors were coming of age, and the trickle of New Wave–inspired films made in America became a flood.

Twenty-eight-year-old Brian De Palma aspired to be, in his words, "the American Godard." Directing twenty-five-year-old Robert De Niro in *Greetings,* De Palma applied himself to the task as if he were crossing items off a checklist. *Greetings* devotes its opening minutes to footage of Lyndon Johnson and the Vietnam War, and features intertitles, characters reading aloud, and much self-consciousness about film, media, and the act of watching. The movie dwells on the romantic concerns of young people, who often romp zanily in the streets, and obsesses about the Kennedy assassination while dropping references to HUAC, *Blow-Up,* and Truffaut's book about Hitchcock. A modest budget and location shooting meant that the final product did not have the polish of a studio film, but that was less important to De Palma than "the kind of freedom . . . you can have by shooting films this way."[23]

Paul Mazursky leaned more toward Truffaut. He would go on to make *Willie and Phil,* a reworking of Truffaut's *Jules and Jim* (as well as *Down and Out in Beverly Hills,* based on the premise of Renoir's *Boudu Saved from Drowning*). After the enormous success of his debut effort, *Bob & Carol & Ted & Alice* (1969), Mazursky, unsure of his next move, settled on *Alex in Wonderland,* a film about an uncertain young director (Donald Sutherland) flush with success from his first picture. Featuring elaborate Felliniesque fantasy sequences, an appearance by Jeanne Moreau, and much agonizing about the struggle between art and commerce—Mazursky, in a great comedic turn plays an obtuse nouveau-riche producer—the movie was derided by some critics as "One and a Half." The comparison was certainly invited; Fellini himself shows up for a cameo, and his *8½* is often invoked by the characters.

Another young Europhile was Francis Ford Coppola, who, like Chabrol, enjoyed some early success and was in turn able to help his friends secure

backing for their projects. "My romantic idea is to be part of an American New Wave," he declared. Among his early efforts, *The Rain People* (1969), inspired by an event in his childhood, has the strongest New Wave imprint. Coppola's cast and crew hit the road with an unfinished screenplay, caravanning in five cars across eighteen states. Not only did they shoot on location, the actors were often inserted into real events and filmed surreptitiously as well. *The Rain People* had much to say about "America," but it can also be seen as anticipating many of the identity-based issues that would be emphasized by the emerging women's movement.[24]

Perhaps the greatest disciple of the new European cinemas was Martin Scorsese, who was in film school during the heroic age of moviegoing: "The French New Wave...the Italian Art Cinema....What these movies gave us film students was a sense of freedom, of being able to do anything." For Scorsese, "the first two minutes of *Jules and Jim* were the most liberating of all." Resnais and Godard were also important influences, as was John Cassavetes, the maverick independent American filmmaker whose jazz-inflected *Shadows* (1959) was an art house sensation.[25] Scorsese was twenty-five when his first feature, *Who's That Knocking at My Door,* debuted at the 1967 Chicago International Film Festival under the title *I Call First.*

Who's That Knocking explores many of the themes and motifs that would reappear in *Mean Streets* (1973): religious iconography, street violence, rock music, and the awkwardness of young men around women. Shot on locations with skeleton crews on the streets, in hallways, at local churches, and in borrowed apartments, the movie concerns a Scorsese alter ego, J.R. (Harvey Keitel), navigating between his ne'er-do-well friends and a new romantic interest. Within its first few minutes *Knocking* features a night-for-night voyage on the Staten Island ferry, jumpy inserts, splintered flashbacks, and conversations about American movies and French magazines. A prowling, jittery handheld camera records two intense party scenes, which owe much to Cassavetes and where just below the surface of male bonding lies an undercurrent of violent rage. Scorsese screened the film for Cassavetes, who loved it, calling the movie honest and truthful, which is what all the new cinemas were searching for.[26]

The Generation of Rock and Roll

Another generational fault line that developed in the mid-1960s had to do with the music. The reemergence of rock and roll was nothing less than a cultural, generational, and implicitly political social movement. The music was taken seriously, and it came to represent a fiercely contested dividing line across American society. Especially important were Bob Dylan, the Beatles, and, later, the

Rolling Stones; but music as identity politics was an across-the-board phenomenon distinguished by dozens of contributions by important artists. Baby boomers looked to new albums "as if a fresh and useful articulation of their own state of mind might be found there."[27] In the fourteen months between March 1965 and May 1966, Bob Dylan released three albums that changed the world: *Bringing It All Back Home, Highway 61 Revisited,* and *Blonde on Blonde.* They were like nothing that had ever been heard before. Following Dylan by about half a year were the Beatles, with *Help! Rubber Soul,* and *Revolver.* The transitional *Help!* featured Dylan-influenced "You've Got to Hide Your Love Away" and "Ticket to Ride" and the ambitious "Yesterday." *Rubber Soul* and *Revolver* heralded the metamorphosis of the Beatles from an intoxicating pop phenomenon into the royalty of a transformative movement. "Oh I get it," Dylan told Paul McCartney at the time, "You don't want to be cute anymore." The Beatle agreed. And so rock music became not just a musical style but "a cluster of values...an ingredient in a variety of youthful subcultures around the world."[28]

Rock and roll pushed establishment panic buttons because it encapsulated and energized, all at once, so much of what was going on in the sixties: civil rights, sexual freedom, drug use, and the generational questioning of traditional norms and values. Rock was, inherently and often explicitly, deeply committed to the civil rights movement. With its roots in the blues, rhythm and blues, and soul, rock music was black music, and white rockers not only consorted with but also revered black musicians. On his first album Dylan (who played at the March on Washington) covered songs by Jesse Fuller, Blind Willie Johnson, and Bukka White. The Rolling Stones started out as a blues cover band; their first album featured songs by Willie Dixon, Jimmy Reed, Slim Harpo, and of course Chuck Berry (who could make a fair claim to have invented rock), whose signature riff was deconstructed and reimagined in many of the Stones' hits. The Beatles also covered black music; "Twist and Shout" was originally a hit for the Isley Brothers, and the Fab Four's signature "wooos" were learned at the feet of the enormously influential Little Richard, with whom they performed. On their first American tour in 1964, when the Beatles learned they were scheduled to appear before a segregated audience in the South, they refused to participate. Paul and George forcefully expressed their disapproval, and John made the band's position clear: "We never play to segregated audiences and we aren't going to now."[29]

Dylan and the Beatles pushed each other toward those musical forms that would force rock into the generational conflicts of the 1960s. "The onslaught of the new," that is, the overwhelming force and promise of Beatlemania in America, encouraged Dylan's leap from folk to rock. In 1964 he experimented with rock arrangements for the songs on his fourth album, *Another Side of Bob*

Dylan, before essentially chickening out. But soon afterwards he "went electric," most notoriously at the 1965 Newport Folk Festival in a controversial, divisive performance. Old-timers Alan Lomax and Pete Seeger were furious; apocryphal stories had Seeger threatening to take an ax to the electric cables, while Peter Yarrow gave the finger to folk purists from the sound board.[30] Yet the larger controversy was real—when one fan shouted out "Judas!" to a stunned Dylan on tour in Britain in 1966, the sentiment was heartfelt, and it was shared by others.

As for the Beatles, Dylan inspired them to take their songwriting into serious territory. As James Miller observed, he "singlehandedly showed the Beatles a new way to fashion themselves." John and George in particular were transformed by the light of the trail that Dylan was blazing. But the idea that rock music could "have something to say" was ridiculed by an older generation, especially the journalists who were displeased at being forced to listen. Rock journalism was, at the time, an oxymoron (*Rolling Stone* magazine was still a few years away), and so press conferences between established, serious, condescending journalists and clever, obscure, defensive counterculture musicians devolved into rehearsals of all kinds of resentful generational conflict.[31]

Dylan also famously turned the Beatles on to pot after his Forest Hills concert in 1964. Previously the Beatles, like so many working musicians before them, had favored speed. But pot and other hallucinogens—especially, into 1966, LSD—left their imprints on the music. Sex and drugs were part of what made the new music so dangerous and controversial. The very phrase "rock and roll" was, among its other meanings, a euphemism for lovemaking, and was at one time viewed as an obscene expression for that reason. Musicians had always been notorious sexual troubadours, and were tacitly understood to dabble in illicit drug use. But with rock, especially its Dylanesque turn toward searching, introspective, and confessional themes, these aspects of the minstrel lifestyle became explicit and seemed to encourage, or at least abet, the new, looser morals that were observable in young audiences. The Rolling Stones, in particular, were notably unsubtle in their celebration of sex and drugs.[32]

Love it or hate it, rock music in the mid-1960s *mattered* as it never had before and, soon enough, as it never would again. The Beatles "now exist not merely as a phenomenon of entertainment but as a force of historical consequence," literary critic Richard Poirier concluded in a major essay that appeared in the pages of the highbrow *Partisan Review.* The Beatles "and Bob Dylan, too," could be placed "within a group who have…infused the imagination of the living with the possibilities of other ways of living." Intellectuals at the *New Left Review* debated whether the Stones were as meaningful as the Beatles, while agreeing in any event that pop music is "perhaps the only art form which has an authentic expressive vitality in England." For Vaclav Havel,

the dissident playwright and future Czech president, with the new music of the 1960s, "taboos could be swept away, social conflicts could be named and described."[33]

Others saw it differently. The conservative mandarin Allan Bloom concluded that rock music "ruins the imagination of young people and makes it difficult for them to have a passionate relationship to . . . art and thought." For Bloom, rock was a "gutter phenomenon" amounting to little more than "Mick Jagger tarting it up on stage." Bloom's observations about Jagger might be dismissed as saying perhaps more about him than they do about rock. But when Bloom equated Woodstock with Nuremburg—and he wasn't kidding—he articulated a position that was held dear by many on the other side of the cultural divide.[34]

Bloom and company notwithstanding, what stands out from the 1960s, especially in retrospect, was the extraordinary eruption of epochal music.[35] The apogee of all this was 1967, the year of the birth of the New Hollywood. It also was the year of the San Francisco hippie, the Summer of Love, the Monterrey Pop Festival, and *Sergeant Pepper.* There was lots of great music put out in 1967, but *Pepper* was a landmark. After directing *Point Blank,* John Boorman returned to London from America "in time to buy [*Pepper*] on the day of its release." Everybody did. "We felt on the brink of a brave new world."[36]

Boorman's sentiment also reflected a broader and essential synergy between the New Hollywood and the New Music. Rock was the soundtrack of filmmakers' lives, and in turn the musicians who came of age during the heroic era of moviegoing were extremely interested in exploring the possibilities of the liberated American cinema. Dylan participated in D. A. Pennebaker's cinéma vérité film of his 1965 tour of Britain, *Don't Look Back* (1967).[37] The film's muddy sound, dark, grainy images, and bobbing camera captured much that seemed authentic—confrontational press conferences, busy hotel rooms, rainy road trips, formal and informal musical performances—and, notably, many unflattering moments that other image-conscious celebrities would surely have trimmed from the final cut. Of course, as Andrew Sarris observed, this was not "Dylan as he really is, whatever that means, but rather how Bob Dylan responds to the role imposed on him by the camera." Nevertheless, *Don't Look Back* reflected the eagerness of artists from each form to engage the other, and their desire to move their art closer to something more truthful.[38]

The Rolling Stones collaborated with Jean-Luc Godard on *Sympathy for the Devil* (1968), which documents the evolution of the song and its recording, interspersed with material that looks, not surprisingly, very much like a Godard film of the period (such as *Weekend* or *La Chinoise*).[39] The effort is most notable as a manifestation of the desire of these artists to work with each other. Mick Jagger (like Dylan and Lennon) took occasional acting gigs, most notably

in Nicholas Roeg's surrealistic gangster film *Performance* (1970), which features a musical interlude (showcasing the song "Memo from Turner") that could stand alone as an early music video.

The Beatles got to the movies first, playing fictionalized versions of themselves in Richard Lester's celebrated film *A Hard Day's Night* (1964) and then *Help!* (1965); the documentary *Let It Be* (1970) captured the group's painful unraveling. Lester, who also directed John Lennon in *How I Won the War* (1967), went to San Francisco (with Roeg along as cinematographer) to shoot *Petulia* (1968). Shot on location in the midst of the Haight-Ashbury counterculture scene, *Petulia*, featuring George C. Scott and Julie Christie, is very much of its time. Flashbacks are shuffled, the Vietnam War is on TV, and hippies are everywhere. And the music is never far away; the movie showcases performances by Janis Joplin and the Grateful Dead. But as in *The Graduate* (1967), what is especially notable about *Petulia* from the vantage point of the intervening years is that a film so purposefully about the generation gap offers its deepest insights about the older generation. Archie (Scott), his wife, and their best friends share scenes that explore the common unspoken mid-life anxieties that have led Archie to inexplicably walk away from his marriage. The generation gap cut both ways, and although *Petulia*'s politics are progressive, it is sophisticated in dwelling on the hard truth that all choices have consequences.

Peace, Love, and ... *Point Blank?*

In 1967 the new American cinema arrived, and John Boorman's *Point Blank* (1967) exemplified the revolutionary new approach to filmmaking. Ostensibly it is a simple revenge picture about a man named Walker (Lee Marvin) who, after participating in a heist, is double-crossed, shot, and left to die in the abandoned Alcatraz prison. But he survives and reemerges to seek vengeance against his wife and best friend, and anyone else who gets in his way, as he pursues the recovery of the $93,000 that is "rightly" his. In this quest Walker ruthlessly works his way up the hierarchy of the mob, into whose hands the loot has fallen.

That accurately describes the source material—the book and the version of the screenplay that Boorman and Marvin first read. But it is little more than the narrative hook they used to provide some (limited) grounding for the film. The filmmakers couldn't care less about the $93,000—Boorman was interested in Walker's "emptiness, desolation, [and] alienation," and so the first thing he did was move the action from joyous, tie-dyed San Francisco to anonymous, monochromatic Los Angeles.[40]

Point Blank is a tone poem that abandons classical linear, closed-form story-telling in favor of a stylized, enigmatic approach that aspires to communicate thoughts and ideas through visual expression. In the film, Walker is a mythic figure navigating a dreamscape, "trying to find his humanity." There is an eerie artificiality about the movie, the result of Boorman's decisions to strip the dialogue to its essentials and to design each scene in a single color, starting out with cold grays and blues, and then moving across the spectrum before concluding with a muted rusty red. The yellows associated with Chris (Angie Dickinson) are especially salient; in addition to costumes and backgrounds, Boorman spilled yellow paint on everything from pillars to telescopes, as Dickinson's scenes mark the film's transition from gangster greens to the fading rust of the return to Alcatraz.[41] The film comes full circle with this return, and it does not explain itself. His money waiting for him, Walker does not claim it but instead fades into the shadows.

Point Blank lends itself to a number of possible interpretations; a popular one is that Walker never leaves Alcatraz, but rather the entire film represents his dying thoughts. This is a sustainable reading (and Boorman does not reject the possibility),[42] consistent with aspects of the stylized violence, the flashbacks and echoes, and the open, inscrutable ending back at the prison fortress. Alternatively, Walker could be seen as a ghostlike figure, which fits with the fact that he never actually *kills* anyone but is present at moments that trigger their demise; this also fits with the way several characters relate to him and lends a double entendre to some line readings. "You died at Alcatraz all right," Chris snaps after a particularly cold move by Walker; in the narrative, she is speaking figuratively of his lost humanity. Later, her disembodied voice (over a loudspeaker) challenges the apparent purpose of his existence, his single-minded pursuit of the money: "What would you do if you got it?" "Why don't you just lie down and die?"

Another reading of the film, however, is more straightforward. At one level the movie does, in retrospect, volunteer a concrete story: Walker is being used by the mysterious Yost to flush out and eliminate his disloyal, plotting subordinates within the syndicate. This doesn't quite account for Yost's mystical attributes—there is an ethereal quality to the way he shows up unexpectedly at crucial junctures, seeming somehow apart from the surroundings—but he does have an agenda, and it does come to closure, and in that sense he needed a "real" Walker to pull it off.

What is certain is that Boorman (and Marvin) were more committed to broader themes and the overall feel of the movie than to its narrative resolution. The director is clear about the mood that he was searching for: repetition, déjà vu, and echoes. "Every single scene was echoed in another scene," Boorman explained, which gives the feeling of being trapped in

a revolving door, an effect "we associate...with Resnais."[43] Boorman also shared Resnais's taste for experimenting with how the passage of time can be expressed, and manipulating the way audiences implicitly depend on the certainty of its inevitable unfolding though the use of fragmented flashbacks and temporal discontinuities.

The early sequences of *Point Blank* illustrate these ambitions as the initial heist is intercut with scenes of Walker's best friend, Mal Reese (John Vernon), desperately trying to get him to participate in the scheme; pleas of "you're my friend," and "trust me" are interspersed with the Alcatraz betrayal. (These tics and flashbacks to prior events, some possibly imagined, occur throughout the film.) With the elliptical passage of unspecified time, a recovered Walker tracks down his wife, Lynne (Sharon Acker); bursting into her home, he empties his gun into the bed, where he expected to find Mal. Spent, he withdraws to the living room and sits silently as Lynne both recites the questions he would have asked and then answers them. "I dream about you, and how good it must be, being dead," she concludes.

Then things get especially strange. A flashback to good times with Lynne and Mal. Back to the "present" with Lynne dead on the bed, an overdose. Peering at Yost on the street through the blinds. Gazing back to the bedroom; Lynne is gone, the bed stripped. Into the living room, now bare of furniture. Sitting in the corner, a shot designed to echo the cell at Alcatraz, with an aural flashback to the gunshots. Then (later? earlier?) a messenger shows up; the house is fully furnished, and Walker, wearing a different suit, extracts the information he needs in an odd, rhythmic, repetitive exchange. For Boorman, "the shots show a disturbing progression into madness." The studio was confused.[44]

Walker, spent, in a sea of grays

Point Blank encapsulated much of what the emerging seventies cinema would be about. It was very much a personal film. Boorman and Marvin were each attracted to the material because it touched on issues that were deeply and personally important to them. For Boorman, the key theme was one of betrayal; aspects of the infidelity and betrayal in the story resonated with experiences that shaped his own upbringing. (From this perspective, it matters little whether Walker literally survived at Alcatraz—with the betrayal by his wife and best friend, he died inside.) For Marvin, it was the bleakness of the character, which he related to the action he saw in the Pacific during World War II, and his fear that "he had lost some element of his humanity in that brutal experience." (At one level Boorman saw the film as a character study of Lee Marvin and his return from a war in which he should have died.) Neither of these themes was central to the gangsters-and-vengeance screenplay that they first read. Legend holds that Marvin agreed to do the picture under one condition—and with a flourish he threw that version out the window. Boorman and Alex Jacobs rewrote the screenplay virtually from scratch, and Marvin's improvisations led to additional revisions during shooting. The Boorman-Jacobs version eliminated the police, added the crucial characters Yost and Chris, recast the treatment of the mob, and abandoned the conventional "happy" ending wherein Walker recovered the money. The moral of the movie was the opposite of the one intended by the original version of the screenplay: Boorman's film was about the futility of the quest for revenge.[45]

Point Blank also had undertones regarding sexuality, morality, and America that would be common to the seventies film. The movie hints that the love triangle between Walker, Lynne, and Mal has a homosexual element to it, at least subtextually; the initial scene with Mal and Walker (incongruously) rolling on the floor, and its echo later, were both shot with this in mind.[46] The visual looping of the (imagined?) lovemaking of each of the four heterosexual pairings, intercut (yet again) with flashbacks to Alcatraz, also hints at some sexual complexity. Also of interest is Boorman's portrayal of the mob not as old-style gangsters but as a modern corporation that operates out of a high-rise office building, complete with secretaries and waiting rooms; there seem to be more accountants than killers on the payroll. It is a running joke that, as Walker seeks his money, none of the executives of this modern outfit actually deals in cash, and they all talk like businessmen. Once again, this was a change that Boorman initiated. Instead of the conventional gangsters originally described, he "wanted to make it the business world," where the organization has legitimate and illegitimate business interests which are virtually indistinguishable. The director wanted his criminals "to look like business men" and cast no traditional ethnic stereotypes: "They've all got blue eyes." Most broadly, Boorman "wanted to make a statement about America," which was not lost on

the French critic Michel Ciment, who compared the film to *Mickey One* in that it is "possible to interpret it as a more complex allegory, as a symbolic portrait of the United States."[47]

In 1967, however, this kind of filmmaking was still relatively unfamiliar, and it generated conflicts during the shoot and in postproduction, with battles commonly drawn across generational lines. Metro-Goldwyn-Mayer was still run by the last generation of Old Hollywood executives, and Boorman had nothing but conflicts with the power brokers of his studio, who were "bewildered and dismayed" by what he was doing. From meeting to meeting, screening to screening, baffled executives were unhappy with the story, its bleakness and confusing ambiance. Moreover, Boorman's color schemes were simply *not how things were done.* They threatened re-shoots. After a screening of the Resnais-inflected time puzzle at Lynne's house, they moved to kick Boorman off the picture. In all instances Marvin, who was a very hot actor at the time, interceded on his director's behalf. The commercial success of *Blow-Up,* which was released while *Point Blank* was in production, also took some of the studio heat off the picture.[48]

Once in theaters, *Point Blank* also attracted some controversy for its content. As with many of the protagonists of the next ten years, Walker was an antihero. In fact, even though the movie has the audience rooting for him, he is a ruthless violent criminal. In addition, the film was, by the standards of the time, brutal in its presentation of violence, breaking taboos previously enforced by the production code. The Summer of Love was also, at the movies, the summer of bloodshed, and this generated debates about the responsible treatment of violence by filmmakers in the absence of censorship.[49] Walker may not actually kill anybody, but his fistfights are frequent and his tactics vicious. Bosley Crowther was not alone in branding the film "candid and calculatedly sadistic," with a hero who "develops no considerable moral sense."[50] For Crowther, things were about to get much worse.

The Controversy over *Bonnie and Clyde*

More than any other picture, Arthur Penn's *Bonnie and Clyde* (1967) heralded the arrival in America of a "New Cinema," as *Time* dubbed it in a cover story featuring the film. It was a big hit. *Bonnie and Clyde* not only made lots of money; it also resonated with the culture, even influencing fashion trends. Set in the past, the movie was nevertheless obviously aimed squarely at the big issues of the present; it reflected new sensibilities and sparked controversy for those reasons. Yet it might easily have slipped by unnoticed. Studio support from pre-production to release was tepid at best, and many of the early reviews

were scathing. Bosley Crowther found it "as pointless as it is lacking in taste." Only after a spirited debate among critics (divided largely along generational lines), and the relentless efforts of thirty-year-old producer-star Warren Beatty to persuade seventy-five-year-old Jack Warner not to bury the project, did *Bonnie and Clyde* find its audience. Warner, who hated the picture, retired from his studio in 1969, the last of the old movie moguls to exit the stage.[51]

Bonnie and Clyde was a long time in coming, written by the "New Sentimentality" journalists David Newman and Robert Benton, who were very much inspired by the French New Wave, which, they recounted, allowed them "to write with a more complex morality, more ambiguous characters, more sophisticated relationships." In fact they were "specifically writing it for Truffaut," and the French director flew to New York in March 1964, meeting several times with Newman and Benton during his visit. Many of Truffaut's suggestions found their way into the final film, but ultimately he passed on the offer, softening the blow with high praise and suggesting as his replacement Godard, who was familiar with and enthusiastic about the project. "Am in love with *Bonnie and Clyde*," he wired Truffaut. But the Godardian interlude did not end well, as the film's original producers were unprepared to move ahead at his breakneck pace.[52]

The project languished until Warren Beatty (at Truffaut's suggestion) bought the rights to the property. He approached Arthur Penn to direct, and also brought in Robert Towne to make revisions to the screenplay.[53] As with *Point Blank,* Penn's film took full advantage of the opportunities provided by the dismantling of the production code and did so from its opening shots. Bonnie (Faye Dunaway) is introduced with images that emphasize her sexual availability, and her dress and mannerisms express a libidinous sexuality. (The way she handles bottles and guns is probably still illegal in several states.) She is also aroused by Clyde's brazen criminality, which presents something of a dilemma, since he is impotent.[54] This works dramatically, since, as Dunaway observed, if they'd had "a happy, successful, serene sexual life together, they probably wouldn't have gone on killing people and robbing banks." The sexual tension between them builds subliminally in tandem with the rising level of violence in the movie, and Bonnie's efforts to arouse Clyde include an allusion to oral sex (another previously taboo subject), which Dunaway performed as "a direct homage" to Jeanne Moreau in Malle's *The Lovers.*[55]

Far more controversial than the nudging of the envelope regarding sexuality was *Bonnie and Clyde*'s radically new and frank expression of violence. That violence comes on suddenly, almost a full half-hour into the movie, and so is all the more shocking. In the midst of a frantic escape, a man grabs hold of the getaway car and Clyde shoots him in the face—and without a cut, contrary to the classical Hollywood composition that audiences at the time would have been accustomed to.[56] From there the violence escalates. It is almost always initiated by the police, and it becomes ever more graphic and brutal. When

Bonnie, Clyde, and Buck Barrow (Gene Hackman) are wounded during various shoot-outs, they are bloodied. Flesh is torn, and the wounds are agonizing. With each successive shoot-out the police bring more and more firepower to bear, elements of overkill that foreshadow the final slaughter of Bonnie and Clyde in a hail of machine gun fire.

For the filmmakers, the treatment of violence in the film was real and honest. "Let's face it: Kennedy was shot. We're in Vietnam, shooting people and getting shot," Penn stated at the time. "So why not make films about it." The director saw "an implicit connection between the film and the Vietnam war." Clyde's death, especially with the effect of a piece of his skull flying off, was supposed to be evocative of the Kennedy assassination.[57]

The violence in *Bonnie and Clyde* was controversial not simply because of its (considerable) shocking effect but also in its implicit normative judgments. The police are more violent, more brutal, and more cavalier in their disregard for human life than are the film's outlaw heroes. As Benton says plainly, "Our sympathies were with Bonnie and Clyde." Bank robbers and killers, yes, but their characters are repeatedly portrayed with great warmth; lawmen and authority figures, by contrast, are uniformly presented as cold and ruthless. Condemnation of the gang's criminal lifestyle is also mitigated by setting it within the context of the Great Depression; the film is dotted with references to foreclosures, Dust Bowl refugees, and heartless bankers.[58] If we take the film allegorically and into the present, as the filmmakers intended, the point is emphatically political. The Barrow gang represents the youthful counterculture of the 1960s, and the police who shoot the outlaws down in cold blood represent the contemporary establishment. Writers Newman and Benton in particular put great emphasis on the tattoo sported by Clyde's sidekick C. W. Moss (Michael J. Pollard). "Just as our parents were 'offended' by long hair[,] ... rock and roll, smoking pot ... we reflected this by inventing the tattoo on C.W.'s chest," Newman explained. "*This* is what offends his father, not that he broke the law." Because of that "*and only that*," Newman insisted, C.W.'s father "rats out" Bonnie and Clyde and "sets up the ambush."[59]

Bosley Crowther was not pleased. The most powerful film critic in the country, he had been reviewing films for the *New York Times* since 1940. Crowther had long been an opponent of movie censorship, but as a dean of establishment liberalism, he expected filmmakers and audiences to treat the free screen he championed with respect and self-restraint, and to use it for the social good. Into the 1960s he was often disappointed, and increasingly uneasy with the irreverence, disrespect, and especially the violence that were characterizing American films. Crowther trashed *Bonnie and Clyde* three times in print—from the Montreal Film Festival, at the close of the festival, and then in his regular review when the film opened in New York.[60] Crowther was not alone in his condemnation of the picture: the review in the *Chicago*

Tribune was bitterly negative; John Simon dismissed it as "puerile antihero worship"; Joseph Morgenstern in *Newsweek* called the picture "ugly" and "stomach turning."[61]

But the tide soon turned, with younger critics in particular rallying to its defense. Morgenstern re-screened the film and took the dramatic step of writing a second, positive review in the next issue of *Newsweek* ("I realized that *Bonnie and Clyde* knows perfectly well what to make of its violence, and makes a cogent statement with it"). Twenty-five-year-old Roger Ebert declared it "a milestone in the history of American movies, a work of truth and brilliance" that is "aimed squarely and unforgivingly at the time we are living in." The violence may indeed be shocking, but "perhaps at this time, it is useful to be reminded that bullets really do tear skin and bone." Pauline Kael pounded out over eight thousand words in defense of *Bonnie and Clyde,* and of a more ambitious American cinema more generally. The "dirty reality of death" was "necessary" in Penn's film—which did not mean that Kael offered carte blanche to movie violence. In the same essay she blasted the "morally questionable" violence in *The Dirty Dozen,* which, she wrote, "offends me *personally.*" Bonnie and Clyde, however, withholds from the audience "a simple, secure basis of identification," and viewers "*should* feel uncomfortable" with its violence.[62]

It was a watershed moment in the emergence of the New Hollywood. Before the year was out, the *Times* announced that Crowther was stepping down as its chief critic; he would be replaced by a twenty-nine-year-old woman, Renata Adler. Looking back on the film ten years later, Crowther recognized it as a landmark, but he stuck to his guns; its "amorality" and "looseness with violence" were offensive and unforgivable. In his estimation, *Bonnie and Clyde* was successful because it gratified "the preconceptions and illusions of young people who had come of age with the Beatles and Bob Dylan, the philosophy of doing your own thing and the notion that defying the Establishment was beautiful and brave."[63]

I'm Just a Little Worried about My Future

Mike Nichols's *The Graduate,* which opened in December 1967, was an enormous (and unexpected) hit and, with *Bonnie and Clyde,* one of the early landmarks of the New Hollywood. Nichols wore his influences on his sleeve; many critics noticed the European touches—the handheld camera work in the early party scene, nontraditional set-ups, and the shot of a rain-drenched Mrs. Robinson isolated against a white wall that looked straight out of Antonioni.[64] There are also little nods to Fellini, including a brief appearance by Edra Gale (who played Saraghina in *8½*). But the greatest influence, as

production designer Richard Sylbert recalled, was the French New Wave, and especially Truffaut. Benjamin's triple-take cut of the naked Mrs. Robinson, for example, parallels the construction of Jeanne Moreau's leap into the Seine in *Jules and Jim*.[65] Lighting schemes, long takes, location work on Sunset Boulevard, and scene-bridging aural overlaps all situate *The Graduate* in the New Cinema. Nichols also checked in with the right Hollywood legends: the deep-focus shot of Benjamin scrambling toward his whisky tumbler matches the shot of the bottle of poison in *Citizen Kane*; and the tight symmetry of the strip club sequence (Elaine struggling to keep up with Benjamin on the way in, he chasing after her on the way out) is Hitchcockian in its construction.[66]

The Graduate was the product of a new generation and its sensibilities. It was a comedy that took on taboo subjects, just as Nichols had made his early reputation as half of an uproarious, cutting-edge improvisational comedy team. A version of that act, *An Evening with Mike Nichols and Elaine May* (directed by Arthur Penn), played on Broadway for nearly a year. Making the transition from theater to film, Nichols directed the production code–busting *Who's Afraid of Virginia Woolf?* (1966). *The Graduate* was written by Buck Henry, who became the hottest young writer in the business.[67] Dustin Hoffman, an unknown when he was cast, became an overnight star and one of the leading actors of the decade. (And a very new type of star at that. Hoffman, like many of his seventies cohort, was no matinee idol). The hip new music of Simon and Garfunkel was featured extensively and for long passages throughout the movie, which not only was a nontraditional choice but also was, of course, overtly youthful. In style, substance, and attitude, the film crystallized the elements of the emerging New Hollywood.[68]

The Graduate is explicitly a movie about generational conflict, and as that, around the axis of materialism. The first line heard in the film is "Ladies and gentlemen, we are about to begin our descent into Los Angeles," and literally and figuratively, Benjamin is leaving behind his considerable academic achievements at college back east and descending into the shallow materialism of southern California. This is exemplified most famously by Mr. McGuire, the family friend who gives Ben the hushed tip about "plastics," but it is clearly associated with all the members of the older generation, including Benjamin's parents and the Robinsons. It was Nichols's intention to express the idea that Ben was drowning in the flood of material goods, and so ever-present water is one of the motifs of the movie, starting with the fish tank and the swimming pool.[69]

In addition to water, Nichols repeatedly shot Ben through glass barriers and other transparencies in order to express his alienation from the adult world.[70] The extra-beat pause on the framed clown print during the initial party sequence also communicates his unease at being paraded about by his parents for the adulation of their friends, a ritual repeated on his birthday, when he is

reluctantly trotted out in his new wetsuit looking very much like a trained seal. Intimidated by the implications of adulthood (not to mention the very long line of old people slowly making their way through a doorway at the Taft Hotel, with a few young people pushing through in the opposite direction), Benjamin aspires to something different. Above all, he does not want to be his parents. Instead, he explains to his father in the film's opening dialogue, "I'm a little worried about my future," which he wants to be "I don't know . . . different," meaning, of course, different from his father's (though his father seems not to catch the implication).

The movie's generational fault line was what everybody talked about, beginning with the critics. "*The Graduate* is not merely a success," wrote Hollis Alpert, but a "phenomenon of multiple attendance" for "mostly young people" lining up around the block in the cold of winter "to see something good, something made for *them*." Many viewers over forty, by contrast, didn't like the movie. "More than that, it made them angry. It was almost as though they themselves felt personally attacked." The fifty-year-old Alpert was more bemused than annoyed by young audiences' identification with Benjamin, recognizing that in the movie, "the cards have been stacked" against the older generation. Forty-something Richard Schickel was less amused, in his review offering "the geriatric musings" of an old "fud" who personally "couldn't care less if the little chaps don't trust me, because I don't trust them either."[71]

Especially in retrospect, it is possible to misread the nature of this generational conflict. Although *The Graduate* was a revolutionary film in both content and style, Benjamin's own rebellion is classical, not countercultural. The idea of disaffected youth longing for something different and pushing back against elders' expectations was not invented in the 1960s. And in the context of his time, Benjamin is not, as critics of the movie tend to point out, a radical or a member of the counterculture (he wears a jacket and tie throughout the film), or even vaguely political in any way.[72] This is partially a function of the fact that the source material dates to 1963 (though with the passage of time, this is an attribute that leaves the film feeling less dated than some of its more topically oriented contemporaries).[73] One truly radical aspect of Benjamin's behavior, and this is significant, is that he and Elaine (Katharine Ross) run off together *after* she has exchanged her wedding vows with another man. This was not how it happened in the book, to the great consternation of its author, Charles Webb.[74] Not only does *The Graduate* flout the Hollywood convention of the hero getting there in the "nick of time," but also, more subversively, Benjamin and Elaine renounce the conventional morality regarding the sanctity of marriage. Finally, it puts an exclamation point on Mrs. Robinson's tragic narrative arc. "It's too late," she hisses at Elaine. "Not for me!" Elaine shouts back. It is too late for Mrs. Robinson (Anne Bancroft), and has been so for some time. She slaps Elaine, twice, the only moment in the movie when she loses her cool.

Those slaps punctuate a different, revisionist, and more pessimistic reading of the film, one that is kinder—at least in relative terms—to the older generation, which is skewered hilariously and mercilessly throughout the comedy. For if the passing of the decades expressed in movie watching can be reduced to that long, humbling shift of allegiance from André to Wally in *My Dinner with André*, so too is it seen in *The Graduate*, with the shift of the aging viewer's attention from Benjamin to Mrs. Robinson. In his 1967 review, for example, Roger Ebert mentions Anne Bancroft in only two sentences, and not until the seventh paragraph. His 1997 re-review, however, opens with and is dominated throughout by an (enthusiastic) discussion of Mrs. Robinson, who, for Ebert, emerges "as the most sympathetic and intelligent character" in the movie. Indeed she is "the only character in the movie who is alive" and "the only person in the movie you'd want to have a conversation with." A few observers caught this at the time.[75]

This rereading, and rehabilitation, of Mrs. Robinson begins with a reminder that in a seventies film, all characters are imperfect and flawed, and therefore, not surprisingly, on closer inspection *The Graduate* is revealed as a film in which all characters, regardless of generation, are suspect. Thus while Benjamin's parents (who seem nice enough) are a bit shallow and materialistic, and Mr. Robinson is clueless and impotent, it is not obvious that the kids are all right. Elaine is a passive object of desire, easily bullied to the altar to wed her vacuous boyfriend. And as for Benjamin—he is no prize.[76] Nothing that happens in the movie suggests that he is anything but quite simple, and he spends much of the film defined by passivity. *The Graduate* begins with a lingering shot of Benjamin staring ahead blankly, followed by his being carried along like a zombie on a conveyor belt, just like his luggage; in the middle passages of the film he spends much of his time literally floating and drifting.

Mrs. Robinson surely has her flaws as well. But in retrospect she emerges as the most complex, even tragic, figure in the film. The crucial scene in this regard takes place in their hotel room, when Ben insists that he and Mrs. Robinson find something to talk about. She suggests art, only to quickly reject it out of hand ("I don't know anything about it"). The conversation then drifts back to the days when Mrs. Robinson was a college student dating Mr. Robinson, who was then in law school, and to her resulting unintended pregnancy and marriage. Benjamin asks what her major was, to which Mrs. Robinson replies, "Art." Benjamin, at first confused, casually reaches the conclusion "I guess you kind of lost interest in it over the years." Her response: "kind of."

This is how it is written, in the book and in the screenplay. On the screen, the moment is crucial. Mrs. Robinson does not want to talk, especially about the past. As they reach this point in the conversation, she turns away from Benjamin but toward the camera. What the audience alone has access to here is Mrs. Robinson's only display of vulnerability. For a few seconds she is despairing and forlorn. Combined with her line reading ("kind of"), that fleeting

Mrs. Robinson prefers not to think about the past

moment reveals the entire trajectory of her life, and her recognition of it, a pain she bears but seeks to bury. What should have been an obvious truth is revealed—that she was not always Mrs. Robinson but was once a young woman with an unwritten future. But her dreams and high hopes—whatever they might have been—were cut short by an unwanted pregnancy, a loveless marriage, and ambivalent motherhood; there were precious few options open to a pregnant coed in the late 1940s.

Mrs. Robinson's life, and her behavior in the film, are the only complex backstory in *The Graduate*. No other characterization runs this deep. (Elaine doesn't even show up until the movie is more than half over.) Moreover, this narrative can be linked with a much more somber reading of the film—that Benjamin and Elaine will end up re-creating the history of their parents' generation; ultimately, their lives will *not* be "different." This is Mike Nichols's oft-stated view—and this is his interpretation of the slightly awkward silence at the conclusion of the film, which ends not with a big kiss or uproarious laughter but with quiet, lingering, forward-looking stares that invite the question, "OK, now what?"[77] This reading of the popular comedy turns it doubly tragic: the story of Mrs. Robinson's foreclosed opportunities and the suggestion that this pattern will be re-created by her daughter.

This reading is supported by the recurrent linking throughout the film of Elaine and Mrs. Robinson, and of Benjamin's mother with Mrs. Robinson. (This latter pairing could be used to support an oedipal reading of the film.)[78] With these parallels, the film suggests that Benjamin (and Elaine) are following in their parents' footsteps. When Mrs. Robinson first offers herself to Benjamin, she does so in Elaine's room; crucially, the first glimpse of her body in this scene appears reflected in Elaine's portrait. Both women also interrupt their education to make a hastily arranged marriage. (When

Benjamin searches desperately for Elaine at her dorm, he is told, "Elaine *Robinson* has left school.") More subtly, the women are also marked by their association with water. It is the tears on Elaine's face at the strip club that spark Ben's relationship with her; it is Mrs. Robinson's rage—expressed as pouring rain the next day when she enters his car (Benjamin at first thinks she is Elaine)—that tears that relationship apart. (And this is depicted differently in the novel, wherein on that fateful day "the sky was bright blue and there was not a single cloud.")[79]

The pairing of Mrs. Robinson and Benjamin's mother is particularly evident when the Robinsons, visiting the Braddocks, approach Ben to say hello. Against the harsh backlighting of the sun, the faces of all four adults are obscured, making their appearances similar (and they all are wearing sunglasses).[80] Additionally, they happen to stand in an "incorrect" order— Mr. Robinson, Mom, Dad, Mrs. Robinson—so if the couples were to be paired up, Mr. Robinson would be "with" Benjamin's mother and Mrs. Robinson with his father. Immediately following this is the scene in the bathroom, where Benjamin and his mother (dressed in a black negligee) have a spat about what he does when he goes off at night. Convinced he is lying, she exits. "Wait a minute," he calls out, a line repeated in an aural overlap into the next scene, which finds Benjamin in bed with Mrs. Robinson.

By putting Benjamin (metaphorically) in bed with his mother, *The Graduate* not only relishes its New Hollywood taboo-busting but also is again more subtly suggesting that he is following in his father's footsteps. This implication of generational continuity, and a rereading that privileges Mrs. Robinson's story, offer a more pessimistic interpretation of the film.[81] This does not alter the fact that, in its moment, *The Graduate* was cheered by its large youthful audience as a generational declaration of independence.

The Youth Market and Its Implications

Bonnie and Clyde, and especially *The Graduate,* called attention to the fact that there was not just a New Hollywood out there but also a very large potential audience for films aimed at younger moviegoers, particularly those in their late teens and early twenties. This momentum had been gathering for a couple of years. Indeed, in 1966, twenty-seven-year-old Francis Ford Coppola made a splash with *You're a Big Boy Now.* Seeing this coming-of-age story with European influences, a flashy kinetic style, location work, and a final "escape" from parental control, Nichols and Henry walked out of the theater fearing they had been scooped. They needn't have worried, but Coppola emerged from *Big Boy* as another young filmmaker on the rise.[82]

Coppola cut his teeth working for B-movie impresario Roger Corman, who had for years been producing (and often directing) innumerable low-budget pictures that typically played at the drive-ins and almost always turned a profit. A generation of filmmakers got their start working for Corman; in addition to Coppola, other Corman "alumni" included Peter Bogdanovich, Monte Hellman, Robert Towne, and Jack Nicholson. In 1966 Corman directed *The Wild Angels,* a "biker picture" co-written by an uncredited Bogdanovich.[83] It is notable mostly for its cast (Peter Fonda, Bruce Dern, Diane Ladd, and Nancy Sinatra), and especially for the fact that it cost only about $350,000 to make but pulled in over $10 million at the box office. In 1967 Corman engaged the youth culture even more directly with *The Trip,* a movie about LSD. Written by Nicholson and starring Fonda, Dern, Dennis Hopper, and Susan Strasberg, once again the film was notable for returning millions on its very modest budget.[84]

Not surprisingly, others got in on the act. In 1967 Nicholson starred in *Hells Angels on Wheels,* and soon enough Fonda and Hopper were cooking up their own low-budget biker picture. The result, *Easy Rider,* directed by Hopper and produced by Fonda, was a cultural sensation (and a box office hit) beyond their wildest imaginations. With its location work (shot by László Kovács),[85] its head-turning performance by Jack Nicholson, the nakedness of Fonda's monologue about his mother amidst the New Orleans crypts, and its mournful counterculture ending, young audiences identified with the antiheroes of *Easy Rider* to an even greater extent than they had with Benjamin Braddock.[86]

And again there was the music. In *Easy Rider* it was wall-to-wall, featuring The Band, Steppenwolf, Jimi Hendrix, and The Byrds. Fonda—who wanted to use "It's All Right, Ma" over the closing credits screened the film for Bob Dylan. Dylan demurred but wrote up some new lyrics on the spot, instructing Fonda to "have [Roger] McGuinn put music to it." McGuinn's version of "Ballad of Easy Rider" (preceded by his own performance of "It's All Right, Ma") closes the film.[87] It is difficult to overstate the enmeshment of these film and musical cultures. A month after *Easy Rider* opened, half a million people showed up for a three-day rock concert in Bethel, New York. Preserving a remarkable tranquility amidst the logistical catastrophe—the event's organizers had anticipated a crowd about one-fifth the size—the young people assembled did seem to represent a true and sizable counterculture. The film of the event (Martin Scorsese shot some of the footage and was an editor on the project) was the sixth-highest-grossing film of 1970, and won the Academy Award for best documentary.[88]

The dreams of the "Woodstock Nation" would not be realized.[89] In fact, within a year, and as the sixties turned into the seventies, that unraveling would become all too apparent.[90] But in 1969, *Easy Rider* and Woodstock confirmed what *Bonnie and Clyde* and *The Graduate* had promised: there was a vast youth market out there that was not much understood by the fading remnants

of Old Hollywood (or for that matter by the corporate titans who bought up the studios). And so a new generation of filmmakers would be given the opportunity to make a new type of film. *Easy Rider* was financed by Bob Rafelson and Bert Schneider; shortly before the film came out, their production company, Raybert, became BBS and embarked on a six-picture deal with Columbia. Next up would be *Five Easy Pieces* (1970); Bogdanovich's celebrated *The Last Picture Show* (1971) would soon follow. "We wanted to have film that reflected our lives, the anxiety that was going on . . . the cultural changes that we were all products of," explained the writer-director Henry Jaglom.[91] This was the ambition of BBS—and of the seventies film.

CHAPTER 3

1968, NIXON, AND
THE INWARD TURN

Tet. King. Kennedy. Chicago. Nixon. Nineteen sixty-eight was a bad year.[1] On January 30–31, during what would typically have been a pause in hostilities for the Tet holiday celebrating the Lunar New Year, communist forces launched a massive coordinated strike all across South Vietnam, including attacks on forty-four of the country's fifty largest cities. The battles raged for months. The United States suffered over 4,700 combat deaths in the first three months of the year; 16,592 American servicemen would lose their lives in Vietnam in 1968. From a narrow military perspective, the offensive was unsuccessful. It did not inspire a massive uprising, as was intended, and communist losses were enormous. But from a political perspective, the Tet Offensive succeeded in that it fundamentally transformed the trajectory of the war. The United States was not going to win in Vietnam—that is, it was not going to achieve its political goals.[2]

America was astonished by the Tet Offensive. On November 2, 1967, President Johnson had met with the "Wise Men," a group of a dozen or so eminent and distinguished members of the foreign policy establishment (men like former general of the army Omar Bradley and former secretary of state Dean Acheson); their consensus was that the war was going well. Johnson ordered William Westmoreland, commander of U.S. forces in Vietnam, as well as Ambassador Ellsworth Bunker to come home and impress upon the public this optimistic assessment. Westmoreland gave a major address in Washington on November 21, stating that "the end begins to come into view."[3]

But by February 1, one thing was clear: despite years of war, unprecedented bombing campaigns, and the commitment of over 500,000 troops, the end was

not in view. Nor was the present pretty. On NBC an estimated audience of 20 million people watched the chief of police of South Vietnam casually execute a bound prisoner by shooting him in the head. A photo capturing the incident won a Pulitzer Prize and seemed, in one frame, to articulate all the doubts about what the conduct of the war was doing to America's moral purpose. On February 8 Senator Robert Kennedy stated that recent events had "shattered the mask of official illusion with which we have concealed our true circumstances, even from ourselves." CBS news anchor Walter Cronkite, possibly the most trusted man in America, got up from behind his desk to see the war for himself. On February 27 he told the nation, "It seems now more certain than ever that the bloody experience in Vietnam is to end in stalemate." The editors of the *Wall Street Journal* reached a similar conclusion. General Westmoreland, unfazed, put in a request for an additional 200,000 troops.[4]

The day after the Cronkite broadcast, Johnson asked Clark Clifford, the hawk he'd tapped as secretary of defense to replace Robert McNamara (and his growing private doubts), to assess Westmoreland's request with "fresh eyes." The president was at a crossroads. The request for a 40 percent increase in troop strength would require the mobilization of the reserves, threaten economic stability (the dollar was already under serious pressure), and contribute further to the atrophy of U.S. forces worldwide. But at the same time, Westmorland reported, "a setback is fully possible if I am not reinforced and it is likely we will lose ground in other areas." Clifford's assessment quickly grew into what became known as an "A–Z reevaluation" of the entire war effort. On March 4 Clifford, who had supported the war and "believed in our policy," presented the president with his conclusions: neither more troops nor more bombing could assure victory, the end was not in sight, and he was now "convinced that the military course we were pursuing was not only endless, but hopeless." On March 25, at Clifford's urging, the Wise Men reconvened and received updated briefings. The majority of the group now favored finding a way to disengage from the Vietnam War.[5]

Things were coming apart for Johnson. In 1967 he had created the Kerner Commission to study the causes of the race riots which had swept across the country that summer. The subsequent report, which concluded that "our nation is moving toward two societies, one black, one white—separate and unequal," landed on his desk during the Tet Offensive and irritated the president, who interpreted the document as a denigration of the accomplishments of his Great Society programs. He chose not to meet with the commission's members. (This in turn irritated Robert Kennedy, who complained to friends that Johnson was "not going to do anything about the war and he's not going to do anything about the cities, either.") On March 12 Johnson was embarrassed by the strong showing in the New Hampshire Democratic primary of Senator

Eugene McCarthy, who was running as an antiwar candidate. Four days later Robert Kennedy declared his candidacy, motivated by opposition to the war, passions about poverty and race relations, and the demonstration of Johnson's political vulnerability. At the end of the month, Johnson stunned the nation by announcing that he would not seek reelection.[6]

The rest of the year wasn't any better, and everywhere, it was violent. Martin Luther King Jr. was assassinated on April 4; disturbances and riots erupted in over one hundred cities. On April 23 protests over the war and Columbia University's uneasy race relations with its Harlem neighbors escalated. By April 26 the university was shut down, and the following day students occupied several buildings. In the middle of the night on Tuesday, April 30, they were forcibly removed by over a thousand baton-swinging policemen. On June 5 Kennedy was assassinated after winning the California primary, leading to another period of national mourning (and Ted Kennedy's greatest speech), and to the disaster of the Democratic National Convention in Chicago. Inside the convention center, Vice President Hubert Humphrey's control of the party apparatus ensured that the platforms of the lethargic McCarthy and the shell-shocked Kennedy delegates would be defeated. Outside on the streets, thousands of Chicago police and National Guardsmen unleashed their fury on the protesters in a series of melees, many captured on TV; it would later be characterized as a "police riot." In response, the Wisconsin delegation urged that the convention be suspended and moved, but was ruled out of order. Senator Abraham Ribicoff of Connecticut, nominating a new peace candidate at the last minute, declared, "With George McGovern as President of the United States, we wouldn't have Gestapo tactics in the streets of Chicago." Mayor Richard J. Daley, caught on camera, was not pleased. The Democrats never recovered; in November, Richard Nixon was elected president by half a million votes out of 72 million cast.[7]

Nineteen sixty-eight was a tumultuous year around the world as well. The week before the Democratic National Convention, Soviet tanks crossed into Czechoslovakia, crushing the "Prague Spring" of political and social liberalization. To the untrained eye, there was little difference between the tanks of Prague and the armored personnel carriers patrolling the streets of Chicago, a frightening parallel. Earlier in the year, in Poland, "Zionists" were accused of having orchestrated student protests against the government; the subsequent anti-Semitic purges, particularly at universities, led to the emigration of half of Poland's forty thousand remaining Jews. On October 2, policemen and soldiers in Mexico City opened fire on unarmed student protesters, killing hundreds in what would become known as the Tlatelolco Massacre.

In western Europe, 1968 is best remembered for the May uprisings in Paris, which, once again, were sparked by the young. On March 22 students at

Nanterre gathered in protest over university conditions and related issues; but as if by necessity, they soon occupied an administration building, which was in turn surrounded by the police. Cooler heads prevailed for the moment, but tensions simmered, new demonstrations erupted, and things came to a head on May 6, with rallies at the Sorbonne in support of the students from Nanterre, now threatened with expulsion. This time cooler heads did not prevail, and thousands of students clashed violently with the police throughout the day and into the night, injuring hundreds. May 10 was another day of rioting; on May 13, perhaps inspired by the students but nursing their own grievances, France's major trade unions called a general strike. Within a week, millions of workers had walked off the job; hundreds of thousands marched through Paris. This larger crisis was finally defused when President Charles de Gaulle, his back to the wall, solidified his position with the military while cutting generous deals with the striking unions.[8]

In France, the New Wave took to the barricades. On May 18 at the Cannes Film Festival, jury president Louis Malle, along with François Truffaut and Jean-Luc Godard, and with the support of others including Milos Forman and Roman Polanski, interrupted the film screenings to express solidarity with the students and strikers. Pandemonium ensued—shouting matches set to the lights of the still flickering projector devolved into a brawl, bringing the inevitable arrival of the police. After heated debate the festival was shut down, and the following day the Cannes insurgents returned to Paris to join the protesters there.[9] The filmmakers took some pride in their own contribution to the atmosphere of May '68, having just recently emerged triumphant from their own confrontation with the state. In February the de Gaulle government unceremoniously sacked Henri Langlois, the director (and co-founder) of the Cinémathèque Française. Langlois was a father figure to many in the New Wave, and the Cinémathèque was the sanctuary where the young cinephiles met in the late 1940s and early 1950s. "Without Langlois, there would be neither *Cahiers du Cinéma* nor New Wave," the journal editorialized. A storm of protest followed; newspapers from across the political spectrum opposed the government's move. *Cahiers* sent out urgent cables to filmmakers around the world, and the responses poured in. "Protest this arbitrary action in the strongest possible terms," read the telegram from Orson Welles. "Will not permit screening of my films at Cinémathèque Française until further notice." Nicholas Ray, Roberto Rossellini, Charlie Chaplin, Elia Kazan, and Samuel Fuller were among the hundreds who supported the boycott. On February 14, two thousand protesters clashed with the police; Truffaut and Godard were roughed up, Bertrand Tavernier was bloodied. Eventually the efforts of the "committee for the defense of the Cinémathèque," the breadth of international protest, and, crucially, the support of the American film industry

led to Langlois's restoration. From Truffaut's perspective, with "the passing of time, it seems obvious that the demonstrations for Langlois were to the events of May '68 what the trailer is to the feature film coming soon."[10]

The Whole World Is Watching

Haskell Wexler's *Medium Cool* was the American film that embodied the spirit of May 1968 in both style and substance. It was an overtly political film—a call to the barricades—and it was infused with New Wave sensibility generally, and in particular with its embrace of Godardian motifs. An intensely personal film, at once explicitly conscious of its own "filmness" yet obsessed with presenting reality with a capital *R* (and with the relationship between movies and the "real world"), *Medium Cool* not only privileges location shooting but also introduces its actors into real (and often dangerous) situations; it features the intermingling of actors and non-actors as well as a documentary style; and it was young—the oldest of the four lead actors was thirty-one at the time and white blues wunderkind Mike Bloomfield wrote the score.

Wexler, a cinematographer who made his early reputation shooting *Who's Afraid of Virginia Woolf?* (1966) and *In the Heat of the Night* (1967), would continue a long and distinguished career over the ensuing decades, working on many notable seventies films such as *Gimme Shelter, American Graffiti,* and *Bound for Glory. Medium Cool,* however, stands out as his signature film, and the one he wrote and directed as well.[11] Slapped with an X-rating and unsupported by a nervous studio (the film in production reputedly attracted the attention of the FBI), the picture now has a considerable reputation but was not a broad commercial success at the time.[12]

Medium Cool derives its title from Marshall McLuhan's characterization of television as a "cool" medium, and Wexler's critique of television, quite distinct from McLuhan's, is the first and most obvious theme of the movie, though over the course of the film it becomes clear that there are lots of topics Wexler wants to cover: race, poverty, and violence, to name a few.[13] But it begins with television and journalism more broadly, with initial scenes that establish the film's two central questions about the media: What is the responsibility of reporters in the context of their stories, and to what extent does television news exacerbate the violence it covers as a consequence of the need to attract the attention of its audience? The first question is introduced implicitly, in the documentary-style opening scene, with TV cameraman John Cassellis (Robert Forster) and soundman Gus (Peter Bonerz) shooting film of a car accident, slowly walking back and packing up their station wagon, and then, finally, casually calling for an ambulance. The second is raised explicitly in the cocktail

party that John and Gus attend, shot cinéma vérité–style as mostly real Chicago newsmen discuss their own experiences. At this function, less than five minutes into the film, Gus renounces any responsibility (and his humanity), claiming to be nothing more than "an elongation of a tape recorder," explaining, "A typewriter doesn't really care what is being typed on it."

From there, *Medium Cool* pursues three distinct narrative strands, which nevertheless share thematic and stylistic traits, and which are supposed to weave together more tightly over time: John at work, especially in the context of the city's anxiety over the prospects for violence as the Democratic National Convention approaches; John's personal life, especially his romantic transition from the freewheeling Ruth (Marianna Hill) to the more mature Eileen (Verna Bloom); and John's pursuit of the story of the black taxi driver (Sid McCoy) who returned $10,000 he found in the back of his cab, which puts John in the company of potentially militant elements in Chicago's black ghettos.

John and Gus's visit to a (real) training exercise of the Illinois Army National Guard sets the tone for much of what follows. A blend of documentary and documentary-style shooting makes it almost impossible for the viewer to determine what is real and what is staged, although in this sequence the overwhelming majority of the footage seems to have been captured on the fly. The images also nicely foreshadow the (real) riots that close the film, mostly during the exercise to comic effect, but at times ominously, such as when a jeep with a barbed-wire front grill rolls by, as one will later on the streets of Chicago. The National Guard visit also provides the first blending of John's camera with Wexler's. At times the two cameras become one, most explicitly during an interview at the shooting gallery later on. Here, when a voice in the crowd shouts, "Get the guys with the cameras," it is Wexler's camera that is engulfed.[14]

But if the character and the director merge at times, they are in other ways very different, as the film makes clear. It is hard to imagine Wexler attending the roller derby, where John and Ruth go on a date and seem to have a terrific, even arousing, evening of entertainment. But the movie is shot to underscore a different attitude about the idea of violence as entertainment and foreplay from the one held by its characters. As we watch the (real) roller derby set to the tune of "Sweet Georgia Brown" (best known as the Harlem Globetrotters' theme), the action appears light and comical, and we take in this amusing fare along with the crowd, enjoying it for a full minute and a half. But Wexler jarringly switches to natural sound, and the violence suddenly seems genuine and ugly, and both this and the loud, vulgar taunts of the crowd chastise the viewer; John and Ruth, unperturbed, kiss. Wexler then executes a second pointed transition, shifting from shouts of "kill her!" to cries of "go-go-go," chants and sound effects that are retained through an elliptical cut and play over the couple's subsequent lovemaking back at John's apartment.

John channels Belmondo

In fact, all of the sexual encounters in the film (even later, with Eileen) are suggestive of violence; the more elaborate second romp between John and Ruth operates on the edge of hostility. Initiated by a spat over (what else?) Ruth's questioning about the ethical obligations of cameramen who worked on the documentary *Mondo Cane,* the chasing and wrangling that follow approach the border of playfulness, and eventually the camera abandons the couple to linger on the execution photo from the Tet Offensive. (The other prominently displayed photo in the apartment is of New Wave icon Jean Paul Belmondo. John mirrors his pose when he lights a cigarette.)

What Wexler wants to say about sex and violence is somewhat obscure, but the general theme of violence, and of America as a violent society, can be traced throughout the movie, whether it is the sports news on the radio ("Cards slaughtered Philadelphia, 9–0"), when John teaches Eileen's son about boxing ("The object is to knock the other guy's brains out, and then you win"), or increasingly in expressions of fear and frustration by the friends of the black cabbie ("Why do you always have to wait until somebody gets killed, because somebody *is* going to be killed").

The integration of the cab driver theme seems incongruous in retrospect at the end of the film because it doesn't really have a payoff. But in all other ways it fits in seamlessly: in addition to location shooting, use of non-actors, and characters talking to the camera, the ghetto apartment scene parallels the cocktail party shown at the start of the film. But here, instead of reporters discussing the media, its subjects (in this case, poor blacks) offer their own

criticisms: "You came down here to do some jive interview," "You are the ex-ploiters... [you] distort, emasculate and ridicule," and so on.

The subplot seems incongruous because Wexler guessed wrong about what was going to happen in Chicago during the convention in 1968: the film antici-pates a race riot, not a police riot. Given the riots that had occurred, and would occur, in American cities at this time, it was not a bad guess, and would have tightly linked together several elements in the movie—lines like "Do you real-ize how much guns and ammunition $10,000 would have bought?"; the jar-ring cut from black anger to the white ladies at the shooting gallery (guns firing at the camera); John's suggestion to Eileen that his getting fired had something to do with his theory of a link between the $10,000, guns, vigilante groups, and a "blow-up this summer"; and his subsequent comment that "people are afraid the Negros are going to tear up their stores, burn neighborhoods."

But even without the full payoff, it is this strand of the film that creates the opportunity for John's political awakening. Actually, "awakening" is too strong a word, but it motivates his increased political awareness, and this is important because the audience is positioned to identify with John in the film, and thus his greater sensitivity to the role of politics in society becomes our greater sensitivity. Because of his interest in the cabbie's story, he is confronted as never before with the now explicit deeds of the state and of corporate capi-talism, and he becomes more aware of the media's effect on society in general. John finds out on the same day that the station has been letting the cops and the FBI study his footage, and that he has been fired. His effort to confront his superiors about these developments illustrates the structural as opposed to the personal nature of corporate power: he runs down long, empty hallways—the corridors of power—yet is unable to find anyone in a position of responsibil-ity. Secretaries are abundant, but his boss is unavailable, and the door to the executive producer's office is locked.

From the perspective of *Medium Cool,* it is the system that betrays and dis-poses of John, not his boss. When we previously met John's immediate supe-rior, he was a harried man overwhelmed by his own problems at work, but not a bad guy. Short of resources and manpower, he nevertheless eventually relents to John's request for film and lab costs (but not before making an exasperated comic gesture at Wexler's camera—"Look, they got film"—cut in almost sub-liminally as a Godardian hiccup).[15] More pointedly, after the scene has served its narrative purpose, the camera lingers to watch him take a phone call from *his* boss, with a very clear "yes, sir," as his first words.

John's relationship with Eileen is another vehicle in his personal evolution from immature political passivity toward maturity and political awareness. Eileen, the thoughtful single mother, gives John a taste of the responsibili-ties of parenting (her son Harold is of course pivotal for the film's narrative;

his encounter with John brings the couple together, and his subsequent flight motivates the search that brings her to the riots); and Eileen and Harold's tenement—they are refugees from distressed West Virginia coal mining country—gives Wexler's camera the opportunity to linger, extensively, on the living conditions of poor whites in Chicago.

With Eileen, John is in transition. Watching a speech by Martin Luther King on television, she is deeply moved, while he at first reacts inappropriately, still the passive cameraman: "Jesus, I love to shoot film," is his initial response. But the "new John" then follows this remark with a diatribe about how the media script tragedy as a way of anesthetizing the public. That evening he dons the coat once worn by Eileen's husband. Later, at a decadent hippie party, he spots his old flame Ruth. She fits right in, but his presence seems awkward and incongruous—he seems to have outgrown these surroundings.

But it is too late. John doesn't live to act on his new emerging sensibilities. The self-consciously fatherless Harold runs off (all of the flashbacks to the family in West Virginia are his), and, in a justly celebrated sequence, Eileen searches for him, placing actress Verna Bloom in the midst of the upheavals in the parks and streets of Chicago. Wexler's camera becomes one among many that are capturing these real events (including some shots of John "working" inside the center during the convention), and Wexler is among those who get tear-gassed; the filmmaker was blinded for twenty-four hours. Protesters call out to the ubiquitous TV cameras; John is present as the Democrats self-immolate at the convention; cops pour into the crowds and are captured on film beating the kids. Eileen sees it all, wading through history as her story plays out in the midst of reality.

John and Eileen, never participants in the protest (or the protest movement), are reunited and leave the chaos behind as they take off in his car in search of Harold. Moments later they die pointlessly in a fiery crash, an event artfully described in advance by the media as the tragedy is reported on the car radio moments before it happens, interspersed with detailed coverage of the violent police riot going on at the same time. The camera lingers on Eileen's face as we await the inevitable, perhaps in disbelief, first-time viewers still processing what they have heard, thinking about her, and about Harold.[16] This ending can be seen as unmotivated and thus unjust, or perhaps just lazy; I would argue that it is defensible. By violently killing characters we know and are necessarily invested in, it makes more palpable the violent deaths of those we don't know in the "real world" and in the movie. Perhaps we can now mourn the anonymous woman in the car crash at the start of the film; chances are she had a family, and a narrative, and a life of her own, even if we didn't know about it. Furthermore, although the message is unsubtle, the little boy who dispassionately photographs the crash parallels the behavior of Gus and

John at the start of the film, another camera indifferent to the suffering it witnesses. And finally, with John's political awakening cut short, Wexler ends the film by showing himself, turning his camera toward us. As the radio coverage continues, devolving into chants of "The whole world is watching," Wexler metaphorically films the audience, implicating us as passive spectators and as consumers of the media, among those who are "watching." The film thus ends by imploring us to wake up (even more necessary now; a "happy" ending would have taken the pressure off) and become more alert and active participants in our own political lives.

Things Fall Apart...

Medium Cool was written as the 1968 presidential campaign was just getting under way, but it was not released until August 1969—and as a result, Wexler's call to involvement came too late. Robert Kennedy was assassinated months after the original screenplay was completed and just two weeks before the start of principal photography (requiring some last-minute changes). The assassination was a watershed event for America, and for the participants in the New Hollywood in particular. After Bobby, the answers were not going to be found at the ballot box, and seventies films would turn inward, embracing, as the feminist movement would articulate, the personal as political. Seventies films would also become, if this was possible, even more downbeat, pessimistic, and infused with a sense of loss. For the New Hollywood generation, Bobby's murder was a triple blow—there was the irretrievable loss (there was no substitute for RFK); the electoral dead end (there would be no antiwar candidate in 1968); and the end of everything (Richard Nixon would now be president).

Kennedy was the candidate of the New Hollywood, and that cohort of filmmakers never fully recovered from his loss. This is not hagiography. "My brother need not be idealized, or enlarged in death beyond what he was in life," eulogized Ted, and Bobby, like all people, had his flaws. Arrogant and ambitious as the chief counsel for several Senate committees in the 1950s, he subsequently earned a reputation as a tough, streetwise political operator as JFK's campaign manager and attorney general. But as Senator Kennedy from New York (elected in 1964 at the age of thirty-seven), he matured, in the last few years of his life, into something special. Devastated—shattered is not too strong a word—by the death of his brother, Bobby would reemerge as his own man, fixated on the problem of widespread poverty in America, dedicated to taking on the issue of race, and, well ahead of the public, reversing course on Vietnam.[17]

Kennedy was unique in many ways that appealed to the New Hollywood— idealistic but not naïve; "the only white politician," NBC's David Brinkley

observed, "who could talk to both races"; against the war while accepting responsibility "before history and before my fellow citizens" as "one who was involved in many of those decisions" that led to the quagmire. Bobby was also young, and youthful. His speechwriters traveled with their guitars, warbling the folk tunes of the day. He wore his hair long, very long for a politician, and this was noticed on both sides of the cultural divide. He campaigned on the streets, and like a rock star, he never did as well on TV.[18]

Thirty-six-year-old John Frankenheimer, director of *The Manchurian Candidate* (1962), and *Seconds* (1966), traveled with the campaign, shooting footage at various events and rallies. Kennedy spent the day of the California primary resting, finally, by the pool at the filmmaker's home. It was Frankenheimer who drove Kennedy to the Ambassador Hotel that evening, becoming agitated when he missed the freeway exit. "Forget about it, John, life is too short," was Kennedy's famous reassurance. "If you want to date a moment when things started to turn, it was really after that night," Frankenheimer recalled, in reference to his own personal demons that he struggled with in the 1970s. "I was left very disillusioned"—a sentiment that would shape the content of the seventies films that followed, and that would only be reinforced by events over the next few years.[19]

With regard to Vietnam, the election of 1968 was one in which all roads led to the same dead end. Humphrey represented a continuation of Johnson's policies; Nixon's vague platitudes amounted to the same thing. Both candidates rejected the peace movement, but neither man was going to pour 200,000 more troops into the country. Without so much as admitting it, they made it clear that one way or another, whoever was the next president, his portion would be to find a way out on the best possible terms. Nixon the candidate handled this transformation brilliantly. He had built his career as an unimpeachable anticommunist, and from 1964 through 1967 he had been an outspoken hawk among hawks on Vietnam, stressing the vital stakes in the conflict, always one escalation ahead of Johnson. But by 1968 Nixon the master politician understood that the war would not be won, and during the campaign he spoke of "ending the war" and "winning the peace." It was Johnson's war. Vague promises from the other side were good enough to win.

If there was anyone who was the opposite of the New Hollywood, it was Richard Nixon.[20] Not just conservative but painfully un-hip, practically born in a tie (photos show him wearing one in first grade), Nixon was a known—and loathed—quantity. In 1946 he won a congressional seat by pursuing a slash and burn strategy that proved to be just a warm-up for his even nastier Senate campaign against Congresswoman Helen Gahagan Douglas four years later. Nixon, who made his reputation as a crusading anticommunist on the House Un-American Activities Committee, stuck with the red-baiting that had worked for him since 1946 and labeled Douglas "pink right down to her

underwear." It was during this election that he earned the nickname "Tricky Dick." The moniker took easily.[21] Just two years later the young western ultraconservative Nixon would be tapped by his party as Eisenhower's running mate to balance the ticket and provide the scorched earth campaign rhetoric that the old man wouldn't touch.

Nixon took his own shot at the White House in 1960, losing a close race to JFK, and lost again in 1962 in his bid to become governor of California. "You won't have Nixon to kick around anymore," he told the press. He was quitting politics. In 1963 Nixon set up shop at a New York law firm (bringing along secretary Rose Mary Woods and Cuban refugee couple Fina and Manolo Sanchez as live-in help), but he wasn't quitting politics. After the Johnson landslide buried the Republicans in 1964, Nixon worked hard for the party and contributed to its good showing in the 1966 midterm elections. Then, positioning himself between the Goldwater (soon to be Reagan) and Rockefeller (soon to disappear) wings of the Republican Party, Nixon cruised to the nomination at the 1968 Republican National Convention in Miami. In the general election, using the student movements as an explicit foil, Nixon ran against the changes of the 1960s—"pot, permissiveness, and protest," he would later call them. With regard to civil rights, his emphasis on "law and order" was part of the "southern strategy" that successfully brought disaffected white Democrats to the Republican Party.[22]

Nixon's early presidency was, if anything, even more alienating for the New Hollywood community. His grand strategy for Vietnam turned out to be bombing the hell out of Indochina while slowly winding down the commitment of U.S. ground forces. Less than two months into his presidency, Nixon ordered the secret bombing of Cambodia—not secret from the Cambodians, of course, or the North Vietnamese—but the president was furious when it was reported in the *New York Times* and became obsessed with stopping leaks in his administration, setting in motion some of the operations that would become Watergate. In July, Attorney General John Mitchell (Nixon's former law partner and campaign manager) testified before Congress against the renewal of the Voting Rights Act and in favor of measures to expand police powers. In November, Nixon began the process of reframing the unwinnable war abroad, pitting the "silent majority" of Americans against the protesters—the enemy within. North Vietnam "cannot defeat or humiliate the United States," the president declared; "only Americans can do that."[23] The sixties were coming to a close, literally and figuratively.

If I Leave Here Tomorrow

The inward turn associated with the loss of Kennedy and the hard reality of Nixon is seen clearly in one of the landmark films of the New Hollywood, *Five Easy Pieces,* which started shooting in late 1969 (the first year of the new

administration) and was released in 1970. *Five Easy Pieces* brought together many of the leading talents of the era. A BBS film, the low-budget ($876,000), naturalistic, character-driven affair was produced and directed by one of the B's, Bob Rafelson, with no studio interference.[24] Carole Eastman, who previously wrote *The Shooting* (1967), an existentialist Western directed by Monte Hellman and starring her good friend Jack Nicholson, wrote the screenplay for *Five Easy Pieces* knowing that Jack would play the lead role. Nicholson's portrayal of Bobby Dupea would propel him to stardom and secure his place as one of the representative leading actors of the seventies film, along with Gene Hackman and Dustin Hoffman. Karen Black (*Cisco Pike, Nashville*) played Rayette, the main female character. The film was shot by László Kovács (*Easy Rider, Shampoo*).[25]

Five Easy Pieces has a generational sensibility, but it is not *of* the counterculture. In contrast with a film like *Easy Rider,* in which the problem is external (society at large) and Jack Nicholson's character is murdered by rednecks, here the problem is *internal.*[26] Society may have its flaws, but that is beside the point. There are only a few moments in the film when generational issues are explicitly invoked, and in each instance the message is ambiguous. When two suits come after his friend Elton, Bobby's reaction is to take them on— but Elton tells him not to; turns out he is wanted for jumping bail, and the plainclothes cops "got the right." In the film's most famous scene of rebellion against authority, on the road when Bobby finds a way to order a side of toast without violating "the rules," his ingenuity is celebrated; but as he points out back in the car, it didn't get him his toast. Even in the most explicit engagement of generational conflict, Bobby's attempt to explain himself to his father in one of the movie's two climatic monologues, the rift between father and son is acknowledged—"Most of it doesn't add up to much that I could relate as a way of life that you'd approve of" and "My feeling is that, I don't know . . . if you could talk, we wouldn't be talking"—but the speech, or confession really, locates the crisis as an internal one: "I move around a lot . . . not because I'm looking for anything. . . . I'm getting away from things that get bad if I stay." The name Bobby may evoke RFK, but he sounds more like another Bobby— Dylan: "How does it feel / to be on your own / with no direction home / like a complete unknown / like a rolling stone?"

At first glance, *Five Easy Pieces* seems to wander about like Bobby Dupea: much of the initial narrative thread is simply abandoned (we never find out what happens to Elton or his family), and there is nothing in the first part of the movie that prepares us for the second half. But although it is, as an exemplar of a seventies film, driven by character and not plot, right down to its downbeat open ending, it nevertheless has a disciplined visual style and a tight structural architecture. Rafelson and Kovács agreed that for exteriors the camera would

not move,[27] and (with a few exceptions) it is these static shots that provide the movie's visual signature, in particular the still camera, employing long shots and long takes, often with characters dominated by their environment (such as the derricks of the oil fields or the various natural landscapes of the Pacific Northwest). This culminates in the final long shot of the gas station, held for over a full minute as the audience considers the characters' possible fates.

The film unfolds in three distinct parts, like the shape of a barbell. Bobby's working-class life in Southern California takes up the first 40 percent of the running time; the long road trip up the coast, lasting about fifteen minutes, provides the thin middle; and the story of the prodigal son returning to his family of accomplished musicians occupies the balance of the movie. Each of these three parts is essential. The anchors seem disjointed, but the two environments share, with remarkable symmetry, Bobby's inability to fit comfortably in either. The extended road trip does much more than provide comic relief. It serves to emphasize not just the physical but the existential distance between the two settings: the Dupea family home is upper middle class, intellectual, aesthetic, reserved, and (literally, on an island reachable only by ferry) isolated. Yet despite these enormous differences, Bobby's bitter and unexpected outburst at Elton in the midday oil field ("I'm sittin' here listening to some cracker asshole who lives in a trailer park compare his life to mine") is almost identical to his subsequent denunciation of the visiting intellectuals in the evening parlor ("you're all full of shit"). Both episodes end in flight—Bobby physically storming off and in each instance he then moves decisively to sever his ties to the location.

The California sequences only hint at Bobby's alienation, which is brought into focus when we reach the family home, but the elements of the story all nevertheless fit together. To some extent, the entire purpose of the first part of the film is to get us to that island, where we come to understand the character's central crisis—his *self*-loathing; his rejection of, but inability to shed, the expectations placed upon him in his youth; and his consequent inability to find his place in the world or among other people.[28]

Bobby isn't just alienated from his father; he's alienated from his brother Carl (a two-way street, seen most obviously in the way Carl closes the door to the music room as Bobby approaches), devoid of close ties to his friends and co-workers, certainly unprepared for responsible adulthood—an issue raised by the whispered possibility of Rayette's pregnancy, by Elton's screaming baby, and more subtly by the father and child seen leaving a diner as Bobby arrives. These dysfunctions have their roots in a common source, and seen in this light, what seems initially to be his shabby treatment of Rayette (not that it isn't shabby) is in retrospect more indicative of Bobby's self-loathing. He is unable to express his love to Rayette early in the film. Maybe he doesn't love

her, but he finds himself in a similar situation with Catherine (Susan Anspach) later on, and he is most definitely very interested in her. Yet when he plays the piano for her and she is moved, he insists that he had "no inner feeling," a line she holds against him, then seems to let go, but which is ultimately decisive in sealing his fate in her eyes.

Catherine's behavior pushes to the foreground the issue of gender in the movie (this important theme for the seventies film more generally is discussed at length in chapter 4). The first words heard in *Five Easy Pieces* are "sometimes it's hard to be a woman";[29] and though the film is about Bobby, there are three women prominently featured in the story, which is very alert to and sophisticated in its handling of gender issues. Even Rayette, who, from today's perspective, can be seen as passive, dependent, and way too often in front of a mirror, has redeeming qualities. She has greater insight into Bobby's character than he does ("you're the pathetic one, not me"); she speaks up for herself and, often, is able to get what she wants. Partita (Bobby's older sister) is a more complicated package. On the one hand, she is an accomplished musician, and the film is on her side when she challenges Carl's crude exclusion of her from a family "summit meeting." On the other hand, she is a compromised figure, a stereotypically high-strung artist type. It also appears that after the death of their mother, Tita assumed something of a maternal role in the family, which tied her to the home and circumscribed her sexuality. Despite the presence of Spicer, a live-in male nurse, she is in charge of their father's care (and is intensely protective of him). She also dotes on and worships Bobby more like a mother than an older sister. Indeed, there is something oedipal about their relationship, which explains two otherwise incongruous moments: Bobby's uproarious sexual encounter with Betty from the bowling alley, which immediately follows Tita's appearance, and his inappropriately angry response after seeing Tita and Spicer together, which leads to another violent outburst—the fight between Bobby and Spicer.

Catherine is the film's strongest female character and represents the hopeful expression of (one type of) feminism. This interpretation can be protested; after all, she does sleep with the star of the movie. But if she didn't, the implication would be that a woman can be independent only by renouncing her sexuality. Catherine is in charge of hers. She left her first husband and is unconstrained by her upcoming marriage to Carl, for whom she has genuine feelings. In her relationship with Bobby, she plays the dominant role throughout; he, however, is uncharacteristically feminized, and to some extent even emasculated. Their first real conversation begins with him saying that he's "been looking all over for her." She's been out horseback riding, and has a subtle hold on a crop in one hand, whereas Bobby is wearing a flower-print shirt, in stark contrast to the traditional solids he sports on most other occasions.[30] As

Catherine dominates her surroundings . . . and Bobby

he follows her into the house, she is somewhat dismissive but arranges to meet him at a time of her choosing, her power underscored by their relative positions on the staircase.

When "the day after tomorrow" arrives, they quarrel at first, and she matches him in argumentation. After they make love, she asks him how he is; he, lying on his back, responds gently, in a voice we have not heard before, "I'm incredible"—perhaps the only moment when we see him content. He is wearing a short (cut at mid-thigh), thin, feminine robe (possibly hers?), emphasized as she directs him to move "discreetly across the hall." At her initiative, they meet again the next morning, but although he is interested in a long-term relationship, she is not, a destiny first suggested when they speak briefly through their windows at the ferry, their cars pointed in opposite directions.

It is during his search for her the next day that Bobby has his encounter with Spicer, a fight plainly choreographed as a sexual act, with Bobby in the submissive role; but this is nothing compared to the speech Catherine lays on him in the following scene. If there is any question as to whether Catherine is a "strong female character," it is answered by her summary dismissal of Bobby, which cuts to the core and represents, in conventional terms, the climax of the film: "I'm trying to be delicate with you, but you're not understanding me. It's not just because of Carl, or my music, but because of you . . . I mean, what would it come to? If a person has no love of himself, no respect, no love for his work, family, friends, something . . . How can he ask for love in return?"

From here *Five Easy Pieces* moves inevitably toward its conclusion. Immediately after talking with Catherine, Bobby finally has it out with his father—more

or less. The stricken, mute patriarch is more of a father confessor. Bobby tries to explain his life, his tendency toward flight, and offers an apology—"We both know I was never really that good at it, anyway"—although it remains an open question whether Bobby lacked the talent, or the discipline, or the courage, or the inclination to pursue a serious musical career.

And so, Bobby is going to leave. He was going to leave the family without saying good-bye, and now, as he has numerous times before, he is going to leave his life behind, this time in the person of (the possibly pregnant) Rayette. At the gas station, we see Bobby ritualistically shed his skin (he gives his wallet to Rayette, he leaves his coat behind), and in the men's room it becomes apparent that we are witnessing a decision that Bobby has made many times in his life, and one that, in this particular instance, has been foreshadowed almost from the start. Early in the film at the bowling alley, the camera lingered on Bobby, alone, in a trancelike state (and the long shot of the gas station across the parking lot there anticipates the Gulf station at the end). In the middle, just before the road trip, Bobby takes a good look at himself in the bathroom mirror at his home in a scene that more explicitly matches the final sequence, but it isn't yet time. He initially leaves Rayette, promising to "send money" (the way he will later leave his wallet), but after an emotional outburst, alone in the car, he reluctantly returns to invite her along on the trip north.

Not this time. But what Rayette intuits and Catherine articulates is that Bobby is doomed. He can run away from particular circumstances, but he can't run away from himself, and the end of *Five Easy Pieces* suggests that Bobby, heading farther north, where it's "colder than hell," may finally have run out of lives. But it's an open ending: we don't know what will happen.[31] Except that Bobby, representing a larger cohort, has no direction home—and that's how it seemed for many who identified with his character and *Five Easy Pieces* in America in 1970.

Meet the New Nixon

Events of the early Nixon years would exceed the worst fears of his opponents, who, if anything, underestimated the extent to which the force of the new president's personality would shape the character of national affairs. If they hadn't, more of them probably would have voted for Humphrey instead of staying home in the resigned conviction that there was little difference between the two candidates. Brooding in private, Nixon was nasty, scheming, and paranoid; he was also smart and introspective, and had a brilliant nose for politics. His behavior occasionally appeared bizarre, partly because he took enormous satisfaction in surprising people (especially his enemies), partly because he was a very strange man.

Nixon made two crucial political decisions from the start. Internationally, he would strengthen the weak hand he was dealt in Vietnam by taking bold, even reckless actions that would force the communists to seek a deal (see chapter 5 on Nixon's war). On the home front, he would energize the silent majority by confronting, and even provoking, the antiwar movement. As always, Vice President Spiro Agnew got the best lines, calling college campuses "circus tents or psychiatric centers for over-privileged, under-disciplined, irresponsible children of the well-to-do blasé permissivists." Nixon just called the kids "bums." But he loved to taunt them. "When I saw some of the antiwar people and the rest, I'd simply hold up the 'V,'" he later recalled. "This really knocks them for a loop, because they think it's their sign."[32]

Nixon's domestic and foreign policy worlds collided in May 1970. The president, by all accounts fortified by multiple screenings of the movie *Patton,* announced to the nation on April 30 that he had ordered U.S. troops to invade Cambodia to wipe out the Vietcong forces using the jungles there as a base of operations. Nixon was not ending the war, he was expanding it, and college campuses across the nation erupted in protest.[33] On May 4, National Guardsmen shot dead four unarmed students at Kent State University; nine others were wounded. The tragedy was not inconceivable. Less than a month earlier, California governor Ronald Reagan, fed up with student protesters, had declared, "If it takes a bloodbath, let's get it over with." Nixon, who had scored points with the silent majority by praising the Chicago police in 1968, stumbled badly this time. "This should remind us all once again that when dissent turns to violence it invites tragedy" was all he had to say. "My child was not a bum," the father of one of the young women who were killed told reporters. Hundreds of universities went on strike; there were violent clashes at many of them. Governor Reagan shut down the entire University of California system, and a massive protest was called for Saturday, May 9, in Washington. The first demonstrators started to arrive Friday night.[34]

Nixon was up all night that Friday, restless after a 10 PM press conference in which he announced that he would limit the scope of the Cambodian effort and fielded questions about the war and Kent State. Over the next six hours he made more than fifty phone calls, took a nap, and listened to a little Rachmaninoff. His valet, Manolo Sanchez, joined him in the Lincoln Room. Impulsively, Nixon ordered a car, and at around 4:30 he and Sanchez drove to the Lincoln Memorial, where the president mingled among and debated with about twenty-five astonished students. And then they moved on; Nixon thought Sanchez should see the Capitol building. Locked out of the Senate, they made their way into the House chamber. At Nixon's urging, Sanchez made a brief speech from the Speaker's chair after which the president and three black cleaning ladies in attendance applauded. "My mother was a

saint," Nixon emotionally told one of them as he shook her hand upon their departure. Haldeman caught up with the president outside the Capitol, and at 6:40, joined by staffers Ron Ziegler and Dwight Chapin, they had breakfast at the Rib Room of the Mayflower Hotel. They returned to the White House, now encircled by a protective ribbon of military buses parked bumper to bumper. "Very weird," Haldeman wrote in his diary. "I am concerned about his condition."[35]

Nixon didn't win over any of the kids at the Lincoln Memorial, but there were signs that the strategy of "positive polarization" was mobilizing the silent majority, or at least its more rambunctious elements. On that same Friday (May 8), hundreds of construction workers clashed with protesters outside the New York Stock Exchange. Then, their ranks swelling, the "hardhats," as they would become known, worked their way eight blocks north to City Hall, chanting "USA all the way!" and beating up any longhairs they saw along the route. The principal target of their wrath, however, was Mayor John Lindsay, who had lowered the flag at City Hall in recognition of the deaths at Kent State. Lindsay wasn't there, but the mob did succeed in getting the flag raised to full staff and led a rendition of "The Star-Spangled Banner." Anti-Lindsay rallies continued for weeks. Nixon was surely delighted, as the New York mayor was featured prominently on the president's "enemies list." On May 20 the hardhats organized a pro-war rally; 100,000 marched down Broadway and burned Lindsay in effigy. A week later Nixon welcomed leading union officials at the White House, who ceremoniously presented Nixon with a hard hat of his own.[36]

Castles Made of Sand

Nixon's America: the continuing war, political polarization, the southern strategy, and a challenging economy not only contributed to an inward turn but also invited a new (and bleak) assessment of the state of the nation, its culture, its purpose, as well as its ideals and institutions.[37] In late 1971, Bob Rafelson, Jack Nicholson, and László Kovács reunited to work on *The King of Marvin Gardens,* a bleak assessment of the American dream against which *Five Easy Pieces* almost looks upbeat. "Everybody I knew was being assassinated or killed," offered Rafelson, describing his mindset while working on the story. "There was a general sense of instability around me."[38] It was also an intensely personal film for the director, who, working with screenwriter Jacob Brackman, drew on some of his own experiences to shape the backstories of the characters.[39] It was shot on location in Philadelphia and Atlantic City with a cast that included two additional seventies notables, Ellen Burstyn and Bruce Dern. Burstyn had

starred in *Alex in Wonderland,* Paul Mazursky's second feature, as well as Peter Bogdanovich's celebrated breakthrough film (and BBS production) *The Last Picture Show,* and she would arrange to have Martin Scorsese direct her in *Alice Doesn't Live Here Any More.*[40] Dern had just finished work on Nicholson's directorial debut, *Drive, He Said* (also by BBS), had previously appeared in Sidney Pollack's *They Shoot Horses, Don't They,* and would go on to star in Michael Ritchie's *Smile,* among numerous other films of the era.

Marvin Gardens is laden with a sense of despair, decay, and faded dreams. The two locations express this mood. "Philadelphia isn't as bad as Philadelphians say it is," a poster displayed early in the film offers halfheartedly, but its graffiti-covered walls suggest otherwise. As for Atlantic City, where most of the action takes place, a more suitable backdrop is scarcely imaginable. Kovács recalled that when his director approached him about the film, Rafelson first talked for hours solely about Atlantic City before finally showing him the script. A bustling and celebrated resort town in the first half of the twentieth century, by the 1970s, before the casinos arrived, Atlantic City had fallen on hard times, its glory faded, its visitors poorer and older, the town struggling with racial tensions and unfavorable economic and demographic trends.[41] And that was on a good day. The movie takes place in the bleak off-season, and the screen is filled with ghosts and decay. Old people, slow-moving old people at that, are ever present, in the hallways, the elevators, and the restaurants; children and younger people in general are notable for their absence. Featured prominently in shots from the beach and the boardwalk are once palatial hotels like the Traymore—presidents used to stay there—now half empty and in disrepair; it would be demolished a few months after the film wrapped. A similar fate awaited the faded glory that was the Marlborough-Blenheim, which was also the location where most of the interior scenes were shot.

The King of Marvin Gardens begins exactly as it will end: with David Stabler (Nicholson) at work, commuting home, and talking with his grandfather, sequences that are framed by scenes at the train station in Atlantic City. (Most of the movie takes place in Atlantic City, bookended by David's arriving and departing trains.)[42] Stabler is a free-form late-night disc jockey, a storyteller, and the movie opens with a six-minute take of David, in close-up, captivating the audience with a tale from his youth, which has the ring of truth (but which we soon learn was not true, at least with regard to some crucial details).

David leaves the studio and takes a long, loner's commute home in the predawn hours, working his way down more dark staircases and empty corridors than would seem necessary to catch the Philadelphia subway. Descending one narrow staircase, David disappears underneath a "No Exit" sign; here and elsewhere in the film Kovács provides "black blacks," that is, deeply saturated darkness. Nicholson called the character a "one-roomer," referring to someone

David does not have much of a future

who lives alone in a studio flat. David lives like a one-roomer, but he shares a house with his grandfather, who rouses him from bed to let him know that his brother Jason is summoning him to Atlantic City.[43] The brothers, described by David as "accomplices forever" on his radio program, have not spoken in almost two years, after Jason's scheme to send them around the world together fell through.

It doesn't take much to persuade the protesting David into going; he's not leaving anything behind, and he can tape his radio shows on the road. He certainly could use an adventure, and his brother's scheme of building a resort on a small island off Hawaii is one that David would like to believe in, however improbable. After all, the brothers had "talked island" for years; maybe this time it will be more than just talk. But Jason's dreams are as farfetched as David's stories. Jason can't even meet his brother at the train station; instead he needs David to bail him out of jail, where he sits on a trumped-up auto theft charge, courtesy of a falling-out with his boss, local mob heavyweight Lewis (Scatman Crothers). Jason had cut a successful career working for Lewis, in particular by presenting a white face for business deals in locations where Lewis would be unwelcome; but the boss seems to have had enough of Jason's eccentricities and self-aggrandizements—a problem, because Lewis's support, or at least his endorsement, is necessary to secure financing for "Stableravia," the would-be island resort the brothers would run together and where they would live like kings.

As with *Five Easy Pieces,* the camera is kept still in the outdoors; though *Marvin Gardens* is shot in a more arty and ambitious style that leans toward

Italian rather than French New Wave, with mostly washed-out exteriors contrasted with existentialist images, such as the brothers' back-lit conversation among the brooding dark pillars under the boardwalk. For the interiors, the motif is one of long takes with a moving, often gliding camera that works its way through underlit hallways and hotel rooms. Scenes in the cavernous lobby feature impressive tracking shots; in the main suite (all of these actual locations inside the Marlborough-Blenheim), the rooms are shot with less light than would typically be used on a studio soundstage. In contrast to the exteriors, however, here rich colors are constantly employed, especially reds and blues (the rooms were dressed specifically for the film), the vibrant interiors contrasting with the bleak exteriors, just as bright unbounded fantasies alive in Jason's mind contrast with the drab limitations of the real world.[44] Colors also distinguish the brothers: Jason is usually seen wearing royal purple, David almost invariably in white shirt and black tie.

On an initial screening, the film appears to unfold to an uncertain rhythm, but almost every scene relates to two clear narrative paths: Jason's increasingly quixotic efforts to secure support for his scheme (financially from Lewis, emotionally from David), and the emerging crisis in Jason's ménage à trois, as Jessica (Julia Anne Robinson) begins to eclipse her stepmother, Sally (Burstyn), as the principal object of Jason's affections. These problems increasingly intersect, such as during the bizarre lobster dinner with two prospective Japanese investors. At dinner Jason sits with his arm around Jessica, while Sally, fuming, is separated and across from them, brandishing an unlit cigarette, trapped between the two Japanese men. As David, spinning an unrelated story, reaches the line "She eventually learned to satisfy his sexual needs," the camera holds tight on Jason and Jessica, laughing and snuggling. Sally abruptly gets up and leaves, and the investors quickly follow. They have an early plane to catch, and, they observe, "since we're talking about Lewis's money, perhaps we'll soon be talking to Lewis."

In sum, although the film strikes an unconventional tone—the passage of time is uncertain,[45] transitions between sequences are often unexpected, and some scenes approach a dreamlike quality (the brothers on horseback, the mock Miss America Pageant)—the movie is not episodic. The sequencing of events is purposeful and consequential, and the principal narrative strands converge and are simultaneously resolved. The lobster dinner marks a turning point in the implicit conflict between the women. Just previously, Jessica had been crowned "Miss America" by her stepmother, "last year's queen" (in fact, in Sally's first appearance, her outfit is evocative of a pageant contestant's costume); immediately after dinner, in a tense scene back at the hotel room, Sally's authority over her increasingly confident stepdaughter is shown eroding. The next morning the older woman ceremoniously acknowledges the changing of

the guard, cutting her long hair short in the glow of the beachfront bonfire into which she has tossed her clothes and a bucketful of beauty products.

That same post-dinner hotel room confrontation also marks the moment when David is no longer able to suppress his growing awareness of the delusional nature of Jason's ambitions. The island is not "all locked up," as Jason had assured him. Instead, David protests, "you're asking me to believe in another dream." David, as he will explain later, would have liked to stay "in the funhouse," but unlike his brother, he can see the exit sign approaching. Reverting to form, David disengages from the group and, left to his own lonely devices, is able to work his way through the black underworld (and the film's racial subtext) and arrange a "summit meeting" with the boss. Lewis is cordial but clear: he is cutting Jason loose, once and for all—and of course there will be no financial backing for the Hawaii adventure.

The movie's twin crises come to a head in a riveting six-minute scene back at the hotel, where Jason, David, and Sally talk past one other in a series of arguments that wind around the protagonists in a tightening circle. Unable to wake his brother from his delusions ("Open your eyes, open your ears!"), David announces he is going home; Sally fears abandonment; Jason, desperate to salvage his scheme, riffs from one contingency plan to the next and talks of leaving both women behind. When Sally shoots Jason, it's not surprising that the movie has reached a violent conclusion—the gun she uses has been passed back and forth eight times among six characters over the course of the film. But who would shoot whom was an open question, and the suddenness of the act itself is shocking.

As with *Five Easy Pieces,* the movie nears its conclusion with Nicholson's character offering an emotional confession of his own failings to an audience who can listen but not respond. This time the monologue takes the form of the version of events he is relating to his radio audience.[46] He returns home to find his grandfather watching old home movies of the two brothers building sandcastles on the beach, as in a way they just were in Atlantic City, dreaming in each instance of the kingdoms they would rule. But David trudges upstairs to his room, resuming instead the life that has turned out, as he once described it to his audience, "comically unworthy."

This theme of alienation, from society and self, would remain an important subtext for many of the films of the decade. Nicholson would revisit the topic in *The Passenger,* his 1975 collaboration with Michelangelo Antonioni, a film that is, in its own very distinct way, a reimagining of the central theme of *Five Easy Pieces.* In *The Passenger,* Nicholson's David Locke, like Bobby Dupea, can no longer bear his life as it is and decides to run away. But Locke's story is even more extreme: an accomplished international journalist, he is much more successful than Bobby, and his despair and self-rejection are more

superficially puzzling. And his tactic—switching identities with the similarly built and similarly named David Robertson, an acquaintance who has died of a heart attack in an isolated Saharan hotel—is more comprehensive. Following the same instinct, David outdoes Bobby by actually shedding his own life and assuming another, in a desperate attempt at escape. His motive is expressed in his disagreement with Robertson about the similarity of exotic locations: "I don't agree. It's us who remain the same. We translate every situation, every experience into the same old codes—we just condition ourselves." Locke nods in agreement with himself as he listens to the taped conversation while switching passport photos with the dead man.

But the result is the same, and, in *The Passenger,* more final. Ultimately, neither Bobby nor David could run away from himself; and so, quixotically chasing the horizon, unable to shake their relentless, indefatigable pursuers, each was similarly doomed from the start. But fighting on with what they had, as they were, where they were, was intolerable. Even David Stabler would have run off to "blue Hawaii," if only it were possible.

An international production, *The Passenger* nevertheless takes its place in the New Hollywood story as the capstone of what can be called Nicholson's "alienation trilogy," along with *Five Easy Pieces* and *Marvin Gardens.*[47] Each features protagonists who do not fit in contemporary society, and, much worse, who are disappointed when they look in the mirror. "However hard you try," Nicholson's David Locke explains, "it stays so difficult to get away from your own habits." Like Bobby Dupea and David Stabler, he feels that he should have done better. America should have done better, too, but that was another story. And one that would be told and retold in the seventies films, most pointedly through the thriving revisionist movement of the era, especially in Westerns but across genres—movies that would challenge America by reinterpreting its mythology. Other films would let go of myths altogether and pursue further the inward turn, focusing on ever more personal and intimate questions, such as the changing nature of relationships between women and men.

CHAPTER 4

THE PERSONAL IS POLITICAL

The civil rights and antiwar movements shook the streets and rattled the structure of American public life. For the most part, however, their enormous import and consequence found expression outdoors, and the front lines were largely engaged by willing participants. Two other upheavals of the 1960s, the women's movement and the distinct but coterminous sexual revolution, pulled at the most basic and intimate building blocks of social life. These transformations unsettled and redefined relationships between husbands and wives, mothers and daughters, men and women; they were felt acutely, and everywhere, and especially in the privacy of the home. This great reassessment proved much harder to sidestep, even by many who were determined to do so.

As discussed in chapter 2, a new permissiveness about sexuality had been emerging throughout the 1960s.[1] Helen Gurley Brown's *Sex and the Single Girl* (1962) mocked the idea that a "nice" single girl could not and should not have a rewarding sex life, derided not sleeping first with a man she planned to marry ("complete lunacy"), and even approved affairs with married men ("frequently marvelous in bed and careful not to get you pregnant").[2] These were, at the time, unspeakable suggestions, at least in polite society or anywhere in public. But times *were* changing. In 1960 "Puppy Love" was a big hit for Paul Anka: "I'll pray that maybe someday / you'll be back in my arms once again." Ten years later Stephen Stills hit the charts with a different approach: "If you can't be with the one you love / love the one you're with."

By the end of the decade, then, the idea of sex outside of marriage—or, more accurately, sex outside of the *expectation* of marriage, something that certainly occurred in the past but had nevertheless been shrouded by a formidable

taboo—had become unscandalous, at least among most young adults. American society more generally still retained much of its puritanism, and it was the clash of these values that raised the stakes and intensified the public and private drama. At the time of the June 1969 Stonewall riots, for example, private, consensual homosexual sex between adults was a crime in forty-nine states.[3] But despite considerable resistance, new attitudes about sex (such as a reassessment of the assumption that a woman's virginity was a commodity to be exchanged for a proper marriage), increased access to birth control, and the comparatively modest threat of sexually transmitted diseases contributed to greater open-mindedness about (and the practice of) less restricted sexual behavior.

You Say You Want a Revolution?

Both the sexual revolution and the women's movement left indelible marks on the seventies film. The end of censorship obviously allowed filmmakers to take on issues of sexuality—topics that could not even be mentioned, much less shown—more frankly than in the past. *Bob & Carol & Ted & Alice* (1969), the debut directorial effort of Paul Mazursky (co-written with his regular collaborator Larry Tucker), is an exemplar of how New Hollywood films embraced the freedoms afforded by the end of censorship, not for their own (prurient) sake but to explore the mysteries of complex adult relationships. Indeed, the film's titular foursome are *not* kids: in their thirties and into the second decade of their marriages, they have kids of their own. Despite its frank talk and promised orgy, *BCTA* is not about sex but about the effect of the sexual revolution (and related awakenings of the 1960s) on a generation that came of age under the old rules but were still young enough to wonder if they were missing out on something special.

Bob (Robert Culp) and Carol (Natalie Wood) return transformed by their participation in an "experiential" workshop, a marathon group encounter of interpersonal and introspective explorations they attended at a retreat modeled on the Esalen Institute.[4] They relate their experiences—and their new emphasis on the honest expression of feelings as opposed to the façades of social convention—to their best friends, the skeptical and more straitlaced Ted (Elliott Gould) and Alice (Dyan Cannon). This is all harmless fun until Bob subsequently follows his honest feelings into a tryst while on a business trip in San Francisco. Mazursky's insight is that this transgression is more subversive of Ted and Alice's relationship than it is of Bob and Carol's. Although Bob is at first overcome by guilt, he and Carol talk it through and decide that his pursuit of sex without love is a reasonable extension of their new philosophy, and one that only strengthens them as a couple.

But Carol's need to share the wonderful news of Bob's affair with Ted and Alice—he is confused, intrigued, and aroused; she is horrified and sickened—provokes a crisis that plays out in a long, torturous bedroom scene in which the unhappy couple implicitly struggle for control, a deeper conflict between them appropriately manifested in his desire and her resistance to have sex. Ted and Alice's unspoken discord contrasts with the (unrelenting) freedom with which their friends express their feelings, and this is reflected in the two couples' respective sleepwear: Ted's pajamas-over-underwear and Alice's layers of flowing robes and nightgowns (and accompanying sleep mask) cover up a whole lot more than Bob's briefs and Carol's little nightie (seen earlier) did.

This extraordinary scene clocks in at over twelve minutes, and like several of the key exchanges in the movie, it goes on for "too long"—that is, it goes on for longer than the viewer implicitly expects. Like the best moments in the films of John Cassavetes, the "long scene" is experienced in three phases.[5] The familiar narrative arc associated with a conventional scene fails to resolve, and continues instead into an unsettling period whereby the scene seems to have outlived its purpose; characters run over the same ground, but the movie stays with them instead of jumping ahead to the next chapter of the action. But finally the audience, forced to linger beyond the traditional tidy ending and stuck with the characters in a difficult and uncertain situation, becomes increasingly aware of the deeper truths that are being exposed. Thus, although *BCTA* is a comedy that moves quickly, carried along by its humor, in retrospect it turns out to have been a movie of relatively few, relatively long scenes, and the pacing within those scenes is unhurried.

Unsettled by the feelings Bob and Carol have stirred, Alice takes to therapy, which serves her well; she becomes increasingly insightful and confident as a result. Ted takes the plunge; at a subsequent barbeque he dives enthusiastically into Bob and Carol's pool and from there into his own tryst on a business trip in Miami. Carol has her own liaison, which Bob stumbles upon (crucially, *after* it is consummated), and which for a moment shakes but does not topple his commitment to the philosophy of free love.

Carol and Ted's infidelities are revealed one on top of the other to Alice in a hotel room in Las Vegas, where the couples are vacationing, at which point she disrobes and insists, to the protestations of her friends, that they immediately commence with the orgy she claims was the unspoken purpose of their trip. Alice, debating all comers confidently in her underwear, challenges Bob and Carol in particular with the rhetoric of their own philosophy. She first wins over Carol ("She's right, this is where we are at"; "We have to be straight about this"), who then convinces the reluctant Bob, to the enormous apprehension and protestations of Ted, the last holdout. But all eventually agree that it would be "purely physical" and "fun." As in the film's iconic advertising image, the foursome climb into bed together.

Free love has its complications

This is the moment that *BCTA* has been promising, or at least hinting at, from the start: an early scene foreshadowed a swap, with Bob resting his head in Alice's lap while Carol and Ted sit closely together across the room; later it was suggested by Alice's "Freudian slip" during a session with her psychiatrist when she substitutes Bob's name for Ted's. But then what? It is a suspenseful moment, and the palpable tension up on the screen was real: Mazursky did not tell the nervous players what was going to happen.[6] Ultimately, nothing does. Kisses and embraces give way to awkward silences; eventually the couples leave their room and hotel, and in a surreal conclusion encounter scores of others milling about in the parking lot, where members of the accumulated crowd intensely regard one another, paralleling the searching experience at the institute that started the film. For Mazursky, this "tells us that the experience at the Esalen Institute worked."[7]

As appropriate for a seventies film, *BCTA* offers no pat answers.[8] It is not a rejection of hearty sexuality or of New Age sensibilities: therapy, encounters, and self-awareness are endorsed, and the traditional role-playing marriage represented by Ted and Alice in the first half of the film is presented as a Kafkaesque nightmare. But at the same time the limits of free love are exposed. As Ted protests, "It just doesn't seem right"; and this is a tricky "it," suggesting the paradox that sex with strangers might be okay, but sex with friends would be, well, wrong. But that would mean sex ultimately is more meaningful than an amusement park ride, and not so easily detached from love. *BCTA* is not a call to return to the safe, repressed shores of the 1950s, but it does warn that navigating the waters of liberated sexuality—an assertion that remains one of the great achievements of the 1960s—might be harder than it looks.

The Whole Equation

Bob & Carol & Ted & Alice had something to say not only about the sexual revolution but also about changing relationships between women and men more generally. These are two very different things, although they were often conflated, often problematically. Sexual freedom presented new challenges for women, especially in terms of managing and maintaining their sexual autonomy, left to navigate a tightrope between freedom and exploitation. As Gloria Steinem observed, for too many the new permissiveness "simply meant women's increased availability on men's terms," a sentiment suggested by the opening lines of the Grateful Dead song "Jack Straw," "We can share the women / we can share the wine," a hippie utopia that still manages to treat women as property. From a feminist perspective, "liberation meant the power to make a choice; that sexuality, for women or men, should be neither forbidden nor forced."[9]

The conflation of upheavals in sexuality and in gender relations is understandable; as noted, these movements occurred at roughly the same time, and women and men are in fact distinguished by their sex, and certainly there were important overlaps between the two issues. *Sex and the Single Girl,* for example, was rather bluntly about sex, and contains many passages that to contemporary eyes are not obviously feminist. But Gurley-Brown's book is not to be underestimated, and she drives home two big, radical, empowering points: that marriage need not be the big brass ring in women's lives ("This then is not a study on how to get married but on how to stay single—in superlative style"); and that women need to assert their sexual confidence, autonomy, and pleasure. In a culture that left many women ignorant of their own bodies and ashamed of their sexuality, Gurley-Brown insisted that a sexy woman "is a woman who enjoys sex" and urged her readers to accept "all parts of your body as worthy and loveable."[10] In 1962 these ideas about sex and about the *single* girl were revolutionary. They were also much more novel and subversive of established gender norms than promiscuity, which, after all, had been around for a while, if once talked about only in whispers and allusions.

Similarly, The Pill (its influence acknowledged by routine capitalization) played a major role both in the sexual revolution and in women's liberation. Although oral contraceptives came on the scene in 1960, it was not until the end of the decade that The Pill was within the practical reach of young, single women. Access to reliable birth control certainly added fuel to the fire of free love, but it also enabled women to plan for and invest in careers with greater certainty. Starting around 1970, women began to marry later, and applications by women to professional degree programs markedly increased; evidence suggests that accessibility to The Pill was a contributing factor to the timing of both of these changes.[11]

But despite these overlaps, the women's movement—a great awakening that affected almost every corner of American society—was different from, and about much more than, the sexual revolution. The demand that women be treated as equals to men—before the law and inside the home—simmered in the early 1960s, was increasingly visible by the end of the decade, and became a considerable force in the 1970s. Despite the cresting of the political wave, numerous setbacks, enduring barriers, and an emerging backlash against "feminism," women's opportunities and interpersonal relations by the 1980s were in many important ways simply unrecognizable compared with the realities and prospects just one short generation removed.

The women's movement was an inside job, driven by changes in women's own expectations.[12] Female college graduates in 1957 expressed little dissatisfaction regarding their future prospects: 84 percent quickly found employment (of those, 54 percent were teachers and 5 percent nurses), and 71 percent planned to quit their jobs when they married or had children. But a survey of the same cohort only six years later reflected much greater frustration, with women reporting stone walls of discrimination in opportunities for pay and advancement, as well as routine bias in daily workplace interactions. In 1962 a Gallup poll found that only 10 percent of women wanted their daughters to have the same kind of lives that they did.[13]

This growing sense of ennui among many American women (paradoxically, it seemed, emerging during a period of unprecedented prosperity) was articulated by Betty Friedan in 1963 with the publication of her best-selling book *The Feminine Mystique*. Friedan gave voice to "the problem that has no name," one that "lay buried, unspoken, for many years in the minds of American women." This silent, desperate unhappiness brought shame and confusion to women who appeared to have everything they were told to aspire to: husband, children, home, security. But what those fortunate women did not have was an independent sense of self. "The feminine mystique permits, even encourages, women to ignore the question of their identity," Friedan wrote. Infantilized, dependent, and discouraged since childhood from intellectual pursuits, women threw themselves into their roles as wives, mothers, and homemakers; well rested (and often tranquilized), many nevertheless fell victim to the quiet pandemic vaguely labeled by doctors "housewife fatigue." For these women, Friedan gave legitimacy to the thought "I want something more than my husband and my children and my home." Many daughters, observing the lives of their mothers, were quick to reach this conclusion.[14]

Friedan's landmark book seemed to come out of nowhere, but of course it did not; strands of these notions can be seen, especially in retrospect, quietly weaving their way through the popular and public discourse of the time. At the urging of Eleanor Roosevelt, in 1961 President Kennedy formed a

Commission on the Status of Women, which, in its 1963 report, duly noted the widespread discrimination against women that was standard practice. To take one common example among many, in hiring and promotion, employers routinely specified the preferred sex for a position without regard for applicants' qualifications. Numerous state laws also limited the times and hours that women could work; ironically, many of these ordinances were written by progressives of a bygone era hoping to prevent the exploitation of young single female laborers, but they also served to inhibit the prospects for women's career advancement.[15]

The following year, a provision against discrimination in employment practices by sex was added to Title VII of the Civil Rights Act of 1964. This was not, however, a response to the findings of the commission but was an attempt at sabotage introduced by an opponent of civil rights. The amendment (and the act) passed, but the issue of sex discrimination was treated as a joke, first as it was debated and subsequently as federal law. Known as the "bunny rule" to invoke the specter of men demanding the right to serve as cocktail waitresses in Playboy clubs, the provision was mocked in editorials by the *New York Times* and the *New Republic*. They need not have worried; the first director of the new agency created to take up discrimination claims, the Equal Employment Opportunity Commission (EEOC), called the law against discrimination by sex a "fluke," and for good measure shared his view that "men were entitled to female secretaries."[16]

The head of the EEOC was a man of his word; the commission did not pursue claims of workplace discrimination put forward by women. Changing the system from within was proving to be a blind alley. And this wasn't the only place where women could not get taken seriously. Politically mobilized outsiders were equally indifferent to women's issues. The otherwise progressive men of the civil rights and antiwar movements, and of the New Left more generally, were, in a word, retrograde in their attitudes and behavior toward women. The women's movement would have to find its own way. Friedan responded to the failures of the EEOC by moving ahead with her plans for an institutional center of gravity to advance women's issues, founding the National Organization for Women (NOW) in October 1966. Younger feminists broke bitterly with the left and splintered in a number of directions.[17]

The nascent women's movement first attracted national attention with a protest at the Miss America Pageant—the only TV program President Nixon said he allowed his daughters to stay up late and watch—by a few hundred women on September 7, 1968, in Atlantic City. Not surprisingly, the event was widely misreported (and trivialized) as an episode of "bra-burning." Less easy to dismiss was the women's strike for equality, Friedan's proposal that women celebrate the fiftieth anniversary of their right to vote (August 26, 1970)

by leaving work and taking to the streets. As many as fifty thousand marched in New York City alone; in the two years since the Miss America protest, more and more women had been reevaluating their own attitudes about gender relations.[18]

One such woman was Gloria Steinem. Steinem had written the brilliant proto-feminist exposé "I Was a Playboy Bunny" in 1963, but she did not consciously experience her own personal awakening until 1969, covering an abortion rights protest for *New York* magazine. New York State was considering liberalizing its abortion laws and had invited fifteen "expert witnesses"—fourteen men and a nun—to testify at the official hearings on the topic. In response, a feminist group held a competing meeting at which women spoke of their experiences with illegal abortions. Steinem, who could have spoken at that gathering, covered the story as a detached professional, but, personally transformed, she never looked back. In 1971, with Friedan and Congresswomen Bella Abzug and Shirley Chisholm, Steinem created the Women's Political Caucus; in 1972 she was a co–founding editor of *Ms.* magazine. The mass circulation monthly became the most visible face of the mainstream women's movement in the mid-1970s.[19]

Did the New Hollywood Hate Women?

One of the most emblematic features of *Ms.* was its letters section, where women often wrote in describing the moment when it suddenly occurred to them that some behavior or expectation they had taken for granted was a reflection of their own unspoken (and complicit) structural disempowerment. It was an age of such reassessments. Kate Millett's *Sexual Politics* cast a feminist revisionist eye across two centuries of political, social, and cultural history. The sweeping book sang the praises of John Stewart Mill, offered a devastating critique of Freud, and illustrated the relationship between patriarchy and controlling social orders (seen most explicitly in both Nazi Germany and the Soviet Union). *Sexual Politics* also revisited the work of major literary figures, in particular D. H. Lawrence, Henry Miller, and Norman Mailer, finding arguably implicit and in some cases (especially in Miller) astonishingly explicit misogyny.[20]

By the mid-1970s, the interrogation of received narratives routinely exposed hitherto unchallenged objectification of women and the marginalization of their concerns. In this atmosphere it is not surprising that some writers set their sights on the movies, and on the seventies film in particular. "From a woman's point of view," Molly Haskell concluded, the years of the New Hollywood "have been the most disheartening in screen history." Joan Mellon, also

writing in 1973, argued that "the current cinema, seemingly so adult and sexually free, is degenerate in its image of women." Haskell offers a similar assessment, concluding that "sexual liberation has done little more than re-imprison women in sexual roles, but at a lower and more debased level." Both authors were seeing "fewer films about strong and independent women [in the 1970s] than in the 1940s"; Mellon instead saw "a despair which portrays the female alternative as empty, disintegrated and alienated."[21]

Was the New Hollywood as a movement misogynistic and a regressive step with regard to the portrayal of women and their concerns on-screen? There are reasons at least to suspect as much: both film noir and the French New Wave—which, as discussed previously, were key primordial influences on the seventies film—have been subject to intense scrutiny and debate regarding their portrayal of women. Film noir (considered more closely in chapter 7) is commonly associated with male anxiety and even masochism, a crisis in masculine identity, and an ambivalence toward if not outright hostility to women.[22] The female protagonists of *The Maltese Falcon, Double Indemnity, Criss Cross, The Lady from Shanghai,* and *Out of the Past* to take but a few iconic examples—are evil, scheming creatures who use their sexuality to corrupt and destroy the men they encounter. *The Asphalt Jungle* offers a virtual rogues' gallery of female dangers. And Geneviève Sellier's thoughtful and not unsympathetic study of the New Wave nevertheless finds (in reference to particular films) a "misogynistic subtext" in Chabrol, "unconscious sadism" (toward women) in Truffaut, a "highly ambivalent" perspective on the breakdown of traditional gender relations in Godard, and (here throughout) the objectification of women in Rohmer's films. (Agnès Varda's *Cleo from 5 to 7* is closely considered but assessed as an anomaly.)[23]

As for the New Hollywood itself, Haskell offers the most detailed and analytical critique. She elaborates three mechanisms through which the changes of the 1960s undermined the position of women. First, while Haskell is no apologist for the production code, and reviews its negative consequences (and problems with the portrayal of women during the censorship era),[24] she nevertheless observes a positive and unintended irony in its the extreme sexual prohibitions (whereby even married couples were shown in separate beds): "The production code, for all its evils, was probably at least as responsible as the Depression for getting women out of the bedroom and into the office." Second, the studio system (again, for all its evils) was a star system, and stars, including female stars, had some power and control over their characters and image. Women of the studio period have "intelligence and personal style and forcefulness." (Mellon also makes this point with regard to the studio system, which "had a place for" and "protected" strong women like Katharine Hepburn, Joan Crawford, Bette Davis, and Barbara Stanwyck.) Third, Haskell argues that the

sexual permissiveness afforded by the end of censorship stripped women of an important source of their power: the power to withhold sex and their sexuality. Mellon offers a similar argument, noting that "the 'free' or 'loose' woman is without the protection accorded her desexualized, domestic sister."[25]

Haskell and Mellon were not alone in making these types of critiques. Also writing in 1973, David Denby observed that while there was plenty of sex in the movies, romantic films, "movies in which male and female equals meet, fight, fall in love, have an affair, get married or don't get married have just about disappeared." Instead, Denby noted the increasing prominence of buddy films, "male competition/companion epics" which are "indifferent or hostile to women." He saw too many Hemmingwayesque heroes and not enough heroines, a state of affairs that he partially attributed to male writers who were "guilty of a sentimental fraternalism that downgrades or simply ignores women." (In many cases, it could be added, such as in Monte Hellman's *Two-Lane Blacktop*, women represent a threat to the privileged bond between the male protagonists.) Stephen Farber's assessment was similar to Denby's; he concluded that "women today have no movies that reflect their concerns, or their fantasies."[26]

Other critics honed in on particular New Hollywood films. John Simon read *Midnight Cowboy* as hostile to women; Monte Hellman's *Cockfighter* has been critiqued as "a glaring example of sexism"; and Francis Ford Coppola's early effort *The Rain People* was said to "portray women as attempting independence and failing." Marjorie Rosen was so outraged by Elaine May's treatment of women in *The Heartbreak Kid* that she dismissed May as an "Uncle Tom" betraying her gender. Sam Peckinpah's *Straw Dogs* was widely perceived (correctly, in my view) to be deeply misogynistic, even by critics not known for their emphasis on such things. Even *Chinatown*, one of the crowning achievements of the movement (see chapter 7), can be seen as catastrophic in its consequences for every female character who graces the screen (and, for that matter, even those who don't). As Barbara Halpern Martineau accurately observed, "Gittes' relations with women are constantly destructive."[27]

To be sure, some of these criticisms are on the mark. There is no denying that individual characters, or, more to the point, individual seventies films, could be misogynistic. (A misogynist character does not make a movie inherently misogynistic any more than a Nazi character makes a movie pro-fascist.) It is also more than plausible that if you forbid people from talking seriously about sex for over thirty years, given the opportunity, they are likely to talk about it a lot. And it would be naïve not to acknowledge that producers often took advantage of the "new permissiveness" in an exploitative way. (Martin Scorsese, for example, was forced to add an unmotivated sex scene to *Who's That Knocking at My Door* in order to secure financing for distribution.)[28]

Nevertheless, it must be recognized that Haskell's discovery of silver linings in the studio system are, as she makes clear, just that—silver linings. For the overwhelming majority of its female characters, the studio system offered *very* limited life prospects, with marriage and family as the only plausible goals. The desexualized wife—neutered, faithful, wise, and often a quietly suffering mother—"maternal," as Haskell notes, "even for the husband," is pretty much the best the studio system had to offer women, and was in fact a better fate than that of the spinster aunt or the lascivious sister, who, if not saved by marriage, was destined for cinematic punishment. Again, as Haskell notes, this all became a bit unhinged with the breast fetishism of the 1950s, whereby, it could be added, absent any dialogue, these archetypes could easily be identified according to their apparent proportions.[29] Whatever the problems that might be found in the seventies film, the good old days were not good at all, at least with regard to women's prospects on the screen.

Additionally, it is just as easy to compile a list of seventies films that center on women's issues and points of view, feature strong female characters, or offer complex and thoughtfully drawn roles for women. These can be seen in readings of *The Graduate* in chapter 2 and *Five Easy Pieces* in chapter 3, and is also evident in *Bob & Carol & Ted & Alice,* which takes its female characters and their concerns seriously, gives them voice (and screen time), and has them develop over the course of the film. In addition, *BCTA* foreshadows and then takes on the issue of sexual double standards, and it does not flinch. Carol has her affair; Bob does not get home "just in time," and he is forced to confront (and overcome) the hypocrisy of his initial, overwhelming emotional reaction. Finally, as noted, Mazursky's film closes with cautionary skepticism regarding the (more often than not masculine-coded) fantasy of free love.

To this list of laudable seventies films could be added *Petulia, Faces, Rachel, Rachel, Wanda, The Last Picture Show,* and *Images.* And still more: *Diary of a Mad Housewife* comes very close to being a fictionalized dramatic account of *The Feminine Mystique* in its minor as well as major details. *Sunday Bloody Sunday* not only takes the concerns of its female lead seriously but also pauses for a scene between mother and daughter, as they debate each other's life choices. "You think it's nothing, but it's not," declares the older woman, in defense of her traditional marriage.

Women and Men in the Context of the Seventies Film

Competing lists of films that are "good" or "bad" with regard to their portrayal of women will generate debate.[30] This sort of contestation is, of course, to be encouraged. But any effort to assess the balance of the feminist ledger of the

New Hollywood by weighing alleged sinners against potential saints misses a larger and more important point. In evaluating the New Hollywood, the treatment of gender and sexuality needs to be contextualized within the broader themes of the movement. By evaluating women's roles in isolation from the ideology of seventies film, critics like Haskell lose this larger (and crucial) perspective. Without this context, it is not possible to understand filmmakers' motivations in making choices about character and story; and analyses are also skewed by the absence of a comparative assessment of the portrayal of men. Finally, retrospective readings in particular risk failing to pay adequate regard to the way in which the social realities of the period shaped the dramatically plausible range of options for women in film.

Thus, while Haskell raises important issues for female characters in a cinema liberated from censorship (not surprisingly, some of the same ones faced by women at the time in real life, such as how to retain an autonomous command of their own sexuality when "free love" is associated with progressive thinking more generally), by focusing exclusively on sex and gender in isolation, she overestimates their role (and purpose) in the seventies film.[31] As discussed in chapter 1, while it is hard to overemphasize the extent to which the end of censorship was the liberation, the reason why is often fundamentally misunderstood. It was not about what could be *shown;* it was about what could be *said.* And the ultimate taboo was not sex but that which the production code was most determined to forbid: moral ambiguity.

Once again, it was this more than anything else that was what the New Hollywood was pushing back against, and that defined its artistic agenda. Above all, the New Hollywood aspired to explore that undiscovered country, the adult world, where choices are not easy and obvious, where authorities and institutions are often imperfect and corrupt, and, especially, where justice does not always prevail. This particularly strong aversion to the classic happy ending (and restoration of order) was both a reaction against the moral certitude of the production code as well as a function of the fact that the seventies film, like downbeat film noir, was a cinema of hard times: of war, protest, upheaval, crime, and the nightmare of Watergate. The New Hollywood was also (as emphasized in chapter 5) revisionist, rebelling against fables of duty, honor, and country. These, then, were not movies that worshiped heroes; to the contrary, this was a cinema that insisted on their imperfection: women and men, flawed, anxious, despairing, and, often, losing.

Thus while Haskell can summarize the best roles for women in the New Hollywood as "whores, quasi-whores, jilted mistresses, emotional cripples, drunks," it is equally possible to summarize the men as losers, fools, brutes, cowards, and thieves. Especially as compared with the studio era, the New Hollywood portrayed men in a harsh and negative light. Denby's essay points

toward this as he critiques New Hollywood films that offer a "journey through corrupt, betraying America" with "two demoralized male characters at the center." Women are out of place in these films because they would offer the possibility of love and resolution rather than the favored "bleak ending." For Denby, then, the problem is not that there are positive male as opposed to negative female role models, but rather that "sometime in the sixties we decided that we no longer deserved to feel good." (Not for nothing had Paul Schrader dubbed it "the new self-hate cinema.") Farber concurs. Though very sympathetic to criticisms of the treatment of women in film in general, and particularly in *The Heartbreak Kid,* he nevertheless argues that this misses an additional point: "The movie as a whole is conceived as a satiric expose of the vanity, cruelty, and emptiness of the *male* hero."[32]

It is simply not possible to assess the attitude of the New Hollywood toward women, or toward anything, for that matter, outside of this context: where the New Hollywood came from, what its influences were, what it was rebelling against, and what it was standing for in the midst of the extraordinary social and political eruptions of the period—all of which together produced films with "a new open-minded interest in examining American experience," as Pauline Kael argued, without supplying "reassuring smiles or self-righteous messages."[33]

Finally, in assessing the attitude of the New Hollywood toward women, especially in retrospect, it is necessary to keep in mind that choices made by female characters need to be understood in the context of *their* times. This excuses nothing but explains much. Many contemporary viewers are only vaguely aware of the legal status of women in the late 1960s and early 1970s, to say nothing of the social norms and expectations that defined the space in which these female characters existed.

If a good number of women now define themselves as "post-feminist," to a large extent it is because they assume as a matter of fact basic rights and opportunities hard won by the efforts of the women's movement. But the behavior of characters in New Hollywood films, men and women, as they pertain to gender, remains of their time, shaped by their witness to the experiences of their mothers and fathers, their upbringing as girls and boys, and implicitly and always of their awareness of the possibilities for and implications of various choices offered to women by society during those years.

And that society was different. In 1968 women were unable to gain admission to Yale University, serve on juries in Mississippi, or run in the Boston Marathon. (One bandit who sneaked in was nearly tackled by an irate official.) In 1969 there were still laws that required a married woman to "perform domestic services" or "have sexual relations on demand"; unescorted women— or escorted women, for that matter—could be denied entry to restaurants and bars. (Betty Friedan was once turned away from the bar at the Ritz-Carlton

hotel, which did not serve women.) In the workplace, what would now be seen as sexual harassment was then commonly endured and understood as part of the job; on the streets, women, especially women without men, faced even greater dangers. In the 1970s, New York (among other states) had onerous legal barriers to the successful prosecution of rape, and in many states "marital rape" was a legal impossibility.[34]

Economic discrimination against women left them second-class citizens in a capitalist society. In the mid-1960s, women accounted for 7 percent of the nation's doctors and 3 percent of its lawyers; in 1970 the University of Texas Dental School refused to allow more than two female students in an entering class of one hundred. Jo Freeman, looking for work at a Chicago newspaper, was told that "all the papers had a quota of no more than 5 percent women on the city desk and there were rarely any openings." Until 1971, businesses could refuse to hire mothers (but not fathers) with small children. And those women who did find work faced inferior pay scales and lower wages. Astonishingly, not until 1975, with the passage of the Equal Opportunity Credit Act, was it illegal for banks to deny credit on the basis of sex or marital status, or to require that women get their husband's written permission when applying for a loan or a credit card. In 1974 Billy Jean King held five Wimbledon singles championships, but she could not get her own credit card; it had to be in the name of her husband, then a law student with no income.[35]

What is particularly consequential about all this is the extent to which it was seen as *unremarkable* to so many. When asked why only three of his first two hundred appointments went to women, and none of those in high-ranking positions, President Nixon squeezed off a joke in response. At one anti-Nixon demonstration, women were allotted, grudgingly, two short speeches; when the time came, they were met with a shower of crude obscenities and shouted off the stage. During George McGovern's presidential campaign, Gloria Steinem was barred from one strategy session by Senator Abe Ribicoff, who simply declared "no broads." But the idea that women faced discrimination worthy of any serious discussion was routinely dismissed, especially in comparison with the "real problems" of others. It was on this basis that the venerable TV news anchor Howard K. Smith felt the need to editorialize about his "modified unsympathy" with the women's movement, after his network covered the 1970 strike for equality as little more than another petulant episode of "bra-burning."[36]

Rereading *Carnal Knowledge* and *Klute*

In this context, with the artistic ethos of the New Hollywood in mind and the legal, economic, and normative circumstances for women during this period

understood, it is interesting to reconsider two notable seventies films, each of which generated some controversy regarding its portrayal of women.

Mike Nichols's 1971 film *Carnal Knowledge* was notorious for its taboo-shattering dialogue, which led to the arrest of a Georgia theater operator on the charge of "distributing obscene material" (a decision upheld by the Supreme Court of Georgia but overturned by the U.S. Supreme Court). Rescued from obscenity charges, the film still stands accused of misogyny. Mellon asserts that the film offers a "vicious" and "one-sided, contemptuous view of female sexuality," that it presents women more broadly as "shallow, crass or stupid," and in the end they "fare badly."[37]

There is no doubt that the central male character, Jonathan (Jack Nicholson), is a misogynist—indeed, this was the intention of the filmmakers, and Jonathan is identified almost solely by this trait. The question, however, is whether the *film* is misogynistic; that is, do the filmmakers—here in particular producer-director Nichols and screenwriter Jules Feiffer (who approached Nichols with a complete play, subsequently rewritten for the screen in consultation with the director) endorse some version of this view?[38] Mellon indicts the filmmakers for "a smug assent, a silent endorsement" of Jonathan's perspective. Haskell and other critics like Janice Law Trecker are slightly less direct, but they do condemn the film in general and accept this point in particular; Haskell finds the film "indulgent" toward Jonathan.[39]

Revisited in the context of the New Hollywood, however, these charges simply do not hold up. The treatment of women is more nuanced than some of the film's critics suggest, and it is very hard to see anything but condemnation, even hatred, of the male characters. Mellon is correct when she notes that the women "fare badly," but the men fare worse—much worse. And as for being "shallow, crass or stupid," that would be a promotion for the male protagonists, Jonathan and his best friend Sandy (Art Garfunkel). Again, this was noted by some critics at the time. For Roger Ebert it was a film about "men who are incapable of reaching, touching, or deeply knowing women"; Pauline Kael observed that "the men have nothing to give, and they never learn anything; their aging is a process of becoming more and more nakedly corrupt"; Vincent Canby found *Carnal Knowledge* "merciless towards both its men and its women."[40]

This relentless criticism of all of its characters, of men, of women, and, of course, of society, centers us clearly in the métier of the New Hollywood. And this is very much an "American New Wave" film, right down to its use of Fellini's cinematographer, Giuseppe Rotunno.[41] Friend and foe of the movie have observed this sensibility. The men are not simply "foolish" and "pathetic"; Kael finds "an element of punishment in the movie's social criticism," laid on pretty thick, "never letting [the men] win a round." One critical essay

summarized the film as the story of a "bastard" and a "dope," with a "nagging, dubious message" that "prosperous middle-aged Americans are soulless." Richard Schickel, somewhat less hostile to the film, nevertheless agrees. "We never get a reasonably satisfactory explanation of why two reasonably engaging youths don't come to a somewhat better end," he writes. "What we get instead is the implication that they, and by extension us, are inescapably corrupted by the wretched values of a materialist society."[42]

A rereading of *Carnal Knowledge* in context supports the contention that the film is fairly hostile to both its male and its female characters; that it condemns both the visceral (Jonathan) and the unconscious (Sandy), the two men at the center of the movie; and that on balance the film is more sympathetic to its female than to its male characters. This is most obvious in the first part of the movie (about 40 percent of the running time), which considers the love triangle between Susan (Candice Bergen) and the two men in the late 1940s. Susan is a rich, strong, complex character who (in cinematic terms) dominates the men. Sandy is a passive, simple, and inarticulate college student who first dates Susan; Jonathan is his crude roommate who betrays Sandy by seeing Susan behind his back.

Susan is articulate and (comparatively) confident—she speaks first at the mixer where they meet when Sandy doesn't have the nerve, and in conversation she is consistently more insightful than either of the boys (Jonathan notes that she is "too sharp"). She plans to be a lawyer and hopes to write novels. She is stimulating, inspiring Sandy to read great books. Susan carries on an affair with Jonathan while she is Sandy's "girlfriend"; perhaps that reflects poorly on her, but she struggles with the dilemma, and it is clearly her choice, and she also chooses which relationship to terminate. At crucial moments we have access to her thoughts, doubts, and concerns. We see her dancing at a pub happily in turn with each; later, at their table, the camera focuses on her, revealing her increasing inability to divide her attention between her suitors, who remain off-screen as her face turns back and forth. This is followed by a scene that brings us even closer to her dissonance, in an exterior shot where she again commands the foreground of the screen. When Susan breaks it off with Jonathan over the phone, she has more than twice the screen time he does, and we see and feel her emotions.[43]

Susan eventually marries Sandy, as we learn in the second part of the film, which takes place in the early 1960s and occupies about half the film's running time. If there is a criticism of this film that sticks, it is about the way she disappears from the movie. Literally we never see her again; she is just the wife that Sandy talks about and ultimately leaves. We never know what happens to her. She did become a wife and mother, and it is very likely that she never became a lawyer or wrote novels, but for all the audience is told, she might as well have

been hit by a truck. Haskell, who acknowledges Susan as "the one intelligent-romantic woman" in the film, argues that she "cannot be envisioned beyond the moment she outlives her romantic usefulness to the men, so she disappears from the movie."[44] This summation is debatable, but the general point is taken. By shedding Susan, the film announces that it is no longer interested in her narrative (which to that point had been the most promising of the three). That does not speak to the strength of her character, though perhaps if women had run the production—writer, director, producer—Susan would have stuck around. But this valid criticism is not a function of the New Hollywood. There were limited opportunities for women writers, directors, and producers in the New Hollywood, but there were fewer still in the Old Hollywood.

Once Susan is gone, the film becomes Jonathan's—no subsequent scene takes place in his absence—and it is not a pretty picture. Jonathan has devolved into the cliché of the aging lothario, unable to sustain meaningful relationships with women, whom he continues to define, solely and crudely, on the basis of their physical attributes. Women are so implicitly unclean to him that throughout the movie Jonathan races to the shower (or any available body of water) immediately after having sex.[45]

Sandy remains his best friend, but even though they talk to each other in language which suggests that their dialogues have been uninterrupted (and thematically unchanged) since college, they are nevertheless drifting apart. In an important stylistic change, conversations between the men now take place increasingly as detached speeches, filmed in isolated close-ups. In the first part of the movie they were more commonly seen sharing the screen, bantering in more traditional two shots.

Worse still, Jonathan is losing his one skill: his indefatigable virility expressed in prodigious serial "conquests" seems to be flagging in a world increasingly populated by more confident women. Nursing a breast obsession from the very start of the film, Jonathan is temporarily cured of his increasing struggles with impotence when he meets the impossibly large-breasted Bobbie (Ann-Margret), a successful commercial actress. Our very first introduction to Bobbie makes it abundantly clear what Jonathan sees in her, but the passionate nature of their early sexual encounters still inevitably fades into routine and dissatisfaction, their growing alienation expressed in the stark geography of Nichols's later bedroom compositions.

Bobbie is very much *not* a strong female character. She pressures Jonathan, to his obvious discomfort, into living together. (This happy moment is negotiated with the two of them on opposite sides of the room, sealed on Bobbie's un-ironic line "You're a real prick, you know that?") She subsequently manipulates him into a failed marriage. Throughout their cohabitation he is unbearably (verbally) abusive of her; and in classic fashion, first he pressures

Alone, together

her to quit working, then he berates her for not doing anything. He wants her available and undemanding ("I want you right here, where you belong"), as an impossible fantasy figure expressed visually in the motif of the ice-skating beauty seen repeatedly on the rink at Rockefeller Center. Bobbie does not have the strength to do what she obviously should do—drop Jonathan like the bad habit he is—and this makes her a somewhat unattractive character (in a great role and performance). Her fate is not entirely tragic, however; by the end of the movie she has shed Jonathan and gained a daughter.

Sandy is not Jonathan, but he is no prize either. Restless with the routine of what he describes as a comfortable and happy marriage to an intelligent and sensitive wife, he too is searching for what will prove unattainable. Ultimately, he leaves Susan to live with Cindy (Cynthia O'Neal), and seems the worse for wear. In fact, almost as soon as we are introduced to Cindy, Sandy is already expressing his boredom with her. Sandy's standing is still further reduced in the context of this relationship, as it is implied that Cindy feels free to explore other sexual opportunities as they present themselves; and so at the end of this part of the film, Sandy is left a serial cuckold on the precipice of a second failed relationship.

Cindy is trickier to assess. On the one hand, she is a very strong female character. She controls her environment: it is she who decides where and when she and Sandy will go ("I'm going, you do what you want"). More subtly, she turns the radio on and off as she sees fit, pours her own drinks, dances when she feels like it. Cindy is better off than Sandy, to be sure; but the film hints that this has come at the price of her femininity. Although both men are sexually attracted to her as a woman, she is often coded, implicitly and explicitly, as masculine, possibly suggesting that this is the only way for a woman to express "strength." She can play tennis with the boys. She is also open to the

possibility of a "visit" from Jonathan, but retains a (stereotypically masculine) double standard: she can sleep with whomever she wants, but if Sandy strays, she'll kick him out. "She's got a great body on her," Jonathan says, "but she wants balls."

To keep score, then, *Carnal Knowledge* offers three visions of womanhood: Susan, smart, complex, feeling, and introspective; Bobbie, weak, manipulative, and abused; Cindy, strong but cold and compromised. None is an angel. But all are better, and end up better off, than our heroes Sandy and Jonathan, as the short final section of the movie makes clear. Ten years later still, these men have devolved further into their worst incarnations. Sandy thinks he has "found himself" and has taken up with a free-spirited young thing less than half his age, who has no speaking lines in her brief appearance. It is hard to believe that the sequence—shot to exaggerate his middle-aged paunch—isn't making fun of his recitation of hippie platitudes; it's harder still to believe that this relationship has much of a future. As for Jonathan, his ever greater (if that's possible) hatred of women is expressed in the rages he vents during his specially prepared slide show, "ball-busters on parade," a historical review of his sex life from childhood to the present day. In the end, the only way he is capable of getting sexually aroused is by hiring a prostitute to follow, to the letter, a specific script that praises his masculinity. We leave him flat on his back, an image that reinforces his utter defeat. *Carnal Knowledge* may not love its women, but it hates its men.

Alan J. Pakula's *Klute* would appear to have three strikes against it. It can be summarized, superficially but not inaccurately, as the story of a prostitute (strike one), a damsel in distress who does not save herself but is rescued from certain death by a heroic male who arrives in the nick of time (two), and with whom she leaves her home to accompany him back to his territory (out). Take out the sex and drugs and it sounds like it could be a John Wayne picture.

None of this went unnoticed by critics of the New Hollywood. Christine Gledhill argues that "the film operates in a profoundly anti-feminist way," and that Bree Daniels (Jane Fonda) is "neurotic, fragile, lonely, and unhappy"; John Klute (Donald Sutherland), by contrast, is presented as a dominant and paternalistic figure. Mellon charges that Pakula gives women only three choices, "call girl, lonely recluse, or dependent wife," and argues that the movie's message boils down to "Life with a strong man is necessary." Haskell does not dwell on the picture but is quickly dismissive of "Jane Fonda's grubby prostitute."[46]

Again, these criticisms take the film out of its context and, in this particular instance, have the gender reading exactly wrong. *Klute* is one of the iconic films of the New Hollywood, the cast and crew a virtual who's who of the movement.

Its gritty New York City locations and murky interiors were shot by seventies virtuoso Gordon Willis ("the prince of darkness"), Michael Chapman operated the camera, Michael Small wrote the music. For producer-director Pakula (whose first three films each featured female leads), *Klute* would become known as the first entry in his "paranoid trilogy" (followed by *The Parallax View* and *All the President's Men;* see chapter 6), films that explored issues of privacy and surveillance, implicit conspiracy, and the corruption of American institutions. These themes are obviously important to *Klute:* the title sequence of the film opens to the playing of a surreptitiously recorded tape, and its ominous turning reels are revisited repeatedly in close-up. It also matters that Bree can pause to condemn, with good reason, the "goddamn hypocrite squares" who represent superficially straitlaced America. But for the present discussion, *Klute* serves as still another classic example of a post-censorship film that is not so much about sex (of which there is actually not all that much, along with relatively modest amounts of nudity), but uses sexuality as a vehicle in the service of a broader character study.

And, crucially, that character is Bree. It is a very close study, and it is entirely her film. Indeed, the only real gender bias to be found in this movie is that it is called *Klute,* when in fact it is completely about Bree. It is concerned with her inner thoughts and her personal struggle and story. The movie includes three sessions with her analyst, and two additional voiceovers from different sessions. We are often alone with Bree, for extended periods (typically in her apartment), and in quiet moments; at other times the film makes clear she is a talented woman—and showing that Bree has real talent, and that she is not well treated by directors and other men she has to deal with in the "straight" world, was important to Pakula.[47] She is the only complex figure in the film.

Compare this with John Klute, a character who is close to being a blank slate, a vacuum who approaches two dimensions. Sure, he's a nice enough guy. He is defined by a refreshing integrity, and he's driven by an admirable sense of loyalty to his friend who has vanished without a trace and stands accused of stalking, and previously beating, Bree. But that's it. We don't know a thing more about him, we don't learn any more about him, and we are *never* alone with him. No other characters in *Klute* are closely considered, and the men are not presented as more attractive than the women. Yes, we meet prostitutes and madams, but in contrast to many traditional Hollywood productions (*Pretty Woman,* for example), *Klute* does not glamorize prostitution. Quite the opposite; in fact we are dragged through some pretty unpleasant places. And the other male figures are even more damaged: Cable, Klute's boss, corporate executive by day, deranged, sadistic rapist by night; Frankie, the evil pimp; Berger, the strung-out druggie.

We have but one multidimensional, fascinating character here, and she is troubled. Her principal issue is one of control, and this defines the attraction of prostitution for her. Our introduction to Bree is at a degrading modeling audition, where she and an endless line of women, soon replaced by a second wave, are lined up and inspected like cattle (in an effective use of the film's widescreen aspect ratio). From this failed interview Bree immediately arranges a quick gig with a "commuter." *Klute* is economically making two points here: first, suggesting that there is little moral difference between the way a woman has to degrade herself to sell her body to a modeling agency and the way she sells herself as a prostitute; and second, that Bree, who is trying to get out of "the life," craves turning tricks to recapture the sense of control that does not exist for her in the straight world.

Control is key, and Bree is struggling with hers. Pakula (despite the widescreen format) features vertical constructions to emphasize her vertiginous state of mind.[48] (There are many examples of these dramatic verticals; the most notable, to the contemporary eye, are several salient shots of the nearly completed World Trade Center buildings rising visibly beyond Cable's office window.) In the first session with her analyst, she is asked what the difference is between working as a model or an actress as opposed to a call girl. "Because when you're a call girl, you control it," she answers, and then uses the word "control" ("over myself...over my life") three more times in her answer. Bree seeks control, and autonomy, but to the extent that she is successful, it has come at the cost of real human connections—as she notes, "You don't have to feel anything." Diane Giddis, in a favorable reading—"*Klute* seems to me to have more to say about women (and men) than any film of the last two or three years"—sees this, the struggle between love and autonomy, as the central axis of the picture, and "nothing less than a metaphor of the intense struggle many women go through" more generally.[49]

This is consistent with a reading of the film that presents Klute and Cable, in cinematic terms,[50] as parallel figures or mirror images, archetypes, even, of the threats and opportunities in Bree's life more generally. They could even be seen (metaphorically) as manifestations conjured by her, each representing a version of her greatest fears (the unleashed mortal dangers of the city, the imprisonment of small-town domesticity). This juxtaposition is emphasized by Giddis, who notes about Bree that "as her attachment to Klute grows, Cable becomes more dangerous," an observation that is supported by Pakula's comments on the extent to which Bree "really almost destroys herself."[51]

The structural similarities between Klute and Cable are remarkable. They both follow her, watch her (Pakula implicates Klute, and the audience, in a scene in which he watches Bree perform a striptease for a client); each secretly tape-records her conversations. Cable becomes obsessed with Bree; Klute's behavior is suggestive of the same thing (Donald "gave the subtext of obsession at times," noted Pakula),[52] and, significantly, each is also beyond her "control."

Bree's "stock in trade" is to manipulate men, as Cable accuses in their final confrontation; or, in her own words, "to lead men by the nose where they think they want to go...and you control it." But Cable transcends her manipulation. He is not role-playing or pretending; he is dangerous. As for Klute, he is initially, and uniquely, unsusceptible to her charms, despite her efforts; later, to her confusion and anxiety, Klute is also unique in that she develops genuine feelings for him.

Those feelings generate internal and external crises at different moments in the film. For example, and in accord with Giddis's theory that Klute's affection and Cable's fury are interdependent, there is the juxtaposition of the greatest moment of domesticity between Bree and Klute with an explosion of Cable's psychosexual rage that literally destroys the fabric of her life. As the very happy and contented-looking couple goes shopping, Bree takes note of a father and child—the only child to appear in the entire film. In this moment she seems to be able to contemplate the idea of marriage and family, an unimaginable (and largely unwanted) possibility up to this point in her life. This is followed immediately by their return to her apartment, which has been ransacked and destroyed, her clothing ripped to shreds and left sexually soiled. Bree clearly has mixed feelings about all this; and indeed, pursuing her love for Klute would destroy the independent lifestyle represented by her modest flat (which is distinguished from the Park Avenue luxury she enjoyed when she was a full-time call girl). She tells her analyst that Klute is the only man she's ever had feelings for, but "all the time, I feel the need to destroy it" probably because, as she says, "I had more control before"—and pretty soon she's taking a wild swipe at him with a pair of scissors after a melee with Frankie.

This episode is foreshadowed earlier in the film, in a crucial scene where Bree, frightened (and this fear is shown), comes down to his basement apartment. Klute sets her up on her own cot, but in the middle of the night, at her initiative, they make love. Soon after she cuts him down, in a very rough moment

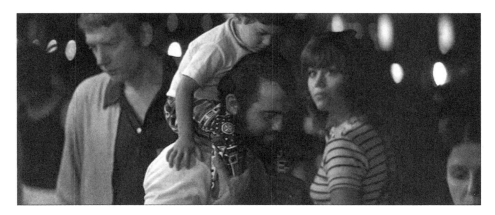

Imagining motherhood

("Don't feel bad about losing your virtue. I sort of knew you would"). It is not definitively established whether she went there with the intention of seducing and then undermining him, or if she was sincere and then got rattled (and defensive) in response to his troubled look afterwards. On the one hand, there is some support for the latter interpretation, given the sequence of shots: after her initial display of warm satisfaction, her demeanor turns, sharply and harshly, after a shot of Klute, isolated and forlorn, as she processes his feelings. On the other hand, the rougher interpretation, that her action was premeditated, is more consistent with her "need to destroy it" issue; it is also in accord with the New Hollywood sensibility, in which it is common, and even appropriate, to show a hero or heroine behaving badly. Either way, this is her most unattractive moment in the film—worse even than when she later physically attacks him—incoherent rage seeming more forgivable than premeditated cruelty. Either interpretation is also consistent with (and important for) the central thread of the film: her inner conflict. (The interlude certainly does not advance the suspense plot.) It also matters for her internal struggle that this ruthless moment is not enough to drive him away. As Bree later tells her therapist, "He's seen me mean, he's seen me ugly," and yet, absent any "act" she puts on, he seems to be genuinely attracted to her.

In sum, *Klute* is a character study of an interesting, complex, talented (and, yes, very troubled) woman who is wrestling with the types of issues that, in their general manifestation, were of great significance to many women at that time, and that are in accord with the social and political themes of the era. Additionally, and contra critics like Mellon and Gledhill, the resolution is much more ambiguous than they describe. Bree's skeptical closing voiceover about their prospects (which, to be sure, is not definitive) contradicts the images that we see. (She is clearly moving out of her apartment and leaving town, and he is with her.) But according to Pakula, in his view there is a "fifty-fifty" chance she'll go straight, but a "good deal less" of a chance she'll make it with Klute. And among the filmmakers, he was the optimist: "I had the feeling that Bree and John Klute maybe had a chance of having a life together, but Donald and Jane thought there was absolutely *no* chance that these people could have a life together."[53] So it is not at all obvious that it was the intention of the filmmakers for her to find closure by marrying the right man. As noted, the New Hollywood did not favor closure in general.

Find the Feminist

As acknowledged previously in this chapter, there were surely misogynistic films made during the heyday of the New Hollywood. Some of these instances—again, such as Peckinpah's *Straw Dogs*—stand out. But misogyny can also be found in unexpected (and contested) places, as shown by a brief

consideration of two seventies films very much and very purposefully concerned with the issues of gender: *Alice Doesn't Live Here Anymore* and *Blume in Love.* Rereading these movies further underscores the point that there is a need to distinguish between the perspectives of particular films as opposed to those of the larger movement, and that films need to be read within a broader context in order to assess their purpose and meaning.

Alice Doesn't Live Here Anymore, which, to be fair, was considered by some to be a film sensitive to women's issues (and, of course, the film clearly is about a single woman and her struggles), was nevertheless vilified in many quarters. Its director, Martin Scorsese, Haskell wrote, "doesn't seem to like women very much." Teena Webb and Betsy Martens argue that the movie's message to women is "You think you've got hidden talents? Well you probably don't. Find a good man and settle down." Karyn Kay and Gerald Perry focus more on a message of motherhood, which they also perceive as reactionary: "Motherhood—defined as the sacrifice of one's identity for the sake of the child—is still the highest and holiest good." And Robin Wood was not alone in underscoring the unlikely perfection of dream man Kris Kristofferson, whose appearance allows for an improbably happy ending.[54]

It is certainly fair game to debate the message of *Alice,* and the meaning of that message in the context of the women's movement. But to label it "antifeminist" or hostile to women is a tricky business, because the film was very much Ellen Burstyn's project. Moreover, she wanted to make a movie that captured the "movement" at that time, the "energy that was igniting the consciousness of women." She brought the property to Warner Brothers, she personally interviewed and hired the director (Scorsese), she saw to it that on the production there were "as many women in positions of authority as possible," and she fought for changes in the script to satisfy her vision of a "change in consciousness" regarding the cinematic portrayal of women. Thus to hold up *Alice* as an exhibit of evidence against the New Hollywood is to make rather forward claims about the definition of feminism and its ownership.[55]

Alternatively, consider *Blume in Love,* written and directed by Paul Mazursky. Mazursky is generally thought to be a director very sensitive to women's issues. As discussed in this chapter, his *Bob & Carol & Ted & Alice* respected and gave voice to its female characters and their concerns. Mazursky would later direct *An Unmarried Woman,* which generated debates about the choices made by some of the characters in the film but was widely regarded as a sophisticated picture about the concerns of contemporary women.

Blume, however, is a *very* problematic film from the standpoint of its gender politics. Certainly the film has considerable strengths. It is entertaining, well done, and weaves in, without obvious preaching, sub-themes regarding issues of race and class, all the while taking on questions of sex and love and gender

that are clearly of continued serious interest to its writer-director. And Mazursky again takes women and their concerns seriously, especially Nina (Susan Anspach), but also Arlene (Marsha Mason), respectively, the wife and girl-friend of one Stephen Blume (George Segal). A particular strength of the film is how it first suggests, and then shows in flashback, that Nina did not leave Stephen simply because she caught him sleeping with his secretary but rather used that as an opportunity to escape a stifling, unfulfilling marriage.

Nevertheless, this film can be summarized, and not unfairly, as follows: Blume cheats on Nina, and they separate, each soon into the arms of another lover, Nina with Elmo (ironically, an even more impossibly perfect Kris Kristof-ferson), Blume with Arlene, a woman whom, from an emotional standpoint, he treats shabbily. Free from Blume, Nina visibly grows and becomes more con-fident, articulate, and self-actualized. "I want to be my own person," she tells him, and over the course of the film, she becomes just that. But for some reason (both true love and male ego are plausible candidates), Blume becomes obsessed with the idea of getting Nina back. So he stalks her—following her around, breaking into her house, eavesdropping on her therapy session—repeatedly confronting her with his desire for reconciliation, which she does not share. She was unhappy with him and is better off without him. "You are not misun-derstood," she retorts accurately during one such protesting encounter.

Stymied on all fronts, Blume finally rapes and, we subsequently learn, im-pregnates Nina.[56] Magically, rape and unplanned pregnancy solve all prob-lems: Elmo leaves, voluntarily and on good terms with all; then, finally, Blume and Nina reconcile, in a big romantic finish in Venice. Again, the film is more thoughtful and nuanced than is suggested by this summary, but it is a fair sum-mary, especially by the standards to which other seventies films have been held to illustrate their hostility toward women. And in this case it is hard to con-ceive of this film as anything but disparaging at best to the notion of a thriving, independent woman.

What is particularly notable about this is that at the time, nobody seemed to notice—or if they noticed, they didn't seem to mind. In fact, if anything, just the opposite happened. For example, in a rather strident essay on the char-acterization of women in Hollywood movies, Howard Movshovitz considered *Blume* to be both a success and at least "moderately sensitive" on the gender front.[57] This is hard to account for. It's *not* because the film was reaching for irony. Yes, the movie was a comedy, but Mazursky meant for the ending to be taken seriously. It was written that way from the start, and from his perspective that ending is deeply moving.[58]

Perhaps we see marital rape differently today—actually, ex-marital rape—but Molly Haskell, in her rave review of *An Unmarried Woman*, notes the "marital rape scene" in *Blume* only to praise Mazursky for having "plunged

into politically sensitive areas"; Richard Corliss wrote that Blume "rapes his ex-wife, listens through a keyhole while she talks to her analyst about him...and still retains our sympathy." Well, his sympathy. David Denby, although he does not take on the politics of the rape or the reconciliation, asks a good feminist question: "Why should we spend two hours rooting for the wife to give in and take her husband back—aren't they better off divorced?"[59]

The puzzle of *Blume*—that is, its general reception on gender grounds, especially compared to a film of deliberate feminist intent like *Alice*—is not easily resolved. *Blume,* arguably, hates (or at least mistreats) its women. But as we have seen in this chapter, it is very hard to make that claim about Mazursky's films more generally. Or, for that matter, about the New Hollywood, which produced films that were unavoidably enmeshed in and inescapably affected by the revolution in gender relations that was going on at the time. The seventies film didn't offer heroines or heroes; it presented instead compromised and compromising adults struggling with their own private fears while attempting to navigate the uncharted waters of the period's ongoing fundamental reassessment of intimate interpersonal relationships. These relationships, it should be noted, would have come under strain during the best of times. Unfortunately for men and women, these were not the best of times. America was fighting a brutal, bitterly divisive, and unsuccessful war abroad. On the home front, increasing crime, grime, and insecurity had people scurrying home before dark, in many cases double-locking their doors—only to find that their living rooms and bedrooms had become a different sort of battleground.

CHAPTER 5

CRUMBLING CITIES AND REVISIONIST HISTORY

When he assumed the presidency, the Vietnam War was not Nixon's war. Although he was one of the country's most prominent and vocal "hawks" throughout the 1960s, Vietnam was not his doing; it was the catastrophic mess he inherited. In fact, much of his campaign rested on the promise, if implicit, that he could clean it up and the country could move on—if not in six months, then certainly within a year. But with his conduct of the war, Nixon managed to take considerable ownership of it: in spending four brutal, unproductive years doing little more than attempting to cover the tracks of America's retreat from and final defeat in that lost war, he presided over its most scarring period. Nixon's ruthless, vengeful prosecution of the war forced the nation to reassess its image as a force for good in the world, a revisionist introspection that left an indelible mark on the country—and on the seventies film.

Nevertheless, the Vietnam War was not Richard Nixon's fault. That was the work of, in increasing order of responsibility, Presidents Truman, Eisenhower, Kennedy, and, especially, Johnson.[1] One tragedy of the war was that from the American perspective, it was never about Vietnam but was instead first about France and Europe, then about anticommunism more generally; it was increasingly motivated by little more than an abstract fear of losing and, in the end, by existential beliefs about American "credibility" coupled with petty personal vanities.

Vietnam was a French colony at the start of World War II, and during that war the United States provided support to Ho Chi Minh—a nationalist and a communist—in his fight against the Japanese occupation of Indochina (Vietnam, Cambodia, and Laos). After the war Ho declared Vietnam's

independence, but France, hoping to recover the *grandeur* lost in its humiliating collapse at the hands of German power and subsequent collaboration with its Nazi occupiers, sought to reclaim the colony. The United States had misgivings about the idea of a French return to Indochina but soon found itself backing the French colonial effort—because, simply put, Vietnam didn't matter, but Europe did. Especially as the cold war emerged in 1946–47, the United States was concerned about the very fate of the West. The French economy was fragile and its communist party formidable, and any effort to reconstruct the war-ravaged economies of western Europe and ensure for its common defense against the Soviet Union required the active participation of a thriving France. France was committed to Vietnam; the United States was committed to France.

For the United States, Vietnam never mattered outside of some larger cold war context. Worse, policy choices there were unattractive and limited from the very beginning. In 1947 the State Department understood "the unpleasant fact that communist Ho Chi Minh is the strongest and perhaps ablest figure in Indochina," and was resigned to the fact that Ho would have to be a part of any solution to the conflict there. But with the fall of China to communism in 1949, the rise of McCarthyism in America, and the sudden surprise invasion of South Korea by the communist North, the conflict in Vietnam was reinterpreted as part of a single orchestrated, militarized bid for communist domination of all of Asia. From 1950 on, U.S. aid to the French efforts increased dramatically, paying nearly half the cost of France's war.[2]

American support would prove insufficient, however, and after losing a decisive battle at Dien Bien Phu in May 1954, France was forced to abandon its effort to reconquer Vietnam. The terms of the French withdrawal were established by the Geneva Accords of 1954, which stipulated that the country would be temporarily divided at the seventeenth parallel. After a brief period, free elections would be held; in the interim, strict limits would be placed on the presence of foreign troops. From this point the United States became the dominant outside power in Vietnam. The goal of its policy was to stem the tide of communism in Asia. According to a widely held view at the time—the domino theory—if Indochina fell to communism, all of East Asia, from Japan to India, would soon follow, tumbling like dominoes before advancing communism.

With the United States running the show, out went the French-supported ruler Bao Dai; in came American-backed Ngo Dinh Diem, chosen because he had not collaborated with the French, but whose domestic base of support was nevertheless very narrow. It soon became clear that elections would have to be avoided, as Ho would likely win.[3] In 1955 Diem repudiated the Geneva Accords. The goal of U.S. policy was now to create a new country, South Vietnam, a self-sustaining entity that would stem the tide of communism in Southeast Asia.

The problems that would plague U.S. efforts for the next two decades were clear from the very beginning: the country it hoped to build in the South was utterly dependent on American support, which poured in unceasingly. Worse, as a more practical and ultimately insolvable problem, Diem (and successive regimes supported by the United States) had a tenuous hold at best on the hearts and minds of the Vietnamese people—and even less control over much of the territory of southern Vietnam. The oppressive nature of Diem's rule contributed to a growing insurgency movement in the South, fighters who blended in, often indistinguishably, with the civilian population. There were thus four principal parties in the Vietnam War: the Republic of Vietnam (South Vietnam); the antigovernment insurgents in the South (known colloquially as the Vietcong); the Democratic Republic of Vietnam (North Vietnam); and the United States. The Vietcong was supported by the North, which also, and increasingly from the mid-1960s on, actively participated in the fighting. The forbidding, largely ungoverned jungles of neighboring Cambodia and Laos facilitated the flow of support from North to South; North Vietnam was in turn supported by communist China and the Soviet Union.

A former General of the Army, President Eisenhower, fearful that its jungles "would absorb our troops by divisions," was unwilling to commit U.S. forces to a ground war in Asia. But he was committed to the cause, and emphasized the importance of Indochina to President-elect Kennedy. Kennedy needed little convincing. Though greeted with a blizzard of pessimistic reports about how poorly the war was going and of the continued erosion of Diem's political power, the young president was a believer in the domino theory and favored a more aggressive U.S. effort of increased aid and more ambitious counterinsurgency efforts. Eisenhower had kept the number of U.S. advisers to a Geneva-limited 685; at the time of Kennedy's assassination, there were over 16,000 U.S. military "advisers" in the South.[4]

Still, the war was being lost. Despite increased American efforts, little progress was achieved against the widespread and highly motivated insurgency; poorly armed Vietcong guerrillas routinely routed better-equipped units of the South's regular army. And as always, the political picture (and thus the possibility of achieving U.S. goals in the war) was even bleaker than the dispiriting military struggle. In November 1963 Diem was finally overthrown, murdered in a coup. Over the next fifteen months a parade of coups and a revolving door of unstable, repressive, and corrupt military regimes followed, fueling the insurgency and further undermining the prospects for a legitimate, viable, stand-alone South Vietnam.[5]

During his time in office Kennedy was not forced to make what would be the hardest decisions about Vietnam. Johnson made those decisions, and he was disastrously wrong at every turn. Out of options, he rolled the dice

on the bet that "bombing the North would save the South," and when that failed, he made the fateful decision to introduce U.S. ground troops. (Not that he stopped bombing. The United States dropped nearly half a million tons of bombs on North Vietnam from 1965 to 1967 and over a million tons on South Vietnam itself, including strikes against villages suspected of harboring insurgents.) Johnson's war is discussed in chapter 3, but to review: 23,000 U.S. troops introduced in January 1965 became 180,000 by December, and then 380,000 one year later, and finally over 500,000 troops at the time of the Tet Offensive. The Vietnam War as we know it was Johnson's war, rooted in his peevish unwillingness to lose it.[6] But in March 1968 Johnson understood that he was no closer to victory, and that he had finally exhausted the range of options that even he could imagine. The war could not be won. In fact, his conduct of the war—the consequences of all that bombing and all those troops on the social fabric of a would-be South Vietnam—had left the United States further from achieving its political goals. Stranded amid the ruins of his presidency, he withdrew from the election of 1968, surely wishing then that he had made different decisions in 1964 and 1965. For him personally, and for the country, certainly, it is hard to imagine policies that could have turned out worse.

Richard Nixon, running for president, reached a similar conclusion. Convinced of the war's vital purpose, Nixon had been a vociferous hawk from the start. His only criticism of Johnson's approach was that it wasn't aggressive enough. Visiting South Vietnam in 1964, he derided the president's policies as "soft"; over the next three years he was always at least one step ahead of LBJ in calling for the next level of escalation.[7] But Nixon knew a loser when he saw one, and even before the Tet Offensive, he was repositioning himself. In a prominent essay, "Asia after Vietnam," Nixon deemphasized the war—in fact he dropped all references to Vietnam about a third of the way through—in favor of a broader (and more modest) "American policy toward Asia," which, he wrote, hinting at the most daring move of his future presidency, "must urgently come to grips with the reality of China." This was Nixon in transition. A few months later, after Tet, he (like Johnson) was transformed. Nixon abandoned talk of victory in Vietnam; instead, starting with a speech on March 5, 1968, he pledged that "new leadership will end the war and win the peace in the Pacific," a phrase that became the standard refrain of his campaign.[8]

Assuming the presidency, Nixon was eager to bring the war to a swift conclusion. "The war must be ended," he had routinely insisted on the campaign trail. And there was reason for optimism. As the new administration took office, Henry Kissinger, Nixon's national security adviser and his intimate partner in the orchestration of American foreign policy, published an essay in *Foreign Affairs* that laid out clearly what had gone wrong with American policy and

what a future settlement would look like. "Our military operations...[bore] little relationship to our declared political objectives," wrote Kissinger. "We have been unable so far to create a political structure that could survive military opposition from Hanoi after we withdraw." An American "commitment to a political solution...and a negotiated settlement" was now "inevitable." Fortunately, the four parties to the conflict had "a fairly wide area of agreement on some basic principles." In particular, Kissinger emphasized a return to the basic understandings of the Geneva Accords, the "ultimate" withdrawal of U.S. forces, and the reunification of Vietnam as a result of negotiations among the local parties themselves. The main disagreement at present had to do with "the status of Hanoi's forces" in the South.[9]

Tragically, although Nixon was eager to extract the United States from the quagmire, he was nevertheless initially unwilling to let go of the fantasy that the war's principal goal—leaving behind a stable, legitimate state of South Vietnam that could stand on its own—could still be achieved. Like Johnson, Nixon was also unwilling to be "the first American president to lose a war." But a "negotiated settlement" required extracting concessions from North Vietnam, which was problematic given that Nixon's signature policy of "Vietnamization" involved the steady drawdown of U.S. troops. Time was on the side of the North: the Americans were unilaterally withdrawing their forces. And so the Nixon-Kissinger strategy was to try to compel the North by *widening* the war, and through a combination of massive force and creative diplomacy.[10] The application of force was brutal and merciless; the diplomacy was tactically innovative and farsighted. By pursuing détente with the Soviet Union, and, even more radically, by opening relations with China (a step only someone with Nixon's anti-communist bona fides could have taken), Kissinger and Nixon hoped to play the communist giants off each other, and to get each of them to nudge the North Vietnamese to the bargaining table. With regard to the war itself, however, every one of these levers—expansion, force, and diplomacy—came up empty. In 1973 Nixon and Kissinger signed a peace treaty that essentially ratified America's defeat and sealed the fate of South Vietnam: cease-fire, the withdrawal of U.S. forces, and the release of American POWs, with no clause requiring the withdrawal of North Vietnamese forces from the South. It was a deal that could have been reached in 1969.

Over four long years, Nixon did little more than prove that he would not go quietly. Almost immediately upon entering office, Nixon and Kissinger decided to take a step that Johnson had rejected—bombing neighboring Cambodia—in an effort to interdict the flow of supplies to the South, and to signal to the North that despite the planned withdrawal of U.S. ground forces, Nixon was a dangerous man who would seek victory by widening the war. "I call it my Madman theory, Bob," he explained to chief of staff Haldeman. "I want the

North Vietnamese to believe I'm capable of *anything.*" Nixon might have been eager to signal his determination to Hanoi, but he was more circumspect about telling anybody else. Shrouded in secrecy (and an elaborate bookkeeping scheme designed to cover the destinations of the flights), Nixon tried to keep the bombing secret from Congress, most of his own administration, and, of course, the American people. As he later explained in his memoirs, "My administration was only two months old, and I wanted to provoke as little outcry as possible." From March 1969 through May 1970, almost four thousand B-52 sorties dropped over 100,000 tons of bombs on Cambodia.[11]

Nixon also bombed Laos, first with tactical aircraft (another half-million tons or so), and then, secretly in February 1970, authorized B-52 strikes that let go of another quarter-million tons of bombs. The president also increased the bombing within South Vietnam, tripling the rate at which B-52s flew over the country. Secret bombing was never secret for long (even if Nixon was invariably furious when the news hit the papers), but when revealed, it raised knotty questions about the way America was conducting itself. B-52 strikes raised similar questions. The giant planes released their massive, unguided gravity bombs from thirty thousand feet onto uncertain targets, guaranteeing that innocent civilians would be caught up in the destruction. During the war the Americans also resorted to firebombing, unleashing 338,000 tons of napalm on the enemy; they also sprayed over 100 million pounds of chemicals in an effort to deforest the country. Whatever the war was about—and increasingly it seemed to be solely about the desire of the United States to demonstrate its "credibility"—its political goals were among the collateral damage of its prosecution.[12]

Tasking young soldiers ten thousand miles from home with "search and destroy" missions against insurgent forces that often vanished into the civilian countryside was another source of the yawning gap between America's military muscle and the achievement of its political goals. One infamous demonstration of this occurred in the hamlet of My Lai, where, on March 16, 1968, more than 350 unarmed civilians (mostly women and children) were brutalized and then murdered by a unit of the U.S. Army. The army originally covered up the incident, but in late 1969 a series of reports by Seymour Hersh brought new attention to the episode. A subsequent army report of March 14, 1970, confirmed the full horrors of the massacre and its subsequent cover-up. The following month, Nixon expanded the war again, ordering 31,000 U.S. troops into Cambodia.[13] (As discussed in chapter 3, the invasion of Cambodia led to widespread protests on U.S. college campuses, at which time the Kent State killings took place.)

Neither increased bombing nor expanding the war changed the facts on the ground; pushing into Cambodia could achieve little more than a temporary

disruption of supplies and force the enemy to fall back deeper into the jungles. The only element of Nixon's strategy that met with success was his commitment to draw down the U.S. troop presence, which was down to 280,000 by the end of 1970 and 150,000 a year later. The United States was pulling out, and at a brisk pace. Still, somehow the thought that expanding the war might compel concessions from the North—or at least that it might cover the tracks of the American withdrawal—continued to hold currency with the administration. In February 1971, U.S.-supported units of the South Vietnamese army opened a new front, invading Laos. After some initial gains, the offensive stalled into a costly draw, followed by an embarrassing, pell-mell retreat back to Vietnam during which the United States lost 168 helicopters and saw more than 600 others damaged.[14]

At some point in this period (late 1970–early 1971) it finally dawned on Nixon and Kissinger that the war simply could not be salvaged. Their goals now were nothing more than to secure the return of U.S. prisoners of war and to find a way to create a "decent interval" between the end of the involvement in the war and the final collapse of the South and its conquest by the North—ideally ratified by some agreement that could, however implausibly, be labeled "peace with honor." In Paris, Kissinger engaged in secret negotiations in search of such an outcome. For Nixon, "peace with honor" also meant venting his rage. There would be a price to be paid for defying the United States—or maybe just for defying him. Meeting with Kissinger in June 1971, Nixon spoke of bombing so intense that "we're going to level that goddamn country." That was anger talking (he was pounding the table), but in calmer moments his general point was clear: "I do not intend to preside here and go out whimpering."[15]

Negotiations progressed slowly as Kissinger made concessions toward the long-held positions of the North, ultimately drawing the line at the demand that the Americans remove South Vietnamese premier Nguyen Van Thieu on their way out. In spring 1972 the North launched a large, audacious conventional invasion of the South, which threatened to end the war then and there. Nixon, furious, vowed, "Those bastards are going to be bombed like they've never been bombed before." A tall order, but Nixon kept his promise. "Linebacker I" unleashed U.S. airpower against North Vietnamese bridges, railways, power plants, bases, and depots—the country's entire infrastructure. The bombing continued for months and was the only time during the entire war when American bombing produced tangible (if limited) results. Linebacker I helped rebuff the spring offensive and brought Hanoi back to the bargaining table.[16]

During renewed negotiations in September, the North dropped its demand that the United States remove Thieu; from there, progress picked up. Within weeks Kissinger hammered out a deal, and upon his return to Washington, Nixon was so pleased that he broke out a special bottle of wine—a 1957 Lafite

Rothschild—to "toast Kissinger's success." At an October 26 press conference Kissinger stated, "We believe that peace is at hand," and suggested all that remained were minor details. But there was a problem: Washington and Hanoi were pleased with the deal, but South Vietnam was not. Presented with the agreement (negotiated without their participation), Thieu and his associates were strongly opposed to the accord, which they thought "tantamount to surrender." Among other things, the proposed treaty explicitly recognized that there was one Vietnam (and that the seventeenth parallel was not an international border), made no reference to the 120,000 North Vietnamese troops currently in the South, and recognized the Vietcong (the National Liberation Front) as a legitimate political entity that would participate in determining the political fate of the country after the American withdrawal.[17]

South Vietnamese opposition put Nixon in a tight spot: it would be hard to claim "peace with honor" if Saigon rejected the agreement. At the same time, Hanoi was unsurprisingly annoyed with Kissinger's attempt to reopen the discussion over issues painstakingly negotiated to an agreed-upon conclusion. The Paris talks broke down. Nixon desperately wanted Thieu's acquiescence but told him explicitly that he was "not prepared to scuttle the agreement or go along with an accumulation of proposals." Nixon played his last remaining card, unleashing an orgy of violence—one final, massive bombardment of the North, dubbed Linebacker II but forever known as the Christmas bombing— designed partly to force the North back to the bargaining table but also, much more important, to persuade the South to sign on to the agreement. By inflicting "maximum physical damage" on the North, "pressure through destruction" would, it was hoped, provide the South with a bit more "breathing room" after the United States left. But if necessary, Nixon made clear to Thieu, the Americans would ultimately sign off on the agreement unilaterally.[18]

For twelve days in December, wave after wave of American B-52s struck targets in Hanoi and throughout North Vietnam. On December 26 alone, over 250 aircraft attacked the capital and surrounding areas. Over the course of the operation, 729 B-52 sorties dropped 15,237 tons of bombs—about one-eighth of the entire tonnage dropped during five months of Linebacker I. The damage to the North was enormous; railway traffic in and out of Hanoi was completely disrupted, and the city lost 75 percent of its capacity to generate electricity. There were other costs as well: fifteen B-52s and eleven other U.S. aircraft were shot down, and condemnation of the American action was heard from every corner of the globe. Journalist James Reston coined the phrase that stuck: Nixon was engaging in "war by tantrum."[19]

And of course in the end, it changed nothing. North Vietnam was indeed bombed back to the negotiating table, and even coughed up a few minor, mostly cosmetic concessions. On January 23, 1973, the president announced

that an agreement had been reached that "would end the war and bring peace with honor." But the treaty was extremely similar to the demands initially presented by the North in 1969, in many instances using the same phrases. In the intervening years Nixon had widened the war and dropped more tons of bombs on Indochina than had been dropped by all the participants in World War II. The South, left to its fate, recognized the pact as a "sellout," but under relentless pressure from Nixon reluctantly went along. There was no doubt as to what would follow the unilateral American withdrawal. Violence in the South continued until a final offensive by the North in early 1975 reunified the country.[20]

Country, and Western

The traumatic, extended, and disturbing prosecution of the Vietnam War held up a mirror before American society and, for many, forced a reassessment of the country's sacred myths and imagined self-identity. This introspection was widespread, and it had a profound influence on the instinctively revisionist seventies film, pushing back as it was against the moral certainty of the production code and the pristine presentations of studio product.

The definition of revisionism is "advocacy of the revision of an accepted, usually long-standing view, theory, or doctrine, especially a revision of historical events and movements." In the world of the movies, genres that invoked a shared understanding of conventions and expectations, and tended to embellish kernels of truth with Hollywood myths, proved fertile ground for revisionists. One such genre was the "war movie," which in its standard form featured goal-oriented good guys participating in noble, heroic sacrifices that contributed to a larger, existentially vital, and ultimately successful effort (like saving the world from Nazis).

Staring down Vietnam, New Hollywood war movies subverted all of these conventions. In 1970 Mike Nichols followed up *The Graduate* with an adaptation of Joseph Heller's iconic novel *Catch-22*, written by Buck Henry and featuring a large all-star cast. The radical daring of *Catch-22* was to explicitly take on the ultimate "good" war—World War II—and present it as just another senseless conflict. The only "heroic" act in the film occurs when Yossarian (Alan Arkin) violates his orders by dropping his bombs at sea instead of over a city which looks less like a legitimate military target and very much like a peaceful civilian enclave. Yossarian, who longs to desert, is presented as a lone voice of reason within a military culture characterized by assorted lunatics atop the chain of command presiding with indifference over battle-scarred and ultimately murderous GIs in war-ravaged Italy. American values are mocked

throughout, and the dark side of capitalism—the encroaching market—is everywhere emphasized, as a corporate entity within the army sells its morphine supplies, speculates on cotton futures, and subcontracts its bombing fleet to the absurd point where U.S. planes bomb an American base.

Robert Altman, one of the leading and most self-conscious revisionists of the period, was relatively unknown when he scored a big hit with his third feature, *M*A*S*H*. The film introduced the Altman style: weaving, understated plotlines; overlapping, ear straining, often improvised dialogue; an inquisitive, zooming camera; and, billed under stars Donald Sutherland and Elliott Gould, a large company of stock players. Released the same year as *Catch-22*, Altman's film also took on a "good" war, but with a new skepticism. *M*A*S*H* is a comedy but, with its medical setting, dwells on the pain and consequences of war; it is devoid of an enemy presence or any meaningful goal achievement. Disrespectful of God and Country (religion and military authority), *M*A*S*H* was set in the early 1950s, but its politics were of the seventies—an impression encouraged by stripping the movie of any references to Korea. Although it was "set in Korea, to me it was Vietnam," Altman acknowledged. "All the political attitudes in the film were about Nixon and Vietnam."[21]

In addition to the war film, the Western and the detective movie proved to be especially attractive genres for revisionists, and it's not hard to see why. They shared big chunks of American mythology—especially the theme of noble individualism—and were associated with contextually distinct but inherently similar themes of honor, heroism, and dedication to implicit moral codes of behavior. Upon reexamination, both genres also invited a consideration of gender politics and offered opportunities to explore complex issues of authority: the Old West was characterized by a fluid and incomplete justice system, and iconic private eyes of the past typically had ambivalent relationships with legitimate law enforcement agencies.

Altman, of course, took on both genres. The revisionist detective movie, including his brilliant, manipulative *The Long Goodbye,* is considered in chapter 7. The focus here is on the revisionist Western, a thriving seventies subgenre that lent itself almost irresistibly well to reassessments of America in the context of Vietnam. The revisionist Western was particularly ripe terrain because it allowed the disillusionment of the 1970s to take the classic myths and tropes of the Western and turn them completely on their heads. The conquest of the frontier could be reinterpreted as American imperial expansionism; the bittersweet march of "civilization" from east to west could become the advance of voracious capitalism (with its economic and environmental exploitation); and the suppression of the savage Indians could be retold as a genocidal project that offered direct parallels both to the Vietnam War and to smoldering racial issues at home. And as the seventies film replaced certainty with moral

ambiguity, heroism could become antiheroism and the problematic definitions of "law" and "outlaw"—negotiable even in classic Westerns—were pushed past the breaking point, as authority became corrupt and outlaw protagonists common. These were the politics of the 1970s revisiting the Americana of the 1870s, and in the age of Nixon and Vietnam, of FBI surveillance and police riots, the bad guys were recast, often dressed as the sheriff and the posse, the landholder and the governor.

McCabe & Mrs. Miller (1971) was Altman's anti-Western, an effort to show the West as it might have been, not as it was traditionally portrayed—and, as always for Altman, to shatter as many comforting myths as possible along the way. The West as seen in *McCabe*—actually the Pacific Northwest as opposed to the traditional, iconic Southwest—is well suited to the task. In the long title sequence, set to Leonard Cohen's mournful "Stranger Song," the West that John McCabe (Warren Beatty) rides through is cold, trash-strewn, and rainy; his destination, a dark, threadbare bar-flophouse, is littered with desperate alcoholics. The lack of plumbing and other creature comforts that never crosses the mind in previous Westerns seems very much present. But this is also the kind of one-horse town that offers an opportunity for the entrepreneurial McCabe, who sets out to bring whoring and gambling to the slowly developing mining settlement.

The look and sound of the film match this ambiance. Beatty and Altman fought over the mumbling, overlapping dialogue and muddy soundtrack; it was Altman's position that in real life we don't catch every word uttered, and characters' behavior is more important than most syllables of dialogue anyway. Some sequences in *McCabe*, however, push this argument to the limit.[22] Also controversial, but in retrospect inarguable, was the movie's visual style. Shooting on location (and in sequence, as the town was constructed with the picture), cinematographer Vilmos Zsigmond put filters on the cameras and, daringly, flashed the negative (briefly exposing it to light). As a result, the picture has an intentionally washed-out look, as if it were an old, faded color photograph.[23] *McCabe* indeed did look different from, and more authentic than, classic Hollywood Westerns, even those shot on location.

McCabe & Mrs. Miller revisits—and indicts—almost every Western myth.[24] McCabe is quickly established as an iconic man of the Old West, a committed individualist who will build his fortune on the foundations of opportunity, hard work, and innate smarts. But it turns out that he is not all that smart, and he becomes a victim of his own success, which attracts the attention of welcome and unwelcome partners. The first is Mrs. Miller (Julie Christie), who talks her way into a partnership with McCabe and shows him how to build his businesses to new heights of success. Mrs. Miller is a central character in the movie (the novel that provided the source material was simply called *McCabe*).

She is, admittedly, not without her own problems, but is nevertheless a strong, independent woman who has the upper hand in her relationship with McCabe and is given the last word on the topic of why prostitution is a better choice for women than the hypocritical burdens of marriage. Their shared success, however, attracts the attention of a large corporation that wants to "buy him out." The advancing capitalists come as harbingers of death: as they arrive, Bart (Bert Remsen, one of the many Altman regulars in the movie) is killed suddenly in a senseless fight right in the path of their carriage. The businessmen's stay is brief; following a disastrous negotiation that McCabe blunders his way through, they quickly turn to plan B, and within days, three ruthless killers arrive in town. Capitalism will advance, by reason or by force.[25]

McCabe is on his own; and he is no John Wayne, confronting his would-be killers on Main Street. There is no Main Street, and he wouldn't have a chance in such a showdown anyway. Instead the killers fan out, and a deadly game of hide-and-seek ensues. In the midst of a driving snowstorm, McCabe acquits himself well, felling one assassin and then another, shooting each in the back. But the third killer gets him, also with a bullet in the back. These men were not looking each other in the eye at ten paces. Playing possum, McCabe is able to take out the last killer with one final shot. He stumbles through the snow back toward town, and for a moment it seems that perhaps he can be saved—by the townsfolk, or by Mrs. Miller, running across the snow, to cradle him in her arms and nurse him back to health.

Not in 1971. The townsfolk are otherwise engaged, putting out the fire that started in that empty, unused building, the new church. And Mrs. Miller is in another part of town, smoking anonymously in a Chinese opium den. McCabe will die in the snow, alone and forgotten. Cue Leonard Cohen ("I'm just a station on your way / I know I'm not your lover") as Mrs. Miller contemplates the contours of a miniature vase, and we the vast darkness of her dilated pupils. She will move on, the company will take over, and the town will continue to grow.

Revisionist Westerns proved extremely appealing for many of the filmmakers of the period. Arthur Penn's *Little Big Man* (1970), with Dustin Hoffman and Faye Dunaway, retold the conquest of the West from the American Indian perspective. It used an episodic structure to revisit (and debunk) almost every Western fable, but it was most committed to portraying a genocidal imperial war. Penn was also keen to engage contemporary race relations; as he argued, by approaching "the problem by way of analogy ... I could express myself better."[26] Penn's former *Bonnie and Clyde* collaborators Robert Benton and David Newman, with Benton directing, engaged the genre with *Bad Company* (1972), which also took on every myth that came along in a dispiriting trek

from east to west. With its draft-dodging protagonists (from the *Union* Army), Newman and Benton also offered a nod to current events. More explicitly on the Vietnam beat was Robert Aldrich's *Ulzana's Raid* (1972), which displayed mixed motives on all sides. Illustrating how getting drawn into irregular warfare would blur the distinction between right and wrong, it ends in a pyrrhic victory. Another notable entry was Peter Fonda's debut effort, directing himself in *The Hired Hand* (1971). Written by Alan Sharp, who also wrote *Ulzana's Raid* (and the revisionist detective movie *Night Moves*), it was shot by Zsigmond; Bruce Langhorne wrote the music. *Hired Hand* thoughtfully considered the themes of male bonding and obligation, but it also, atypically, was intensely interested in its main female character, played by Verna Bloom (cast on the strength of her performance in *Medium Cool*). Fonda was attracted to the script for this element, which provides the backbone of the film. Molly Haskell praised the movie for its sophisticated treatment of gender roles, and in particular for the "open-eyed integrity" of the exchanges involving Bloom.[27]

The second male lead in *Hired Hand* was Warren Oates, Fonda's "first and only choice" for the role. Oates had appeared in innumerable Westerns and was a fixture in the films of Sam Peckinpah, including his early, landmark revisionist Western *The Wild Bunch* (1969).[28] The combative, hard-drinking, mercurial Peckinpah is appropriately seen as the master of the subgenre. Of the West, Peckinpah served in the marines in World War II, and in the 1950s he wrote and then directed TV episodes of *The Rifleman* and *The Westerner* before turning to similarly themed, well-received feature films. But the mid-sixties proved difficult—troubled productions and studio conflicts—and in 1968 Peckinpah was slowly rebuilding his career as he took cast and crew down to Mexico to shoot *The Wild Bunch* entirely on location.[29]

Peckinpah's protagonists in *The Wild Bunch* are a group of aging outlaws. And, crucially, they are not misunderstood: there is no doubt that they are indeed outlaws, and even less doubt that the audience is intended to identify with them. "If they move, kill 'em!" Pike (William Holden) barks at one of his men, referring to the customers and staff held at gunpoint during a bank robbery. The frame freezes upon the utterance, and Peckinpah's title credit appears. *The Wild Bunch* was a very personal film, and the aging, weathered Holden is the director's surrogate on the screen.[30] The bad guys, by contrast, are the railroad men, the bounty-hunting rabble they employ, and authority structures on both sides of the Rio Grande.

In their pursuit of the bunch, with the law on their side, the heartless, manipulative, bullying railroad magnates show an utter disregard for innocents caught in their crossfire, as an early massacre attests. In contrast, Pike, especially, articulates the codes of honor that must guide the behavior of his gang, attributes Peckinpah admiringly described as "courage, loyalty, friendship,

grace under pressure." At several pivotal moments Pike is required to lay down this law, especially to younger members of his outfit: "When you side with a man, you stay with him. Otherwise you're like some *animal*. You're finished!" Nevertheless, as Paul Schrader observed, despite this rhetoric, it's clear that Pike and his men "have only remnants of the code."[31] It is a movie about the end of such things, set in 1913, well into the new century, at the dawn of autos, aviation, and the approach of World War I, each referenced in passing.[32] Holden was fifty at the time, Edmond O'Brien fifty-three, Robert Ryan pushing sixty—and they all looked older than their years. Searching for one last score, scarred, compromised, and haunted (in flashbacks) by regrets and mistakes, the best of the bunch are well past their prime.

They cannot be rehabilitated, nor can they reconcile with changing times. But they can be redeemed. "Let's go," Pike declares cryptically. But he is understood, and the bunch set out, for a third and final time, in defense of one of their own. The film ends, famously, as it began, with an unprecedented, unrelenting, extended outburst of bloody violence. That violence would prove enormously controversial. Peckinpah, "Bloody Sam" as he quickly became known, was impressed with the violence in *Bonnie and Clyde*—the blood, the squibs, the slow-motion ballet of death—and he was determined to top it, which he did, by a lot. Using multiple cameras shooting at various speeds, Peckinpah expanded and contracted time and spilled blood gruesomely and indiscriminately, often and in every direction.

The film bitterly divided the critics, re-creating, to some extent, the debates over the portrayal of violence in *Bonnie and Clyde*. At one preview screening for critics and industry insiders, "the audience reaction was extreme," Roger Ebert recalled. "Some people walked out" (a common occurrence at other prescreenings). Others booed. At the difficult press conference that followed, Ebert felt the need to stand up and declare, "I just want it said: to a lot of people, this film is a masterpiece." Richard Schickel concurred, calling it "the first masterpiece in the new tradition of the dirty western." For Stephen Farber, "the film is sharper and more honest than *Bonnie and Clyde*," in that Penn's outlaws kill only in self-defense, but *The Wild Bunch* "does not flinch about showing the brutality of its heroes."[33]

Peckinpah was vigorous in his own defense of all the violence. "I tried to make a film that showed violence as it is, not as some goddamn Hollywood piece of shit," he insisted, arguing further that "actually, it's an anti-violence film because I use violence as it *is*.... [I]t's not fun and games and cowboys and Indians, it's a terrible, ugly thing." The director also dismissed those who criticized his treatment of lawmen in the film, noting that although his film was shot before the police riots at the 1968 Democratic National Convention, they "prove the point I was trying to make, that power corrupts as much as lawlessness."[34]

Peckinpah, with *The Wild Bunch* and, increasingly, with a number of violent films that followed, rekindled the debate about the responsible representation of violence on-screen, taking the side of those who insist that failing to show the realities and consequences of violence trivializes its true meaning.[35] From this perspective, it was a question of truth-seeking. "We're all violent people, we have violence within us," Peckinpah insisted. "It's wrong—and dangerous—to refuse to acknowledge the animal nature of man." People who "complain about the way I handle violence," he argued plausibly, are really saying, "Please don't show me; I don't want to know, and get me another beer out of the icebox."[36]

That may be, but the risk of living on the edge, in film as in life, is that you might go too far—especially as "too far" is often a judgment call. Peckinpah's *Straw Dogs* (1971), with Dustin Hoffman, is easily interpreted as endorsing the violence it presents. As David Denby observed, "with *Straw Dogs*, we have a film which is as brilliant as *The Wild Bunch* but a lot harder to defend."[37] And Peckinpah's eighth and final Western, the blood-soaked *Bring Me the Head of Alfredo Garcia* (1974), with Warren Oates clearly standing in as the director's alter ego, brought his cycle of revisionist Westerns to a squalid, unmotivated, nihilistic dead end.[38]

But Peckinpah was on stronger ground—much stronger ground—when he compared the outcry against some of his films with the more tepid public responses to real, consequential, horrifying violence, such as the My Lai massacre. On March 29, 1971, a court-martial jury of six military officers sentenced Lieutenant William Calley to life in prison for his pivotal role in the slaughter. Two days later Nixon ordered Calley released from prison pending appeal. On April 4 Peckinpah, on location in England, sent a telegram to the president. Freeing Calley, he wrote, "even for a short time may be politically advantageous but morally it serves only to indicate the sickness within our country. . . . I must beg you once again to consider the moral issues involved." Instead, Nixon ultimately commuted Calley's sentence, which in the end amounted to three years of house arrest. Peckinpah never got over what he saw as an indelible stain on America's soul. Shrugging off the massacre was in some ways worse than the incident itself, and for years the former marine returned to the issue time and time again. "Nixon's pardoning Calley was so distasteful to me that it really makes me want to puke," he told one interviewer. He also routinely invoked the massacre in private correspondence with people who wrote to him complaining about the violence in his films, challenging the consistency of their standards.[39]

In truth, Nixon had been giving Peckinpah indigestion, at least, as far back as his days in Congress; and with the president very much in mind, the director played one last trump card, his most comprehensive statement of the

Western as an allegory for contemporary politics: *Pat Garrett and Billy the Kid* (1973). A troubled production,[40] it starred James Coburn and Kris Kristofferson. Bob Dylan had a featured part and penned the music for the movie, including "Knocking on Heaven's Door." Rudy Wurlitzer wrote the screenplay; he had previously written Monte Hellman's cult road movie *Two-Lane Blacktop* (1971), and at one point Hellman was slated to direct *Pat Garrett*.[41]

The ultimate anti-Western, *Pat Garrett* is about the closing of the frontier, the ambiguity of the law, and the ruthless criminal expansion of capitalism and its essential partnership with ambitious politicians and the institutions of government authority. America was coming into maturity and leaving behind any youthful innocence it might have had. At the same time, despite its rich western iconography and deep-focus photography, the film is also a very personal allegory about two people. In fact, at this level the film could be read as being about one person and to imagine that Pat *is* Billy—that is, an older version of the same man. *Pat Garrett* does not discourage this interpretation. The movie is framed by two parallel murders. It opens, in the "future" of 1909, as an aged Garrett (Coburn) is killed by an assassin hired by the landowner Chisum. This murder is crosscut with events from the present (1881), which finds Billy and his gang shooting the heads off chickens. Garrett approaches, unseen from behind, and has a clear shot at the back of Billy's head. But he takes out one of the chickens instead, actions matched and intercut with his own later demise. The movie closes with Billy's murder by Garrett, with the authority of the law and, with intended irony, at Chisum's wish.

Peckinpah's revisionism here is even more committed and overt than in *The Wild Bunch*. Kristofferson's Billy, as one reviewer put it, is "preposterously likeable," whereas his principal adversaries, Chisum's enforcers, are sadistic thugs. Much more refined is the governor (Jason Robards), whose concern is for "protecting investments": Billy is bad for business, and so the governor puts a bounty on his head. Religion is even worse than the state; briefly held in jail, a wild-eyed, gun-toting evangelical tries to encourage Billy to repent for his sins with a swing of his rifle butt—a sequence that concludes with the only appearance of an American flag in the movie.

At the heart of *Pat Garrett*, however, is its construction of the parallel experiences of Pat and Billy. Garrett, now with a badge, in search of the Kid's trail, is forced to confront members of a gang he used to ride with. As the men shoot it out, they reminisce about old times. Billy, on the run, finds himself across the dinner table from an old friend who has been reluctantly deputized. His honor at stake, he can't just let Billy walk away. But honor only goes so far. Both men cheat in their "pistols at ten paces" duel, but Billy cheats better and lives to see another day. Throughout these adventures Peckinpah emphasizes the arbitrary distinction between law and outlaw ("The law's a funny thing,"

Shooting Billy is shooting himself

Billy observes convincingly at one point), the similarity of the protagonists, and the hollowness of that core Western myth—sticking with a man above all else. After all, Pat and Billy were true friends.

But the two men have made different choices. "This country is growing old," Garrett observes, and "I intend to grow old with it." But when Pat tells Billy that "times have changed," Billy responds, "Times, maybe, but not me." Billy won't flee the territory; Pat is obliged to enforce the law. Tracking the Kid down to one final sanctuary, he waits to make his move. Just before he does, Coburn shares the stage with Peckinpah himself, cast, appropriately, in the role of a coffin maker, to bear disapproving witness to the events about to unfold. Garrett shoots Billy and then turns and shoots his own image in a mirror. As he approaches it, the punctured glass leaves a gaping hole in his chest exactly where he had shot his old comrade. Shooting Billy was shooting himself.

Meanwhile, Back in Gotham City

In the late 1960s and early 1970s it was easy to look back on the "heroic past" with a revisionist eye, because looking out the window at the present encouraged, if not required, a certain jaded cynicism. These were difficult times for the country; its armed forces were fighting halfway around the world, and often, it seemed, there was a war on at home as well, with struggling cities on the cusp of devolving into lawless urban combat zones. In 1971 a flood of movies suggested this fate. *Little Murders* in particular offers a vision of New York City not so different from the punishing theaters of urban warfare in Vietnam. By the end of the film its protagonists have fortified and sealed off their apartment, trading sniper fire with unseen adversaries. And that movie started out as a comedy.

Star Elliott Gould (who bought the rights to the property) approached Jean-Luc Godard about directing the film, adapted by Jules Feiffer from his own play; eventually Alan Arkin, who had directed the play on the New York stage, took the helm.[42] *Little Murders* is a radical film that farcically exaggerates the crime problem—by only so much—and, beneath all the humor, has serious things to say about its social consequences. Initially it plays as a hypermodern romantic comedy: the energetic Patsy (Marcia Rodd) pursues the apathetic Alfred (Gould), who has been laid low by a city of ubiquitous crime and irrelevant police. Patsy manages to bring Alfred back to life, and they are married in an outrageously godless wedding ceremony officiated by an existentialist minister (Donald Sutherland). Alfred's resurrection is marked by his spellbinding six-minute monologue in which he recalls his days as a student activist and a correspondence he initiated with the FBI agent assigned to read his mail. But at this moment of rebirth, Patsy is murdered in a random act of violence more common to war zones than cities, even crime-ridden ones. In a sequence that rings very true, the dazed, blood-soaked Alfred stumbles home by subway, with nary a single passenger batting an eye.

Patsy's murder, two-thirds of the way through a movie that seemed headed for some qualified redemption, is unmotivated, and it breaks the narrative spine of the film—disconcertingly so. But this, says Feiffer, was his intention: "The traditional happy ending turns horrific, unpredictable, chaotic—like the times we lived in." From there, *Little Murders* loses all contact with reality. Or does it? Director Arkin shows up as an unhinged police inspector, convinced that 345 unconnected, motiveless unsolved murders must have a connection: a vast conspiracy to undermine confidence in the police. Patsy's father (Vincent Gardenia) follows this with a speech about the need for emergency measures, unlimited surveillance, increased police powers, random searches, and summary arrests—all necessary to "protect our freedom." The rhetoric is breathless and overheated, but it did reflect the basic ideas of a large segment of American society at the time. Feiffer's presentation of his vision was satirical, but it was also a trenchant critique of the "law and order" mentality.[43]

Little Murders takes place in New York City, which should come as no surprise. In any discussion of cities in crisis, New York loomed very large. America's flagship city, much larger than any other metropolitan area in the country, it mattered for reasons of sheer size; in 1960 no *state* government had a larger budget than did the City of New York. This salience was magnified by its roles as the country's media center, headquarters for the lion's share of Fortune 500 corporations, and cosmopolitan interlocutor with global finance and culture. The troubled metropolis was also afflicted, precociously and overwhelmingly, by the problems that would challenge most of the country's urban centers during this era.[44] In despairing moments, the decline of New York could be seen as a metaphor for the decline of America.

Even in the robust days of the early 1960s, the city's underlying structural problems were increasingly evident. Two trends were fundamental: the secular decline of New York's manufacturing industries (and employment), and suburbanization. These developments threatened the pillars that had supported the mythic metropolis at mid-century. The once massive garment industry was especially hard hit by (initially domestic) low-wage competition. Formerly vibrant waterfronts atrophied as the merchants, sailors, longshoremen, and commerce that had for centuries been defining characteristics of the city faded away. Containerization shifted port activity away from New York, and the Brooklyn Navy Yard, which had employed 71,000 in 1944, accounted for only 7,000 jobs in 1965, the year before it shuttered. Much of the waterfront fell into abandonment and disrepair, as did many other parts of the city, both the cause and effect of millions of middle-class residents fleeing to the suburbs. In 1940 the city accounted for almost two-thirds of the population of the greater metropolitan area, in 1970 less than half. These developments inevitably put pressure on the city's tax base; Mayor Robert Wagner balanced his final budgets with smoke and mirrors.[45]

John Lindsay won a close three-way election in 1965. The young, Kennedy-handsome liberal Republican ran on a "city in crisis" theme. It was a self-evident argument: the city was losing eighteen thousand factory jobs a year in 1965, and signs of decay were everywhere; on an average day, 40 percent of its aging fleet of garbage trucks were out of service. Promising honest government and fiscal responsibility, the new mayor had good intentions, but they nevertheless ran into a buzz saw of political challenges, solutions to which were hampered by growing pressures on the city's financial resources. As something of a political free agent (as opposed to the product of a party machine), Lindsay had no natural political or ethnic base of support, and his patrician demeanor often mixed uneasily with the horse-trading style of urban politics. Immediately upon taking office, the mayor stumbled with his handling of a disruptive transit strike. Lindsay did a better job with the transit workers two years later, but his first term was plagued by conflicts with the large municipal unions which had strengthened during the Wagner years. Confrontations with (and strikes by) the teachers' union were routine, and in February 1968 there was a disastrous work stoppage by the sanitation workers. Garbage piled up on city streets at the rate of ten thousand tons a day; things got so bad that midway through the strike Lindsay asked Governor Nelson Rockefeller to call in the National Guard. (The governor refused.)[46]

By far the biggest problem New York City faced, however, was not its garbage but its crime. In 1960 there were 390 murders in the city; in 1969 there were 1,043; in 1972, 1,691. Robberies jumped twelvefold from 6,579 to 78,202 during the same period. Other crimes also recorded four- and fivefold

increases in the 1960s: 1969 recorded 85,796 car thefts and 171,393 burglaries, about 230 and 470 *per day,* respectively. Part of this surge in crime was fueled by the growing drug problem, with desperate addicts seeking cash for their next fix. This, too, was reflected in a wave of films that focused on the city's metastasizing heroin subculture, including *The Panic in Needle Park* (1971) and *Born to Win* (1971). Similar films wrought by common concerns, they take full advantage of the city's grimy, downbeat locations, dwell unflinchingly on the unattractive aspects of addiction (if observing the fetishistic rituals of the lifestyle), and conclude, appropriately, with open, uncertain endings. With its particularly devastating finale—George Segal sitting on a park bench with a packet of almost certainly tainted junk in his pocket, withdrawal slowly overtaking his better judgment—*Born to Win,* directed by Prague Spring émigré Ivan Passer (and featuring Karen Black and Paula Prentiss), lingers in the mind a bit longer than *Panic,* written by husband-and-wife team Joan Didion and John Gregory Dunne, directed by Jerry Schatzberg, and starring the then-unknown Al Pacino.[47]

Both junkie films show how heroin contributed to the crime epidemic. But no one factor could account for the city's descent into lawlessness, the primal pathology that poisoned every other aspect of urban life. A city in fear is not so much ungovernable as it is unlivable; and in New York and elsewhere, even more pervasive than the crime itself was the fear of crime, the expectation of crime, the normalcy of crime, each of which had toxic effects on society. The murder of Kitty Genovese in 1964 became famous because thirty-eight of her neighbors failed to respond to her screams. But before that element of the story became known, the murder of a young woman in a quiet residential neighborhood was barely news; it got a few paragraphs on page 26 of the *New York Times.*[48]

Enmeshed with the problem of crime was the issue of race. The middle class that fled New York for the suburbs was mostly white; newer residents were mostly people of color, who often joined the city's rapidly expanding welfare rolls. Many working-class ethnic whites (such as Italian and Irish Americans), job prospects diminishing, neighborhoods declining and dangerous, harbored animosities toward the city's increasingly vocal minorities. Serious rifts also emerged between black and Jewish communities over housing and education. (The predominantly Jewish teachers' union was often embroiled in bitter conflicts with local leaders.) Even more dangerous were relations between the (institutionally corrupt, commonly racist) police force and the residents of minority neighborhoods.[49] In the summer of 1964, riots erupted after an unarmed black teenager was shot and killed by the police. Similar events unfolded in 1967. In general, despite Mayor Lindsay's uncommon commitment to minority concerns and the remarkable drama of his (Bobby) Kennedy

moment—mixing, unprotected, with angry crowds on 125th Street in Harlem the night Martin Luther King Jr. was assassinated—his term in office coincided with a very difficult era in the city's race relations, tensions that exacerbated many of its other problems.[50]

In 1965 Lindsay's campaign slogan was "He is fresh and everyone else is tired." By 1969 Lindsay looked more like everybody else. Remarkably, and as the result of a number of political victories, he had kept budgets balanced throughout his first term. But few disputed the notion that New York was in much worse shape at the end of his first term than it had been at the beginning. Nevertheless, mending political fences and facing weak opponents, Lindsay managed to eke out another plurality win in a three-way race. Victory rang hollow, however, for the city's intractable problems would only get worse. Political scientist Ted Lowi urged the mayor to recognize "that the suburbs are parasites upon the city," declare "the city is ungovernable," and fight for a new regional approach to municipal management.[51]

The city certainly seemed ungovernable. Crime continued to rise, the quality of life deteriorated further, and its population declined. New York's expenses and operating costs, however, only increased. Worse still was the national recession that emerged in 1969, which hit New York particularly hard, once again squeezing the remnants of its manufacturing sectors and the decent jobs once found there. The downturn also marked the end of two decades of robust economic growth, reducing both local revenues and the flow of state and federal assistance to the city. Corners were cut everywhere: the downtown Tombs prison, designed to hold 932 inmates, was packed with 1,992 men when riots erupted there in the summer of 1970. In an effort to keep afloat the provision of basic services to the deteriorating, crime-infested city, Lindsay and his successor, Abe Beame, turned increasingly to borrowing. New York's fiscal policy was no longer sustainable.[52]

In 1974, Beame, sixty-eight-year-old product of the Brooklyn Democratic Party machine, inherited an unkempt city with a collapsing economy, racial polarization, union militancy, routine criminality punctuated by shocking acts of random violence, and, not surprisingly, general ill-temper. Between 1969 and 1977, manufacturing employment fell precipitously. Especially hard hit were construction and the garment industry, which shed one-third of its employees. With few obvious alternatives, the unimaginative Beame continued Lindsay's second-term policy of borrowing to meet expenses. But the stage was set for a "Wile E. Coyote" moment: marketing $600 million in short-term notes each month, with $11 billion in overall debt and 11 percent of the budget dedicated to servicing those obligations, there was no ground underneath the city's frantically spinning financial feet.[53]

That moment arrived in early 1975 when the city needed to borrow a whopping $5 billion to remain solvent. But the big New York banks, reeling

from the deep national recession of 1973–1975, were wary of taking on still more New York debt; in fact, they had been quietly selling some of their notes. The city, teetering on bankruptcy, staggered for months and ultimately sought federal help. The *Daily News* headline of October 30 summarized the initial response "Ford to City: Drop Dead." In order to persuade local powerbrokers and state and federal authorities to contribute to a coordinated reorganization of the city's finances, Beame finally stepped forward with a real austerity package, measures that elicited wildcat strikes by sanitation and highway workers and menacing protests by laid-off cops. As one observer recalled, it was "that extended moment in the mid-1970s when the city seemed on the verge of bankruptcy and social collapse, when daily life became grueling and the civic atmosphere turned mean."[54] Ultimately the city (and the country) would recover, and even thrive, in future decades. But during the era of the seventies film, New York's troubles seemed to mirror and magnify the anxiety of the nation as a whole at the time, a period of economic distress, profound uncertainty, and a sense of existential despair about the meaning of and future for America as it limped toward its bicentennial in 1976.

Hard Times in New York Town

New York, for all its troubles—indeed, because of its troubles—was a favored setting for the seventies film. In fact film production was one of the city's few areas of growth. Mayor Lindsay in his salad days had labeled the town "Fun City," and he took measures to encourage film production in New York. But it was the Ungovernable City that offered the perfect backdrop for the tough times, gritty locations, downbeat themes, and uncertain endings of the New Hollywood. As Vincent Canby observed, "As reflected in good movies and bad . . . New York City has become a metaphor for what looks like the last days of American civilization."[55]

Midnight Cowboy (1969) was one of the first films to use the mean streets of the city as a virtual character in the story. When it won the Academy Award for best picture, it also reflected the hope for what the seventies film might accomplish. Originally rated X (it would be the only X-rated movie ever to win that award), it was a picture, like *Medium Cool*,[56] that was intended as "adult" entertainment—a term that, at the time, meant material that was ambitious, challenging, and thoughtful, and that engaged themes unsuitable for children. This was not an uncontroversial aspiration at the time: 1969 was also the year of *Easy Rider, Bob & Carol & Ted & Alice,* and *The Wild Bunch,* but none of those had been nominated for best picture. Such nods were reserved for the G-rated *Hello Dolly* and other wholesome fare. And when *Cowboy* won the statuette, Old Hollywood stalwart Bob Hope felt the need to editorialize: "At

a time when our moral values need to be restated and reaffirmed, I would personally like to see this industry lead the American people back to their true heritage of freedom—but freedom with honor and decency and a real respect for law and order and the things that made this country great."[57]

Ironically, *Midnight Cowboy* sticks very close to the generic structure of an old school Hollywood romantic comedy. A couple "meet cute" in an initial encounter that ends badly; they then separate and spend time apart until reunited by chance. Slowly, they come to discover that they are soul mates, only to have that bond threatened by an ultimate crisis that seems certain to separate them forever. But fate intervenes, and in the nick of time the worst is averted and the couple is reunited, for good. The only difference is that since this is a seventies film, the couple is not composed of a too-smart-for-her-own-good literary editor and a tough Vivaldi-loving businessman with the buried heart of a poet. Instead our "lovers" are Ratso Rizzo (Dustin Hoffman, fresh from *The Graduate*), a filthy, wheezing, handicapped, small-time grifter, and Joe Buck (Jon Voight, then an unknown), a barely literate, psychologically scarred Texas dishwasher. Joe sets the film in motion by cashing out his modest resources and investing in a cowboy get-up and a bus ticket so as to make his way to New York seeking fortune as a male prostitute for the city's well-heeled but (to his mind) sex-starved women. (Bob Dylan's song "Lay, Lady, Lay" was written for the film but arrived too late to be included in the picture.)

"Lovers" is properly seen in quotes. Although, in desperation, Joe is ultimately forced to seek out male customers, he and Ratso are not explicitly presented as lovers, a choice that left some critical of the film for lacking the courage of its convictions. And while director John Schlesinger and producer Jerome Hellman explicitly decided that "it could not be a homosexual film," *Midnight Cowboy* is quite courageous in its choice of subject matter and in the unflinching presentation of very difficult material it insists that the audience sit through. Moreover, the film is unambiguously a love story between the two men.[58] A sexual relationship between them would have been redundant and disruptive of the narrative.

Midnight Cowboy was developed over several years. Schlesinger, who directed a number of high-profile socially conscious films in his native Britain, including *Billy Liar* (1963) and *Darling* (1965) with Julie Christie, read the novel in 1965 and was keen to take it on. Waldo Salt, blacklisted in 1951 for refusing to name names before HUAC, came on board in 1967. He produced twelve drafts, revisions shaped over the course of an active three-way correspondence with Schlesinger and Hellman. Salt was also on hand for weeks of improvising which continued during shooting, integrating the contributions of Hoffman and Voight, who added much of the dialogue in Ratso's "apartment," and the moment when Joe uses his shirt to wipe the perspiration from Ratso's face.[59]

The movie begins and ends outside the city, with images of unfulfilled dreams. It starts with a shot of the empty screen at an abandoned drive-in movie theater and ends with Ratso dead on a bus, embraced by Joe, a few miles short of his imagined paradise, Florida. *Midnight Cowboy* unfolds in three principal movements: Joe in New York, Joe and Ratso's lives together, Ratso's decline. In the first part, Joe is proverbially chewed up and spit out by New York City; failing at every turn, he is eventually reduced to homelessness and hustling in Times Square. This rock bottom is signified by the ketchup he accidentally dumps on himself, the indelible red stain leaving him metaphorically castrated as he makes the decision to seek out his first male customer. Soon after that disastrous, heartbreaking encounter he is reunited with Ratso, and the narrative shifts to the travails of the two men, living in a condemned building, resources dwindling, scheming to resurrect Joe's would-be career as a male escort. In the final act, as bitter winter and a looming wrecking ball threaten, Joe finally scores with a well-off woman, with the promise of more to come. But this success threatens his bond with Ratso; not coincidentally, at Joe's moment of triumph, Ratso tumbles down a flight of stairs. When Joe returns to their dwelling, flush with success, Ratso can no longer walk.[60]

Love trumps all, and Joe drops everything in an effort to save his tubercular friend. He secures funds with a sudden burst of violence, and the two men head for Florida on a Greyhound bus. That shocking outburst—Joe's unnecessarily savage beating and robbery of an elderly would-be John—was the sort

Joe's success sends Ratso reeling

of act that the naïve Texan was, to his credit, repeatedly unable to perform in his early days on Manhattan's mean streets, even at times when he would have been in the right. It's hard to be a saint in the city, *Midnight Cowboy* and so many other movies of the era seemed to suggest. But unlike Ratso—who to some extent *is* New York, beaten down and dying—Joe is saved by leaving the city. (If the point were not clear enough, he sheds his cowboy clothes and dumps them in the trash at a rest stop.) The New York he leaves behind is a city of loneliness, materialism, ill will, and stratification; of crazies, street people, freaks, and parasites; of self-loathing and desperation, seen most despairingly in the ubiquitous, hollow-cheeked cohort of Midnight Cowboys who compete with Joe in Times Square, and in their furtive, anxious clientele.

This was more than the New York City of *Midnight Cowboy;* it was the New York of the seventies film. *The Taking of Pelham One Two Three* (1974) captured the nadir of the Beame years, pitting transit cop Walter Matthau against a band of brazen mercenaries holding a subway car hostage (the broad ethnic mix of the passengers suggesting a microcosm of the city itself held at gunpoint). *Pelham* portrayed a cash-starved city—filthy, trash-strewn, impatient, racially charged—overseen by an unpopular, bedridden mayor uncertain where he might find the million dollars demanded, and debating with his advisers whether the price per hostage made it a bad deal. Cinematographer Owen Roizman (who also shot *The French Connection, Three Days of the Condor,* and *Network* on the city's streets) reached for a "dismal and dingy" look, shooting on locations and pre-flashing the negative to further wash out the image.[61] It was an ambiance that reflected the rotting Big Apple on the screen long before City Hall was *really* out of cash. Three years before *Pelham* opened, Pauline Kael had already certified the verisimilitude of these movies: it was "literally true that when you live in New York you no longer believe that the garbage will ever be gone from the streets or that life will be sane and orderly." With reference to twenty recent films shot in town, Kael also noted the influence of the city on the New Hollywood more generally: it had "given movies a new spirit of nervous, anxious hopelessness, which is the true spirit of New York."[62]

That spirit was certainly evident in the New York of *The French Connection* (1971), based on a true story (and a real cop). Gene Hackman plays "Popeye" Doyle, a head-busting, rule-breaking narcotics cop, obsessive in his pursuit of big-time French heroin smugglers in town to execute a massive score. For some reviewers the film tacitly endorsed Popeye's methods; one critic, while praising the film, argued that "its principal subliminal message" was that "arbitrary power is good because it keeps society from falling apart." But the movie is more ambivalent about such things—befitting a seventies film, it has attractive villains, compromised heroes, and no easy answers. Director William Friedkin, who had previously shot *The Boys in the Band* (1970), a pathbreaking

ensemble piece about a group of homosexual friends, was, at least at the start of his career, another New Hollywood kid who revered Hitchcock, Welles, and the French masters. (He would later remake Clouzot's classic *The Wages of Fear*.)[63] *French Connection* has the sensibilities of that cohort, both in style (location shooting, murky visuals, handheld shots), and substance, in the form of an ungrounded moral structure. "A tremendously thin line exists between cops and criminals," Friedkin observed at the time, a basic sentiment that, as noted earlier, motivated the revisionist Western as well. Friedkin also went out of his way to present the main heavy in the picture, Alain Charnier (Fernando Rey), as suave and attractive, and in contrast with the coarse Doyle (and his partner, played by Roy Scheider). There is a class-based element to this, as the blue-collar cops wolf down hot dogs while they stake out their prey dining in fine restaurants; nevertheless, Friedkin noted, "I was obviously trying to make the audience identify with Charnier."[64] Doyle, by contrast, is routinely presented in an unflattering light, and in the film's most famous sequence, the car-train chase, Popeye is recklessly indifferent to innocents at risk and ends matters by shooting an unarmed crook in the back.

Of course, New York's problems with crime, violence, corruption, and lawlessness were not unique; to some extent they plagued most big cities in America at the time. And at the movies, San Francisco proved to be another cinematically attractive urban jungle. *Bullitt* (1968), directed by Peter Yates (who also took urban despair to the streets of Boston with *The Friends of Eddie Coyle*), is a notable entry in this mix for several reasons. Relatively early in the era, it anticipates a number of themes that would develop more fully in the following years. A movie best known for a car chase (the famous sequence in *The French Connection* was expressly designed to top it), it actually takes its time and has a lot to say. *Bullitt* is steeped in what would become the visual motifs of the New Hollywood: saturated darkness, handheld cameras, all-location shooting, and documentary style. A thoughtful film, it lingers impressively on the consequences of violence, most notably with a twenty-five-minute-long sequence at a hospital, a location also utilized to explore the film's interest in race, with subtle observations about the treatment of a black surgeon (Georg Stanford Brown). Steve McQueen, in the title role, is another rogue cop, but in *Bullitt* his independence sets him apart from corrupt institutions—the compromised police brass and the crooked, hypocritical politicians controlling them, in this case an ambitious bigwig called Chalmers (Robert Vaughn), whose signature line is "integrity is something you sell the public."

The Bay Area also provided the background for the reactionary Nixonian law-and-order fantasy *Dirty Harry* (1971 yet again), and the underrated, more nuanced police procedural *The Laughing Policeman* (1973). Produced and directed by Stuart Rosenberg, best known for a series of pictures he did with

Paul Newman,[65] *Laughing Policeman* is something of a descendant of *Bullitt,* with its close attention to detail and sensitivity to violence. The movie opens with a massacre on a city bus, but then lingers for eighteen minutes, observing as the police work through the night at the bloodstained crime scene, and from there on to hospitals, morgues, and restaurant kitchens, places that seem very real. Walter Matthau's cop Jake Martin doesn't have the charisma of Steve McQueen's Bullitt, but he isn't supposed to; 1973 was less hopeful than 1968. (Or maybe Jake Martin is second-term Lindsay to Bullitt's first, now punched out from years of fighting urban problems to something less than a draw.) Martin's police force isn't so much corrupt as it is lazy and resigned: his bosses don't want to open old cases; his partner (Bruce Dern) has one eye on his pension. Still, conservative by nature and with a belief in the job, Jake doggedly pursues the case through washed-out city streets littered with junkies and sex traffickers. But his determination comes at a price: "Work in the gutter, you never see anything good." *Laughing Policeman* is ultimately more about making this point than solving the case, but its attention to detail compensates for its lack of interest in sustaining the plot to the end. No street scene fails to linger on garbage or homelessness, and the police exercise authority with arbitrary and disproportionate violence. San Francisco looks about as bad off as New York.

But it was New York that was the signature setting for the seventies film. And shot on location during the scorching, desperate summer of 1975, *Taxi Driver* (1976)—a landmark on its own terms as a character study of loneliness, alienation, and madness—is also a summary statement about the city teetering on the brink of the abyss. "The steam billowing up around the manhole cover in the street is a dead giveaway. Manhattan is a thin cement lid over the entrance to hell, and the lid is full of cracks," Vincent Canby wrote in his review. Travis Bickle (Robert De Niro) "is a projection of all our nightmares of urban alienation." Written by former critic Paul Schrader at a time when, he said, "I couldn't distinguish between the pain in my work and the pain in my life," *Taxi Driver* is best seen as a fusion of the distinct but ultimately convergent personal visions of Schrader, De Niro, and director Martin Scorsese. Early in their careers and passionate in their commitments, each was working for a very low fee, which kept the budget down and minimized studio interference. "We didn't make any compromises," Schrader insisted.[66]

Scorsese was approached for the project on the strength of another intense, personal "New York" movie, his breakthrough film *Mean Streets* (1973). Now recognized as a classic, it almost didn't get made. Scorsese, treading water, had just completed an exploitation picture for Roger Corman (*Boxcar Bertha*) and was set to begin work on another. But then he screened *Bertha* for John Cassavetes, who told him, "You just spent a year of your life making a piece of shit," and urged Scorsese to work on a personal project that he believed in.

Scorsese dropped out of his next Corman picture and returned to a draft of a screenplay he had been working on with Mardik Martin, then called *Season of the Witch.* The result, *Mean Streets,* was an elaboration of themes from *Who's That Knocking at My Door?* (1967) and was an attempt, says Scorsese, "to put myself and my old friends on the screen, to show how we lived." The cast included Harvey Keitel and De Niro, and it is easily recognizable as a Scorsese film, with rock music an essential element (a good chunk of the film's tiny budget went toward securing the rights for the songs), and its sudden, jarring eruptions of violence. For the director, there was something distinct about "New York" violence, in particular its random nature.[67]

Mean Streets also anticipated the visual style of *Taxi Driver,* with its prowling, curious camera sniffing around characters for a better view, the heavy use of an orange filter, and, of course, the integration of city streets and locations as the defining, delimiting contexts in which each film takes place. *Taxi Driver*'s cinematographer, Michael Chapman, shared with Scorsese "some need about New York that we wanted to express." The two men also were also dazzled by Godard and the freedom his work implied: that "you can do absolutely anything you want." Not surprisingly, the close-up into Travis's glass of Alka-Seltzer is a direct homage to a similar shot in Godard's *Two or Three Things I Know about Her.*[68] But Godardian nods are the tip of an iceberg. *Taxi Driver*—which featured the last score composed by Bernard Herman, who did the music for countless films, including *Citizen Kane* and *Psycho*—was indelibly marked by the cinephilia of its creators. Schrader leaned toward the existential, citing Bresson's *Diary of a Country Priest* and *Pickpocket,* as well as Malle's *The Fire Within* as influences. Scorsese most often references the pulp late-noir *Murder by Contract* and John Ford's *The Searchers;* it is not hard to see the influence of Melville's *Le Samurai* as well.[69]

In addition to his own isolated despair (a downward spiral of alcohol, pornography, and hospitals), Schrader cites Arthur Bremer (the tortured would-be assassin of George Wallace) and Harry Chapin's wistful song "Taxi" as inspirations. For Schrader, theme comes before plot, and "the theme of *Taxi Driver* is loneliness."[70] Scorsese certainly shoots the film that way, never missing an opportunity to emphasize Travis's physical separation from others, such as during the scenes with his fellow cab drivers at the diner. And often overlooked in De Niro's famous "You talking to me" scene is the answer he provides: "I'm the only one here." Later Travis states quite plainly, "All my life I've been alone," a condition underscored by the happy couples who invariably show up on his TV screen— such as those dancing to Jackson Browne's "Late for the Sky," a song that seems to capture Travis's condition: "Awake again, I can't pretend / and I know I'm alone."

That condition is compounded by his inability to make connections with other people, despite numerous if clumsy efforts on his part to establish them.

Loneliness becomes alienation, which, unfortunately, is compounded by Travis's ambivalent feelings about women and hostility toward blacks, instincts that generate barely suppressed rage that he will ultimately prove unable to control. A key narrative strand of the film is rooted in Travis's Madonna/whore conception of women and his parallel efforts to "save" first Betsy (Cybill Shepherd) and then Iris (Jodie Foster) from corrupting patriarchs, the politician Palantine, and the pimp Sport (Harvey Keitel). More problematic is Travis's racism. *Taxi Driver*'s treatment of gender, gun violence, and especially race has been a source of some controversy.[71] My own reading emphasizes the racism of the character, not of the movie. Despite the remarkable authenticity of its city streets, *Taxi Driver* almost exclusively shows the world through the prism of Travis's unreliable, distorted vision of reality. Scorsese deploys numerous expressionistic effects to emphasize this, which are especially pronounced during racially charged moments, such as in the slow-motion pan on the street when Travis locks eyes with, and tracks, a group of passing thugs.

All of this—Travis's loneliness, alienation, misogyny, racism, and potential for violence—comes to a head in a crucial thirteen-minute sequence about a third of the way into the film. His date with Betsy ends catastrophically as she charges out of the porn film he took her to. (Outside the theater, the image of Betsy, in white, is subtly framed and echoed by a slim blonde hooker in a red tank top, a visual play on Travis's two versions of feminine possibility.) The next scene is of Travis's pleading phone call. In the first shot conceived by Scorsese for the film, the camera dollies to the right and stares down the empty

Travis has a Madonna/whore complex

hallway, as if it was "too painful to watch."[72] This is followed by the confrontation at Palantine headquarters; as he exits, Travis reaches the angry conclusion that Betsy was "just like the others," and women are "like a union."

As this voiceover lingers, the film's most frightening character (played by Scorsese himself)[73] hails Travis's cab. Perhaps. It is also possible to read the scene as if he is not real but rather a manifestation of Travis's unleashed racist, misogynist rage. Real or not, the passenger directs the cab to an apartment building, where a lovely Hitchcockian camera move (up the building and then across) reveals the (too perfectly cinematic?) silhouette of a woman in a negligee, smoking. Scorsese explains that the woman is his wife, waiting for her (black) lover—and he plans to kill both of them, with the final blow a blast from his .44 Magnum (one of the guns Travis will soon buy) directed at her genitals. The scene includes an incongruous shot of the back of Travis's head—straight on, rather than from the side, where Scorsese is sitting—inviting the thought that this is all taking place in his mind. Certainly Travis realizes that he has "some bad ideas in my head," as he tells Wizard (Peter Boyle), the wise older cab driver he immediately seeks out after the Scorsese episode. But once again he fails to make a connection; the two men talk past each other (although Boyle's existentialist rap is quite impressive). The encounter with Wizard ends ominously—with a long shot of his cab pulling away, leaving Travis behind. The sequence signifies Travis's descent into madness and begins the transition toward *Taxi Driver*'s violent conclusion, the inevitable "one path" that Travis soon articulates.

The bloodbath at the end of *Taxi Driver* was an additional source of controversy—so bloody that Scorsese had to add a masking red tint to avoid an X rating. It was yet another seventies film that raised the bar for the portrayal of violence on the screen. For Schrader, the violent end was the natural and necessary conclusion, like the ending of *The Wild Bunch,* which he considered one of the "two greatest films of the sixties."[74] And as Sam Peckinpah might have argued, the violence in *Taxi Driver* had nothing on Vietnam. Travis is explicitly coded as a Vietnam vet, although other than his ominous comment about being "good with crowds," Scorsese and Schrader both seem reluctant to pin much on the specific influences of that war. For Scorsese, the film was a reflection of "growing up in New York and living in the city."[75] Unlike the blood-soaked revisionist Westerns of the time that were reimagining American myths through the lens of contemporary disillusionment, *Taxi Driver* wasn't trafficking in allegory. New York in 1975 was bad enough on its own.

Seen in broader perspective, both the revisionist Western and the cinema of urban despair can be understood as interrelated expressions of an underlying crisis that was gnawing at society more generally. Looking abroad, many Americans lost their faith in the idea that their country was a white knight, a

force for truth and justice that would always do the right thing; back home, belief in the American dream buckled under new insecurities, locked doors, barred windows, and a reluctance to walk the streets at night. It was not an unreasonable time to reassess the nation's cherished myths, or question its current disposition. After the assassination of Bobby Kennedy, John Updike suggested that perhaps God had "withdrawn his blessing from America."[76] In the years that followed, it was easy to feel, somehow, a sense of betrayal, as if some unwritten compact had indeed been violated. Moving deeper into his presidency, Nixon would take that sense of betrayal to previously unimaginable heights.

CHAPTER 6

PRIVACY, PARANOIA, DISILLUSION, AND BETRAYAL

Richard Nixon haunts the seventies film. Occasionally in the text, usually in the subtext, always looming; as one writer observed, "his inescapable, uncomfortable presence helped provide a climate for these movies to occur in."[1] It was not a warm climate—Nixon was a hater. He hated the East Coast professional elites, who he assumed looked down on him. He was pathological in his fixation on "the Jews" (expletive deleted). He assumed that his enemies, real and imagined, would do anything to destroy him, and so it would be foolish not to do whatever it took to destroy them first. He was obsessed with his image and how history would judge him, especially in comparison with the Kennedys, whom he loathed and feared. During his first month in office he admonished a young aide for relating the "uniformly excellent" treatment of the White House in the media. "You don't understand," Nixon scolded him. "They are waiting to destroy us."[2]

Nixon was a politician, always, like a figure from Greek mythology: halfman, half-candidate. He surrounded himself with a small circle of ruthless, calculating, bullying, even menacing political operators, the kind of men who, as children, your mother told you not to play with: H. R. Haldeman (chief of staff), John Ehrlichman (assistant to the president), Henry Kissinger (national security adviser), John Mitchell (law partner, campaign manager, attorney general), and Charles Colson (special counsel to the president). A final member of the inner circle was Rose Mary Woods, Nixon's personal secretary since 1951, the legendary "fifth Nixon" (after Dick, Pat, Tricia, and Julie), and the most loyal of them all: if Watergate were an episode of *The Simpsons,* Woods would have been Smithers to Nixon's Mr. Burns.

"I must build a wall around me," Nixon wrote to himself during his first days in office. And so Haldeman and Ehrlichman, with their Teutonic surnames, became known as the Berlin Wall; *no one* could get to the president without going through them—not the most senior members of the cabinet, certainly not the vice president. Haldeman in particular was Nixon's alter ego, his "Siamese twin," as Ehrlichman put it. He took care of all the business that Nixon was loath to touch, such as difficult confrontations, and especially telling people no. Haldeman did that well. "Stories spread about Haldeman's alleged rudeness to Cabinet members and party leaders," Nixon wrote in his memoirs. "Most of these stories were apocryphal, although I'm sure some of them were not." Kissinger, Mitchell, and Colson made it over the wall most often. Nixon was determined to direct foreign policy from the White House, and Kissinger, as national security adviser, was his chosen partner in this. Defense and the State Department (which Nixon disdained) were frozen out of the policy process. Mitchell was a trusted friend and an "indispensable" adviser, Colson a kindred spirit in bare-knuckled politics. "I always admired his hardball instincts," wrote Nixon, who valued Colson as part of his inner circle.[3]

In a seventies film it is usually easy to spot the Nixon; after a while, it becomes impossible not to see him everywhere. Surely James Mason in John Huston's *The Mackintosh Man* (1973) is Nixon; corrupt, red-baiting, hypocritical, he double-crosses Paul Newman. And why not? Newman was on the original White House enemies list. Kirk Douglas, directing himself as an ambitious, corrupt, untrustworthy "law and order" marshal in the revisionist Western *Posse* (1975) *had* to be Nixon. Jack Lemmon in *Save the Tiger* (1973) is the most controversial Nixon: hardworking, sympathetic, besieged, Lemmon's Harry Stoner finds himself sliding incrementally from little crimes to bigger ones in a desperate effort to keep his struggling business afloat. *Tiger,* nostalgic for the forties and unimpressed with the legacy of the sixties, can be read as an apology for Watergate, and it was by some less-than-amused critics. Pauline Kael called the movie "a moral hustle."[4]

The most Nixonian of them all is Michael Corleone in *The Godfather, Part II.* Ruthless, tactically brilliant, but increasingly isolated within an ever smaller circle of intimate advisers, Michael, like Nixon, becomes ever more alone, estranged from his wife and obsessed with his enemies, whom he needs not simply to defeat but to destroy. Shot by Gordon Willis in ever darker settings, Michael ends up alone with his demons in Lake Tahoe, just as Nixon ended up, in Reeves's perfect phrase, "alone in the White House." The links between them are intriguing. The real Nixon would have been presiding over the Senate when the fictional gangster testified before it in 1958; it is not hard to imagine Nixon liking, or at least (a greater honor) respecting, Michael. After all, unlike the bluebloods of "fashionable Washington," Nixon found Joe

McCarthy "personally likable"; he saw in Generalissimo Francisco Franco "a subtle, pragmatic leader" and in Hafez al-Assad "a man of real substance" with "a great deal of mystique . . . and a lot of charm." There were, of course, notable differences between Richard Nixon and Michael Corleone: Michael had his brother killed; Nixon only tapped his brother's phone.[5] But it was that instinct which contributed to his undoing.

Set It Straight, This Watergate

"Watergate" is too easily misunderstood as it recedes further into the historical imagination. Watergate is commonly associated with the break-in at Democratic National Headquarters in the wee small hours of June 17, 1972, and with the fact that Nixon had been secretly taping conversations with friends and foes alike. These salient memories can obscure the bigger picture. The break-in, for example, was not that important in the grand scheme of things. But getting caught at the Watergate was monumental because it threatened to expose a boatload of secrets—dark and dirty secrets that Nixon was desperate not to have exposed. He feared that such revelations could cost him the election that fall. As for the tapes, they did not matter for their legality; they mattered because ultimately they could prove who was lying about what. After knowledge of the tapes became public, Nixon fought hard to avoid turning them over to the various authorities who sought them. He claimed that releasing them would undermine executive privilege and tie the hands of future presidents. He knew the tapes would prove his guilt.

But Watergate, especially for society in general and the seventies film in particular, was not simply about the (many) violations of the law that did take place (Haldeman, Ehrlichman, Mitchell, Colson, and about a dozen others would eventually go to jail). It was about the collapse of faith in institutions, a foreboding sense of the erosion of privacy, and a basic loss of trust: in one's president, in one's colleagues, in one's (presumed) friends. Presidents in the past had surreptitiously recorded conversations, if none with the zeal of Nixon, who had secret automatic systems installed in the Oval Office, its telephones, the president's hideaway in the Executive Office Building, and at Camp David. Part of the culture of Watergate paranoia was that everybody became afraid that others were secretly recording them, which they often were. Many, like Howard Baker, ranking Republican member of the Senate Watergate Committee, were reluctant to talk on the phone (he made secret visits to the White House instead). As seen in *Klute* (chapter 4), *The Passenger* (chapter 3), and of course *The Conversation* (this chapter), the ominous, rolling reel-to-reel tape is a prominent motif in the seventies film. Sidney Lumet's *The Anderson Tapes*

(1971) was a precocious entry, depicting a world where the best-laid plans of many are undone by the cumulative, overwhelming weight of competing surveillances.

Beyond the spying was the lying, and this also scarred the American psyche. Nixon was a liar, as if by vocation. As if he found it hard to tell the truth. Nixon told so many different lies to so many different people that one stands in awe of his ability to keep track of which lies he told to whom. In private conversations with his lawyers, with his aides, with members of his family, in press conferences and televised addresses, lies were stacked upon lies, some often superseding and invalidating others. As the tapes would eventually show, in every public statement, speech, and explanation Nixon made about the Watergate affair for over eighteen months, the president was knowingly and purposefully lying. Usually whoppers. For many, this mattered even more than whatever (even illegal) business Nixon might have been up to. When the so-called smoking gun tape was finally released, John Wayne expressed the reaction of many loyal longtime Nixon supporters when he exclaimed, "Damn, he lied to me."[6]

Nixon lied about Watergate from the start. That little black-bag job at Democratic headquarters was a small part of a much larger campaign orchestrated by Nixon and conducted by his men as a central component of his broad political vision and narrow reelection strategy. Nixon had lost a very close presidential election in 1960 and won a close one in 1968 ("far too close for comfort" in his assessment); worse, he anticipated that if the Democrats could unite around a strong candidate, they "would be hard to beat" in 1972. From his first days in the White House, Nixon was obsessed not just with winning in 1972 but with winning big. And as always, he was determined "not to let the other side be politically tougher than we were." It would be his last campaign. "What I want everyone to realize," he instructed his staff, "is that we are in a fight to the death for the big prize." Nixon's keen political antennae drew him to lock in on four men: Senator Ed Muskie, who would be the toughest of the Democratic hopefuls to defeat; George Wallace (another independent run by the Alabama governor could undermine Nixon's "southern strategy"); Senator George McGovern, whom the president dreamed of running against; and in his nightmares, Nixon heard the hoof beats of undeclared dark horse Ted Kennedy. He did not think he could beat the crown prince of the Camelot dynasty.[7]

The basic strategy was in place from the start: stop Muskie, divide the Democrats, and watch out for Teddy. And Nixon planned to fight with loaded gloves—intelligence, gathered by any means, and "dirty tricks," financed on the sly. Still, for the first few years Nixon found himself on the political ropes. The 1970 midterm elections, not bad for the incumbent party by historical

standards, were nevertheless deeply disappointing to the administration; 1971 was a very rough year for the economy—Nixon yanked the dollar off the gold standard and imposed wage and price controls. In early 1972 he was trailing front-runner Muskie in the polls.[8]

The Watergate break-in was an intelligence-gathering operation executed by men who were also involved in the planning of various dirty tricks; their arrest threatened to expose both extralegal arms of the Nixon reelection machine. The target of the break-in was Larry O'Brien, a Democratic strategist and top McGovern adviser who had long been in Nixon's cross-hairs. As early as March 1970 Haldeman noted in his diary, "[Nixon] wants us to move hard on Larry O'Brien." Nixon admits in his memoirs that he "repeatedly urged Haldeman and Ehrlichman" to have the IRS investigate and harass his opponents, and O'Brien in particular (the audit turned up nothing). Nixon says he was curious about O'Brien's relationship with Howard Hughes; Nixon's biographer Steven Ambrose suspects the tap was motivated by the president's fear of what O'Brien might have known about Nixon's financial relationship with Hughes.[9]

Chances are that Nixon did not have advance knowledge of the specific details of the June 17 break-in. But he was from the very beginning actively and intimately involved in the effort to undermine and contain the investigation that followed. Nixon's principal crimes in this regard were to pay hush money to the burglars and to orchestrate a broader obstruction of justice, most famously with his order to the CIA to get the FBI to drop its pursuit of the matter on the (fictitious) grounds that it was an issue pertaining to national security. Nixon took these desperate measures because he knew that without them, the full range of the "White House horrors," as Mitchell would later dub them in his Senate testimony, would be exposed. Arrested in connection with the break-in were Howard Hunt and G. Gordon Liddy, and the burglars were carrying a lot of cash, mostly in hundred-dollar bills. Very few at the time realized that these were daggers pointed at the heart of the White House, but Nixon did. Hunt was on the White House payroll, and he was Colson's man. Liddy reported directly to Mitchell, and he had previously done illegal work for a clandestine outfit supervised by Ehrlichman. The money, though laundered through a South American bank account, ultimately could be traced to the Committee to Re-Elect the President (forever known as CREEP), and further still to a secret cash fund at CREEP that financed sabotage operations. Haldeman (if often through subordinates) controlled the secret fund; he also had a man in Mitchell's operation who quietly kept him informed.[10]

Nixon understood all of this. The secret fund was his idea—in his first month in office, back in 1969, he had ordered Haldeman to set it up—and he knew that Haldeman ("acting in my name") controlled it. He knew of Hunt,

and the link from there to Colson ("my political point man"), and what Colson was capable of. On May 16, a month before the break-in, Nixon ordered Ehrlichman to "use Colson's outfit to snake out things. I mean, he'll do anything. I mean anything." He knew Mitchell and Ehrlichman were each supervising ongoing covert domestic political operations. Nixon spoke to Mitchell on June 20 about the Watergate break-in, but no tape of that call has been found. That same day the tape of Nixon's conversation with Haldeman contained the famous eighteen-and-a-half-minute gap; later that day Haldeman told Nixon that the burglars were "a pretty competent bunch of people" who have "been doing other things very well." He would also (erroneously) reassure the president that one "break is they can't trace the currency." Nixon was relieved ("so, we're okay on that one"); he knew that "unless we could find some way to limit the investigation the trail would lead directly to the CRP."[11]

In the next few days the early phase of the cover-up took shape—paying hush money and dealing with the "problem area," as Haldeman put it: "The FBI is not under control." This posed a threat because of the money trail, and because an investigation of Hunt, Nixon knew, could "uncover a lot. . . . [Y]ou open that scab there's a hell of a lot of things in it." Mitchell and White House counsel John Dean came up with the plan to have Nixon order the CIA to tell the FBI to back off. Nixon agreed. The effort was unsuccessful, but this attempt at obstruction, on June 23, was recorded on what became known as the "smoking gun tape." Dean was put in charge of managing the cover-up and keeping tabs on the FBI investigation. The latter was fairly easy: acting FBI director L. Patrick Gray gave Dean regular updates about what the bureau knew.[12]

The goal of the cover-up was first to essentially freeze the ball until after the election, and beyond that to prevent the exposure of the dirty money and the White House horrors. Dean was successful with the first, and met regularly with Haldeman and Ehrlichman and occasionally with the president, who initially at an August press conference began to make reference to a (nonexistent) comprehensive "Dean Report" which he said had totally cleared the White House of any wrongdoing. Actually, Nixon's personal lawyer (and longtime bagman) Herbert Kalmbach was instructed by Ehrlichman to put together the cash for the hush money; before the year was out, the Watergate defendants had received $187,500. Hunt was the squeaky wheel, often through Colson, who secretly recorded their phone calls and passed the tapes on to Dean. Keeping Hunt happy "was very expensive," Haldeman complained to Nixon. "It's worth it," the president responded. "That's what the money is for. . . . [T]hey have to be paid."[13]

"Follow the money," shadowy informant Deep Throat urges *Washington Post* reporter Bob Woodward in the movie *All the President's Men*. Actually, Deep Throat never said that; the line was screenwriter William Goldman's.

It was good advice, though: "the money" came from that secret fund Nixon had ordered established in 1969. Although it was initially staked by drawing on an undisclosed surplus from the 1968 campaign, its coffers were filled by skimming cash from a parade of illegal contributions to CREEP (the long list of the guilty would include Goodyear Tire, American Airlines, Phillips Petroleum, Associated Milk, Minnesota Mining, and of course George Steinbrenner), and other secret donations from wealthy Nixon supporters like Thomas Pappas, who had close ties to the Greek military junta.[14]

And there was a lot of money to follow, much of it laundered through banks in Mexico and Venezuela, some of it stowed in safe deposit boxes in New York, Washington, Miami, and Los Angeles. CREEP's finance chair kept over $1 million in his office safe. He handed $250,000 to Kalmbach, no questions asked; Liddy got $199,000 from the same source. At one point Haldeman deputy Alexander Butterfield carried $350,000 in his car. In one two-day period, CREEP's treasurer handled $6 million in cash. (All of these figures need to be multiplied by at least five to get a sense of what that money would be worth today.) As Nixon later explained, the cash was "for intelligence gathering and other campaign projects that had to be handled discreetly." Or as Haldeman wrote in his diary just months into the administration's first term, the president "wants to set up and activate 'dirty tricks.' "[15]

The money was put to a wide variety of uses. In July 1969 Ehrlichman sent two detectives (on annual retainer from the secret fund) to Martha's Vineyard to pose as reporters in an effort to dig up dirt on Ted Kennedy. The following April, Nixon told Haldeman to get investigators "on Kennedy and Muskie." Kennedy was followed everywhere; one tail in 1970 took photos, reviewed by Nixon, of Kennedy in Europe "dancing till dawn with the daughter of the former King of Italy." When told in July 1971 that a man was still tailing Kennedy, Nixon's response was "Just one?" In 1972 non-candidate Kennedy was given Secret Service protection; Nixon told Haldeman to plant two agents in the detail that he "could get to," who would not just protect Kennedy but report back to Haldeman about anything useful that they saw.[16]

The White House obsession with the Kennedys reached into the grave. Colson ordered Hunt to scour hundreds of cables between Washington and Saigon from late 1963, hoping to implicate JFK in the assassination of South Vietnamese president Diem. Coming up empty, Hunt resorted to a (literal) cut-and-paste job, fabricating a cable that would make the Kennedy administration look responsible. Days after Hunt's Watergate arrest, Dean had the Secret Service break into Hunt's White House safe and took possession of the fake cables and a potpourri of papers relating to other covert operations. Dean passed them on to FBI director Gray, who held them for six months before burning the incriminating documents at his home.[17]

Nixon craved information and seethed when it slipped from his control. Two months into his first term, the president authorized a "secret bombing" of Cambodia; the story broke in the *New York Times* in May. Nixon was furious and, convinced that a leak had come from the National Security Council, ordered Kissinger to secretly wiretap his own staff. FBI director J. Edgar Hoover approved the action, Kissinger supplied the names, and Mitchell signed the orders (though he would later deny it). Turning up nothing, the taps were extended, by Kissinger's request, to four journalists. Kissinger also, through his assistant Alexander Haig, asked the FBI for taps at the Defense and State departments. From May 1969 to May 1970 the FBI sent thirty-seven top-secret letters to Kissinger reporting on the status of the surveillance. One thing the FBI would not authorize was a tap on reporter Joseph Kraft, apparently for the crime of writing a negative story about Nixon. So one of Ehrlichman's operatives climbed up a telephone pole outside Kraft's home and did it himself.[18]

These episodes were remarkable for their unremarkability: "domestic surveillance"—eavesdropping, wiretapping, planting of spies and informants, opening mail—was standard operating procedure. In 1970 Nixon approved the "Huston Plan" authorizing these tactics, as well as some nakedly illegal ones, like "surreptitious entry." The Huston plan was, in theory, directed at dangerous domestic groups. If laws were broken, Nixon reasoned, it was because "sometimes the letter of one law will conflict with the spirit of another," and as president, he needed to take "emergency measures . . . to defend the nation." Unfortunately, as seen with the Kraft tap (and countless other examples), Nixon could not distinguish between violent enemies of the state and political adversaries of the president.[19]

Nixon's need to control information and his obsession with his enemies came to a head over the Pentagon Papers. On June 13, 1971, the *New York Times* published the first installment of the papers—some seven thousand pages of secret documents revealing that the Kennedy and Johnson administrations had spent years deceiving the American public about the Vietnam War—which had been photocopied and passed on to the *Times* and the *Washington Post*. Nixon, unscathed by the papers, was nevertheless apoplectic at the leak, which he attributed to "some group of fucking Jews." Whatever the source, he could not abide it. "We've got a counter-government here and we've got to fight it," Nixon told Colson. "I don't care how it is done." It was this leak that led to the formation of a special operations group in the White House— appropriately nicknamed "the plumbers"—which involved Colson and operated under Ehrlichman's authority. Initial attention focused on the Brookings Institution. Kissinger, who made a career out of goading Nixon ("They are calling you a weakling, Mr. President," always seemed to work), innocently opined, "I wouldn't be surprised if Brookings had the files." Nixon wanted

them back. "I want the Brookings Institute's safe *cleaned out*," Nixon ordered at an Oval Office meeting with Mitchell, Haldeman, and Kissinger. "Don't discuss it here. You talk to Hunt. I want the break-in."[20]

"We're up against an enemy, a conspiracy," Nixon told Haldeman and Kissinger. "They're using any means. *We are going to use any means.* Is that clear?" Those means, however, would be directed not at Brookings but at Daniel Ellsberg, the former military analyst who did in fact leak the Pentagon Papers. Hunt and Liddy led a team of plumbers who broke into the office of Ellsberg's psychiatrist, an operation approved by Ehrlichman, designed to find information that would discredit Ellsberg. Ehrlichman sought to insulate the president at the time, though years later he would emphasize Nixon's culpability. Nixon's version of events is classically Nixonian. "I do not believe that I was told about the break-in at the time, but it is clear that it was at least in part an outgrowth of my sense of urgency," he wrote in his memoirs. "I cannot say that had I been informed of it beforehand, I would have automatically considered it unprecedented, unwarranted, or unthinkable."[21]

Nixon found few things unthinkable. When George Wallace was shot in May 1972, the president and Colson discussed sending a man to break into would-be assassin Arthur Bremer's apartment to plant some left-wing literature; they feared he might be a right-wing nut, which would be bad politically. (Actually, he was just plain nuts, and an inspiration for Travis Bickle in *Taxi Driver*.) Nixon had never taken his eye off the Wallace threat: assessing him vulnerable in the 1970 gubernatorial primaries, he had Kalmbach secretly pass $100,000 in cash to Wallace's rival; when Wallace wobbled, Nixon sent in $300,000 more. But Wallace won, and was, as Nixon feared, soon running for president. Colson sent Howard Hunt on the Bremer job. In the fall of 1971 the plumbers had been folded into the campaign apparatus. Reporting now to Mitchell and Haldeman, they shifted their efforts to the dirty tricks initiatives.[22]

Nixon loved "dirty tricks," and he relished bantering about good ones with his closest advisers. In the 1972 campaign there were two principal sets of operations: Liddy's ex-plumbers, now at CREEP, and a group led by Donald Segretti. By the end of 1971, Segretti had twenty-eight people working in seventeen states, engaging in all kinds of infiltration and sabotage designed to take down Muskie (then running ahead of Nixon) and build up McGovern. Financed by Kalmbach, Segretti called the White House every day at noon from a pay phone to check in. As for Liddy, on January 27, 1972, he presented to Mitchell (then the sitting attorney general) his ambitious, bizarre "gemstone" operations, with a $1 million budget and schemes involving drugging, prostitutes, and kidnapping. Mitchell (judiciously, he must have thought) told Liddy to scale it down, and initially gave him $250,000, with a promise of additional funds as needed.[23]

Nixon under Siege

Nixon crushed McGovern in a landslide, but the fruits of victory would be short-lived. On election night the president felt a strange "melancholy," which he could not explain. On January 2 he told Colson the "only problem" with the Segretti operation was that it was "too goddamn close.... [T]hat kind of operation should be on the outside." Nixon knew he was vulnerable: "It was a mistake to have it financed out of Kalmbach. It was very close to me." Nixon was right. Although Mitchell had drawn some heat (and eventually stepped aside as campaign manager), Watergate was successfully kept under wraps during the campaign, but by March the cover-up was unraveling. Colson was quietly eased out of the White House, and the president was soon meeting with Dean on a daily basis. Pressure was mounting on three fronts: legal, political, and in the press. At the trial of the Watergate burglars, Judge "Maximum John" Sirica, convinced he was being stonewalled, was determined to get to the bottom of the case and was digging hard. Called out by Sirica, the Senate began its own investigation into campaign irregularities. Events in Sirica's courtroom and before the Senate committee chaired by Sam Ervin finally got the attention of the reputable media, which, outside of the dogged reporting by inexperienced, un-connected Bob Woodward and Carl Bernstein of the *Washington Post,* had to that point paid little attention.[24]

By the end of April 1973, the Nixon presidency was effectively over. Haldeman and Ehrlichman were gone, Nixon was forced to appoint a special prosecutor, and bombshells were dropping daily before the Senate Watergate committee. But Nixon would tenaciously hang on until August 1974, putting the country through what his successor, Gerald Ford, would call "our long national nightmare." Nixon further isolated himself, relying almost exclusively on his young, caustic press secretary, Ron Ziegler, and his ruthless new chief of staff, Alexander Haig. Nixon also needed (and retained) new lawyers. (Kalmbach was under investigation and would eventually go to jail, as did Dean.) Nixon lied to them all. By May, Nixon was orchestrating, in Stanley Kutler's phrase, "an even wider cover-up"—a cover-up of the cover-up. The taping ceased. Nixon hunkered down; increasingly isolated, he moved from bunker to bunker—to his homes in Key Biscayne and San Clemente, to the presidential retreat in Camp David. Things got increasingly surreal. Concerns mounted with each passing month about the president's odd behavior. Either he was drinking heavily, or he could not hold his liquor, or both.[25]

"Not only was I unaware of any coverup," Nixon told the nation in August, "I was unaware that there was anything to coverup." But of course Nixon knew the opposite was true. He had ordered the cover-up from the very start, and on March 21, 1973, Dean gave him a comprehensive review—his crucial two-hour

"cancer on the presidency" presentation in the Oval Office. The cover-up was collapsing, Dean explained, because "we're being blackmailed" (Hunt in particular was demanding more money), and "people are going to start perjuring themselves very quickly." Obstructions of justice have taken place, Dean intoned, and "Bob is involved in that; John is involved in that; I'm involved in that; Mitchell is involved in that." So, of course, was Nixon, who favored continuing the blackmail payments. Nixon assured Dean that he could raise the $1 million, in cash, that Dean estimated it would take to keep people quiet.[26]

Immediately after the Dean presentation, Nixon asked Rose Woods to check the White House safe for "substantial cash for a personal purpose." That evening, $75,000 was delivered to Howard Hunt. Nixon also had several cryptic conversations with Woods about something "quite important," getting in touch with Pappas, and about "the money you got from that fellow." Nixon was eager to make sure that Pappas would not talk if questioned. "Is it . . . safe for me to talk on the phone?" Woods asked. "No, don't talk on the phone," the president responded.[27]

Dean's instincts were right: things were coming apart, and any slight touch would cause the dominoes to fall quickly. Two days after the "cancer" presentation, Sirica's courtroom exploded as one defendant revealed that perjury had occurred and that others, not as yet identified, were involved in the Watergate break-in. This revelation threatened to expose many and sent some scrambling. Other small fish started talking, and it was a fast trip up the food chain. Mitchell, Colson, and Dean were immediately vulnerable. Dean's instincts also told him, and not without reason, that he was now being set up as the White House fall guy. He quietly retained an outside lawyer. The shoes dropped like rain. Nixon's new lawyers told him in April that Haldeman and Ehrlichman could not survive. On April 17 Ziegler caused an uproar with his casual announcement that all previous White House statements on Watergate were now "inoperative."[28]

Nixon knew he had to fire Haldeman and Ehrlichman, but the prospect was unbearable, and he delayed for weeks, seeking advice and support. Kissinger found the president "nearly incoherent with grief." Finally, on April 28, Nixon met individually with his two men and told each the same thing: that he'd prayed the night before that he would not wake, and that letting them go was like "cutting off one arm, and then the other." Haldeman went out like a good soldier; Ehrlichman was "cordial but blunt," Nixon recalled. "He told me he thought I should recognize the reality of my own responsibility. He said all the illegal acts ultimately derived from me, directly or indirectly." The conversation "really jarred" the president, Haldeman wrote, "as well it might." Two days later Nixon announced the resignations, along with those of Attorney General Richard Kleindienst and John Dean. (FBI director Gray

had resigned days before when his destruction of the Hunt documents came to light.) Nixon appointed as his new attorney general Defense Secretary Elliot Richardson, who took the job on the condition that he could name Archibald Cox as special prosecutor to look into the Watergate affair.[29]

Nixon would never recover from the loss of Haldeman and Ehrlichman. "It's all over, Ron," he told Ziegler on that day; for more than a year after that he made no entries in his diary. In his memoirs, Nixon would write what others observed: "From that day on the Presidency lost all joy for me."[30] But his presidency would continue for more than fifteen months, as the nation watched Nixon slowly melt under the bright lights of the Watergate investigations.

On May 22, Nixon issued a statement making seven "categorical" claims. Six of them were not true. One month later Dean appeared before the Senate committee. Convinced in April that he was going to be "thrown to the wolves," he jumped instead. His seven-hour, 245-page opening statement, confessing some of his own crimes and explicitly implicating the president, stunned the nation. Either Nixon or Dean was lying. "We must destroy him," Nixon repeatedly emphasized to Ziegler and Haig. The hearings had been filled with notable moments, both colorful and shocking, and the crimes acknowledged by administration officials mounted. But it all came down to this. It might have been irresolvable had not Butterfield, reluctantly in response to a direct question, acknowledged the existence of the White House tapes. That would settle the matter. The committee, Judge Sirica, and special prosecutor Cox each demanded access to the tapes. Nixon refused, and the struggle over the tapes would dominate Watergate's final year.[31]

The carnival continued. At an August press conference, the president seemed to slur his words amidst the hostile questions and answers. At the September ceremony confirming Kissinger as secretary of state, Nixon riffed non sequiturs about his adviser, a performance Kissinger found "bizarre." In October, Cox grew more vociferous in his pursuit of the tapes. On the twentieth, Nixon ordered Richardson to fire him. Richardson refused, and resigned. His deputy, William Ruckelshaus, was ordered to fire Cox. He refused, and was dismissed. Robert Bork, the number-three man at Justice, became acting attorney general, and he fired Cox. FBI agents sealed off the offices of Cox, Richardson, and Ruckelshaus, and at 8:22 that evening Ron Ziegler took to the podium to announce, "The Watergate Special Prosecution Force has been abolished." But the move backfired with the public, the press, and, most important, with Nixon's supporters, who were outraged by the blatant disregard for the rule of law. To many, it looked like a coup; it was at the very least a constitutional crisis. In his legendary November ("I'm not a crook") press conference, the president was asked serious questions about the survival of the republic.[32]

Nixon's back was to the wall. With no real choice, he gave in and appointed a new special prosecutor, Leon Jaworski; he also agreed, in principle, to release some tapes. In November the president's lawyers flew to Key Biscayne to urge him to resign. He refused to see them. Rumors about his behavior multiplied. In December, influential senator Barry Goldwater attended a dinner at which Nixon "jabbered incessantly, often incoherently." When the chairman of the Joint Chiefs met with the president to discuss budgetary matters, he was treated instead to a "long rambling monologue" about Nixon's enemies in the eastern establishment. That month Jaworski listened to the March 21 "cancer" tape. He told Haig he was "stunned" by what he heard, and that the president "had engaged in criminal conduct." In January, Jaworski asked for more tapes, including the tape from June 23, 1972, not yet known as the "smoking gun tape." Nixon refused to comply, and the case went to the Supreme Court.[33]

Nixon took one last shot at holding on to the tapes, releasing in April edited transcripts. Predictably, Nixon's transcripts lied; the "errors" and omissions told a story closer to what the president wanted, and held back the crucial stuff. The transcripts did not quench the thirst for the tapes, but they had an unintended effect. Nixon unplugged, even the sanitized version, repelled. The transcripts did not show crimes, but they exposed the president as cold, calculating, cynical, scheming, crude, vengeful, paranoid, vulgar, and amoral. These things mattered, and they mattered most to Nixon's core support, his "silent majority." Those idealized Americans—married, midwestern, churchgoing, teetotaling, patriotic—were repulsed by the Nixon revealed on the transcripts. It was like finding out Norman Rockwell was a hustler who sold paintings to finance his drug habit.[34]

On July 24 the Supreme Court unanimously ruled that the president must turn over the tapes. As the tapes trickled slowly out of the White House, each revealing new horrors, the House Impeachment Committee began voting on articles of impeachment; on July 27 article 1 (obstruction of justice) passed, 37–11; on July 29 article 2 (abuse of power) passed, 38–10. On August 5, Nixon released the smoking gun tape: he had known everything from the beginning, he had obstructed justice, he had orchestrated the cover-up. The next day Senator Goldwater, "Mr. Conservative," called Haig to tell him, "[Nixon] has lied to me for the last time." In the House, the ten Republicans on the committee who had sided with the president now expressed their intention to support impeachment in the upcoming House vote. Nixon announced his resignation on August 8.[35] "Always remember," he told his staff, concluding his farewell address the next day, "others may hate you, but those who hate you don't win unless you hate them, and then you destroy yourself." Nixon had written his own epitaph.

What They Do with the Tapes Is Their Business

Francis Ford Coppola's *The Conversation* (1974) is *not* about Watergate. It was conceived in the late 1960s and rooted in Coppola's interest in advances in surveillance technology and the erosion of privacy. A first draft was completed in 1970 and the shooting scrip submitted in November 1972, months before the scandal erupted into the public consciousness. Nor was Coppola interested in making an overtly political film; on the contrary, he wanted it, he said, "to be something personal, not political, because somehow that is even more terrible to me."[36]

Nevertheless, with eleven months of postproduction, the film was not released until 1974, and it touched a nerve. Although it was indelibly influenced by Antonioni's *Blow-Up* (1966) and the films of Alfred Hitchcock, as Mark Feeney has argued, no other film "is so *atmospherically* Nixonian."[37] Harry Caul (Gene Hackman) certainly has a lot of Nixon in him; wary of truth-telling, socially awkward, self-isolated, prone to obsession, and dysfunctionally paranoid, Harry is destroyed by his own tape recordings. But that is too easy, and it is a mistake to run too far with these parallels. Harry is really done in by the crushing weight of his own sense of guilt and responsibility. This was not one of Nixon's problems. *The Conversation* resonates, then and now, not as an indictment of the disgraced president but as one small, brilliant Nixonian nightmare.

Coppola's New Hollywood masterpiece is everything the seventies film aspired to be: personal, meticulous, riveting, profound. It is both a character study and a suspense film. To get caught up in the spellbinding mystery is to miss the point: the solution doesn't matter; in fact, it is quite likely there are no solutions, conventionally speaking. With this inward turn Coppola parts company with both Hitchcock and Antonioni. About the souls of their protagonists we learn little, whereas, like *Night Moves* (chapter 7), *The Conversation* is about the character, not the crime. And what a character: Harry is neither a hero nor an antihero. Rather, as Walter Murch, the film's editor (and crucial collaborator), points out, Coppola chose to focus the entire film on what in a standard thriller would be a minor character, the wiretapper, some guy who drops off the tapes and leaves. But *The Conversation* is about this essentially "anonymous person," just as New Wave icon Claude Chabrol insisted that a film about "a hero of the resistance" is no more profound than one about "the barmaid who gets herself pregnant"; in fact, "the smaller the theme is, the more one can give it a big treatment. . . . [T]ruth is all that matters."[38]

The Conversation begins with a long shot of Union Square in San Francisco, ever so slowly moving in on the busy lunchtime crowd. As with the entire film, the opening scene was shot on location, in this case unobtrusively

with very long lenses that allowed the players to mix in with people going about their normal business. The focus of the shot is at first uncertain, then a mime catches the eye; a tip of the hat to the mime in *Blow-Up*, it also brings attention to Harry, as the mime follows and mimics his actions. At first Harry does not notice, and then with some effort sheds the unwelcome irritant. This initial piece of business, Coppola has said, is the first invasion of privacy in the movie, which is of course a principal and ubiquitous theme.[39]

A sniper's crosshairs, focused on a young couple, are much more ominous. Given the period, it would be natural to expect that an assassination is about to take place. But a more intimate sin is occurring. The scope is aiming not a rifle but a sophisticated listening device, one of three devices that are tracking this couple and secretly recording their conversation. Harry is in charge of the operation, and as the camera follows him to the van from where the job is being orchestrated, he is associated with an aural motif: a piece of the conversation that is repeated five times, always matched with a shot of Harry, usually in close-up. The girl, Ann (Cindy Williams), is saddened by an older homeless man she sees sleeping on a park bench. "I always think that he was once somebody's baby boy," she tells her furtive companion, Mark (Frederic Forrest), "and he had a mother and a father who loved him and now there he is, half dead on a park bench, and where are his mother or his father or all his uncles now?"

Like the homeless man, Harry seems very much alone, and he prefers it that way. Obsessed with his own privacy, he is dismayed to learn that his landlady has a set of keys to his apartment—solely to save his valuables in case of fire, she explains reassuringly. But Harry has nothing he values, "except my keys," which he thought gave him exclusive access to his triple-locked apartment. The "action" in his apartment is shot in a distinct style: a static camera, master shot. Harry walks in and out of empty frames; only when the camera seems to realize that he is not coming back, it mechanically pans to pick him up, like a surveillance camera in a convenience store. Not that there is much worth seeing. Harry does not entertain; he spends the evening playing the saxophone to a record of a live jazz performance.[40]

There are two people with whom Harry has some human connection, his assistant Stan (John Cazale) and his lover Amy (Teri Garr). Harry and Stan bicker at the warehouse workshop that serves as Harry's headquarters. Stan is curious about the content of tapes, but Harry is concerned, and insistently so, only with getting a "big, fat recording." In two virtuoso scenes, Harry gets just that, piecing together one seamless tape from the fragmented multiple recordings. He is a master craftsman, absorbed in his work. Here the link with *Blow-Up* is most explicit, as he massages ribbons upon ribbons of tape to create one (ultimately enigmatic) representation of reality, just as the gifted photographer Thomas seeks to do in Antonioni's film.[41]

Harry retreats behind translucent barriers

With Amy, Harry is, if anything, even more circumspect. He pays her rent, watches her from a distance, and listens to her phone calls, yet she knows nothing about him. When he crawls into bed with her, it becomes clear that he isn't even going to take off the thin translucent raincoat that he wears throughout the film (despite the fact that it never rains). Harry is often shot through plastic and glass barriers, which both protect and expose—phone booths, curtains, screens, dividers and, as Murch points out, "whenever he's threatened or something bad is going to happen, he retreats behind" some opaque shield. The raincoat is part of this larger "metaphor of seeing through things," Coppola explains; it also has an affinity with Harry's last name, C-A-U-L, as he spells it out on several occasions, which is a thin membrane that encases a fetus. The name serves as a reminder of his childhood frailty (like Coppola, Harry had polio) and the fact that, although now so desperately alone, he was once indeed "somebody's baby boy."[42]

Harry's encounter with Amy ends abruptly; she has grown impatient with his secretive nature. When Amy probes between kisses for innocent scraps of information, such as what he does for work, Harry first lies and then, recoiling from the invasion of his privacy, flees her apartment. The next day brings another unconsummated encounter. Harry goes to deliver his tapes to the director of what appears to be a large if nondescript corporation but is met by the director's assistant Martin Stett (Harrison Ford) instead. With a telescope between them (one of the constant reminders of secret observation that litter the film from start to finish),[43] the two men awkwardly talk business. Harry's

instructions were to give the tapes only to the director himself. Suddenly the smooth-talking Stett makes a grab for them. Harry wrestles them back and escapes the skyscraper with Stett's warnings ringing in his ears: "Don't get involved in this, Mr. Caul . . . those tapes are dangerous; you heard them, you know what they mean."

But actually Harry is not quite sure what is on them, and so he revisits the recording. A key part of the conversation had been drowned out by a steel drum. Again with a virtuoso display of craft, Harry manages to isolate the missing line: "He'd kill us if he had the chance." There it is. Until this point in the movie Harry had protested, in retrospect too much, that what was on the tapes he made for others was none of his business. Yet from that revelation Harry immediately seeks out the confessional, where he has not been in months. He atones for various minutiae—lifting newspapers, impure thoughts—as the camera, as if bored, slowly shifts its focus toward the priest. "This happened to me once before. People were hurt because of my work, and I'm afraid it could happen again," Harry says. Or does he? As the focus of the image drifts away from him, the track shifts to voiceover, as if Harry can reveal these thoughts only to himself. But he does seek absolution. "I was not responsible," he insists, "in no way responsible."

Harry is in crisis: burdened by guilt, followed (on-screen) by Stett, his relationships crumbling, he is unable to reach Amy, who has moved and disconnected her phone, and Stan now seems to be seeking employment elsewhere, perhaps with a rival. In a crucial bridging sequence Harry attends a convention of surveillance experts (an actual convention, filmed on location), and from there finds himself with some business acquaintances, girls in tow, back at his warehouse for a few drinks. Harry locks away some papers in a room secured by a chain-link fence, but nothing can protect him from Bernie Moran. Chillingly portrayed by Allen Garfield, Moran, more than Harry, is the Nixon of the piece. Seething, ruthless, amoral, squeezed into an ill-fitting suit, Moran is self-made and proud of it, still walking around with the chip on his shoulder from his tenement youth. Self-declared "best bugger on the East Coast," Moran is obsessed with the fact that Harry is at least as good as, and certainly more esteemed than, he. If not Nixon himself, Moran would undoubtedly have been at home in the basement of the Nixon White House, plotting dirty tricks; he stalks Harry with almost equal measures of jealousy and respect.

Moran floats the idea of a partnership, but Harry is more interested in being spirited away from the group by Meredith, the model who worked Moran's display booth at the convention. With her encouragement, Harry shares with another person, haltingly and for the only time in the film, some of his private thoughts. He wonders (obliquely in the third person) whether Amy might return to him. Her response is heartbreaking ("How would I know that he loves

me?"), and Murch is justly proud of the three camera moves, slow, rotating reveals (constructed during the editing of the film), which unmask Harry during this exchange.[44]

But no good deed goes unpunished. Meredith is not an angel of mercy; she is an agent of the corporation. She stays behind after the others leave and offers some comfort to Harry, who is shown prone and dazed on a cot, a matching shot that pays off a final overheard reference to the homeless man "half-dead on a park bench," bereft of the people who once loved him.[45] "Forget it, Harry, it's just a trick," she urges. "You're not supposed to feel anything about it; you're just supposed to do it." She ought to know. She slips out of her dress and spends the night. Harry, tormented by the thought of more innocent blood on his hands, dreams fitfully of catching up with Ann and alerting her to the mortal danger: "He'd kill you if he had the chance." In the morning Meredith is gone, and so are the tapes.

The last forty minutes of *The Conversation* flirt again with Hitchcock; except for "the conversation" itself, there is very little dialogue, recalling the long, silent sequences in so many of the Master's suspense films. Potential threats— the ominous man waxing the floor, the large, unattended dog—come and go without incident, and it turns out that the director got the tapes after all. But neutral locations, like the bathroom, erupt with horrors when least expected.[46] Privacy is again invaded, opaque curtains are parted, translucent barriers bloodied, see-through shower curtains murderous, and Harry's worst nightmares are realized.

Or not. Harry had it all wrong, as he soon finds out. He heard the tapes incorrectly, misunderstood the intrigue, wept for the wrong victim. Seeing (and hearing) it again in his mind, he reimagines the murder: that's probably what happened; we'll never know. But the bad guys—different bad guys than he thought—know that he knows. They call Harry at home and make it clear that they have bugged his apartment. "We'll be listening to you" is the last line in the film. In the movie's final sequence, Harry, searching for the bug, destroys his apartment and its contents, fixture by fixture, outlet by outlet, wall by wall, floorboard by floorboard, until he is left, unsuccessful among the ruins, with nothing left but his saxophone. He had not lied to his landlady; none of his possessions mattered to him as much as his keys, or at least what they represented. Which was worse—the violation of his privacy, or that he was out-bugged, possibly by somebody better, perhaps even by Moran? For Coppola, "the tearing down of the room... [was] synonymous with a kind of personal tearing down," rooted in Harry's overwhelming guilt. In the end, it occurred to Coppola that he hadn't made "a film about privacy," as he had "set out to do, but rather a film about responsibility."[47] In that sense, finally, *The Conversation* was not about Nixon at all, but what the age of Nixon had taken away.

Something Rotten in the State

The arc of the Nixon administration coincided, and not coincidentally, with a broader decline in public trust. Trust in government, obviously, but also trust in social institutions more generally, and in assumptions about the integrity of business practices and the motives of once implicitly reputable professional associations. In 1964, only 22 percent of Americans thought that "you cannot trust the government to do right most of the time"; in 1974, 62 percent held that view. Not surprisingly, polls tracked a marked decline in those trusting the executive branch of government, but there was also from 1968 to 1974 a collapse in the belief that business weighed "the interests of the public" in its pursuit of profits.[48]

These trends were reflected in the seventies film. In Hal Ashby's classic road picture *The Last Detail* (1973), the military is not so much purposefully evil as it is listlessly indifferent. Robert Towne's screenplay tells of two cynical navy lifers (Jack Nicholson and Otis Young) charged with escorting a naïve young sailor (Randy Quaid) from Norfolk, Virginia, to Portsmouth, New Hampshire, where he is staring down an eight-year sentence for petty theft. The movie was shot with New Hollywood darkness-and-documentary-style realism by first-time cinematographer Michael Chapman (he would later shoot *Taxi Driver*). The U.S. Navy withheld its cooperation from the bleak, unflattering film, requiring Ashby to cast his absentee ballot for McGovern from location in Toronto.[49] But *The Last Detail,* with its joyless whorehouse, is down on much more than the military, just as *The Hospital* (1971), where bureaucratic dysfunction kills so many patients that the body count of a serial killer goes unnoticed in the mix, is about more than problems with health care. Both reflect a loss of faith in things once depended on, and the need to game an unjust system by whatever means necessary. In Robert Altman's *Thieves Like Us* (1974), the implicit punch line of the title is that the only difference between outlaws and "legitimate" enterprise is that the reputable members of society keep their dirty business under the table.

This wasn't all Nixon's fault. Certainly the Vietnam War and the way it was fought, and insecurities generated by the end of the long postwar economic boom, contributed to these trends. But the Nixon administration took a tire iron to the public faith, and not just with Watergate (though the act of flipping over that rock exposed a lot of slime that might otherwise never have come to light). Nixon had a cozy relationship with the Associated Milk Producers—in 1969 and 1970 that organization delivered $235,000 in cash to Kalmbach—and in March 1971 the president exchanged an increase in federal milk production subsidies for a $2 million campaign contribution. "Don't say that while I'm sitting here," admonished the president, coming off more than

a bit like Tony Soprano, who also liked to leave the room before the money details were discussed. The president's men kept busy: a $400,000 campaign contribution from ITT was linked with the settlement of an antitrust case against that company, and Chrysler claimed that Kalmbach asked for a "gift" as the automaker sought a delay in emission control standards. These were not isolated incidents; most of the corporations that had provided illegal contributions reported similar shakedowns.[50]

Nor was the public trust enhanced by the fact that Nixon paid no income tax in 1970 or 1971, or by the backdated, dicey "donation" of his vice presidential papers. (In April 1974 the IRS would rule that Nixon owed over $430,000 in back taxes and interest for failing to declare income and for impermissible deductions.) But this was nothing compared to the troubles of Vice President Spiro Agnew, who was suddenly engulfed by scandal in 1973. The self-righteous law-and-order Agnew, it turned out, had spent his Maryland political career hip-deep in bribes and kickbacks. Nixon was told that Agnew was indictable on forty counts, and that it was an "open and shut" case. "Thank God I was never elected governor of California," Nixon joked at the time. Agnew and Nixon were not close, to say the least, but a corrupt vice president added to the general stench of criminality emanating from the White House. The same day Agnew resigned (October 10), the *New York Times* reported that Nixon's close friend Bebe Rebozo had previously received $100,000 in cash as a "campaign contribution" from Howard Hughes.[51]

The national loss of faith was a function not simply of money but also of hypocrisy. As noted earlier, Nixon's transcripts gambit didn't just fail; it backfired, exposing the "real" Nixon, and the sting was felt more by friends than by foes. "Sickening," opined the *Chicago Tribune*. "The key word here is immoral." Another longtime supporter published an editorial urging Nixon to step aside: "He makes us feel, somehow, unclean."[52] What *wasn't* the administration capable of? When Howard Hunt's wife died in a plane crash, $10,000 in cash was found on her body. Dorothy Hunt was a key distributor of hush money to the Watergate burglars; she handled over $200,000 and kept detailed records. Nixon was concerned that the money would be traced back to CREEP. Haldeman told him that Dean "spent most of the weekend on that." Beyond the White House, wilder questions were raised. What about the flight insurance she purchased, with no named benefactor? Was the plane deliberately brought down?[53]

No evidence of sabotage was found, but such was the tenor of the time that the questions didn't seem unreasonable. This was an administration that did whatever it had to do to get things done—just as it would do what it could to bring down the government of Salvador Allende in Chile. Kissinger warned Nixon that the election of the socialist government there "poses for us one of

the most serious challenges ever faced in this hemisphere." Nixon agreed, and Kissinger told CIA director Richard Helms, "We will not let Chile go down the drain." The CIA in turn cabled its station chief in Santiago, "It is firm and continuing policy that Allende be overthrown by a coup." But it was also "imperative," the cable continued, that the "American hand...be hidden." Thus, in addition to imposing economic sanctions, the United States funneled $6 million in covert assistance to Allende's domestic opponents.[54]

The Chilean president was eventually ousted in a coup that brought to power the horrifyingly brutal regime of Augusto Pinochet. Even Kissinger managed to cough up, "I do not mean to condone all the actions of the junta, several of which I consider unnecessary, ill-advised and brutal." Nevertheless, the Nixon administration steadfastly supported the new regime as it liquidated its opponents, and Kissinger and Nixon shared a celebratory phone call in the wake of their success. "Our hand didn't show on this one," the president boasted. Years later Kissinger still felt the need to lie about the American role in the Chilean affair. Nixon was somewhat more forthcoming; he had more important lies to tell. His memoir is sprinkled with moments of candor designed to provide cover for the rewritten versions of the darker episodes of his career. But two could play that game: Kissinger also wrote to his own legacy, and was more than willing to throw Nixon overboard in order to buoy his own reputation. Regarding the House impeachment vote, Kissinger writes passively, "Had I been on that committee my duty would have been to vote with the majority." More ominously, Kissinger concludes that whatever the particulars, Nixon "was at the heart of the Watergate scandal.... [H]e set the tone and evoked the attitudes that made it inevitable."[55]

The same could be said—Nixon set the tone—for that particularly seventies subgenre: the paranoid thriller. Sydney Pollack's *Three Days of the Condor* (1975) is an exemplar of the variety, with deconstructions of trust taking place at the global, national, and personal levels. As Faye Dunaway recalled of reading the screenplay, "The story that unfolded as I read seemed to capture the mood of the country in the aftermath of Watergate."[56] That story, impossible to fully grasp fully with just one viewing (as a paranoid thriller should be: hard to follow in the moment but airtight in retrospect), follows the exploits of Joe Turner (Robert Redford), a thoughtful, bookish nice guy who happens to work for the CIA. Not as a spy, but as a "reader," one of a small group of agents who devotedly read much of what is published in the world, searching for new ideas, possible leaks of CIA activity, and camouflaged communications of known and unknown spy networks. Inexplicably, Turner's entire unit is wiped out by a team of professional killers, save for Turner, who is left on the run. From there, *Condor* unfolds as a classic Hitchcockian "double chase": Turner, pursued by killers and suspected of the crime, must solve the mystery as the

only means of saving himself.[57] And he eventually does, uncovering a "CIA within the CIA" that has plans to seize control of Middle Eastern oilfields.

Three Days of the Condor is a seventies film that has elements of a more classical Hollywood product. It was shot on location, for example, but the look is very clean, and the romance between Redford and Dunaway leans toward a glamorous old school affair. These reflect the dualities both of director Pollack, who started his career with several New Wave–influenced pictures but who often worked with big budgets and bigger stars, and of actor Redford, a gigantic movie star who was nevertheless also attracted to probing material. But *Condor* is rightfully placed in the seventies pantheon, and Pollack and Redford were instrumental in bringing the more topically oriented paranoia to the table. Lorenzo Semple Jr.'s first draft followed the main thread of the source material, which was a more linear story with fewer layers of intrigue. David Rayfiel's rewrite polished the material and, especially, punched up the dialogue (his forte). While both Semple and Rayfiel improved the material considerably (Semple moved the action to New York, enhanced the romantic relationship, and tightened the dramatic focus; Rayfiel contributed many of the movie's best lines), it was Pollack (and Redford) who pushed the material into seventies territory.[58]

Changes to several characters, different or undeveloped in the novel, highlight this sensibility, with its emphasis on moral ambiguity and with complex shades of gray favored over simple black and white truths. Most important among these changes was to the assassin Joubert (Max von Sydow). In the book, Joubert is a one-dimensional villain, vulgar and unpleasant, without any redemptive quality. In the film, by contrast, he is wise, charismatic, even with hints of warmth. In a departure from the book, "we began to construct a man whose amorality was more solvent than the CIA morality," Pollack recalled. "The von Sydow character is an honest bad guy, which I prefer any day to a lying good guy." Which is not, of course, to endorse the character, a contract killer; but his undeniable appeal is of a piece with seventies ambiguity. Other complex characters include John Houseman as Wabash, the director of the CIA, and Cliff Robertson as Higgins, Turner's main CIA contact during his flight. Wabash understands the difference between the 1970s and the 1930s and misses "that kind of clarity"; Higgins is an organization man, doing the best he can and believing in it (and, as Pollack emphasizes, the movie gives the character "a voice," as Higgins is allowed a speech that states his position forcefully at the end).[59] Of course, none of that stops Wabash from manipulating Higgins into arranging the murder of one of their own in order to cover up the entire sordid affair.

Unambiguously evil are the CIA renegades who operate within the agency (again, a plot machination of interwoven duplicity not present in the novel). In

particular, Turner's section chief, Wicks, who comes to New York to kill Condor (Turner's code name) and ends up killing his friend Sam instead, is the embodiment of *Condor's* darkest nightmares. "Was she ever Condor's girl?" Wicks asks upon learning that Sam, his wife, and Turner were all friends in college. The punch line, subtly expressed later in the film, is that she was. This occurs naturally to Wicks, and to the movie, which never fails to pause and explore the issue of trust. "I actually trust a few people," Turner tells his superior before things go haywire, explaining why he is "not entirely happy" working for the CIA. "I tried to deal, as much as I could, with trust and suspicion, paranoia," Pollack explained at the time, "which I think is happening in this country, when every institution I grew up believing sacrosanct is now beginning to crumble."[60]

Pollack's visual style underscores these themes. As Alan Pakula would do in *All the President's Men,* monuments and icons are referenced to emphasize the contrast between the national ideals they represent and the corrupt depths to which the country has fallen. In New York, the Brooklyn Bridge and downtown Manhattan skyline are repeatedly invoked (and iconic Midtown is seen clearly from Higgins's World Trade Center office window).[61] In the nation's capital, multiple murders are arranged as the Washington Monument and Lincoln Memorial loom in the background—and not accidentally. These were complex shots that took some effort to pull off. Working with cinematographer Owen Roizman, Pollack also reached for longer lenses whenever possible in order to give the movie a voyeuristic feel, as if the audience were spying on the action as it unfolded.[62]

Condor also concludes as a seventies film, with its open ending. "You can take a walk," Higgins warns Turner, "but how far can you go if they don't print it?" referring to the story Turner has given to the *New York Times* in the hopes that the paper will expose the CIA's deeds and afford him some protection as well. "They'll print it," he responds, with some hesitation. Higgins's retort, "How do you know?" is the last line of the film; the final image is of Turner looking back over his shoulder, uncertain.

In 1975 it was not surprising that Turner would appeal to the *New York Times* as his best hope of getting the truth out (another major departure from the novel); certainly those would have been Redford's instincts. In doing background research for his politically charged film *The Candidate* (1972), the actor got wind of the Watergate story well ahead of the public. He approached a skeptical Woodward and Bernstein about a movie in April 1973, even before their book *All the President's Men* was written. Ultimately Redford purchased the rights to the book, and his production company matched Warner Brothers' stake in the film. Redford hired Alan Pakula to direct on the strength of his work on *Klute.* William Goldman wrote the screenplay adaptation and received

Turner leaves the movie still looking over his shoulder

sole credit (and an Academy Award), but the script went through numerous, varied drafts. The version as shot emerged from six weeks of work by Redford and Pakula, rewriting in consultation with Woodward and Bernstein.[63]

As Steven Soderbergh has observed, *All the President's Men* somehow manages to work as a suspense film despite the fact that everybody knows the outcome in advance. Pakula draws the audience into the increasing paranoia of Woodward and Bernstein (Redford and Dustin Hoffman) as they work their way through each impossible twist of the Watergate investigation. *We* know the conspiracy is vast and the trail leads all the way to the top; they are astonished. *We* know it will all work out in the end; they start to fear for their lives. The story could have been told very differently, and more heroically. The movie's anxious undercurrents are attributable to Pakula's approach to the material, the final entry in his "paranoid trilogy" after *Klute* and *The Parallax View*. All three films are also draped in the signature darkness of cinematographer Gordon Willis, which contributes to that general tone. The darkness in *All the President's Men,* however, most notably in the intense garage scenes featuring Hal Holbrook's spooky incarnation of Deep Throat, is contrasted by the piercing brightness of the *Washington Post*'s newsroom. Pakula emphasized the contrast, sharply cutting from murky nighttime exteriors to the harshly lit headquarters of the *Post,* this to emphasize that in the newsroom, truth reigns, a clarity of vision subtly buttressed by the innovative use of a diopter (bifocal) lens, which portrayed both foreground and background in crystal-clear focus.[64]

Even in a story in which hardworking underdogs take down the singular villain of the times, seventies ambiguity lingers. "I guess I don't have the taste for the jugular you guys have," a fellow reporter wistfully confides. And especially with repeated viewings, Woodward and Bernstein, even as they retain our loyalty, come across as calculating, manipulative, and ambitious. "I think

we feel the reporters' ruthlessness in the film," Pakula notes. In fact, aside from Jason Robards's star turn as *Post* editor Ben Bradlee (nothing but a good guy), many of the characters are presented against type. Nixon campaign treasurer Hugh Sloan and even dirty tricks maestro Don Segretti (both encountered quietly in their homes) are warmly lit, self-effacing, and portrayed as casualties of circumstance—Watergate's collateral damage. The real bad guys, like Ziegler, Agnew, and Nixon, are held from the audience at a dispassionate distance, seen only on TV (or others, like Mitchell, heard only over the phone).[65]

But at least for once, the good guys win, a rarity for the New Hollywood. (It was a true story, so options were limited.) More appropriately despairing is Pakula's *The Parallax View* (1974), the mother of all conspiracy movies: in the words of one reviewer, "not only a film about paranoia, but a deeply paranoid film." *All the President's Men* "represents . . . my hope," Pakula remarked, *The Parallax View* "my fear." It was being shot as the Senate Watergate hearings were taking place (during breaks, cast and crew members would often watch the proceedings on the TV in Warren Beatty's trailer), and the daily revelations abetted the movie's pessimistic immersion.[66]

Parallax opens with a Fourth of July parade in Seattle—Pakula wanted to "start with sunlit Americana, the America we've lost"—a sequence that ends atop the Space Needle with the sudden assassination of a youthful senator running for president.[67] Three years later, obscure muckraking reporter Joe Frady (Beatty) is approached by an old friend who tells him that witnesses to the assassination have been mysteriously dying. She is terrified; they were both there on that day, but Frady has problems of his own ("You want to hear about my day?" he responds impatiently). She enters and exits through a billowy white curtain—Frady should have known better—as the film cuts immediately to the morgue. It is common in conspiracy movies that the "accidental" death of an alarmist compels the protagonist to take up the cause. This is beautifully communicated in *Parallax* with the way this scene is framed, the horizontal corpse contrasted with Frady's upright figure, a scale between them reflecting the empty scales of justice (her death has been ruled a suicide), as well as the weight of his guilt, which is also captured by the heaviness of his head and his hesitation before exiting the frame.

All of this is very different from the book by Loren Singer; the screenplay was written and rewritten so many times that the final version is virtually unrecognizable from the source material. Lorenzo Semple Jr. wrote the first draft; in that incarnation the victims were all present on the grassy knoll in Dallas the day President Kennedy was assassinated. David Giler did the first rewrite; he also worked on the script with Pakula. Beatty, as he often did, called in Robert Towne for some uncredited polishing, and as shooting approached—and into the production itself—Beatty and Pakula continued to feverishly rewrite, at times working with actor Hume Cronyn. As with *Condor,*

The burden of responsibility shifts to Frady

the resulting screenplay transcends the book, and again takes a "simple" conspiracy story and adds layer upon interweaving layer of disorienting duplicity. Beatty favored the investigative reporter angle. (His character was originally a baseball player and then a cop; it was not hard for reviewers to pick up on the affinity between the shaggy-haired Frady and the youthful, unpolished Woodward and Bernstein.) The implicit shift from JFK to a Bobby Kennedy–type figure also reflected the actor's interests; Beatty was (and remained) a great admirer of RFK and had campaigned for him actively in the Oregon primary.[68]

"Paranoia strikes deep," Buffalo Springfield once sang, and Pakula uses every arrow in his quiver to hit this target—especially long (and lengthy) shots, enveloping darkness, and Hitchcockian silences. Pakula holds shots without a cut to build the tension, which he further encourages by the recurring employment of anxiety-provoking long shots. That central visual motif of the film comes in two varieties. First, Frady is often shot from a great distance, suggesting that he is under observation (such as during his amusement park ride with the "ex-ex-FBI agent"), an unease subsequently subtly reinforced when he is, in fact, unknowingly under watchful eyes toward the end of the film. Second, and even more unnerving, are the long subjective shots of others from Frady's perspective, usually observing a conversation that he (and the audience) cannot hear. The sequence with Austin Tucker (William Daniels), a witness on the run, is particularly effective in this regard. By this point in the movie it is impossible to know whether Tucker, or anyone, is friend or foe, and his several (likely innocent, in retrospect) inaudible conversations with his bodyguard raise already heightened suspicions.

Tucker, seen as a confident professional at the start of the film, has been shattered by the experience of living in fear (like America?), and he takes on childlike qualities: he purses his lips, cradles his brandy glass, curls to nap in a fetal position, and looks up hopefully at his bodyguard for reassurance.

An alternate (or perhaps complementary) reading would code the two men as lovers; the bodyguard's sexuality at least is clearly hinted at, and this would be one of the few vestiges of the ambiance (though not the substance) of the novel, which has a more prurient fascination with homosexuality.[69] Regardless, Tucker lives long enough to give Frady a classic seventies warning, mocking the idea of the heroic investigation (a theme discussed in greater detail in chapter 7): "Fella, you don't know what this story means."

Tucker is right, of course, but Frady does at least get closer to the truth: he has stumbled onto a shadowy organization that recruits assassins. Presumed dead in the explosion that kills Tucker, Frady secretly makes contact with his editor, Bill Rintels (Cronyn), and explains his plans to try to infiltrate the program.[70] Rintels's office, with its wood-paneled walls and warm yellow lights, represented to Pakula "certain nineteenth century American humanist values," in contrast with most of the other locations in the film, which are shot by Willis in scene after underlit scene, as the cinematographer flirted with the limits of visibility. Frady is often literally in the dark, which is in accord with the fact that he is figuratively and fatefully in the dark, a disorientation highlighted by the director's tendency to favor unbalanced compositions within the widescreen shooting ratio chosen for the film.[71]

As in *The Conversation,* the dialogue diminishes in the last third of the film. In *Parallax* this includes several long, silent passages, including a remarkable twelve-minute sequence that could hardly be improved upon, during which Frady follows a man, finds himself on a jumbo jet, realizes that there is a bomb on board, and must think of a way to get the plane to turn back without exposing himself to scrutiny. He pulls it off and saves the day (and the plane), but the victory is fleeting. Frady ends up not as undercover faux-assassin but as real-life fall guy (a supply of which the organization also needs), as the murder of another politician takes place and the blame is pinned on our hero. *The Parallax View* ends with a second government investigating commission (matching the one from the start of the film), shot as if floating away into the darkness, intoning that this assassination was, like so many others, the work of one deranged gunman: "There is no evidence of a conspiracy." The movie leaves open the question whether the government is incompetent or complicit, but in either case, in 1974, it is surely not to be trusted.

Trust No One

"If the picture works," Pakula said of *The Parallax View,* "the audience will trust the person sitting next to them a little less at the end of the film." And lurking beneath the labyrinth of conspiracies of the paranoid thriller is something more basic: fear about that essential loss of trust. Pollack wanted *Three Days of the Condor* to be about "how destructive suspicion really is, because it's the opposite of trust which is the basis of society and all relationships." Joe

Turner starts out the movie explicitly identified as a "man who trusts," but by the end of the film he is so disoriented with paranoia that, for an eerie moment in the smoke-filled Hoboken train station, "he distrusts his lover," who has risked everything for him.[72] The most chilling thing about the Nixon administration, then, was not its primal bunker-mentality mindset that divided the world into "us versus them," complete with the enemies list and Dean's cover memo about how "we can use the available federal machinery to screw our political enemies." Even worse is stepping through the looking glass into the byzantine world of the Nixon White House to learn that the president and his men treated "us" with as much suspicion as "them." It is one thing to go after your perceived enemies—"Bob, *please* get the names of the Jews, you know, the big Jewish contributors of the Democrats"—it is another to go after your (supposed) friends.[73]

How did Nixon treat his friends? The morning after his landslide election in 1972, he walked into the Cabinet Room, according to Kissinger, looking "grim and remote." After a few words of thanks he left, turning the meeting over to Haldeman, who instructed all the members of the cabinet and White House staff to tender their resignations immediately and make a list of the documents they each had in their possession. Not surprisingly, "the audience was stunned." Looking back, Nixon would see this as a mistake, having underestimated the "chilling effect" it would have on the morale of those "who worked so hard during the election and who were naturally expecting to savor the tremendous victory instead of suddenly having to worry about keeping their jobs." But the demand, however cold and ruthless, reflected the president's preference to keep his people insecure and in the dark. One of Nixon's favorite management techniques was to encourage rivalries and animosities among his closest advisers. Ehrlichman clashed with Mitchell (and he hated Dean, whom he saw as an agent of the attorney general); Mitchell saw Colson as a rival (actually, everybody hated Colson, other than the president); even Nixon's most intimate confidants, Haldeman and Woods, were pitted against each other.[74]

Nixon felt the need to assign two full-time rivals to Kissinger, who had to find a new space to store his ego when New York City's landmark Penn Station was torn down. Even though the president had essentially frozen Secretary of State William Rogers out of the foreign policy process, the slightest media attention to Rogers could send Kissinger into a tantrum, and the president knew how to use this to manipulate his national security adviser when it seemed necessary. "He's like a psychopath about Rogers," Nixon told Haldeman, whose diaries are filled with references to days spent managing the squabbles between the two men, which he attributed to Kissinger's "unbelievable ego." Nixon's relationship with Colonel Alexander Haig also served this purpose. Kissinger was concerned that his deputy, who had "a good measure of ruthlessness," was

undercutting his relationship with the president. It was not an idle concern, as Nixon rapidly promoted Haig to four-star general and later tapped him to be his chief of staff. "Nixon was right, as usual," Kissinger notes in his memoirs, in his "psychological estimate of me," that "I might resent seeing my former subordinate in a technically superior position."[75]

With Nixon's proclivities for secrecy and deception added into the mix, it was a White House that all but encouraged spying and backstabbing, behaviors that were not much of a stretch for the president's men to begin with. Everybody was spying on everybody. While at the National Security Council, Haig kept an eye on Kissinger, who secretly had all of his phone conversations transcribed by a pool of eavesdropping secretaries. The home phone of Nixon speechwriter William Safire was tapped (Kissinger would testify under oath that he was "astonished" to learn of the tap, but it was one of the alleged "national security" taps that originated at the NSC); Safire describes Kissinger lying to him about it "in an unstudied, amateurish way." The Pentagon had its own spy at the NSC. Kissinger was furious when Nixon did nothing about it, but the president preferred to hold knowledge of the incident over the heads of the Joint Chiefs. Besides, spying on Kissinger was virtually standard operating procedure. Furious at the way Kissinger would disingenuously distance himself from unpopular administration policies by leaking to the press, Nixon ordered Colson to have the Secret Service log all of his outgoing calls. Haldeman would later have the records on his desk as Kissinger lied to him about whom he hadn't called.[76]

It was not an environment conducive to trust. "Haldeman spoke rather darkly of the fact that there was a clique in the White House out to get him," the president wrote in his diary in 1972. "One thing I've lost ... is trust in anybody," Haldeman would lament months later. "Except me," Nixon quickly interjected, three days before ordering his resignation. If Haldeman had to worry about his enemies in the White House, nobody was safe. Dean was assured, as the Watergate pressure mounted, that he would not be thrown "to the wolves," but the writing was on the wall. The day before Nixon had told Haldeman, "We're not throwing you to the wolves, with Dean."[77] And it was of course Watergate that set the president's men, already eyeing one another warily, at each other's throats. "Everyone had his secrets," Ehrlichman wrote, and each of the president's confidants tried to convince him that it was the others who were exposed and vulnerable. Ehrlichman invariably campaigned for Mitchell to take the fall; Mitchell, unwilling, blamed Dean and Haldeman; Haldeman fingered Colson, who in turn told Nixon that it was Haldeman and Ehrlichman who were the most vulnerable. Ehrlichman was somehow certain that he alone was innocent. As Jonathan Schell puts it: "Ehrlichman was not willing to throw himself on a sword. The person he was willing to throw on a

sword was Dean." Nixon, always the savvy politician, understood all too well what was going on. "It will be each man for himself," the president wrote in his diary, "and none will be afraid to rat on the other."[78]

In the penultimate scene of *Three Days of the Condor,* the assassin Joubert hands a surprised Turner his gun, "for that day," he explains, when "someone you know, maybe even trust, . . . will smile, a becoming smile, . . . and offer to give you a lift." Years later Nixon would express similar sentiments, writing in his memoirs: "The tapes were my best insurance against the unforeseeable future. I was prepared to believe that others, even people close to me, would turn against me . . . and in that case the tapes would give me at least some protection." Nixon was wrong about the tapes, but he knew he couldn't trust his friends.[79]

On June 25, 1973, John Dean, convinced that he was being set up by his friends, began his tell-all testimony before the Senate Watergate Committee. The following day a similar morality play opened in New York City: *The Friends of Eddie Coyle.* It received mostly positive reviews but remains underappreciated to this day.[80] A quintessential seventies film, shot entirely on real locations in and around Boston by director Peter Yates (who had at one point been slated to direct *Condor*), the movie sticks with most of the principal plot points of its source material, drawing heavily on the justly celebrated dialogue of George Higgins's novel. (The movie does cunningly tack on yet an extra layer of duplicity and betrayal.) Higgins worked on racketeering cases as a federal prosecutor in Boston, which informed this, his first book; he would subsequently go into private practice as a defense attorney with clients ranging from Black Panther Eldridge Cleaver to Watergate burglar Gordon Liddy.[81]

Eddie Coyle, portrayed by the incomparable Robert Mitchum in what is arguably his greatest performance, is a small-time operator in big trouble. Just over fifty, with a wife and three kids, he is looking at jail time in New Hampshire for getting caught behind the wheel of the wrong truck, time that, given his age and responsibilities, he is desperate not to serve. Ironically, his sentence is more for *not* talking than for bootlegging: he took the rap without implicating his friend Dillon (Peter Boyle), who owns a bar but who is also a reputable hit man, all the more incentive for Eddie to keep quiet. Unbeknownst to Eddie and his other friends, Dillon is also an informer, on the payroll of federal agent Dave Foley (Richard Jordan). The line between the cops and the crooks in *Eddie Coyle* is thin indeed; initially it is not obvious that Foley is a cop, and he bears a passing resemblance to gun merchant Jackie Brown (Steven Keats). "I should have known better than to trust a cop. My own mother could have told me that," Coyle complains to Foley, who hooks Eddie and then changes the terms of their understanding in midstream. As one observer noted, *Eddie Coyle* paints a universe of us versus them, but "they" are creatures of the

seventies: the "criminals-and-police who wage an armed truce but might any day form an alliance which would spell the obliteration of everyone else."[82]

Coyle, a decent, likable guy, is a jack-of-many-trades, though his specialty is in moving clean merchandise of questionable provenance, these days guns for his bank-robbing friends. Eddie understands the business. He picked up his nickname, "Fingers," from an old deal gone bad: wares he passed on to one of his clients turned out to be traceable. They did time; he got his hand crushed in a dresser drawer by some of their friends. Eddie explains this by way of warning to the young gun wholesaler Brown, neither as complaint nor boast, but a fatalistic lesson in the way the world works. But despite this savvy, and his uncanny ability to impart pearls of wisdom throughout the film ("One thing I've learned is never ask a man why he's in a hurry"), Eddie's desperation leads him to steps he is loath to take (he later fingers Brown in a failed attempt to buy his freedom), and he never quite grasps the depth of the corruption of his friends. Eddie is past his time. At the Boston Garden, he admires Bobby Orr—"What a future he's got"—a final telegraphing of Coyle's fate and a reminder of what Tanya (Marlene Dietrich) tells Hank (Orson Welles) in *Touch of Evil:* "Your future is all used up."

Eddie Coyle's committed realism is particularly rewarding, and can be relished not just for the obvious authenticity of the location work but for the subtle, genuine mannerisms of all of the characters, like the small moments of Foley's indecisiveness ("let me think a minute") and his edge-of-control adrenaline rush during the bust at the Sharon railway station. Shot in documentary style ("like a newsreel" was Yates's goal), but unobtrusively, even when handheld cameras are deployed, the movie features washed-out pastels by day and inky blacks at night. Dillon's bar, Eddie's home, the diners and dives, the police station, an abandoned factory: it is not a pretty picture, but it is not a pretty world.[83]

Ultimately, desperate times force Eddie into a desperate measure. He contacts Foley, offering up his friends, the bank robbers, now wanted for a murder committed during their last heist. "You're too late, Eddie, it all happened without you," he is told. Foley gets up and walks away without looking back; Coyle has nothing for him. Somebody else already gave his friends up. They assume that he did it, though, and they hire Dillon to kill him, as revenge. And so Eddie is murdered by one of his friends for a betrayal he did not commit— but one that he was willing to commit—by the man who, it turns out, was the real snitch. Walking through Government Center with Foley, the usually reliable Dillon doesn't have any information to share about what happened to Coyle. The cop takes it in stride: "I never asked a friend yet to do something he really couldn't do." The men share a look and part company. For the fourth and final time, Foley ends the conversation with his signature sign-off: "Have a nice day."[84]

Of course, Eddie's friends weren't *really* his friends; but the protagonists in Elaine May's *Mikey and Nicky* (Peter Falk and John Cassavetes) are real friends, and have been since childhood. Such roots run deep, which the movie underscores by calling attention to childlike aspects of their behavior and relationship. But the impetuous Nicky, who interrupts running for his life to pick up some candy and comic books, and the nurturing, exasperated Mikey, have some grown-up problems. Nicky has ripped off their boss, a local mobster. His partner in this crime has been killed, and Nicky, convinced there is a contract on his life, has summoned Mikey to aid in his escape. For the first two reels our sympathies are with Mikey, as he tries to break through Nicky's sleepless paranoia—he is so afraid he even thinks his best friend is setting him up—so as to coax him out of his hotel hideout and spirit him out of town. But then we are with Nicky when it turns out that Mikey *is* setting him up. Then, finally, over the course of one long dark night, our loyalties shift away from Nicky as revelations of his lifetime of small betrayals slowly accumulate, tipping back the scales of personal infidelity.

A buried treasure, *Mikey and Nicky* was shot in that troubled summer of 1973 over the course of sixty nights (and only nights, even for the interiors) on location in Philadelphia; fifty more nights of shooting took place in Los Angeles after the studio forced the profligate May closer to home. Editing the movie took over a year of wading through the deluge of a million-plus feet of exposed film. *Mikey and Nicky* is clearly influenced by Cassavetes, with its obsessive realism and intense, emotional rawness matched by an anxious camera, often handheld, featuring occasionally disconcerting close-ups and a paucity of establishing shots. His film *Husbands* (1970) comes to mind, which also featured Falk, Cassavetes, and a bucketful of existentialism. Both pictures had the same cinematographer (Victor Kemper, with Cassavetes lending a hand in each case). But *Mikey and Nicky* is May's film. She had worked on the story for years, and it was infused with her experiences; despite the important collaboration of her two leads, she was the writer-director. And as Jonathan Rosenbaum observes, as with all of May's films, *Mikey and Nicky* explores "the same obsessive theme: the secret betrayal of one member of a couple by the other."[85] There is also a difference between influence and imprint. May's style is more linear and disciplined than Cassavetes's, especially within scenes, and her sense of humor is very evident throughout.

Stanley Kauffmann, another of the movie's (relatively few) champions, argues that the film, sometimes marginalized as small or offbeat, "is an implicitly large film about deep darkness."[86] And dark it is, literally too, often flirting with imperceptibility, as with the eight-minute scene about *everything* when the boys visit the grave of Nicky's mother. (Kemper was no stranger to working in the dark; he shot *Eddie Coyle* as well.) They talk to each other; they talk to

the dead, although only one of them is a believer. The remarkable scene is a pivotal one, part of the central arc of the film that constitutes its middle third. In the cemetery, and on the city bus ride leading up to it, Mikey wavers and considers running off with his friend. But Nicky's implicit self-destructiveness will not allow it: next stop is his girlfriend's house. There Nicky humiliates his friend, first by having sex while Mikey fidgets in the almost semi-privacy of the kitchen, and then by goading him into trying his luck, knowing he will be rejected. This final, definitive rupture between the two is telegraphed by the bright red walls of the kitchen (a brightness that starkly contrasts with the muted color scheme elsewhere in the film), where the men take turns positioned in isolation, and then finally together, in a long shot framed by May to emphasize the disjointed triangle: Mikey, Nicky, and other, the latest version of a scene played throughout their lives, but in the stress of the moment it explodes in red jealousy and rage.

The action spills out onto the dark streets, a scene that Falk rightly considers the linchpin of the movie. "You got all the friends, you got all the money," Mikey shouts. "Did you have to do that to me?" A lifetime of grievances rushes to the surface. They fight, this time for real, and go their separate ways. Nicky, on the run, retraces the ruins of his past, finding no safe harbor. Mikey meets up with the hit man (Ned Beatty), who has been one step behind them all night. He is ordered back home, where his friend will soon be murdered on his doorstep, banging desperately to get in. At the last moment, he knows his best friend has indeed set him up. As producer Michael Hausman notes, "That's tough to die with, and tough to live with."[87]

"Among the most deeply ingrained American myths," Kauffmann wrote in reference to *Mikey and Nicky,* "is the one of the two male friends." But in Nixon's America, you could not trust anyone. Not your friends, not even your real friends. As the interview-shy May put it after a screening of her film at the Museum of Modern Art, "Nobody fingers you but your best friend."[88]

CHAPTER 7

WHITE KNIGHTS IN EXISTENTIAL DESPAIR

The war was finally over. The last U.S. troops quit Vietnam in 1973. Nixon quit the White House a year later. "My mother was a saint," choked the sleepless, sweaty (about to be ex-) president in his farewell address to his staff. With a final incongruous flash of his famous double-barreled "V for victory" salute, and to the thumbs-up of a grinning Al Haig, on August 9, 1974, Nixon helicoptered off into the sunset. One month later he was granted by President Ford a "full, free, and absolute pardon... for all offenses against the United States which he, Richard Nixon, has committed or may have committed or taken part in." What he had promised in 1962 was really true this time: there would be no Nixon to kick around anymore, although Dan Aykroyd did a pretty good job of it on *Saturday Night Live*.

And so Nixon and the war, the two great motivating forces of the era, were gone. But the mood was hardly one of triumph. It was too late for that, and sifting through the wreckage was dispiriting, to say the least. Kissinger bagged a Nobel Peace Prize for his efforts; eighteen months later, the communists overran Saigon. Thousands of Americans and South Vietnamese were airlifted out of the city in a desperate evacuation. On off-shore aircraft carriers, helicopters were pushed off the decks and into the sea to make room for the teeming arrivals. Back home, the Rockefeller Commission and then the Church Committee supervised the scandalous (if unsurprising) coroner's inquest into the myriad abuses of power. The U.S. government had "initiated and participated in plots" to assassinate foreign leaders. The intelligence community had routinely engaged in illegal "covert action programs" in order to "disrupt the lawful political activities of individual Americans," often with the explicit approval of "senior administration officials."[1]

Post-Vietnam, post-Watergate, post-Nixon, and for half of the baby boomers, post-college: some were even pushing thirty. "What do we do now?" Bill McKay (Robert Redford) asks his campaign manager (Peter Boyle) at the end of *The Candidate* (1972). They had thrown everything they had into winning the election and were left empty-handed by the victory. And like McKay, the baby boomers were getting older. The earnest idealism of youth was bumping up against the tough realities of adulthood. Saddled with the baggage that comes with the trip to that foreign, foreboding country—jobs, kids, compromises—some of them would throw their responsibilities overboard and dive headfirst into carefree hedonism; others settled quietly into the best lives they could make. Many were haunted, more or less, by a sense of unfulfilled promise.

You could hear it in the music. In October 1974 the Rolling Stones released *It's Only Rock 'n Roll.* It was a good record, but unlike *Beggars Banquet, Let It Bleed, Sticky Fingers,* and *Exile on Main Street,* the grand slam of albums they released from 1968 to 1972, the new LP *was* only rock and roll, and even if you liked it, the Stones would never matter the way they once did. That same month John Lennon released *Walls and Bridges,* after which he largely withdrew from the public eye (and with Nixon gone, the FBI lost interest in hounding him as well). It would be his last album of original material for six years.[2] Not surprisingly it was Dylan, now thirty-three (a year younger than Lennon), father of four, and, as he anticipated, "soon to be divorced," who put out the record that captured the moment. Recorded in late 1974 and released on January 17, 1975, *Blood on the Tracks* was a devastating compendium of heartbreak and regret. It was also, unlike Dylan's previous masterpieces, very much an adult album, and one burdened with a sense of what had been lost. No longer was there "music in the cafés at night / And revolution in the air." That was then. This was now: "He started into dealing with slaves / And something inside of him died / She had to sell everything she owned / And froze up inside." And that was just the first song.

These sentiments inevitably found expression in New Hollywood films as well. What was implicit in the revisionist Western becomes explicit in contemporary crime films: country, authority, ideology, heroism—these don't amount to much on mean city streets where police enforce the law with the disposition and capriciousness of an occupying army. And so, not coincidentally, a spate of films released in December 1973, including *The Laughing Policeman* and the generally unhinged *The Seven-Ups,* reflected the general sense that law enforcement institutions were at best suspect, arbitrary, dilapidated, and compromised.[3]

That same month *Serpico,* based, it should be emphasized, on a true story, offered an even darker vision of the law. The movie portrays a New York City Police Department so endemically corrupt, and so dependent on its code of

silence, that it could not tolerate the prospect of an honest cop in its midst. Frank Serpico (in real life and as played by Al Pacino) is harassed by his fellow cops, ignored by a timid district attorney's office, and, finally, shot in the face during a drug bust under the witting indifference (or worse) of his partners, who then fail to come to his assistance. Ultimately, Serpico testified before the Knapp Commission, whose subsequent report detailed the scope and depth of police corruption and the wall of silence that sustained it.[4] Soon after his testimony, Serpico left for Europe, alone.

With slim hope for justice within the law, or from the law, for that matter, what's a good man to do? In the world of the movies, two paths beckon: the noble outlaw and the private eye. Honor among thieves offers at least some moral framework from which to operate—an understanding of what is respectable and what is transgressive, a grounding that is especially attractive if the authorities are corrupt. "When you live outside the law, you have to eliminate dishonesty," says one character in Don Siegel's 1958 film *The Lineup*.[5] But as seen in *Mikey and Nicky* and *The Friends of Eddie Coyle*, in Nixon's America, even honor among thieves was on the ropes, and Siegel seemed to agree. His late 1973 entry, *Charley Varrick*, positions an outlaw hero (Walter Matthau) between the corrupt institutions of the law *and* the mob. Varrick is, instead, a free agent: the motto of his crop-dusting firm (which is inscribed on his van, his coveralls, and his business card) is "last of the independents," which was in fact the working title of the movie. Siegel thought that title "made sense" because "Charley was . . . the last of the independent bank robbers."[6]

Varrick and his crew of small-timers hit a sleepy New Mexico bank. But Charley's wife and two cops are killed in the robbery gone wrong; worse, the little locally chartered branch was a laundromat for mafia cash. The bank wants no part of the cops, the mob suspects an inside job, and the local grifters can't be trusted. On Saturday, October 20, Vincent Canby's positive review observed that with the exception of Charley (a bank robber) and one minor character, "everyone in the movie is to a greater or lesser extent rotten." Canby was right, and we shouldn't be surprised. The next day his paper's headlines covered the "Saturday Night Massacre"—two attorneys general resigning in quick succession and the "independent" Watergate special prosecutor fired, with FBI agents seizing and sealing off his offices (see chapter 6).[7]

Andrew Sarris concludes that "*Charley Varrick* ends with the triumph of the individual over the bureaucratic routines of both the mafia and the police." True, but it is also clear that the days of the independents have passed. To survive, Charley has to fake his own death and disappear, his "last of the independents" coveralls last seen consumed by flames as part of his illusion and escape.[8] All that's left, then, in the 1970s (as in the 1940s), for those in the market for some portion of what's right, or as close to it as one can hope to get

in hard times, is to make it yourself. Thus the appeal of the private investigator, who, in theory at least, answers to no one, doesn't have to compromise, can search for "the truth" no matter where it leads, and maybe even gets to help a few okay people along the way. Not the worst internal exile, especially when truth and justice are otherwise in short supply and the American Way seems a hollow enterprise.

Released a few days after the very first Watergate indictments were handed down (and attracting even less public attention), *Hickey and Boggs* offered an image of the private eye as the last honest man standing, although "standing" is a relative term. As the movie opens, establishing shots take us from the oppressive L.A. smog into a cheap saloon, where we meet our heroes debating which bills are absolutely necessary to pay to keep their threadbare operation afloat. "Hero," of course, also has a hollow ring: Al Hickey (Bill Cosby) is despondently separated from his wife and daughter; he is an ex-cop, presumably because he was unable to conform to the rigidities, politics, and indifference that pushed Jake Gittes off the same LAPD forty years previously in *Chinatown*. Frank Boggs (Robert Culp) is an alcoholic who nurses an even more dysfunctional relationship with his own ex-wife; the film also hints, with melancholy (rather than titillation), at ambiguities in Boggs's sexuality.[9]

Bankruptcy is postponed by the appearance of a client with a missing persons case, who, as Sam Spade once remarked, was obviously lying but paid enough to make it okay. ("Thank you for your honesty," suggestively deadpans one crook in the face of similar lies.) And so soon enough, Hickey and Boggs find themselves in the midst of a bewildering crossfire between violent L.A. mobsters, enigmatic Chicano bank robbers, and a potpourri of underground black militants and their curious assortment of Bel Air affiliates and hangers-on. Not quite sure of the big picture but usually just ahead of the mob and two steps in front of the hapless, harassing cops, Hickey and Boggs stay on the case after they are let go because once engaged, they are professionally unable to simply drop the matter, or, as they put it, "What else do we have to do?"

The only feature film directed by the actor (and occasional writer) Robert Culp, *Hickey and Boggs* reunited Cosby and Culp four years after their successful and groundbreaking partnership in the TV show *I Spy*. It was much darker fare than had been previously associated with either actor. This probably contributed to its failure to find a large audience; but those few who rolled the turnstiles saw an archetypal seventies film. Written by Walter Hill, the screenplay is not much concerned with explaining every little thing (or, for that matter, some bigger things). It features gritty location shooting and considerable but consequential violence. (The unnecessary and varied appearance of dependent children underscores the stakes involved in the death of adult characters, of which there are many.)[10]

With *Night Moves* (discussed later in this chapter), *Hickey and Boggs* shares a fixation on the metaphor of competitive sports (not to mention a small role by James Woods)—boxing, baseball, football—which yields particularly strong, authentic sequences shot at Dodger Stadium and the L.A. Coliseum. Especially of the seventies is the film's portrayal of the mob both as a modern, businesslike corporation (as in *Point Blank,* with which this film has some affinity), and as morally indistinguishable from the police. Boggs describes the kind of killers they are up against: "They're soldiers, that's all. No questions, no time to ask, no talk. The cops are worse, and less predictable." Later, Hickey gets through his partner's drunken stupor with a similar warning about the cops and the crooks: "They are going to bury us—one side or the other."

Hickey and Boggs actually beat the bad guys in the end. But the cost is high, the victory hollow, and the ending downbeat. *Hickey and Boggs* anticipates the nihilist strand that would weave its way through the great neo-noirs of the coming years. "It's not about anything," Hickey observes in resignation, two or three times, and again at the end. "Yeah, I know, you told me," Boggs replies. But they have each other—their friendship, their trust, and their shared sense of justice, which endures among the ruins of the times. "You can't make up for what you missed," Boggs tells Hickey after one particularly devastating setback. "The only thing you can do is to try and even it out, make it right." Pushing deeper into the seventies, *The Long Goodbye, Chinatown,* and *Night Moves* would take that away, too.

Cracking the Code

Hickey and Boggs had each other; Philip Marlowe (Elliott Gould) in Robert Altman's *The Long Goodbye* was very much alone. At the start of the movie he is even abandoned by his cat, who leaves in protest and never returns. The extended opening sequence, which is not in the Raymond Chandler novel on which the film is based, would appear unrelated to the rest of the movie. But this prologue, a microcosmic morality play about loyalty and deception between man and friend (or in this case, between man and cat), establishes, however comically, the principal theme of the film.[11]

As discussed in chapter 5, Altman's approach is instinctively irreverent and revisionist. But how does one revise a style—that of the 1940s private eye film noir—that was itself subversive and revisionist? Films noir, to the extent that they could be seen collectively, aspired, especially in comparison to classical studio productions, to be different, more "realistic" (if visually stylized), dark, despairing, daring, and cynical, in much the same way that the New Hollywood aimed to distinguish itself from its studio-bound predecessors.

Marlowe doesn't see what's right under his nose

Revisionist revisionism sounds too clever by half—but the movies discussed in this chapter show that it can be done, and brilliantly, in any number of ways.

Altman's approach, working from a script by Leigh Brackett, who co-wrote the forties film noir classic *The Big Sleep* (based on another Chandler novel featuring Philip Marlowe), was to retain Marlowe's personal integrity and his commitment to the code of the classic private eye (a crucial continuity overlooked by the film's detractors) while stripping away everything else. In particular, taking Marlowe as if cryogenically frozen in the black and white forties (he wears a white shirt and black tie throughout) and dropping him into the decadent sun-drenched wasteland of the seventies—"Rip Van Marlowe," Altman and Brackett liked to call him—brought three big revisions, each of which undermined and diminished the once heroic character. First, and not surprisingly, Rip Van Marlowe is disoriented and confused. As Pauline Kael noted, "even the police know more about the case he's involved in than he does," a galling state of affairs unimaginable for the Marlowe of the forties, whose cool insight and savvy always kept him at least one step ahead of the cops. Second, and here is where Altman's irreverence shines through most clearly, even the defrosted Marlowe is aware that, after two or three decades, the private eye, in real life and in the movies, is now saddled with generic conventions and clichés. "This is the part where you say, 'I'll ask the questions around here,'" Gould's Marlowe sasses the cops—and both the character and, to an even greater extent, the movie are self-consciously aware throughout of this history, the way that real mobsters have come to imitate gangster films. *Chinatown* avoids this problem by situating the action in the 1930s. Even *Night Moves,* which also plays it straight, explicitly acknowledges the influence of these legacies. Altman, leaning toward satire, pushes further, and is also not

shy about reminding the viewers that they are watching a movie, right down to the vintage recording of "Hooray for Hollywood" played over the closing credits.[12]

Finally, and most important, *The Long Goodbye* is revisionist in taking away that which is most precious to Marlowe—not his own commitment to the code, which is unwavering, but the commitment of others to that code, especially those who should know better. It is an unspeakable betrayal. In a world of corruption, one lives by the code, and article 1 of those unwritten conventions is that you stick by your friends, no matter what. So when Marlowe's friend Terry Lennox (Jim Bouton) shows up in trouble in the middle of the night, Marlowe drives him to the Mexican border, no questions asked. And when the police are waiting for him when he gets back, saying that Lennox killed his wife, Marlowe clams up and is left to rot in jail. And when he is released, told that Lennox is a suicide and that as far as the cops are concerned both cases are closed, it is Marlowe's duty to clear his friend and find out what "really happened."

Along the way he gets enmeshed in overlapping complications. He is hired by Eileen Wade (Nina Van Pallandt) to find her troubled, alcoholic husband—and the Wades were neighbors of the Lennoxes, it turns out. Marlowe is also pursued by the sadistic gangster Marty Augustine (Mark Rydell), who says that Terry Lennox made off with his money—a lot of money—and he thinks that Marlowe knows where it is. Roger Wade, it seems, may owe money to Augustine too. In a bravura performance by Sterling Hayden—who is arguably playing some combination of late period Ernest Hemingway, Altman's vision of Raymond Chandler in winter, and, almost certainly, himself (most of the dialogue in Hayden's scenes with Gould was improvised)—Wade has an uncommon depth that grounds the picture.

What Roger Wade owes to whom is never established with certainty in the movie, which is not in the certainty business. Altman and cinematographer Vilmos Zsigmond (who had also shot Altman's *McCabe & Mrs. Miller* and *Images,* along with many other New Hollywood films) adopted a style of unmotivated camera movements—the camera would almost always, however subtly, be in motion which Altman thought would give the film a voyeuristic feeling, and which also undermines the idea of a static or "objective" point of view on the unfolding action. Zsigmond also flashed the unexposed negative by 50 percent; this softened the very sharp contrasts that could have been produced with the available technology of the day, and which would have yielded a hyperrealist look that, Zsigmond argues, gives an artificial feel to many contemporary films. By taking down the contrast, the film more closely approximates actual human vision.[13]

The result is a film of great visual beauty which counterpoises sun-drenched daytime scenes with jet-black night-for-night sequences, including

the most important of the picture, Roger Wade's suicide, as he forges into the rhythmic, pounding darkness of the Pacific Ocean at night (the scene was shot at 3 AM, modestly lit from a boat at sea). This is a crucial change from the book, where Wade is murdered and his suicide faked. It is also the scene on which the narrative hinges; it reveals information heretofore unknown to Marlowe, it places him in ever greater danger, and it finally sends him back to Mexico, where he discovers that his friend Terry Lennox is very much alive, had stolen that money, killed his wife, and left Marlowe to be the fall guy. In the film's most controversial departure from the text, Marlowe pulls a gun and kills Lennox in cold blood. As he leaves, he passes Eileen Wade on a tree-lined street in a scene that mirrors the closing images of *The Third Man,* as we, and Marlowe, now realize that Eileen, who to this point has been portrayed in an attractive (if enigmatic) light, is Terry Lennox's lover and partner in crime. It is an especially appropriate allusion, since, as Kael astutely observed, Lennox had become "the Harry Lime in Marlowe's life."[14]

The Long Goodbye received a good number of positive reviews (not surprisingly, from critics like Vincent Canby, Roger Ebert, and Kael),[15] but it attracted more than a few negative notices as well. Those who hated it usually *really* hated it, and in most instances, they got the point exactly wrong. Charles Champlin complained that "Brackett and Altman have made one major plot change, and its effect is to deny almost everything that was honorable about Marlowe." *Sight and Sound* was so similarly offended that it panned the movie in two different issues. "Chandler's novel [is] about the importance of friendship, about human loyalties being more trustworthy than legal ones," wrote the first reviewer, all of which is lost when "Lennox becomes a murderer and a manipulator." The second reviewer concurred: turning Lennox "into a coldly calculating murderer... destroyed the basis of faith and comradeship that provided the moral basis and narrative spine of the book."[16]

These critiques misread the meaning of the conclusion, which does not take down Marlowe but rather indicts the times he was living in. In the 1970s, not only was the world corrupt, but also there was no sanctuary to be found through a shared understanding of the code. Gould spends the entire movie muttering "It's all right with me," his own improvisation and one that reflected Rip Van Marlowe's utter confusion at the behavior he sees around him in 1970s L.A. But Lennox's betrayal is the one thing that is *not* okay with him. As Brackett acknowledges, killing Lennox "is something the old Marlowe would never have done." But "Gould's Marlowe is a man of simple faith, honesty, trust, and integrity"; having him just "walk away from it," she argues, would not have been a "moral ending." She sees their "only achievements" in revising the book as turning Lennox into a "clear cut villain" and having Marlowe kill him in the end, which to her "seemed right, and honest."[17]

Altman was even more adamant on this point and agreed to sign on to the film on the condition that Brackett's ending not be altered. "The one thing we left Rip Van Marlowe with was his faith that a friend's a friend," Altman explained. "My intention was that the greatest crime that could be committed against Philip Marlowe, who was a romantic, is that his friend broke faith with him. So he killed him."[18] Marlowe's murder of Lennox can be seen, in this context, as the only act of moral enforcement that occurs in the movie. According to Gould, when he showed the film to Donald Sutherland, his friend's reaction to the ending was: "Oh, I see. It's all about morality."[19]

Altman was not the only director who picked up on this theme. Sydney Pollack's *The Yakuza* (1975) and Sam Peckinpah's *The Killer Elite* (1975) are both set in motion by similar acts of fraternal betrayal. (Each also suggests that America—or perhaps Western society more generally—is so irretrievably corrupt that vestiges of timeless honor and integrity can be found only in the Orient.) *Killer Elite* opens with several scenes that do little more than establish the intimate and implicit bond between two partners (Robert Duvall and James Caan), which makes Duvall's sudden, incomprehensible, and brutal stab in the back especially shocking. In a film drowning in a sea of duplicity, that act stands alone in its scandalous infidelity. In *The Yakuza,* written by Paul Schrader and rewritten by Robert Towne, Robert Mitchum travels to Japan to help out an old friend in big trouble. Mitchum asks no questions—a friend is a friend—until it becomes all too clear that he has been double-crossed. Mitchum calls in favors in Japan (at least his word is still good), and in setting things straight (as he must), he also, at great personal sacrifice, goes out of his way to resolve a debt of honor he has carried for twenty years. For Pollack, the movie was about "the limits to which one will go to keep one's word," yet at the same time, it was a melancholy acknowledgment that Mitchum and his kind "are over the hill and existing in a world that has passed them by." Anachronistically seeking honor in a world gone wrong, they continue (like Rip Van Marlowe) to "live by a set of moral standards that have become outmoded."[20]

Forty Shades of Noir

As noted in chapter 1, film noir had an irresistible attraction for New Hollywood filmmakers (and their audiences).[21] The affinities between the seventies film and film noir are remarkable. Visually, each reached for a more "realistic" presentation of reality, with a greater use of source lighting, location work, and a murkier, less pristine look than was associated with highly polished classical studio productions. At times these choices were partly inspired by tight budgets; but as a matter of honor, both film noir and the seventies films found

"realism" in imperfection. The point is debatable, but the differences are clear: the studio philosophy holds that a technically flawless product, with perfect sound, unobtrusive lighting (which actually means lots of artificial light), and invisible editing, allows for the suspension of disbelief—you enter the dream world and forget that you are watching a movie—whereas the revisionist perspective holds that this is stagy and artificial, and in the "real world," sounds and images are often muddled and unclear.[22]

For film noir, not surprisingly, this difference is most obviously notable with the use (and absence) of light. Classical studio productions had "key" lights (the main sources of illumination, usually from above); "fill" lights (which filled in the shadows created by the key); and "back" lights, which, working subtly from behind the actors, created attractive outlines that enhanced the visual stature of the players. Noir productions took down all these lights. Scenes were more often lit for night, and thus less brightly; fill and back lights were more or less abandoned; and low, off-center source lights (like desk lamps) were commonly used as important sources of illumination. All this threw shadows and produced asymmetrical, often disorienting compositions, which left actors relatively diminished by their surroundings. Another calling card of film noir (and of the seventies film) is night-for-night shooting—and this particular embrace of the shadows can't be attributed to budgetary constraints, as it is more expensive and challenging to shoot at night as opposed to day-for-night (using special filters and other techniques to give the illusion of darkness while actually filming during the day). Worth the money and effort, night-for-night shots yield deep, saturated blacks that add to the realism (and the darkness) of a picture.[23]

Beyond the visual style, films noir were also, in Raymond Chandler's famous phrase, "dark with more than night." Like the seventies film, film noir was shaped by the political context of its times, which was even more despairing than what the sixties and seventies had to offer: the depression, the horrors of fascism, world war, postwar disillusionment. Not surprisingly, all of this resulted in films defined by a certain cynicism, pessimism, and fatalistic resignation.[24] Each of these four historical factors had an impact. The Great Depression: "I see one-third of a nation," President Roosevelt called out in his second inaugural address, "ill-housed, ill-clad, ill-nourished," conditions that can blur the distinctions between right and wrong for people forced to make difficult choices in hard times, aware that they are trafficking on tough city streets among others similarly situated—hungry, desperate, and rootless. The rise of the fascists in Europe: nightmarish police states on the cusp of the full onslaught of the Nazi horrors sent a wave of refugees to Hollywood, men like Billy Wilder, Fritz Lang, Robert Siodmak, Otto Preminger, and countless others, who brought with them not only the German expressionism that wrought the noir style but also the sense of terrible foreboding that informed its substance.

And then the war itself, with its unprecedented carnage—death every-where, one's own survival reduced to random chance—left postwar audiences receptive to tougher, more realistic fare than before, and yielded characters, of-ten combat veterans, who had seen more than their share of death and carried a certain stoic understanding that circumstances were beyond their control. "Think of what had gone on," remarked writer-director Abraham Polonsky. "An extraordinary, terrible war. Concentration camps, slaughter, atomic bombs, people killed for nothing. That can make anybody a little pessimistic." Finally, after the war, beyond the euphoria and relief of victory, there followed for many a rocky transition to normal life, as both the returning soldiers and the America they'd left had been changed fundamentally by the experience. This postwar disillusionment, seen in films like John Huston's *Key Largo*, por-trayed servicemen coming home to find "a society something less than worth fighting for."[25]

Although both the seventies film and film noir were contra the studio sys-tem, a particularly fascinating aspect of noir is that it challenged from within strict confines, pushing the moral certainty of the production code to the limit. Moreover, almost no film noir has an unambiguously happy ending. *Crime Wave* and *The Woman in the Window* come to mind as exceptions, but even in those cases, "happy" is a pretty strong word, and darker readings are more than plausible. More common are films like *Criss Cross, Out of the Past, Double Indemnity, D.O.A., The Asphalt Jungle,* and *Angel Face,* each of which ends with the death of the protagonist who had our loyalty from the start.[26] And even in a film like Orson Welles's *The Lady from Shanghai,* where at the end the mystery is solved, the hero is saved, and the guilty are brought to some form of justice, you don't leave the theater humming. Consider these lines from the final monologue: "I went to call the cops, but I knew she'd be dead before they got there. . . . I'd be innocent, officially. But that's a big word, inno-cent. . . . Maybe I'll live so long that I'll forget her. Maybe I'll die trying."

Film noir also expressed, as did the seventies film, a fascination with sexu-ality, male anxiety, and gender issues more broadly. As discussed in chapter 4, the central position of femmes fatales in these films—scheming, ruthless women who use their sexuality to manipulate men and lead them down the path to destruction (see, for example, *The Killers, Out of the Past, Double In-demnity, Murder My Sweet, The Postman Always Rings Twice, The Lady from Shanghai,* and *Crime of Passion*)—remains a point of controversy. Another noir staple in this vein is the ubiquity of the coded homosexual character. Not only does Sam Spade (Humphrey Bogart) in John Huston's *The Maltese Fal-con* have to deal with Brigid O'Shaughnessy (Mary Astor)—the mother of all femmes fatales—his male adversaries are all coded in this way. Not that this ruffles Spade's feathers any, but watch what Joel Cairo (Peter Lorre) does with

his umbrella in his first scenes in the film. It also slipped by the censors that Gutman's (Sidney Greenstreet) young enforcer Wilmer (Elisha Cook Jr.) is repeatedly referred to as a "gunsel," which can be understood as shorthand for "gunslinger" but is also defined as a young man kept for sexual purposes.

In sum, film noir and the seventies film are kindred spirits, right down to the type of criticism they cultivated. John Houseman (the legendary producer and actor), in an essay panning, of all things, *The Big Sleep,* complained that "what is significant and repugnant about our contemporary 'tough' films is their absolute lack of moral energy, their listless fatalistic despair." Houseman bemoans the absence of moral purpose in such films, concluding that the "moral of our present 'tough' picture, if any can be discerned, is that life in the United States of America in the year 1947 is hardly worth living at all," a charge that critics would commonly level at the New Hollywood in 1974 as opposed to 1947.[27]

Still, there were important differences between the seventies and the forties, and this was not simply a function of the new permissiveness available to the former. One key difference, of course, is that the seventies filmmakers were very much aware of the film noir tradition and thus toiled in the shadows as well—in this instance, the shadow of film history. And in that context, it seemed, they were committed to getting even blacker than noir. This found expression in three principal revisions. First, they stripped away the code—the last vestige of honor—not from the hero but from the world around him. In the end, despite the integrity of the private eye, it may take two to code. Second, the classic noir private eye, however threadbare his existence and no matter how many knocks he has taken, is nevertheless distinguished by his smarts. Always ahead of the cops, with a preternatural ability to sense the character and motives of those he encounters on the job, he may not win the game, but he always sees through it. Finally, the classic noir hero knows he isn't going to change the world, but at the end of the day, some small corners of it are a bit better because he was there. The seventies film changed all that.

The first two qualities can again be seen in a comparison between *The Long Goodbye* and its antecedents. In the *Big Sleep,* two scenes bookend the sequence involving Harry Jones (Elisha Cook Jr.) In the first, Jones watches, hidden in the shadows, as Marlowe (Bogart) is beaten to a pulp. "You could have yelled for help," complains Marlowe later. "A guy's playing a hand, I let him play it. I'm no kibitzer," Jones responds. "You got brains," Marlowe acknowledges approvingly. Later the roles are reversed: a hidden Marlowe is silent witness when Jones, protecting a woman, is forced to take a drink he knows is laced with poison. It's the second time he earns Marlowe's respect, but that's as far as it goes. Again, the rules governing relationships between "a couple of right guys," however modest, run deep, in contrast to *The Long Goodbye.* Altman's

film also contrasts with the classics in emphasizing Marlowe's (lack of) savvy. "Chandler's Marlowe always knew more than the cops," Leigh Brackett observed, whereas in their revision, "he became the patsy."[28] Compare Gould's Marlowe—drunken, childlike, drenched and disheveled on the beach, inarticulately berating the cops with information they have long known—with Bogart's Marlowe, or his cousin Sam Spade from *The Maltese Falcon,* in scenes of clipped staccato where Bogie explains to confused cops and beleaguered district attorneys just enough to keep them off his back, or in more urgent moments, how he has no choice but to solve the mystery for them in order to clear his good name.

In the end, Sam Spade (like Walter Neff, on the other side of the law in *Double Indemnity*) didn't get the money, and he didn't get the woman. But he didn't hurt anybody, either. In fact, you got the sense that the world was a better place with people like Spade and Marlowe around; they talked a good nihilist game, but deep down you could tell they wanted to do good.[29] And unbeholden to the system, they were more likely to do so as well: free to pursue the case no matter whose feathers were ruffled, to uncover meaningful truths, however inconvenient, and, here and there, to win some modest but important battles. In the neo-noir masterpieces *Chinatown* and *Night Moves,* these hopes—for freedom, meaningful truths, small victories—were all stripped away. In the mid-1970s the nihilism ran even deeper. It was dark, all the way down.

The *Citizen Kane* of the Seventies

Chinatown, directed by Roman Polanski, is a perfect film.[30] Robert Towne's brilliant, initially sprawling screenplay was revised over a feisty, hardworking two-month period by writer and director and then relentlessly cut down by Polanski, leaving a final script so tight you could bounce a quarter off it. (Towne's published version of the screenplay still includes a number of scenes not in the final cut of the film, along with other subtle differences.)[31] The film's twin mysteries—of the water and of the woman—converge with an orchestrated precision. There is nary a wasted moment or character, or a missed opportunity to set down a marker or an echo that will be picked up later on in the story. Curly shows up at the beginning, ostensibly (and effectively) to help establish the setting, but then reappears near the very end to play a vital role. Gittes loses a shoe at the reservoir, just as Hollis Mulwray did, telegraphing not only Mulwray's murder but its motive as well. In an old photograph of Mulwray and Noah Cross at the Department of Water and Power, the two men look eerily similar; at the mention of her father's name, Evelyn instinctively covers her breasts with her forearms. These and other hints of incest wash by during an initial screening but stand out over repeated viewings.

Her father and her husband

Chinatown, shot by John Alonzo, is also distinguished by its visual style, which is in effortless harmony with its reconstruction of late 1930s Los Angeles. It does not have an assertive New Hollywood look: about two-thirds of the film was shot on sets, source lighting was not emphasized, and the compositions and camera movement are predominantly (but not exclusively) traditional. At the same time, the film is not at all trying to imitate the past; rather, in both style and substance, it revisits the period from the vantage point of the 1970s. "I wanted Panavision and color," Polanski later noted, "but I also wanted a cameraman who could identify with the period."[32] Color, then, but muted yellows and browns throughout. Noir evocations—private eyes and venetian blinds—but not noir itself. "Like everyone who loves cinema," Polanski told an interviewer, "I adore Hollywood detective films and Chandler and Hammett's books." And on this point, writer and director were on the same page. For Towne, "Hammett, of course, was a major influence."[33] In the end, however, revisionism trumps homage with a knockout blow at the finish that is shocking and yet, in retrospect, inevitable.

That ending—the innocent Evelyn Mulwray shot dead through her flawed eye by the cops—was famously controversial. Towne, ultimately barred from the set, fought for a different resolution. But Polanski knew better: "If *Chinatown* was to be special... Evelyn had to die"; without this, the movie's "dramatic impact would be lost." This was 1974. "I wanted the film to end in utter tragedy" and for Noah Cross "to get away clean, just like most bad guys really do."[34] As Polanski intended from the start, the ending is more than foreshadowed, it is preordained, both visually and verbally. Not long before the finish, Evelyn slumps her head against her car horn in despair, anticipating her fate. Her eye, blown apart, is but the last in a long series of shattered eyes presented to us throughout the film: the pocket watch crushed under Mulwray's tire, the dead eye of Jake's luncheon fish, the lens punched out of his sunglasses, the

kicked-out taillight of Evelyn's car, the black eye sported by Curly's wife, the one cracked lens of Cross's incriminating bifocals, and of course the intimate flaw Gittes notices in Evelyn, "something black in the green part of your eye," which she calls "a sort of birthmark."

Even more determining than these visual clues, however, is the very meaning of the film: Chinatown—the place, the metaphor for the impossibility of knowing, for the absence of justice and the inability to do anything about it. "You may think you know what's going on here, but believe me, you don't," Cross tells Gittes, just what the district attorney told Jake years before in Chinatown. And the cruel truth is they are both right. But Jake, unlike Hollis Mulwray, *will* make the same mistake twice.[35] Chinatown haunts Gittes because it was the place, he says, where "I was trying to keep someone from being hurt, and I ended up making sure she was hurt." These are two of the most important lines in the movie, and it is this sensibility that brings the weight of the 1970s to the late 1930s. Certainly that was Polanski's intention. "A film that doesn't make any statement at all about society—and ourselves—would be completely empty," he said at the time, defending the picture; and eventually even Towne would admit, "In hindsight, I've come to the feeling that Roman was probably right about the ending."[36]

Chinatown's politics run deep, and they find considerable expression through the character of Noah Cross (John Huston). In a film in which the actors, down to the smallest parts, play their roles so exceptionally and invisibly it's as if they were written expressly for them (which in one instance was the case: Towne wrote the screenplay with his friend Jack Nicholson in mind),[37] one small part looms large. Huston has only a few key scenes in the movie, but his character carries a lot of philosophical water, standing for the dark side of humanity—evil, greed, lust. Noah Cross, as many have observed, rapes both his daughter and the land; worse, perhaps, is that he does it without flinching. "You see, Mr. Gittes, most people never have to face the fact that at the right time, and the right place, they're capable of *anything*." It is for this unstated reason that Cross insists on serving fish "with the heads on": it's more honest to look your kill in the face.

Cross also represents the corrupting influence of wealth, which is suggestive of *Chinatown*'s underlying class politics and, more overtly, its belief that the wealthy are above the law. ("He owns the police!" Evelyn shouts, and we know that she is right.) In a telling deleted passage from the first few pages of Towne's script, Curly threatens to murder his straying wife and her lover, citing "the unwritten law." "I'll tell you the unwritten law," Gittes chastises forcefully. "You gotta be rich to kill somebody, anybody, and get away with it."[38] Gittes, who makes a good living, nevertheless has a strong working-class sensibility; he pronounces the word "rich" as if it were an obscenity. Jake repeatedly

explains that he's not after the "family men" caught up in trying to get ahead, but would rather "hang it on a few rich guys" who are pulling the strings from behind the scenes, and who he knows, instinctively, are motivated by an insatiable appetite for more. In point of fact, he "wants to nail" them. And why not, the audience might easily think; back home on TV these same politics played out with comforting results. As Jeff Greenfield observed, every episode of *Columbo* featured the working-class lieutenant taking on one aristocrat after another—surgeons, art collectors, symphony conductors—and always getting his man. (In the episode closest to *Chinatown*'s release date, Columbo even nailed one of his superiors, the deputy police commissioner, for murdering his wife in their posh Bel Air home.)[39] But that's not what would happen in *Chinatown*, or, it was suggested, in real life—and certainly not in the seventies film.

No small part of *Chinatown*'s effectiveness comes from the way it not only acknowledges but also takes advantage of our understanding of noir conventions. The presence of John Huston, legendary writer and director of *The Maltese Falcon*, evokes thoughts of classic private eye movies, as does, if more subtly, the unseemly haste with which Hollis Mulwray's name is scraped from his office door (just as Sam Spade coolly orders "Spade and Archer" replaced with "Samuel Spade, Private Investigator," upon his partner's death). These and other elements prime the audience's implicit expectations, especially about Evelyn Mulwray (Faye Dunaway), who is positioned structurally in the story as the femme fatale. This was how Dunaway approached the role, with Mary Astor's performance from *The Maltese Falcon* as her template. Of course, Evelyn is no femme fatale—just the opposite—but Dunaway played the role to exploit the viewer's assumptions, constructing, she says, "each of Evelyn's reactions so that the audience would think at that moment I was guilty," and yet, when recalling those moments at the end, "they would realize that my reaction was not because I was guilty, but because of the truth."[40]

Those watching the movie may or may not be led down this path, but Jake Gittes (Nicholson), *in* the movie, thinks he's Sam Spade, dutifully following the code (he falls hard for the girl but has to back off when he thinks she might be guilty), and even echoing Spade's tactics in bullying the truth out of a deceptive lover.[41] Unlike Spade, however, he gets it wrong, completely wrong, and tragically so. And from the perspective of the movie, his failures are our failures, as we are with him and see the world exclusively through his eyes for the entire film.[42] He doesn't get to the bottom of the mystery and set things right. His mistakes, right up to the end, are the cause of the problem, not the solution. Jake (not to mention Evelyn and daughter Katherine, who probably would have escaped) would have been better off if he had followed the advice he half-heartedly offered the fake Mrs. Mulwray: "You know the expression 'let sleeping dogs lie'? You're better off not knowing." But to reach this

conclusion, again (as in Altman's *The Long Goodbye,* but for different reasons), is to strip away whatever modest hopes the classic detectives had to offer a despairing world.

Chinatown's revisionism is different from that of *The Long Goodbye.* Altman took a character from the forties and set him down in the seventies; Polanski brought the weight of the seventies back to the classic era (an approach also taken by the Robert Mitchum vehicle *Farewell, My Lovely*).[43] Arthur Penn's *Night Moves* takes a third approach—a movie of the seventies, in the seventies, with a resigned awareness of the traditions, triumphs, and tragedies of the past.

He Played Something Else, and He Lost

Released with tepid studio support, *Night Moves* remains a film of relatively modest renown, despite the fact that it was well received by many of the more serious critics.[44] This is unfortunate, because *Night Moves* not only is an exemplar of everything the "seventies film" was about but also stands as one of the towering achievements of the period. Alan Sharp's brilliant screenplay comes with a boxful of crackerjack lines; rewritten in collaboration with director Arthur Penn (and honed further in improvisational rehearsals with cast members), the script is brought to life by Gene Hackman and a noteworthy supporting ensemble, which includes Susan Clark, Jennifer Warren, and a very youthful James Woods and Melanie Griffith. Hackman's work on the picture is outstanding, and the same can be said for director Penn and his production team, drawn from the top of the seventies talent pool: cinematographer Bruce Surtees, composer Michael Small, and Penn's closest collaborator, editor Dede Allen.[45]

Hackman plays Harry Moseby, an ex–Pro Bowl football player who now gets by, more or less, running a one-man private eye agency. By convention, he is hired to track down the wayward daughter of a disreputable guardian, and by convention, the routine investigation must disturb and uncover darker and more dangerous secrets. Against genre, however, Harry not only has a wife but also finds out (by accident) that she has taken a lover, one with a limp and a cane, no less, both mocking his masculinity and depriving him of the right to square things with a good sock to the jaw.

Instead of confronting the problems in his personal life head-on, Harry lets his work run interference and delay the close and introspective consideration of a marriage that seems worthy of salvation. On the missing persons case he is more confident and direct, effectively tracing the clues from Los Angeles to New Mexico to the Florida Keys, and in relatively short order returns child to

Harry's life is passing before his eyes

mother. Unfortunately the reunion, first predictably unhappy, turns unexpect-
edly tragic, and the Code of the Private Eye, of course, requires that Harry
revisit the case. Retracing his steps, he is again able to connect the dots with
consummate professionalism. But Harry never grasps the big picture until the
very end, where the revelation serves no purpose other than to confront him
with the depths of his failure. We leave Harry betrayed, wounded, and literally
at sea, going in circles.

Wife notwithstanding, *Night Moves* is unambiguously and by design a
revisionist neo-noir. Early in the movie, when his wife, Ellen (Susan Clark),
asks which team is winning the football game he is watching, Harry responds,
"Nobody. One side's just losing more slowly than the other," an echo of the
words spoken by Robert Mitchum in *Out of the Past* (1947), appropriately the
most fatalistic of the great noir classics. When Paula (Jennifer Warren) refers to
her first boyfriend, Billy Dannreuther, she is invoking the name of Humphrey
Bogart's character in John Huston's *Beat the Devil* (1953). More to the point,
almost every character in the film treats Harry's profession as anachronistic
and feels compelled to cross swords with him by invoking the clichés asso-
ciated with his craft in the popular imagination. This is usually done with
humor, more or less gently, but some of these barbs are daggers that land more
than surface scrapes, as in the separate confrontations Harry has with his
wife and her lover. "Well, come on, take a swing at me, Harry, the way Sam
Spade would": the line reading decisively exposes the impossibility of simple,
classical solutions.

Other noir conventions remain intact. The convoluted plot stands up to scrutiny, but its architects are content, even determined, not to tie up every loose end. And certainly noir is thrown onto the screen from the projection booth; underlit interiors compete with eye-squintingly dark night-for-night exteriors. Penn came up with the title *Night Moves;* Sharp's working title by the time Penn saw it was *The Dark Tower.* They sound equally noirish, but the director's title, which he felt was suggested by the dialogue (and which more accurately reflects what goes on in the movie), is a considerable improvement. It retains the black paint and allows for the play on words that caught the eye of Vincent Canby—*knight moves*—which adds three additional layers of meaning. In his personal life, as Canby noted, Harry tends to move like a knight, preferring indirect routes (like when he approaches his wife's lover first). Harry is also a chess player, and a famous chess match featuring "three little knight moves" provides the central metaphor for the film. And finally, and fittingly, it brings us back to Chandler and his own antiheroic chess metaphor: "The move with the knight was wrong. . . . [K]nights had no meaning in this game. It wasn't a game for knights."[46]

In addition to its relationship with film noir, *Night Moves* is also influenced, primordially, by the French New Wave. Penn had always been captivated by the movement: his 1965 film *Mickey One* was nothing less than a full-blown New Wave feature produced (if reluctantly) by a Hollywood studio.[47] And it was Penn who decided, with particular purpose (he rejected other "art" films that were suggested), that Harry would discover his wife's infidelity outside a screening of *My Night at Maud's.*[48] Rohmer's film perfectly captures the love triangles that also populate *Night Moves,* and it doesn't hurt that the characters in *Maud* engage in an ongoing debate about how one could lead a meaningful life in a (possibly) godless universe. Penn also added to the screenplay Harry's formative story of how, using his detective skills, he tracked down the father who had abandoned him as a child, only to come within a few feet of him before turning away (another knight move?). This is in fact the real life story of François Truffaut, who hired a detective to track down his biological father. Truffaut traveled to Belfort (Harry went to Baltimore), and saw the man in question, but turned away at the last moment.[49]

Night Moves also embraces the New Wave's philosophical and visual sensibilities. The editing style does not strive for invisibility, and in particular, the subtle motif of multiple refracted images challenges the position that there is an objective "point of view" (which happens to be the name of the boat featured in the movie), and suggests instead that everything is open to interpretation and seen through the particular perspective from where one stands. Improbably, both Harry and his romantic rival favor circular nested windows that produce multiple focal points. The audience, already struggling with the twisting plot

and murky visuals, is also invited to try and identify images eerily distorted by the frame of a glass-bottomed boat or through the windows of a submerged airplane. Sometimes even the invitation is withheld—as with the key scene shown, inconclusively, from two different camera angles (raw footage from a movie within the movie), leaving the audience in the dark as to what exactly has happened. And all this to deliver us to an open ending, another New Wave (and New Hollywood) favorite.

Reading *Night Moves* through the lens of the New Wave shifts our attention from the investigation to the investigator, and this is what the filmmakers wanted. Sharp's goal was to take the classic private eye drama as a point of departure for a movie that was actually about the detective and the "crisis in his life"; he had little interest in the nominal mystery itself. Penn's intention was to "make a seventies detective movie as opposed to the traditional detective films that always present a problem followed, at the end, by the solution." *Night Moves,* however, "presents a problem whose solution doesn't exist," at least not in a conventional sense. "I'm trying to say," explains Penn, "that the solution lies in some kind of interior investigation, that the detective story is inward rather than outward." As for Harry's inability to solve these inner mysteries— of his relationship with his wife, with his father, and of his own identity "that seems to me the central idea of the film; the mystery is inward, and perhaps the solution is inward."[50]

That *Night Moves* is ultimately about the investigator, not the investigation, raises the stakes considerably—because Harry Moseby isn't just anybody. He's America. Post-Vietnam, post-Watergate, down a peg and directionless, with the hopes of the sixties long given way to the hollowness of the seventies, Harry, stranded at the embarrassing age of forty (a melancholy milestone emphasized repeatedly in the movie),[51] is defined by disappointment and lost opportunity.

Writer Sharp, a Scotsman, clearly saw the movie as a vehicle to puzzle through the American enigma, as he had done with his script for the revisionist Western and Vietnam allegory *Ulzana's Raid* (1972) for Robert Aldrich. Appealing to an America that once was, Harry attributes his ability to resist the advances of young nymph Delly to conjuring the pure thoughts of Thanksgiving and George Washington's teeth; elsewhere Benjamin Franklin is invoked. (But Penn also urged Sharp to make Harry "real" and flawed—and Sharp did not need much pushing in this direction; his novelization betrays a much less nuanced critique of both Harry and America.)[52] America forlorn: for both writer and director, but for Penn most pointedly, it was the Kennedy assassinations that represented the watershed between what America could have been and what it had become.[53] In response to a question about the assassinations, Moseby answers, "When the president got shot I was on my way to a football

game in San Diego; when Bobby got shot I was sitting in a car waiting for a man to come out of a house with his girlfriend—a divorce case." Harry states the facts and doesn't dwell on the point, but a more concise summary of America's fall from grace is unlikely to be found.

Indeed, the central theme of *Night Moves* is one of loss and regret. Harry passes the lonely hours of surveillance playing chess and reenacting classic matches on his portable set. One match he plays over and over again is from 1922. Black had a mate. "Three little knight moves": Harry shows them to Paula—twice. But the chess master Bruno Moritz didn't see it. "He played something else, and he lost. Must have regretted it every day of his life. I regret it, and I wasn't even born yet."

Despite this ominous foreshadowing, we have reason to hold out hope that some of Harry's losses are retrievable, especially as we shift our focus away from the external trappings of the mystery story to the internal exploration of the character and of the prospects for Harry's troubled marriage. Ellen appears in ten scenes, and of these, three in particular stand out: the astonishing and intense fight in the kitchen, where husband and wife shout past each other in the darkness; much later, an act of subtle catharsis in the bedroom, where Harry tells Ellen for the first time the truth about what happened when he tracked down his father; and finally, at the airport, where infidelities are obliquely confessed and acknowledged via the greatest line in a movie full of great lines, "I know what you *didn't* mean." As Harry departs to return to Florida, the movie leaves open the possibility that they might reconcile upon his return.

Back in the Florida Keys, Harry (amidst a mounting body count as the film approaches its conclusion) will be reunited with Paula, a fascinating woman with a quick wit and street smarts, and, so it would seem, a good heart, a woman who would probably have done better in life had she been dealt more decent cards.[54] Harry spent a night with Paula during his first trip to Florida in what might have been the film's most memorable scene had it not been to a very large extent left on the cutting-room floor. In the released version, their sex scene is relatively brief; but in the penultimate cut, the scene was much more elaborate. Over the extended course of an involved and risqué lovemaking session, Paula's escalating passion is accompanied by her increasingly feverish monologue about her own history and the intertwined significance of Bobby Kennedy's assassination. According to Dede Allen, "it was a wonderful scene, just heartbreaking." Sharp was similarly enthusiastic about its power.[55]

The return to Kennedy is, of course, no surprise. "With the assassination of both Kennedys and the arrival of the Nixon tribe on the scene, we all went into a kind of induced stupor," Penn stated at the time *Night Moves* was released. "And I think that these people in *Night Moves* are some of the mourners

of the Kennedy generation." The puzzle, then, is why the scene was cut, over the strong objections of his collaborators, when Penn made the decision to trim about eight minutes in various places in order to tighten the film's pacing and sharpen Harry's character. Allen was "very, very upset" about the decision to cut the scene, and Sharp reports his own "huge disagreement with Penn" over the issue: "The decision to cut offended me."[56]

According to Sharp, Penn privately showed the rough cut in New York to a group of friends (including Bob Rafelson, Robert Benton, Jack Nicholson, Warren Beatty, and Terrence Malick), and their reaction to the film was that Harry came across as too weak. Sharp also holds that Penn was "very nervous" about how the suits at Warner would react to the sex scene. Allen's recollection is somewhat different: "Arthur's friends in New York... all thought it was a wonderful scene," but at the Hollywood screening for the Warner Brothers executives, "the men didn't like it." Penn, who had the right of final cut, remembers it differently still and strongly denies being influenced by the studio (in particular) or the New York Friends. "I looked at it so many times," he recalled, "it was good in, it was good out." Ultimately, despite the fact that it was a great scene, he decided it did not serve the film as he envisioned it.[57]

Penn will not say definitively what motivated the cut, but he does recall that the scene was "too complete" and that he "wanted to keep them" (Harry and Paula) "ungrounded." These comments are compatible with an interpretation that the impact and the timing of the scene might have shifted the balance of emotional power away from Ellen to Paula (and this also fits with Warren's recollection that the scene "was intimate emotionally as well as physically"). In fact this was Sharp's inclination. He would have preferred that Harry's marriage not be salvaged. But Penn held the opposite view. He rewrote the crucial airport scene from Sharp's version, which implied their final separation, and shot instead his own version, which leaned toward Harry and Ellen's reconciliation.[58]

Another possibility is that the scene was cut because it rendered a deeply pessimistic film even more of a downer (as if that were possible) by undermining further two key characters. After all, Paula seduces Harry with mixed motives at best, as one reason she is there is to keep him occupied so Tom Iverson can make a night move and quietly return to the submerged airplane. Dwelling on this scene might have left Harry seeming even more artlessly nearsighted and Paula more duplicitous than would allow for the audience to retain their commitment to them. But both Penn and Warren, however, reject this interpretation.[59] And as it is, the movie is already overwhelmingly down and despondent.

Night Moves was dark and pessimistic because it was made "during a time of despair," Penn later explained. "I was looking for a film to deal with this

despairing aspect, the loss of confidence and optimism that I associate with the American temperament." On these big themes Penn and Sharp were in complete agreement. Sharp's original title for the screenplay was "An End of Wishing" (a phrase linked in his novelization with the Kennedy assassination), and which to Sharp meant "a recognition that the world is more complex than what it was believed to be and that there are things that just cannot be solved." He also saw Moseby as the personification of "the understanding that Americans will not always be able to triumph in all things undertaken," a seventies realization borne by the sixties generation that once upon a time had been associated with unlimited possibility.[60]

As for the mystery itself, it mattered little; in fact what was important about the mystery was that it *didn't* matter. As Penn insisted, "We were trying to counter the impulse toward solutions in this type of film" and emphasize instead "Harry's blindness in relation to himself." Thus Penn is cheerfully unconcerned with answers to what would normally be considered major plot points (and a few minor ones as well). Was Delly's death a premeditated murder? The director is "not entirely sure." Does Harry die at the end? Penn doesn't think so, but mostly he thinks the question is beside the point. (Sharp gives contradictory answers as to whether Harry survives, but more often than not suggests that Harry doesn't make it, or at least that this was his preferred ending.)[61]

Penn can get away with not knowing, but it's Harry's job to do better. Delly's death requires him to return to the case and solve the mystery. Harry watches the footage of the fatal car crash and develops a theory—an erroneous one, centered on Quentin (James Woods)—in which all the pieces seem to fall into place. But here, and now inevitably in common with the ill-fated chess master Moritz, the correct answer was right in front of him. "Look, Harry, I did it," the injured Joey says despondently. In the moment, it seems he is dutifully taking responsibility as the driver of the car. In retrospect, looking back from the revelations at end of the movie, it becomes clear that he might as well have been signing his confession. But Harry didn't see it. He played something else, and he lost. And he regretted it for the rest of his life.

CHAPTER 8

BUSINESSMEN DRINK MY WINE

The thirty forgettable months of the Ford administration accomplished little more than to turn the page on some of the darker chapters in American history. Decades after he left office, Ford would enjoy a modest revisionist appreciation, with observers emphasizing, rightly, that he was a decent guy who'd been dealt a dismal hand.[1] And his longevity and good manners served him well, allowing for favorable comparisons with some of his less distinguished successors. But benign nostalgia notwithstanding, the Ford years were, nevertheless, the bleary-eyed hangover that followed the punched-out exhaustion of Vietnam, Nixon, Watergate, and all the other traumas of the preceding decade. Not coincidentally, the end of the Ford presidency also brought the era of the seventies film to a close.

Gerald Ford was selected by Nixon to assume the vice presidency on October 13, 1973, three days after Agnew resigned in disgrace and pled "no contest" to charges of tax evasion and money laundering. Ford was a compromise choice; unlike Rockefeller, Reagan, and (Nixon's favorite) former Texas governor John Connally, he had neither advocates nor adversaries, and the latter quality was decisive in the midst of the Watergate scandal. The House minority leader was little known and held in modest esteem—but he could, and would, be easily confirmed by Congress. Loyal to his party and his friends (five days before Nixon's resignation he was still professing the president's innocence), Ford, though not blessed with natural charisma, was seen as a solid citizen and a stand-up guy. But the only president never to have been elected to national office could not exactly hit the ground running; his only "mandate" was to be a caretaker and clean up the mess he inherited.

There were few attractive policy options available to Ford, who stumbled out of the gate. His September pardon of Nixon was extremely controversial; however well intentioned it might have been, after years of scandals and lies it inevitably smacked of cronyism. In October, the president's speech on economic policy was even less defensible. An utter disaster, his administration's response to galloping inflation would be impotent rhetoric that called for voluntary restraints and individual belt-tightening, packaged as a "plan" to "Whip Inflation Now." Ford revealed his WIN button to the nation in the middle of the speech, and for some reason anticipated that millions of Americans would choose to wear one proudly. A few months later, in his first State of the Union Address, Ford had no choice but to acknowledge the truth: "I must say to you the state of the union is not good."[2]

The nation was stumbling uncertainly toward its bicentennial, and so was its president. Ford was, by all accounts, an athletic man, but he was a clumsy one as well, tumbling on ski slopes, slipping on staircases, getting ensnared by his dog's leash. His verbal skills were similarly challenged: "an accident-prone President with an amiable but bumbling style," offered one supportive account. A friendly biographer described Ford's speaking style as "slow and uninspiring" with "labored" pronunciation; he was especially "rigid and unspontaneous" in front of a TV camera. These qualities informed his election strategy during the 1976 campaign: stick close to the White House in order to "avoid verbal or physical gaffes."[3]

The election of 1976, with the nation's bittersweet bicentennial as its backdrop, pitted Ford, who narrowly defeated insurgent conservative Ronald Reagan for the Republican nomination, against another outsider, the nationally unknown one-term governor of Georgia, Jimmy Carter. Given the political and economic realities of the time, the election was the Democrats' to lose, which Carter, who, like Ford, was not a barnstorming campaigner, almost did. Neither candidate elicited passionate support; Carter appealed more for what he wasn't than for what he was, promising time and again that he would "never lie to the American people." As their first televised debate was about to begin, the sound went out. With nowhere else to go, TV cameras fixed silently on the two candidates as they stood awkwardly for twenty-seven minutes. At the second debate, Ford famously blundered by declaring that eastern Europe was free from Soviet domination; given the opportunity to clarify, he compounded the error. Carter, who had for months been squandering a large lead, held on to win.[4]

It Don't Worry Me

An interrogation of the assumptions of the (eroding) American Dream was a common theme of Ford-era movies. In Nicolas Roeg's *The Man Who Fell*

to Earth (1976), space alien David Bowie's most consequential descent is not his touchdown on earth but the fall from grace as his soul is hollowed out by a materialist and spiritually bankrupt mid-seventies America. In a film of mood and scene as opposed to narrative and story, performances by Buck Henry, Rip Torn, and Candy Clark capture the loneliness and resigned paranoia of characters dispirited by forces they sense are beyond their control. Michael Ritchie's *Smile* (1975) takes some easy shots at the superficial culture of teen beauty pageants, but at its heart is the story of Big Bob (Bruce Dern), a metaphor for America, whose boyish optimism and can-do spirit are beginning to fray as he stalls in middle age. As Ritchie observes, *Smile* suggests "there's very little hope for the Big Bobs of the world."[5] It is a film about the emerging dissatisfactions of its characters.

In *Smile,* the beauty pageant is lost; Robert Altman takes despair to a whole other level in *California Split,* which ends in empty victory. Not pyrrhic victory—empty victory. In a movie with more downs than ups, compulsive gambler George Segal finally gets on a hot streak and, atypically for a seventies film, wins big in the end. But he just wanders away from the action and slumps himself down in a chair. "There was no special feeling," he explains to his partner (Elliott Gould), which Altman thought was "the whole point" of the movie. It wasn't about winning, it was about *gambling.*[6] Having, it turned out, was less exciting than wanting. Released, coincidentally, the day before Nixon resigned, *California Split* powerfully evokes a sentiment that must have been felt by Nixon haters everywhere (such as Altman): "Now what?" So many people had thought so long and so hard about getting rid of Nixon. And then he was gone. And then pardoned, and out of reach.

Of course, Altman would go on to produce the ultimate bicentennial/election year/what-is-America film, his mid-period masterpiece, *Nashville* (1975). Tom Wicker, political columnist for the *New York Times,* described the film as a "cascade of minutely detailed vulgarity, greed, deceit, cruelty, barely contained hysteria, and the frantic lack of root and grace into which American life has been driven."[7] It is also the quintessential Altman film, featuring twenty-four characters with interweaving narratives; as they bump up against one another in different combinations they play different "roles" within the multiplicity of their own lives. The genius of Altman's approach is to reveal how the sum of those interactions forms a collective character—a sociological ecosystem—to which every character's individual behavior contributes without any intention or awareness of producing that greater whole. The behavior of each character shapes the nature of the social system, which returns the favor, imposing the incentives, prohibitions, and limitations that shape the choices of and prospects for each character.

Having the collective community as the underlying center of gravity liberates the form. The movie could have been about any one set of characters

as easily as another. And in fact, given the enormous amount of footage shot, at one point Altman considered releasing two versions of the film: "red" and "blue." In one version, the story of eight characters would have been in the foreground with the others in the background; the other version would have relegated the "stars" of the first movie to minor participants in the lives of a different set of eight others.[8] This "beehive" perspective also informed Altman's approach to the screenplay, which is often (although not in *Nashville*) a point of controversy between writer and director in his films. Much is often made of the extent to which dialogue is improvised on some of Altman's projects, but the meaning of this is easily misunderstood: it is not a denigration of the writer but rather a distinct attitude about the writer's role. For Altman, the screenplay establishes the story and its structure, provides essential pieces of information, and, crucially, shows the actors who their characters are. Within that context, Altman often encouraged his players to improvise dialogue, speeches, and behavior, and to contribute to the creative process at that level, in order to provide a naturalistic and unpredictable feel.[9]

"Writing" *Nashville,* then, was a layered process. Altman sent Joan Tewkesbury down to Nashville to get a feel for the city and its music; she produced a script that featured eighteen characters. Altman, influenced by the growing Watergate scandal, worked with Tewkesbury to add the political dimension, the fictional presidential campaign of Hal Phillip Walker, which increased the company to twenty-four principal players.[10] During shooting, the actors' improvisations and other contributions further refined the action. Geraldine Chaplin contributed to her extensive monologues; Barbara Baxley wrote out her long, heartfelt speech about the "Kennedy boys" (drawn from her own experiences), of which only a powerful few minutes appear in the final cut. The last argument between Barnett and Triplette (Allen Garfield and Michael Murphy) took on a life of its own, emerging from the intensity of the performers' emotions; and of course, often with the help of musical director Richard Baskin (who appears as Frog), the actors wrote the songs they performed in the film. The players also fought with Altman over the behavior of their alter egos, often for the better: Ronee Blakley persuaded Altman to abandon his original plans for Barbara Jean to have a second fainting spell in favor of her much more effective breakdown on stage; Lily Tomlin, also in her first film role, rose to the defense of her character and insisted on reorchestrating her departure from Keith Carradine's hotel room. More generally, as Altman wired everybody for sound, encouraged improvisation, and shot mountains of footage, the players were kept on their toes by the uncertainty over which pieces of business would ultimately make it into the movie.[11]

Nashville opens with extraordinary efficiency. Within three minutes Altman establishes the importance of the music (the title credits take the form of a

mock record advertisement) and of election year politics—the film opens with Hal Phillip Walker's van and the broadcast of his first campaign monologue—before cutting to the bicentennial: Haven Hamilton (Henry Gibson) recording his patriotic ode to America ("We must be doing something right to last two hundred years"). The entire cast then assembles at the airport as assorted out-of-towners arrive and locals descend to pick them up, before they get stuck, collectively, in a massive traffic jam (based on Tewkesbury's actual experience sitting for three hours in stopped highway traffic upon her own arrival in Nashville). Here and at the very end (at the Parthenon concert/assassination) are the only two locations where all of the characters are in one setting; in the interim they weave together and wander apart in various combinations.[12] The multiple story threads include those involving the status ballet of the Nashville music community, the machinations of Walker's political advance man, the tribulations of a disintegrating folk trio, and the quieter domestic dramas of various locals caught up by happenstance in one aspect of the action or another.

Visiting hospitals, house parties, hotel rooms, and, always, concert halls, Altman's camera reveals much about America in its bicentennial year. Not surprisingly, *Nashville* is deeply cynical about politics. Walker's plain-talking independent campaign has captured the imagination of young people, but his operators are effectively portrayed as manipulative dealmakers, indistinguishable in their methods, lies, and Machiavellianism from any other. More subtle is the movie's treatment of status and celebrity. Among the stars, relative status within general stratification is everywhere implicitly understood, which is why the rise of newcomer Connie White (Karen Black) and the troubles of superstar Barbara Jean are so subversive of an order based on everyone knowing his or her place. (Haven Hamilton understands the rules of that kingdom, and his every measured step is dedicated to preserving the institution and his place within it.) Among the crowd, *Nashville* observes the desperate measures that people will take for a chance to gain entrance into that Promised Land of fame and fortune, or, failing that, to spend a few precious moments rubbing elbows with the stars. Thus the talentless Sueleen (Gwen Welles) is reduced to stripping at a political smoker; more heartbreaking still is the way that Opal (Chaplin) coaxes a buried moment of intimacy from Haven's repressed, dutiful son, only to abandon the moment to chase after a celebrity (Elliott Gould, playing himself in a cameo role).

Altman's film also offers understated commentary on race and gender relations in mid-seventies America. Linnea (Tomlin) is trapped in a loveless marriage; navigating her dreams and responsibilities, she steps out for a rendezvous with Tom (Carradine) but won't risk the stability of her children's home. Barbara Jean is dominated by her manager-husband (Allen Garfield, who brings the same frightening, barely contained intensity he previously showcased in

The Conversation). And Tommy Brown (Timothy Brown) understands his place as a black singer in a white community, a man who is superficially respected but structurally scorned—rudely by rabble-rousing drunks, subtly by his nominal friends. (One telling moment of marginalia goes by almost subliminally when Haven passes Tommy a piece of watermelon at the speedway.)

As these characterizations suggest, although *Nashville* is an ambitious picture with big things to say, it is attentive to small, meaningful moments in its character's lives as well. Altman, with his freewheeling style, is not best known for the precision of his compositions, but two character-probing sequences show him to be a master of this craft. One is the brilliant cinematic economy of the four-minute church sequence. About halfway through the film, Altman shows all of the locals (but none of the visitors) attending Sunday services. Four different services are shown, and which one the characters attend (and with whom) tells us something about each: Linnea and her husband, Delbert (Ned Beatty), for example, go to different churches; Lady Pearl (Baxley) attends a Catholic mass; Haven Hamilton takes his place modestly among others in a choir, the first hint that he may in fact believe some of the things that he says. All told, Altman shows twelve characters in four settings in a matter of minutes, revealing information about each of them, their beliefs, and their relationships, and about the difference between those who are members of the Nashville community and those who are just passing through.

A second sequence is more intimate, centering on the performance of two songs at the Exit/In. The exposition of the second song, "I'm Easy," is justly famous for how the camera, surveying the crowd, shows how four different women each think that Tom (Carradine) is singing the song directly to them. In a celebrated passage, Altman moves in slowly on Linnea, who is deeply affected by the performance, and the camera reveals the true measure of the sacrifices she has made in her life. Less discussed but equally notable are the events surrounding the first number, "Since You've Gone, My Heart Is Broken," performed by the disintegrating trio of Tom, Bill, and Mary. The group is coming apart. Tom has his sights on a solo career; the marriage of Bill (Allan Nicholls) and Mary (Cristina Raines) is on the rocks. In fact, Mary has been sleeping with and fallen hard for Tom; an earlier bedroom scene left no doubt as to the sincerity of her feelings. This leads to that painful moment when Opal gracelessly announces that *she* and Tom have slept together. With Bill and others around the table, Mary can do little but turn away, devastated, hand over mouth. Only the camera and the moviegoing audience have access to her feelings. A few difficult moments later, Tom invites (what he identifies as his former) partners to join him on stage. Bill and Tom sing the song as they always have, but for Mary, whose heart *has* been broken, singing lines like "He's all I ever wanted / why did he run from me" take on new meaning. When she looks

Private pain in public places

into Tom's eyes, the intimacy of the character's experience creates its own reality within the fiction.

All of these small investments in disparate storylines strengthen the overarching impact of the movie's finale, as *Nashville* brings all twenty-four players to the Parthenon for the concert and political rally that will close the film. In this final location, Altman makes three choices, each of which challenges the audience to reassess their preconceived expectations, none the easy way out. First, the killer turns out not to be the soldier who has stalked Barbara Jean throughout the movie; he was actually a sincere (if ill-fated) guardian angel, which is not the way American soldiers were seen at the time. Second, Haven Hamilton—who knew?—behaves heroically under fire. Badly wounded, he thinks not of himself but attends to others and commands the crowd to order. Finally, and most controversially, the film ends with an assassination, as so many battle-scarred seventies films do, but of the "wrong" person: not the candidate but the singer. Many were outraged by this choice—Tewkesbury initially fought against the move, and production designer Polly Platt quit the picture in protest—while others, with John Lennon's assassination still a few years in the future, simply didn't find it plausible. For Altman, asking the question "Why kill the singer" provides its own answer: "Everyone assumed it would be the political candidate who would be assassinated, because that's something we can accept, we buy that. But he shot the entertainer, and we don't know why," which was closer to the confusion that characterized America on the occasion of its two-hundredth birthday.[13]

In the midst of the chaos, Haven Hamilton rebukes the panicking crowd and insists that they sing, handing the microphone to stardom-chasing housewife Albuquerque (Barbara Harris). On the run for the whole film, seeking one big chance, she gets it, and leads the crowd, at first tentatively, but soon in

a rousing rendition of the Tom, Bill, and Mary hit "It Don't Worry Me." For the last time, the camera catches the fragmented lives of the cast, as they each process the meaning of what they have just witnessed and disperse to their separate pathways, no longer bound together by the silk strings of the concert, the political campaign, or the gravity of Barbara Jean's stardom. All that remains is the large crowd of "real" people from Nashville, attracted to the location by the promise of a free concert. They join in singing "You might say that I ain't free / but it don't worry me," as Altman pulls back to emphasize the massive American flag, and then the sky, as the song continues over the credits. What does it mean? Is the refrain condemning mindless Middle America, zombified and numb to the surrounding horrors? Or is it more optimistic, suggesting a collective resilience in the face of tragedy and difficult times? Either reading is plausible. Altman offers an appropriately ambiguous seventies interpretation: he sees it as "both a positive and a negative comment."[14] But that sounds like Altman on an uncharacteristically hopeful day.

Anxious as Hell

The sluggish American economy of the 1970s stood in sharp contrast with the fat years of the 1960s: from 1964 to 1969, real economic growth in the United States averaged a robust 4.86 percent; from 1970 to 1975, the economy grew at less than half that rate, about 2.3 percent. But the seventies brought more than "hard times"; they brought *anxious* times, an era of uncertainty and instability visited on a public accustomed to the expectation of ever-better things almost as a birthright. The quarter-century after World War II was known as the golden age of capitalism—and it was the only economic condition that baby boomers had ever experienced. The U.S. economy was the Rock of Gibraltar, the envy of the world, and every American was the master of his or her own destiny. In the land of opportunity, talent went a long way, and hard work would be rewarded.

In concrete terms, the economic difficulties of the seventies reduced material prospects and expectations; more consequential, however, was the psychological effect of that malaise on society, provoking an existential crisis of confidence. What had been certain became uncertain. The dollar, for example, used to be "good as gold." From 1934 to 1970 the price of gold was always $35 per ounce, and after World War II, American planners designed and supervised a global monetary order built around the promise of that inviolable gold-dollar link. But in 1971 Nixon broke that promise and "closed the gold window." Initially the hope was that with some modest devaluation (say, to $38 an ounce) the global dollar order could be repaired. But the patches failed to

hold, the international monetary system collapsed, and the untethered dollar tumbled. The price of gold soared to $120 in June 1973 (the same month John Dean was preparing his Watergate testimony). What was the dollar worth? After decades of certainty, it was suddenly impossible to say; its value changed daily on foreign-exchange markets.

At about the same time, America lost control over energy, the lifeblood of its economy. For much of the twentieth century, the United States dominated global oil production, accounting for over half of the world's output through 1950. Cheap and readily available oil was another constant of the American Century. In 1960, the United States was still the world's largest producer, and, like the unchanging dollar, the price of petroleum displayed remarkable stability. The cost of oil sat undisturbed throughout the 1960s, the only subtle movement a gentle downward drift to $1.21 a barrel in 1970. But with U.S. production maxing out and global demand soaring, the Persian Gulf overtook the United States as the most important source of the world's oil. Markets tightened and prices crept upward from 1971 to 1973, which meant that when the Arab countries announced an oil "boycott" against the United States for its support of Israel during the Yom Kippur War, the stage was set for another tumultuous change. Oil consumers panicked, and the world price soared. In 1974 the price of crude hit $12.12 a barrel, or ten times what it had cost in 1970.[15]

Panic buying made a bad situation worse. Americans had gotten hooked on cheap and plentiful energy and never gave it a second thought. From 1950 to 1974, the United States doubled its consumption of oil, and with 6 percent of the world's population it now accounted for one-third of global energy consumption. With the sudden eruption of the energy crisis, as it immediately became known, big cars formed long lines at gas stations, whose reserves often ran dry; fistfights broke out. President Nixon addressed the nation and urged Americans to lower their thermostats, cut back on air travel, and increase carpooling; he also ordered a reduction in highway speed limits. Nixon was the first of eight U.S. presidents to call for energy "independence"—but he was also the first one who had to. Starting in the 1970s, Americans no longer controlled the price and supply of the energy that fueled their cars and heated their homes.[16]

Rising oil prices contributed to another big economic problem: inflation. From 1952 to 1967, the annual inflation rate was typically under 2 percent and never over 3 percent. But from 1968 it began to creep upward, reaching 6 percent in 1973 and then spiking to 11 percent in 1974 and 9.2 percent in 1975. Inflation reflects the erosion of real purchasing power, eating away at wealth and putting pressure on family budgets as prices rise faster than wages. Inflation is also uniquely unsettling because of its psychological and behavioral

components: the mere expectation of inflation can cause prices to rise faster than the economic "facts of the matter" (such as changes to the money supply) would suggest. Inflationary dynamics thus always threaten to take on a life of their own. And always lurking in the background are fears that spiraling inflation—as producers and workers scramble to react to rising prices—can spin out of control, as it did during legendary hyperinflations throughout history. It was yet another new economic problem that was not just diminishing but destabilizing.

Another unnerving factor about the seventies inflation was that it did not fit the expectations of the postwar economic theories that seemed to work so well in the 1950s and 1960s. Previously, when inflation was up, unemployment was down, and vice versa. But in the mid-seventies, as inflation soared, unemployment was on the rise as well. In 1969 unemployment stood at 3.5 percent, but in 1975 it set a postwar record of 8.5 percent, touching 9 percent in May. And although there had been recessions even during the golden age of capitalism, the downturn of 1973–1975 was the longest and deepest of the postwar era, and once again, it suggested uniquely intractable problems. In the mid-seventies, the fear of losing one's job was eclipsed by a relatively novel anxiety: a real concern about where the next job would come from.[17]

That fear was not unfounded. Unlike the downturns of the 1950s and 1960s, this recession signaled the end of something larger. The American economy had grown robustly during the decades of the postwar boom, but in many parts of the world, growth was faster still. And some of the extraordinary competitive advantages enjoyed by the United States during that period were just that—extraordinary. America had emerged from the war as the only center of industrial activity not ravaged by the conflict. With much of the rest of the world bombed out and flat on its back, in the early postwar years, U.S. production accounted for close to half of global economic output. International trade represented only a small share of the enormous American economy; foreign competition was even less of a concern. But with the recovery of western Europe, the unprecedented, breathtaking rise of the Japanese economy, and strong growth in many parts of the developing world, key U.S. industries—textiles, steel, and autos, among others—newly found themselves under relentless pressure from dynamic competitors abroad. In sum, although sluggish productivity, rising prices, and shortsighted economic policymaking contributed mightily to America's economic problems in the 1970s, even under the best of circumstances, the U.S. economy would never again enjoy the extraordinary invulnerability it had experienced over the course of more than a generation.

Economic distress and, more pointedly, economic anxiety provide the context for *Network*, another signature film of the seventies. Midway through the

film, when news anchor Howard Beale (Peter Finch) gives his "mad as hell" speech—the moment that would come to define the movie's iconic status—he is, within the story, successfully giving voice to the unarticulated rage of a public frightened by the loss of control over their own lives. It was also more than likely that the angry monologue, a venting of pent-up frustrations about inflation, Arab oil producers, crime, and recession, resonated with moviegoing audiences as well.

First and foremost about the corrosive influence of television on society, *Network* is a thematically overstuffed movie. It has something to say—something interesting to say—about almost everything that was in the ether at the time: gender, generational conflict, economy, society. And it expresses those ideas through the recognizable motifs of the seventies film. The visual style, especially in the first half of the movie, is dark, naturalistic, and gritty, appropriate for yet another film defined by its location shooting in New York City. (Cinematographer Owen Roizman had previously shot *The French Connection* and *Three Days of the Condor*.) *Network*, in another nod toward realism, had no musical score, a choice also informed by the desire to avoid potentially undercutting the dense dialogue and long speeches that already filled the soundtrack. In fact, as written, the screenplay on paper looked "wrong." The script pages for a typical film reveal much more white (paper) than black (words), and the thick black passages in this script contributed to some industry wariness about the project.[18]

Network also features a who's who of seventies players: Faye Dunaway (*Bonnie and Clyde, Chinatown, Three Days of the Condor*), Robert Duvall (*The Godfather, The Conversation*), Ned Beatty (*Deliverance, Nashville, Mikey and Nicky*), as well as older pros like leading man William Holden (*The Wild Bunch*), once again bringing gravity as the weathered elder statesman under siege. And befitting the period, all of the characters are compromised at best; director Sidney Lumet told Dunaway from their very first meeting that if she tried to sneak in any "vulnerability" in her character (Diana Christensen), he would make sure it ended up on the cutting room floor.[19] It is very seventies out there in *Network*, most obviously with its rain, darkness, despair, and climactic assassination, but also in its more subtle Nixonian touches. At her triumphant appearance before the affiliates, when Diana tells the cheering crowd that the UBS network "will be number one," Lumet shows her repeatedly, from front and back in long shots, arms raised in Nixon's unmistakable "double-V" posture. Also *very* Watergate is the way Lumet shoots the final scene, in which the network executives decide that their only logical course of action is to kill Beale. The camera sticks with a master, static "surveillance" shot, similar to Coppola's composition in *The Conversation*. One character jokes, "I hope you're not recording this," only to catch a twinkle in the eye of

the otherwise enigmatic poker face of Frank Hackett (Duvall). And when the president of the network observes, "We're talking about a capital crime," as in the Nixon White House, his concern is not for ethics but for ensuring that they can get away with it. "The Network can't be implicated," he insists.

In 1976 *Network* was seen by many as an impossibly over-the-top farce, even without its final assassination. Today it plays more like a documentary, as the worst fears about the media imaginable in the 1970s have been considerably eclipsed, with cable, satellite, and Internet outlets scrambling desperately and outrageously to get noticed above the din of the elbowing crowds. (Similarly, Stuart Rosenberg's *WUSA,* a 1970 Paul Newman vehicle that anticipates aspects of both *Nashville* and *Network* by way of *The Manchurian Candidate,* plays today less like a paranoid thriller than an exposé of right-wing talk radio.) But the creative forces behind *Network,* writer Paddy Chayefsky and director Lumet, were well positioned to fear the beast. Both grew up before television and made their early professional reputations during its "golden age," in the live TV dramas of the 1950s. Lumet had worked in live television for six years before directing his first feature film, earning an Academy Award nomination for that debut effort, *Twelve Angry Men* (1957), which was based on a live TV drama. Chayefsky won his first Oscar for the screenplay of *Marty* (1955), which was based on his earlier teleplay.

Chayefsky represented something virtually unheard of in Hollywood: a powerful writer. Respected as a "serious" writer and with a proven track record, the combative Chayefsky was able to parlay those attributes into greater creative control of his work by shepherding scripts through his own production company. For *The Hospital* (1971), it was Chayefsky who hired George C. Scott, fired the movie's first director, and provided the voiceover narration. *The Hospital,* like *Network,* has an atypical writing credit ("by" Paddy Chayefsky appearing prominently in the main titles), and *The Hospital* can be seen as an important precursor to the later film. Scott, in a role that has more than a little Chayefsky in it (and also has parallels with his portrayal of Dr. Bollen in *Petulia*), is a midlife-crisis protagonist struggling to endure within a dysfunctional institution. The dark, monologue-rich, seething farce cast a jaundiced eye on its younger generation and won Chayefsky a second Academy Award. In *Network,* which won him an (unprecedented) third, the writer poured different parts of himself into Max Schumacher (Holden) and Howard Beale; Chayefsky's own exhaustion from writing Beale's speeches became a part of the character, who would collapse at the end of his monologues.[20]

For Sidney Lumet, *Network* was also a personal film that followed naturally from the trajectory of his previous projects. *The Anderson Tapes* (1971), *Serpico* (1973), and *Dog Day Afternoon* (1975) were all New York City films defined by their location work. *Anderson Tapes,* a caper movie notable as an

early exemplar of those films defined by their suitably seventies surveillance anxiety, is a relatively minor effort. Like *Serpico, Dog Day* is much more ambitious, and based on a true story. It also has multiple affinities with *Network:* naturalistic street scenes, intense emotional outbursts, and something to say about a truckload of themes. (*Dog Day* checks in on race, gender, cops, fame, and, not surprisingly, how the presence of television news shapes the reality that it is purporting to "observe.")[21]

On *Network,* Lumet worked for two months polishing the script with Chayefsky (who co-produced) and kept him on hand during weeks of rehearsals and then shooting. The partnership worked well because writer and director were in basic agreement on the main themes of the film, holding firm, for example, against pressure from the studio, which got cold feet about the ending.

For Lumet, *Network* was about how "television had really taken over our lives," something that came to pass in the mid-seventies, "when we first had a generation that had never lived without television." Chayefsky's attitude toward TV was even more hostile: the "basic problem of television," in his view, was that "we've lost our sense of shock, our humanity." These sentiments make their way quite clearly into the film, culminating in Max's final speech to Diana. For Chayefsky, "she represents television, he represents humanity," and in that (characteristically) long monologue, this dichotomy is articulated explicitly, as he tells her that she is "television incarnate . . . indifferent to suffering, insensitive to joy," and, ultimately, incapable of love. Television reduces humans to "humanoids," repackaging genuine sentiment as commercial product.[22] "War, murder, and death" are no different from "bottles of beer" to be sold, just as, ultimately, Howard Beale's death is packaged and sold, and as the film ends, images of his corpse compete with the advertisements cueing up on control room screens.

Beyond its powerful (and prescient) indictment of television, *Network* retains considerable interest because it also has much to say about other issues that were important at the time and remain of great relevance in the present day. Implicit to the story, but not raised as an overt topic for discussion, is the fact that Diana is a female executive in a male-dominated environment; there are no other women in positions of authority at UBS. Dunaway fought for the character to be portrayed very much as a woman, toward rather than away from her sexuality.[23] Diana has long hair and is attractively attired, a look underscored and made a bit provocative by her apparent lack of interest in wearing undergarments. She is also a "strong" woman, confident in addressing superiors and managing her staff, and in control of her sexual choices. In one early scene she is shown with a lover solely to give her the opportunity to say, "Knock it off, Arnold," shutting down his renewed advances when they distract her from

coverage of the Beale meltdown. Yet these strengths are balanced by corresponding weaknesses. Diana has clearly sacrificed everything for her success. Her life is her job, comically illustrated in her disjointed sexuality, whereby the arousal she experiences talking about ratings and potential hit shows is greater than anything physical acts of love provide her.[24] With substantial scenes for Max's wife, Louise (Beatrice Straight), and communist provocateur Laureen Hobbs (Marlene Warfield), *Network* does not provide answers about women's changing roles in American society, but it puts a discussion of the relevant questions on the table.

Lumet and Chayefsky are able to entertain a multitude of serious concerns seamlessly by enmeshing them within the context of *Network*'s titular theme. Thus even when it is nominally concerned with "television," the film is also using TV as a *vehicle* to engage those larger issues. One of them is generational change.[25] *Network* is very self-conscious about its generational politics. In the opening minutes of the movie, Max tells an old story about himself that comes with the punch line of a cab driver pleading with him, "You're young, you've got your whole life ahead of you!" Max then tells this story again about thirty minutes into the movie, as he is cleaning out his office, and the point is clear: he is no longer young, his life is no longer ahead of him. The principal generational conflict in the film is between Max's generation (self-identified as "sentimental" and possessing "simple human decency") and the younger TV generation, "raised on Bugs Bunny."[26] These differences are apparent in the set decoration; in Max's warmly furnished apartment, the walls are lined with books, in contrast to the sterility of Diana's bright modern duplex. Max's world is disappearing: he is fired; his friend George Ruddy, chairman of UBS, suffers a heart attack and is forced out; Beale (told plainly by Arthur Jensen [Beatty], "You are an old man"), descends into madness.

Network, at its most ambitious, introduces a true-to-life aspect of the changing television industry to take on a larger issue: the encroachment of "the market"—that is, of an economic calculation of value—into spheres of life that had not previously been determined by market forces. The motivating narrative conflict of the film is about profit: the UBS network has been acquired by the gigantic CCA corporation, and aptly named CCA hatchet man Hackett is sick of the news division and its "annual $32 million loss." Traditionally at UBS (and at real American television networks at the time), the news division was given a budget and was not expected to make money. News was part of the "public service" provided by networks in recognition of the fact that they broadcast their shows over the "public airwaves," which belonged to the people collectively. But Hackett wants to bring the news division under general programming, making it no longer autonomous but "responsible to network," and, of course, now expected to turn a profit. News shows (like *The Howard*

Beale Show) would become another form of entertainment, with format, allocation of resources, and content dictated by market incentives: low costs and high ratings.

The relentless expansion of the market sphere is seen everywhere in *Network;* as much as the film is about television, it is about this encroachment of economic pressure into areas traditionally under the purview of social and cultural values and purpose. The visible co-optation of the communist Laureen Hobbs (who theoretically represents the antithesis of market order) is telling in this regard. Early in the film she is presented as a woman with a modest, functional wardrobe and a calm, articulate intelligence; she is shot in a naturalistic style that matches her demeanor. But as events develop, and she becomes increasingly associated with television, her wardrobe becomes flashier and the rhythm of her speech faster; she is shot with more artificial light. In her final scene, Hobbs is dressed in fashionable, modern clothes, angrily ranting about ratings, market shares, and competing TV shows in Diana's brightly lit office. The two women, originally introduced as opposites, have become essentially interchangeable: even the communists have been overtaken and absorbed by the market.

Network's thesis of the encroaching market sphere is presented clearly in the sequence when Beale announces on his show that the "Saudi Arabian Investment Corporation" is about to merge with CCA in exchange for $2 billion. Beale, in his desire to protect America's corporations (and the autonomy of its people) from being "taken over by the Arabs," urges his viewers to send telegrams to the White House to stop the sale, which they do, en masse. Hackett is devastated: CCA "needs that Saudi money bad," and he assumes that he will be fired for his role in killing the deal, since the Beale show was his baby. A few hours before, he was on top of the world, but by tomorrow, he despairs, he will be finished, "a man without a corporation."

But in taking on the forces of global capitalism, Beale has overreached. They are more powerful than he, as Lumet efficiently illustrates. Beale's anti-merger rant is not shown live from his New York studio but seen on a bar-top TV in Los Angeles. Next to the TV, sitting undisturbed in the center of the frame, are two bottles. One is Coca-Cola, then the signature brand of American corporate multinationalism, the other is Cutty Sark whisky, named after the legendary nineteenth-century British trading ship that is prominently displayed on the label. These stoic icons contrast with the image of a frantic Beale flickering on the TV set; he hasn't a chance against them. Summoned to CCA headquarters, Beale absorbs a fire-and-brimstone message from Mr. Jensen, its evangelical owner. Jensen deploys some of the same turns of phrase that Beale heard from a disembodied voice as he was going mad, which he identified as the voice of god. But Jensen is not preaching the holy gospel. Instead, in a

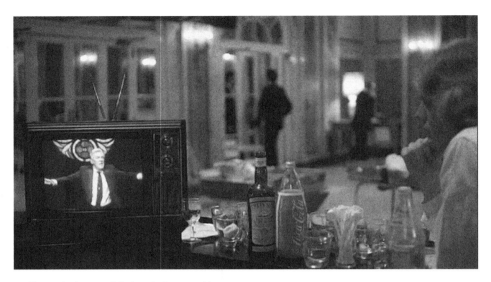

Howard takes on global capitalism—and loses

room illuminated by accounting-shade-green desk lamps, he delivers a magisterial dissertation on the logic of globalization, almost twenty years before the phrase would be coined. "There are no nations, there are no peoples," Jensen thunders, describing a world absent of ideology, in which all human activity is determined solely by the play of market forces. "The world is a business," he explains, "a collage of corporations."

Beale is converted and begins to preach this new gospel on his show. But this new feel-bad, individuals-don't-matter message isn't as popular as his angry, empowering rants were, and his ratings decline. And so he becomes the victim of the ultimate encroachment of the market: "the first known instance of a man being killed because he had lousy ratings."

The Encroaching Market

As discussed in chapter 5, the revisionism of the seventies film was characterized by a multifaceted reassessment of the American experience. Among these themes was more a skeptical attitude toward and greater attention to the darker aspects of capitalism. One common motif in this area—as seen with *Point Blank* (1967)—was the blurring of the cinematic distinction between organized crime and corporate capitalism. The most celebrated statement of this was *The Godfather*. "I always wanted to use the Mafia as a metaphor for America," said Francis Ford Coppola. "Both America and the Mafia have their

hands stained with blood from what it is necessary to do to protect their power and their interests. Both are totally capitalistic phenomena and basically have a profit motive."[27] That profit motive legitimizes all kinds of crimes and, perhaps worse, all kinds of transgressions. *The Godfather* concludes with Michael (Al Pacino) ruthlessly dispatching all of his enemies: "Today I settle all family business." But a quieter and more telling moment follows that bloody sequence: Tessio (Abe Vigoda) has betrayed Michael and plotted his execution. But he tips his hand and is led calmly away to meet his fate. "Tell Mike it was only business. I always liked him," says Tessio. "He understands that," Tom (Robert Duvall) answers reassuringly. Business is business.

In Michael Ritchie's *Prime Cut* (1972), the blurred distinction between gangsters and businessmen is even more explicit, as are the perils of an ever-expanding market sphere. A movie absent any legitimate authority (the only thing that comes close is the official staff working a country fair where crowds partake of midwestern amusements, oblivious to the murderous chase in their midst), its moral center takes the form a freelance mob enforcer (Lee Marvin), sent from Chicago to Kansas City to collect a debt from a murderous meatpacking magnate (Gene Hackman). But Hackman is peddling more than just sausages. He also keeps naked girls drugged and penned at his cattle ranch, available for sale to the highest bidder. "Cow-flesh, girl-flesh, all the same to me: what they're buying I'm selling."[28]

Easily lost in a summary of seventies concerns about capitalism is this crucial theme of market encroachment. At bottom, anxiety about marketization is not a dissent rooted in economics; it is not a protest against profits, wealth, or moneymaking more generally. It is instead the expression of a fundamental sociocultural concern: *Where* should the market rule? This is not a radical disposition; almost all nations, cultures, and institutions tend to "embed" the working of economic forces within some broader social purpose. Most countries have laws against people selling their organs; universities believe that grades are earned, not auctioned; cities protect landmark buildings from capitalists' wrecking balls. Mid-seventies economic distress—and the range of possible policy responses to it—pulled the underlying question of market encroachment closer to the surface. From the left, the seventies slide from idealism to hedonism disparaged tradition and suggested that everything had a price. From the right, the discipline of market forces appealed as a corrective to "big government."

New Hollywood filmmakers were in a position to be particularly sensitive to this dilemma of the market. On the one hand, they were voluntary participants in a commercial enterprise, in business to make money. Wealth was attractive for its own sake, and since movies are so expensive to make (and well beyond the means of most individuals), consistently losing money would make

it hard to attract investors for future productions. On the other hand, film-makers are artists, and many of them (and all of them worth taking seriously) seek to create something that expresses a vision which takes its place alongside other works of art. For the filmmaker, "the encroachment of the market" is often manifested as "studio interference," which is why those special, coveted deals of the period—those that traded low budgets for control over product—were part of what made the seventies film possible.[29]

The perennial conflict between art and commerce informed many seventies films (as did the related Faustian perils that come with the lure of potential hits). Particularly appealing, not surprisingly, were stories involving musicians, whose careers often presented parallel dilemmas. In *Cisco Pike,* Kris Kristofferson (who also wrote and performed the songs) is a onetime rock star out of step with changing times. Fresh out of prison, hoping to go straight and resurrect his career, he finds that other than his girlfriend (Karen Black), all of the players in an increasingly superficial, drug-addled L.A. music scene value him more as a dealer than as a musician. Gene Hackman co-stars as an appropriately malevolent (if somewhat undermotivated) cop; Harry Dean Stanton, as Cisco's former sidekick, shows up long enough to serve as a poster boy for the dark side of sex, drugs, and rock. *Cisco Pike* suggests that by 1972 the good old days were long gone. Another movie about a musician, *Payday* (1973), does little to disabuse its audience of that notion. Accurately promoted as "thirty-six hours in the life of a madman" (a magnetic, intense Rip Torn), the film shows the dispiriting state of (not quite big) stardom in America. Underneath it all a love of the music remains; but life on the road is an endless stream of deals with and payoffs to club owners, disc jockeys, and assorted wannabes and hangers-on. Maury Dann (Torn), obviously talented, is also chemically dependent, selfish, nasty, manipulative, and above all, enabled—by women who want to be near him and an entourage whose livelihoods depend on him. "Fix it" is his stock instruction to his manager, but Maury's talent for self-destruction, as shown in his last thirty-six hours, finally outpaces the ability of his minions to clean up the mess he leaves in his wake.

As discussed throughout this book, rock music was a primordially formative influence on the New Hollywood. The music was also "ahead of the curve"; rock became revolutionary, and important, a few years before the movies did. But its golden age also came to a close, once again getting there first, anticipating trends in American film. In August 1969, one month after men walked on the moon for the first time, the Woodstock festival reflected the idealized possibility of a hippie utopia. Half a million spectators overwhelmed the capacities of the event's organizers but managed to comport themselves with remarkable tranquility. Anything seemed possible, including the emergence of

a true "counterculture," a social movement of self-governance, essential music, recreational drug use, and free love. Less than six months later, however, the sixties came crashing down to earth at another free concert, headlined by the Rolling Stones at the Altamont Speedway outside San Francisco. The two free concerts, each captured on film, summarized the shift from hopes and dreams to lost illusions. Altamont is mostly remembered for the murder of an armed black audience member a few feet from the stage at the hands of an aggressive pack of Hells Angels. But the remarkable documentary *Gimme Shelter* (1970) paints an even more dispiriting picture, as that brutal stabbing was not an isolated incident. The entire frightening, chaotic "festival" was characterized by violent confrontations, mostly initiated by the Angels, who, providing "security," also prowled the stage, commandeered microphones, and leveled threats. Sets were interrupted by various commotions, as well as by (unheeded) pleas for calm from performers, including the Jefferson Airplane and the Stones themselves. There was always a potentially dark undercurrent to the sixties' shedding of inhibitions, and it was exposed on that December day.[30]

Altamont, closing the 1960s, was a portent for the end of the golden age of rock music, the sunset of which was suggested in 1970. One hundred days into the new decade, the Beatles split up. Once upon a time, their arrival on the scene heralded the start of something new; their departure from the stage, a breakup painfully depicted in the documentary *Let It Be* (1970), just as definitively signaled a curtain coming down. Paul, John, and George each released solo albums in 1970. "The dream is over," Lennon sang. "I don't believe in Beatles." George was more philosophical, as was his wont, observing with his album title, *All Things Must Pass.*

It wasn't just the Beatles who understood that times were changing. In August, Neil Young released his mournful *After the Gold Rush,* an album that "brooded over the problem of reconciling one's self to the denigration of the dream."[31] August was also the month of the disastrous Isle of Wight festival, which attracted as many as 600,000 young people off the coast of southern England. An event many hoped would recapture the spirit of peace, love, and understanding, instead (and once again recorded in discomforting detail by documentary filmmakers)[32] the festival, even more than Altamont, was the anti-Woodstock. Theoretically, at least, violence can be controlled and order maintained. But the Isle of Wight exposed deeper rifts in the would-be Woodstock nation. This festival's producers were determined, rudely and tactlessly, to make certain that its audience would pay in full; and the musicians, now often wealthy members of a new aristocracy, were becoming alienated from their increasingly jaded fans. Crowds pounded at the gates; others, within the grounds, were boorish. Kris Kristofferson ("I think they're going to shoot us," he told his band mates) cut short his set and walked off the stage; waiflike Joni

Mitchell stopped in mid-song to chastise the crowd. The Isle of Wight was not Woodstock's love child; it was its shady brother-in-law, and he had taken over.

It must be acknowledged that drugs and other contradictions within the counterculture contributed to the end of that golden age when rock music had real relevance. Arthur Penn's *Alice's Restaurant* (1969), released the same week Woodstock took place, offered a sympathetic but cautionary treatment of the counterculture. Outspokenly on the side of the sixties, with this film Penn nevertheless observed that in adulthood, free love sometimes leads to complications, and if everybody is hanging out and having fun, a lot of work will be left undone. He also reminded his audience of the lethal perils of drug abuse (this before the deaths of Jimi Hendrix and Janis Joplin, weeks apart in that watershed year of 1970). But it was a warning that went largely unheeded. Drugs (especially cocaine), hedonism, and irresponsibility would march through the 1970s, taking lives, derailing careers, and encouraging a headlong plunge into debauchery. If the psychedelics of the 1960s helped some musicians think creatively, in the 1970s cocaine mostly made people think they were brilliant; heroin made people dead.[33]

But even without the drugs, the market and marketization were going to have their way with rock and roll, and would prove to be even more relentlessly corrosive forces on the integrity of music. Whatever else they might have stood for, Woodstock and subsequent festivals revealed beyond doubt that there was a mass audience out there with a vast and untapped potential, and record company executives (and marketing agents everywhere) took notice. The ascent of corporate rock skewed incentives and changed the game. Money doesn't necessarily hurt the music (although handing very young people millions of dollars rarely works out well), but the search for a mass audience—big hits, big tours, big crowds—necessarily does. Rock music, which had only a decade previously been seen by many as genuinely *dangerous* in its mixed-race heritage, implicit politics, overt sexuality, and antiestablishment ideology, was by the mid-1970s to a large extent co-opted and folded into a mainstream commercial enterprise.

In ways that would previously have been unthinkable, musicians sold out, and music sold product. George Lucas, whose well-received dystopian science fiction drama *THX-1138* was a commercial disappointment, had a big hit in 1973 with *American Graffiti*, which peddled rock-as-nostalgia. Set comfortably in 1962, quite explicitly before the revolution, *Graffiti* was a step back from the cutting edge and toward integrating rock as one element of a packaged product.[34] Just as the era of the seventies film came to a close, the embedding of rock within commerce changed attitudes—of both rock stars and their audience—regarding what the music was about. Of the Rolling Stones' 1976 Album *Black and Blue*, legendary critic Lester Bangs concluded: "They

really don't matter anymore.... [T]his is the first *meaningless* Stones album."
Worse, he observed, "they are perfectly in tune with the times."[35]

Who Do You Love?

How did it come to this? *Shampoo* (1975), described by its producer and star
Warren Beatty as a film "about nice myopic people going to hell in a handcar
and not noticing," traces the roots of mid-seventies desolation back to that *annus horribilis* of 1968. Set on election eve and day, and shot in the naturalistic
style of cinematographer László Kovács, *Shampoo* brings the New Hollywood
full circle, back to the moment of Nixon's election. But rather than sharing a
story of heroic struggle, heartbreaking loss, or idealistic youth manning the
barricades, the film instead is "a study in narcissism," set, inevitably, in Los
Angeles.[36]

 Shampoo was the product of three occasionally clashing talents: Beatty
(who also co-wrote); his close associate Robert Towne, one of the most impor-
tant writers of the period (in addition to writing *The Last Detail* and *China-
town*, he was a coveted script doctor, contributing to *Bonnie and Clyde*, *Cisco
Pike*, *The Godfather*, and *The Parallax View*), and director Hal Ashby. Ashby,
following a highly successful run as an editor, had directed the cult favor-
ite *Harold and Maude* (1972) and *The Last Detail* (1973); his future credits
would include the extraordinary *Being There* (1979) and the Rolling Stones
concert film *Let's Spend the Night Together* (1982). Ashby also had a reputa-
tion for flexibility, which is one reason why Beatty, a notorious control freak,
hired him. Many of Ashby's friends thought the director was treated poorly
on the set, often squeezed behind the camera between Beatty and Towne, who
would call for retakes and even suggest the blocking of specific shots. *Sham-
poo* is in the final analysis a Beatty film with Towne's contributions widely
acknowledged, but it would be a mistake to underestimate Ashby's influence.
He was indeed behind the camera; he brought some of the innocent aspects of
the character to George (Beatty), actively engaged in preproduction rewrites
(first with Beatty, then with Towne, revealing a talent for shuttle diplomacy),
and had a relatively free hand in the editing room, which gave him consider-
able voice in the final cut. Ashby was also most influential in orchestrating the
film's crucial music: Paul Simon's minimalist score, used sparingly but always
in key moments, and the iconic rock music played during Sammy's party.[37]

 Shampoo is nominally a comedy about sex, in particular George's insa-
tiable, almost compulsive lovemaking. Over the course of twenty-four hours
he has sex with four different women (sometimes twice), flirts with count-
less others, and spends the rest of his time blurring the distinction between

George gets the heads in the shop

hairdressing and foreplay (the blow-dryer-as-fellatio shot is but one example of this). Moreover, that was the genre its audience was anticipating at the time, perhaps with the added attraction of a peek behind the curtain of stardom. The close similarities between the character George and the fantastically promiscuous Warren Beatty would not have been missed; George even takes phone calls during sex, one of the more colorful myths of the Beatty legend. Nor were they disappointed; *Shampoo* delivers as a sex farce with comedic timing that would have succeeded on the French stage.

But as befitting a seventies film, the sex in *Shampoo* is not about sex so much as it is a vehicle to explore troubled characters and broader themes. Underneath all the comedy is a serious and chastising message. And what distinguishes Beatty's film is that although it is certainly critical of Nixon's America, *Shampoo* is more interested in holding up a mirror to the American left, whose indifference and self-indulgences let Nixon happen. For Beatty, who admired and was greatly influenced by Bobby Kennedy, the election of Nixon "was the end of a lot of dreams." He would make only three movies between 1968 and 1974, turning down the lead role in what seemed like every major American film of that period. Instead he threw himself into the McGovern presidential campaign; after stumbling as a "celebrity presence" on the campaign trail, he retreated to a behind-the-scenes fundraising role. "He was one of the three or four most important people in the campaign," McGovern recalled, "and he never sought credit." Ashby, more of a free-spirited anarchist, was nevertheless also a deeply committed artist, most evident in a soul-baring letter written to his mother at two o'clock in the morning, hours after Bobby Kennedy's

assassination. Ashby thought that movies could make a difference in the world, as reflected in many of his choices: *The Landlord* (1970), a racially charged comedy-drama; *Bound for Glory* (1976), the Woody Guthrie biopic; and the post-Vietnam drama *Coming Home* (1978).[38]

"Nobody understood that it was about politics," Beatty would later complain, with some irritation. Those politics were poured into two key party scenes, one Republican and one (implicitly) Democratic, both of which were written by Beatty. The election party at the bistro takes its shots at the conservative establishment not for supporting Nixon, who, after all, represented their interests, but for their hypocrisy, a huge theme for Beatty, who wanted to express that "we're not being honest about the way we're governed . . . [and] we're not honest about what we stand for." Which returns us to the role of sexuality as a vehicle: for the producer-star, *Shampoo* is "about the intermingling of political and sexual hypocrisy."[39]

Nixon (and Agnew), seen throughout the film giving speeches on television, are presented for what they are. Ashby (who had associated Nixon's image with villains in previous pictures) used those clips that would provide the most irony in hindsight, with campaign and victory speech promises of "an open administration" that would "bring us together." But *Shampoo* suggests that the problems run much deeper. At the Republican dinner, Lester (Jack Warden), juggling wife and mistress, serves as one of the symbols of contemporary American hypocrisy. Coded throughout the film as the embodiment of capitalism, driving around in his Rolls-Royce (a radio tuned to the business news is his personal soundtrack), accompanied by henchmen prepared to do his bidding, Lester provides another characterization of capitalism as organized crime. His business "involves handling money for a lot of touchy people," which makes divorce a risky prospect for him, since any settlement would expose his books. Lester's political commitment derives solely from his need to keep track of which palms to grease.

That pro-Nixon dinner is famous for Julie Christie's line "Most of all, I'd like to suck his cock." Much has been made of this vulgarity, and the other very blunt language that startles the ears (at least it did in 1975), which the studio wanted cut and some critics decried as cheap sensationalism. But Beatty properly defends what was his addition as "more than a dirty moment where she says a dirty line."[40] It was instead the moment when political and sexual hypocrisy converged. Jackie (Christie) is responding to the advances of an older man, a respectable married Republican, who, sidling closer to her chair, assures her, "I can get you whatever you'd like." It was quite clear what *he* wanted, and what he would do to get it. Jackie's response burst the bubble of respectability that packaged his entreaty and exposed it for what it was.[41]

But it is the participants at the second party who are the true targets of Beatty's disapproval. "We set it on election night because the point is . . . Nixon never really misled us—he was an open book."[42] How, then, did he get elected? *Shampoo* argues that it was not due to the votes cast by his supporters, but because of the votes *not* cast by his opponents, the decadent indifference of those who *should* have opposed Nixon. Accused by Lester of being "antiestablishment," George, uttering a quick and sincere denial, is more than anything confused by the charge. He has no political views at all. He certainly didn't vote, nor did any of the other attendees at the massive party at Sammy's estate. And what a party—a hippie utopia of free-flowing sex and drugs, set against a backdrop of some of the best music ever recorded, by the Beatles, Neil Young, and Jimi Hendrix. (How the filmmakers got the rights is undoubtedly a story in itself.)[43] This was a group of childlike sybarites dancing while Rome burned.

Events at Sammy's party also set in motion a personal crisis in George's life. And when confronted about his infidelities by Jill (Goldie Hawn), he is forced to do something he has spent years avoiding: examine and explain his life. The result is a telling speech that cuts to the bone. At that moment, at least, it is hard to distinguish between George and Beatty, and it was a brave producer who left it in. It need not have been. As the scene was initially shot, George gives his speech towering over Jill, lecturing condescendingly that "everybody fucks everybody."[44] But it wasn't quite right. The scene was rewritten and reblocked, distancing the characters, isolating George, and yielding Beatty's remarkable, hesitant confession: "Let's face it; I fucked 'em all." Continuing with an emerging self-awareness, he articulates the thrill of it, how it makes his day, how "it makes me feel like I'm going to live forever."

George also admits that he should have accomplished more by this point in his life, not just linking his compulsive sexuality with a fear of death but recognizing it as a diversion from maturing into responsible adulthood. This is in accord with *his* visual motif: seen constantly in motion (usually in countless and otherwise unnecessary shots of him on his motorcycle) but to uncertain purpose. Or as Jill observes, "You never stop moving and you never get anywhere."

Jill and Jackie are done with waiting for George to grow up.[45] Jill ends their relationship; Jackie, to whom George finally professes his heartfelt love, is instead going to marry Lester. George pleads with her one final time, but she rebuffs his offer of marriage and leaves him on the hilltop. In a long shot, George watches as Jackie returns home, embraces Lester, climbs into his Rolls, and drives away. *Shampoo* is a comedy, though not in a Shakespearean sense; none of the characters leaves the film in a better place. Jackie has taken the money, Lester, Jill, and Felicia (Lester's wife, played by Lee Grant) have moved laterally, into modified versions of their previous lives. And George, following in the footsteps of a parade of seventies protagonists, is left defeated and alone, with the ghosts of his mistakes to keep him company.

All Things Must Pass

On November 25, 1976, The Band held its farewell concert at the Winterland Ballroom in San Francisco. Guest performers included, among other luminaries, Bob Dylan, Van Morrison, Neil Young, Eric Clapton, and Muddy Waters. Robbie Robertson, impressed with the knowing, essential integration of music in *Mean Streets,* hired Martin Scorsese to direct a concert film/documentary about the experience. Storyboarded in detail by Scorsese, the marathon event was recorded by seven cameras; Michael Chapman, László Kovács, and Vilmos Zsigmond were among the operators. The concert and subsequent film, *The Last Waltz,* captured the intimate partnership between the seventies film and the golden age of rock. But the New Hollywood, like The Band, did not make it to 1977.

Everything ends. To ask why the era of the seventies film came to a close risks losing sight of the answer by misstating the question. More remarkable is that the New Hollywood ever occurred. It was possible only because of an extraordinary coincidence of special attributes, when audience, industry, artists, politics, and society all converged around a certain moment. Each one of those elements was not in 1977 what it had been in 1966. In the intervening decade, the seventies film thrived. But it was as if a window that had opened in 1967—which provided the opportunity for a certain type of commercial film to flower—was closing shut ten years later. There would, of course, be great and even important films made in the following years and decades. But the movies would never again, collectively, matter as they did during the last golden age.

According to Warren Beatty, "what animated Hollywood in the '70s was politics. You can mark the end of that with the election of Carter," who assumed office on January 20, 1977.[46] Carter was the anti-Nixon: nobody hated him. A year before he took office, few had even heard of him. The Carter years were also the years of disco, the anti-rock. Whatever its appeals might be, no one would ever suggest that disco *mattered;* if anything, it was an invitation not to think, a goal of many at the time. Something had gone awry, and Tom Wolfe gave it a label, dubbing the seventies the "Me Decade." His long and uneven essay, which at its high point considered the social implications of Bergman's *Scenes from a Marriage,* managed to capture how the worst excesses of the 1960s seemed to have outlived the nobler aspirations of that decade.[47] Wolfe's smirking cynicism suggested a self-congratulatory satisfaction with this state of affairs, but his condemnation of the culture rang true. And the moviegoing audience was morphing into something very different as well. In 1966 critic Stanley Kauffmann coined the term "the Film Generation," designed to capture what he described as the "hunger for film that young people were full of in the sixties...the enthusiasm, the appetite, the avidity for film." But within two decades Kauffmann would write quite a different essay, bidding farewell to all that. In "After the

Film Generation," he "depicted the decline of this sensibility," a development he traced to the late 1970s and which he called "indisputable."[48]

As its audience was changing, Hollywood as a business was also regaining its footing after the very difficult years of the later 1960s, a time when studios lost fortunes, confidence, and a generation of old lions. But by the mid-1970s, the industry was in the midst of a run of flush years, and a younger generation of studio suits fancied themselves hip and in tune with the times. The business model was also changing, again. *Jaws,* released on June 25, 1975, "opened wide"—that is, it was released simultaneously on hundreds of screens across the country and was supported by an expensive advertising campaign. A standard practice today, these were innovations at the time, and they paid off. *Jaws* produced enormous grosses and is commonly seen as the first "summer blockbuster." But the birth of the blockbuster would fundamentally alter the relationship between movies and their audiences. Previously, films were released slowly and selectively before distribution in wider release, in order to capitalize on critical acclaim and positive word of mouth. Movies opening everywhere at once, however, aggressively marketed and highly dependent on the first few weeks of grosses, were less reliant on the opinions of cinephiles and the influence of serious critics. Talking about movies, and, worse, arguing about them, would become less important.

Big hits and big action and big stars also meant big money, and this changed the nature of the business as well. As the *scale* of production increased, so did the cost of making the average movie. Sinking a fortune into a film requires that it have a very large audience in order to recoup its investment, no less turn a profit. In such a business model, big, broad features with mass appeal are favored over smaller and edgier projects. As Pauline Kael noted at the time, although there had always been a tension between art and commerce, by the late 1970s "production and advertising costs have gone so high that there is genuine nervous panic about risky projects." Instead, studios turned to simple themes, "bankable" stars, and pre-packaged deals that were easier to advertise and locked in advance sales.[49]

It should also be recognized that after a run of breakthroughs and triumphs, many of the leading talents of the New Hollywood seemed to hit the wall as well. This is not surprising. Lightning can be caught in a bottle for only so long—as seen with the astonishing bursts of creativity from musicians which also came in waves that crested (for example, Dylan, 1962–1966; the Beatles, 1965–1969; Van Morrison, 1968–1972). Moreover, wealth, fame, and adulation can take their toll on the creative process: Scorsese's cocaine consumption almost killed him; Coppola became a caricature of Hollywood excess during his five-year trip from *Godfather II* to *Apocalypse Now*. Others, like Penn and Altman, avoided spectacular flameouts but nevertheless found themselves

coming down to earth from the heights of their earlier achievements, as did many notable members of that extraordinary seventies cohort.[50]

But the filmmakers were the least of the problem. Some of them may have stumbled, but by 1977 the New Hollywood was left on the side of the road by studios unwilling to finance its projects and audiences less interested in what it had to say. The culture was changing. On March 28, 1977, four seventies films—*All the President's Men* (Pakula), *Bound for Glory* (Ashby), *Network* (Lumet), and *Taxi Driver* (Scorsese)—were up for best picture at the forty-ninth annual Academy Awards. They lost, to *Rocky*, which also won for best director, John Avildsen, whose competition included Lumet, Pakula, and Ingmar Berman. *Rocky*, in the words of one critic, was a film "never concealing its intention to please" and "calculated to warm one's heart."[51] The story of a simple, decent underdog triumphing against all odds, *Rocky* was also a movie with an advertising campaign (and, increasingly in sequels, a lead character) that wrapped itself in the American flag. It thus anticipated the resurgence of conservative values and right-wing politics that would culminate in the Reagan Revolution of the 1980s.[52]

Less than two months after *Rocky* took home its Oscar, the blockbuster *Star Wars* sealed the deal: the business model and cultural sensibilities had entered a new age. "I realized after *THX* that people don't care about how the country is being ruined," said director George Lucas, who decided he no longer wanted to make "some angry, socially relevant film." He turned instead to upbeat themes. In 1964 David Newman and Robert Benton wrote of the New Sentimentality, anticipating the seventies film (as would their screenplay for *Bonnie and Clyde*). In 1977 Lucas favored the old sentimentality, looking back fondly on the 1950s which the New Hollywood had rejected. "Some of my friends are more concerned about art or being considered a Fellini or an Orson Welles, but I've never had that problem," Lucas insisted. "If I wasn't a film maker, I'd probably be a toy maker." And *Star Wars* was a toymaker's movie, a fable that pitted the powerful forces of unmitigated evil against the simple goodness of ragtag underdogs. Everybody loved *Star Wars,* it seemed, although Jonathan Rosenbaum found it "very clean and bloodless" and a "guiltless celebration of unlimited warfare."[53]

Before 1977 was out, Steven Spielberg followed up *Jaws* with another mammoth hit, *Close Encounters of the Third Kind.* In 1981 Lucas and Spielberg teamed up on yet another gigantic blockbuster, *Raiders of the Lost Ark.* For films like these, worldwide grosses were counted in the hundreds of millions. The stories were kept simple. There were good guys, and there were bad guys. (Or as Indiana Jones once observed of his adversaries: "Nazis. I hate these guys.") The good guys won. Moral ambiguity, the hallmark of the seventies film, was

out. Hollywood was no longer interested in small, challenging films; it was in the business of guessing what would please the largest possible mass audience.

This new equilibrium was further encouraged and reinforced by other basic changes that were transforming the industry and that discouraged support for the types of productions associated with the New Hollywood. International markets were becoming more and more important for a film's financial success. This shaped content, as certain types of movies—those with simple stories, fast-paced action, dizzying special effects, and broad physical comedy—translated most easily into foreign languages and across disparate cultures. At the same time, home viewing on videotape was also emerging as an important determinant of a movie's prospects for profitability. But this meant that movies would often be watched on the small screen, and back then, television screens were much smaller and much narrower (with a 4-to-3 aspect ratio) than found in homes today—and they certainly contrasted with the enormous wide screens found in theaters.[54] Commercial pressures were such that movies were increasingly made with an eye toward home viewing. Many productions even had a video consultant on the set who favored certain TV-friendly color patterns and encouraged directors to nudge the action toward the center of the frame. This, obviously, was not an environment friendly to filmmakers who valued subtle camera movements and ambitious visual compositions.

In sum, contra the confluence of conditions that facilitated the emergence of the New Hollywood, a very different status quo was emerging. It was characterized by big budgets, blockbuster ambitions, a bias toward action, effects, and physical comedy, and the aesthetic incentives of the early video era—all in the context of a newly confident industry and basic cultural and political shifts in American society more generally. It was a setting that could not have been better designed by a concierge eager to show the scruffy seventies film the door.

The effects of all this were swift and obvious. Robert Altman was offered a ton of money to direct something called "M*A*S*H II." But for his own projects, he said, "suddenly no one answered my phone calls." He sold his production company. "Every studio wants 'Raiders of the Lost Ark,'" he said at the time. "The movies I want to make the studios don't want, what they want to make, I don't."[55] Great movies would still be made in these less hospitable times. Indeed, it was even possible to make movies like *Manhattan* (Woody Allen, 1979), *Raging Bull* (Martin Scorsese, 1980), and *Prince of the City* (Sidney Lumet, 1981), which, had they come out a few years earlier, would have demanded close attention as important seventies films.[56] But films like these were exceptions to the new rules. The American film culture had changed. It wasn't about anything anymore. The era of the seventies film had passed.

APPENDIX:

100 SEVENTIES FILMS OF THE LAST GOLDEN AGE

Key: D: Director; W: Writer; P: Producer; C: Cinematographer; M: Music. Film titles in bold indicate twenty nominees for the seventies canon.

Mickey One (September 27, 1965)
D/P: Arthur Penn; W: Alan M. Surgal; C: Ghislain Cloquet; M: Eddie Sauter; With: Warren Beatty, Alexandra Stewart, Hurd Hatfield, Franchot Tone, Teddy Hart, Jeff Corey, Kamatari Fujiwara, Donna Michelle, Ralph Foody, Norman Gottschalk.

Seconds (October 5, 1966)
D: John Frankenheimer; W: Lewis John Carlino; P: Edward Lewis; C: James Wong Howe; M: Jerry Goldsmith; With: John Randolph, Frances Reid, Murray Hamilton, Thom Conroy, Jeff Corey, Will Geer, Richard Anderson, Rock Hudson, Wesley Addy, Salome Jens.

Blow-Up (December 18, 1966)
D/W: Michelangelo Antonioni; P: Carlo Ponti; C: Carlo di Palma; M: Herbie Hancock; With: Vanessa Redgrave, Sarah Miles, David Hemmings, John Castle, Jane Birkin, Gillian Hills, Peter Bowles, Veruschka von Lehndorff, Julian Chagrin, Claude Chagrin.

Bonnie and Clyde (August 13, 1967)
D: Arthur Penn; W: David Newman and Robert Benton; P: Warren Beatty; C: Burnett Guffey; M: Earl Scruggs; With: Warren Beatty, Faye Dunaway,

Michael J. Pollard, Gene Hackman, Estelle Parsons, Denver Pyle, Dub Taylor, Evans Evans, Gene Wilder.

Point Blank (August 30, 1967)
D: John Boorman; W: Donald E. Westlake (as Richard Stark), Alexander Jacobs, David Newhouse, and Rafe Newhouse; P: Judd Bernard and Robert Chartoff; C: Philip H. Lathrop; M: Johnny Mandel; With: Lee Marvin, Angie Dickinson, Keenan Wynn, Carroll O'Connor, Lloyd Bochner, Michael Strong, John Vernon, Sharon Acker, James Sikking, Sandra Warner.

Don't Look Back (September 6, 1967)
D/W: D. A. Pennebaker; P: John Court, Albert Grossman; C: Howard Alk, Jones Alk, Ed Emshwiller, D. A. Pennebaker; With: Bob Dylan, Albert Grossman, Bob Neuwirth, Joan Baez, Alan Price, Tito Burns, Donovan, Derroll Adams, Marianne Faithfull, Allen Ginsberg.

Who's That Knocking at My Door? (November 15, 1967)
D/W: Martin Scorsese; P: Betzi Manoogian, Haig Manoogian, and Joseph Weill; C: Richard H. Coll and Michael Wadleigh; With: Zina Bethune, Harvey Keitel, Anne Collette, Lennard Kuras, Michael Scala, Harry Northup, Tsuai Yu-Lan, Saskia Holleman, Catherine Scorsese.

The Graduate (December 21, 1967)
D: Mike Nichols; W: Calder Willingham and Buck Henry; P: Lawrence Turman; C: Robert Surtees; M: Dave Grusin and Paul Simon; With: Anne Bancroft, Dustin Hoffman, Katharine Ross, William Daniels, Murray Hamilton, Elizabeth Wilson, Buck Henry, Brian Avery, Walter Brooke, Norman Fell.

David Holzman's Diary (1967)
D/W/P: Jim McBride; C: Michael Wadleigh; With: L. M. Kit Carson, Eileen Dietz, Lorenzo Mans, Louise Levine, Fern McBride, Michel Lévine, Robert Lesser, Jack Baran.

2001: A Space Odyssey (April 2, 1968)
D/P: Stanley Kubrick; W: Stanley Kubrick and Arthur C. Clarke; C: Geoffrey Unsworth; With: Keir Dullea, Gary Lockwood, William Sylvester, Daniel Richter, Leonard Rossiter, Margaret Tyzack, Robert Beatty, Sean Sullivan, Douglas Rain.

Petulia (June 10, 1968)
D: Richard Lester; W: John Haase and Barbara Turner; P: Raymond Wagner; C: Nicolas Roeg; With: Julie Christie, George C. Scott, Richard Chamberlain,

Arthur Hill, Shirley Knight, Pippa Scott, Kathleen Widdoes, Roger Bowen, Joseph Cotten.

Bullitt (October 17, 1968)
D: Peter Yates; W: Alan Trustman and Harry Kleiner; P: Philip D'Antoni; C: William A. Fraker; M: Lalo Schifrin; With: Steve McQueen, Jacqueline Bisset, Robert Vaughn, Don Gordon, Simon Oakland, Norman Fell, Robert Duvall, Georg Stanford Brown, Justin Tarr, Vic Tayback.

Faces (November 24, 1968)
D/W: John Cassavetes; P: Maurice McEndree; C: Al Ruban; With: John Marley, Gena Rowlands, Lynn Carlin, Fred Draper, Seymour Cassel, Val Avery, Dorothy Gulliver, Joanne Moore Jordan, Darlene Conley, Gene Darfler, Elizabeth Deering.

Greetings (December 15, 1968)
D: Brian De Palma; W: Charles Hirsch and Brian De Palma; P: Charles Hirsch; C: Robert Fiore; M: Eric Kaz, J. Stephen Soles and Artie Traum; With: Jonathan Warden, Robert De Niro, Gerrit Graham, Richard Hamilton, Megan McCormick, Tina Hirsch, Jack Cowley, Jane Lee Salmons, Ashley Oliver, Melvin Morgulis.

Midnight Cowboy (May 25, 1969)
D: John Schlesinger; W: Waldo Salt; P: Jerome Hellman; C: Adam Holender; M: John Barry; With: Dustin Hoffman, Jon Voight, Sylvia Miles, John McGiver, Brenda Vaccaro, Barnard Hughes, Ruth White, Jennifer Salt, Gilman Rankin, Bob Balaban.

The Wild Bunch (June 18, 1969)
D: Sam Peckinpah; W: (screenplay) Walon Green and Sam Peckinpah, (story) Walon Green and Roy N. Sickner; P: Phil Feldman; C: Lucien Ballard; M: Jerry Fielding; With: William Holden, Ernest Borgnine, Robert Ryan, Edmond O'Brien, Warren Oates, Jaime Sánchez, Ben Johnson, Emilio Fernández, Strother Martin, L. Q. Jones, Albert Dekker, Bo Hopkins.

The Lost Man (July 11, 1969)
D/W: Robert Alan Arthur; P: Edward Muhl, Melville Tucker; C: Jerry Finnerman; M: Quincy Jones; With: Sidney Poitier, Joanna Shimkus, Al Freeman Jr., Michael Tolan, Leon Bibb, Richard Dysart, David Steinberg, Beverly Todd, Paul Winfield, Bernie Hamilton.

Easy Rider (July 14, 1969)
D: Dennis Hopper; W: Peter Fonda, Dennis Hopper, and Terry Southern; P: Peter Fonda; C: László Kovács; With: Peter Fonda, Dennis Hopper, Antonio Mendoza, Phil Spector, Luke Askew, Luana Anders, Sabrina Scharf, Jack Nicholson, Toni Basil, Karen Black.

Medium Cool (August 27, 1969)
D/W/C: Haskell Wexler; P: Tully Friedman, Haskell Wexler, and Jerrold Wexler; M: Mike Bloomfield; With: Robert Forster, Verna Bloom, Peter Bonerz, Marianna Hill, Harold Blankenship, Charles Geary, Sid McCoy, Christine Bergstrom, William Sickingen, Peter Boyle.

Alice's Restaurant (August 20, 1969)
D: Arthur Penn; W: Arlo Guthrie (song "The Alice's Restaurant Massacree"), Venable Herndon, and Arthur Penn; P: Hillard Elkins and Joseph Manduke (as Joe Manduke); C: Michael Nebbia; M: Arlo Guthrie; With: Arlo Guthrie, Patricia Quinn, James Broderick, Pete Seeger, Lee Hays, Michael McClanathan, Geoff Outlaw, Tina Chen, Kathleen Dabney, William Obanhein.

The Rain People (August 27, 1969)
D/W: Francis Ford Coppola; P: Ronald Colby and Bart Patton; C: Bill Butler; M: Ronald Stein; With: James Caan, Shirley Knight, Robert Duvall, Marya Zimmet, Tom Aldredge, Laura Crews, Andrew Duncan, Margaret Fairchild, Sally Gracie, Alan Manson, Robert Modica.

Bob & Carol & Ted & Alice (September 17, 1969)
D: Paul Mazursky; W: Paul Mazursky and Larry Tucker; P: Larry Tucker; C: Charles Lang; M: Quincy Jones; With: Natalie Wood, Elliott Gould, Robert Culp, Dyan Cannon, Horst Ebersberg, Lee Bergere, Donald F. Muhich, Noble Lee Holderread Jr., K. T. Stevens, Celeste Yarnall, Lynn Borden.

*M*A*S*H* (January 25, 1970)
D: Robert Altman; W: Ring Lardner Jr.; P: Ingo Preminger; C: Harold E. Stine; M: Johnny Mandel; With: Donald Sutherland, Elliott Gould, Tom Skerritt, Sally Kellerman, Robert Duvall, Roger Bowen, Rene Auberjonois, David Arkin, Jo Ann Pflug, Gary Burghoff, Fred Williamson, Michael Murphy.

The Boys in the Band (March 17, 1970)
D: William Friedkin; W: Mart Crowley; P: Mart Crowley; C: Arthur J. Ornitz; With: Kenneth Nelson, Frederick Combs, Cliff Gorman, Laurence Luckinbill, Keith Prentice, Peter White, Reuben Greene, Robert La Tourneaux, Leonard Frey.

Woodstock (March 26, 1970)
D: Michael Wadleigh; P: Bob Maurice; C: Malcolm Hart, Don Lenzer, Michael Margetts, David Myers, Richard Pearce, Michael Wadleigh, Al Wertheimer; With: Richie Havens, Joan Baez, The Who, Joe Cocker, Crosby Stills and Nash, Santana, Sly and the Family Stone, Janis Joplin, Jimi Hendrix.

Catch-22 (June 24, 1970)
D: Mike Nichols; W: Buck Henry; P: John Calley and Martin Ransohoff; C: David Watkin; With: Alan Arkin, Martin Balsam, Richard Benjamin, Art Garfunkel, Jack Gilford, Buck Henry, Bob Newhart, Anthony Perkins, Paula Prentiss, Martin Sheen, Jon Voight, Orson Welles, Bob Balaban, Norman Fell, Charles Grodin, Peter Bonerz.

Performance (August 3, 1970)
D: Donald Cammell and Nicolas Roeg; W: Donald Cammell; P: Sanford Lieberson; C: Nicholas Roeg; M: Jack Nitzsche; With: James Fox, Mick Jagger, Anita Pallenberg, Michèle Breton, Ann Sidney, John Bindon, Stanley Meadows, Allan Cuthbertson, Anthony Morton.

WUSA (August 19, 1970)
D: Stuart Rosenberg; W: Robert Stone; P: John Foreman and Paul Newman; C: Richard Moore; M: Lalo Schifrin; With: Paul Newman, Joanne Woodward, Anthony Perkins, Laurence Harvey, Pat Hingle, Don Gordon, Michael Anderson Jr., Leigh French, Bruce Cabot, Cloris Leachman.

Five Easy Pieces (September 11, 1970)
D: Bob Rafelson; W: (screenplay) Carole Eastman (as Adrien Joyce), (story) Carole Eastman and Bob Rafelson; P: Bob Rafelson and Richard Wechsler; C: László Kovács; With: Jack Nicholson, Karen Black, Billy Green Bush, Fannie Flagg, Sally Struthers, Richard Stahl, Lois Smith, Helena Kallianiotes, Toni Basil, Lorna Thayer, Susan Anspach, Ralph Waite, William Challee, John P. Ryan, Irene Dailey.

Husbands (October 1970)
D/W: John Cassavetes; P: Al Ruban; C: Victor J. Kemper; M: Ray Brown (additional music); With: Ben Gazzara, Peter Falk, John Cassavetes, Jenny Runacre, Jenny Lee Wright, Noelle Kao, John Kullers, Meta Shaw Stevens, Leola Harlow, Delores Delmar.

Gimme Shelter (December 6, 1970)
D: Albert Maysles, David Maysles, Charlotte Zwerin; P: Porter Bibb, Ronald Schneider; C: Albert Maysles, David Maysles; With: Mick Jagger, Keith Richards, Mick Taylor. Charlie Watts, Bill Wyman.

Little Big Man (December 14, 1970)
D: Arthur Penn; W: Calder Willingham; P: Stuart Millar; C: Harry Stradling Jr.; M: John Hammond; With: Dustin Hoffman, Faye Dunaway, Chief Dan George, Martin Balsam, Richard Mulligan, Jeff Corey, Aimée Eccles, Kelly Jean Peters, Carole Androsky, Robert Little Star, William Hickey.

Puzzle of a Downfall Child (December 16, 1970)
D: Jerry Schatzberg; W: Carole Eastman; P: John Foreman; C: Adam Holender; M: Michael Small; With: Faye Dunaway, Barry Primus, Viveca Lindfors, Barry Morse, Roy Scheider, Ruth Jackson, John Heffernan, Sydney Walker, Clark Burckhalter, Shirley Rich.

Little Murders (February 9, 1971)
D: Alan Arkin; W: Jules Feiffer; P: Jack Brodsky; C: Gordon Willis; M: Fred Kaz; With: Elliott Gould, Marcia Rodd, Vincent Gardenia, Elizabeth Wilson, Jon Korkes, John Randolph, Doris Roberts, Lou Jacobi, Donald Sutherland, Alan Arkin.

Wanda (February 28, 1971)
D/W: Barbara Loden; P: Harry Shuster; C: Nicholas T. Proferes; With: Barbara Loden, Michael Higgins, Dorothy Shupenes, Peter Shupenes, Jerome Thier, Marian Thier, Anthony Rotell, M. L. Kennedy, Gerald Grippo.

Bananas (April 28, 1971)
D: Woody Allen; W: Woody Allen and Mickey Rose; P: Jack Grossberg; C: Andrew M. Costikyan; M: Marvin Hamlisch; With: Woody Allen, Louise Lasser, Carlos Montalbán, Nati Abascal, Jacobo Morales, Miguel Ángel Suárez, David Ortiz, René Enríquez, Howard Cosell, Charlotte Rae, Stanley Ackerman, Dan Frazier.

Drive, He Said (June 13, 1971)
D: Jack Nicholson; W: Jeremy Larner and Jack Nicholson; P: Steve Blauner and Jack Nicholson; C: Bill Butler; M: David Shire; With: William Tepper, Karen Black, Michael Margotta, Bruce Dern, Robert Towne, Henry Jaglom, Michael Warren, June Fairchild, Charles Robinson, Bill Sweek, David Ogden Stiers.

Klute (June 23, 1971)
D: Alan J. Pakula; W: Andy Lewis and David P. Lewis; P: Alan J. Pakula and David Lange (co-producer); C: Gordon Willis; M: Michael Small; With: Jane Fonda, Donald Sutherland, Charles Cioffi, Roy Scheider, Dorothy Tristan, Rita Gam, Nathan George, Vivian Nathan, Morris Strassberg, Jean Stapleton.

McCabe & Mrs. Miller (June 24, 1971)
D: Robert Altman; W: Robert Altman and Brian McKay; P: Mitchell Brower and David Foster; C: Vilmos Zsigmond; M: Leonard Cohen; With: Warren Beatty, Julie Christie, Rene Auberjonois, William Devane, John Schuck, Corey Fischer, Bert Remsen, Shelley Duvall, Keith Carradine, Michael Murphy.

Carnal Knowledge (June 30, 1971)
D/P: Mike Nichols; W: Jules Feiffer; C: Giuseppe Rotunno; With: Jack Nicholson, Ann-Margret, Art Garfunkel, Candice Bergen, Rita Moreno, Cynthia O'Neal, Carol Kane.

Two-Lane Blacktop (July 7, 1971)
D: Monte Hellman; W: Rudy Wurlitzer and Will Corry; P: Michael Laughlin; C: Jack Deerson; M: Billy James; With: James Taylor, Warren Oates, Laurie Bird, Dennis Wilson, David Drake, Richard Ruth, Rudy Wurlitzer, Jaclyn Hellman, Bill Keller, Harry Dean Stanton.

The Panic in Needle Park (July 13, 1971)
D: Jerry Schatzberg; W: Joan Didion and John Gregory Dunne; P: Dominick Dunne; C: Adam Holender; With: Al Pacino, Kitty Winn, Alan Vint, Richard Bright, Kiel Martin, Michael McClanathan, Warren Finnerty, Marcia Jean Kurtz, Raul Julia, Angie Ortega, Paul Sorvino.

The Hired Hand (August 11, 1971)
D: Peter Fonda; W: Alan Sharp; P: William Hayward; C: Vilmos Zsigmond; M: Bruce Langhorne; With: Peter Fonda, Warren Oates, Verna Bloom, Robert Pratt, Severn Darden, Rita Rogers, Ann Doran, Ted Markland, Owen Orr, Michael McClure.

Sunday Bloody Sunday (September 8, 1971)
D: John Schlesinger; W: Penelope Gilliatt; P: Joseph Janni; C: Billy Williams; M: Ron Geesin; With: Peter Finch, Glenda Jackson, Murray Head, Peggy Ashcroft, Tony Britton, Maurice Denham, Bessie Love, Vivian Pickles, Frank Windsor, Thomas Baptiste.

The Last Picture Show (October 3, 1971)
D: Peter Bogdanovich; W: Larry McMurtry and Peter Bogdanovich; P: Stephen J. Friedman; C: Robert Surtees; With: Timothy Bottoms, Jeff Bridges, Cybill Shepherd, Ben Johnson, Cloris Leachman, Ellen Burstyn, Eileen Brennan, Clu Gulager, Sam Bottoms, Sharon Ullrick, Randy Quaid.

The French Connection (October 7, 1971)
D: William Friedkin; W: Ernest Tidyman; P: Philip D'Antoni; C: Owen Roizman; M: Don Ellis; With: Gene Hackman, Fernando Rey, Roy Scheider, Tony Lo Bianco, Marcel Bozzuffi, Frédéric de Pasquale, Bill Hickman, Ann Rebbot, Harold Gary, Arlene Farber.

Born to Win (December 1, 1971)
D: Ivan Passer; W: David Scott Milton and Ivan Passer; P: Philip Langner; C: Richard C. Kratina and Jack Priestley; M: William Fischer; With: George Segal, Karen Black, Paula Prentiss, Jay Fletcher, Hector Elizondo, Robert De Niro, Ed Madsen, Marcia Jean Kurtz, Irving Selbst, Tim Pelt.

The Hospital (December 14, 1971)
D: Arthur Hiller; W: Paddy Chayefsky; P: Howard Gottfried; C: Victor J. Kemper; M: Morris Surdin; With: George C. Scott, Diana Rigg, Barnard Hughes, Richard Dysart, Stephen Elliott, Andrew Duncan, Donald Harron, Nancy Marchand, Jordan Charney, Katherine Helmond.

Cisco Pike (January 14, 1972)
D/W: Bill L. Norton; P: Gerald Ayres; C: Vilis Lapenieks; With: Kris Kristofferson, Karen Black, Gene Hackman, Harry Dean Stanton, Viva, Joy Bang, Roscoe Lee Browne, Severn Darden, Antonio Fargas, Howard Hesseman, Allan Arbus.

The Godfather (March 15, 1972)
D: Francis Ford Coppola; W: Mario Puzo and Francis Ford Coppola; P: Albert S. Ruddy; C: Gordon Willis; M: Nino Rota; With: Marlon Brando, Al Pacino, James Caan, Richard S. Castellano, Robert Duvall, Sterling Hayden, John Marley, Richard Conte, Al Lettieri, Diane Keaton, Abe Vigoda, Talia Shire, John Cazale.

Prime Cut (June 28, 1972)
D: Michael Ritchie; W: Robert Dillon; P: Joe Wizan; C: Gene Polito; M: Lalo Schifrin; With: Lee Marvin, Gene Hackman, Angel Tompkins, Gregory Walcott, Sissy Spacek, Janit Baldwin, William Morey, Clint Ellison, Howard Platt, Les Lannom, Eddie Egan.

The Candidate (June 29, 1972)
D: Michael Ritchie; W: Jeremy Larner; P: Walter Coblenz; C: Victor J. Kemper; M: John Rubinstein; With: Robert Redford, Peter Boyle, Melvyn Douglas, Don Porter, Allen Garfield, Karen Carlson, Quinn K. Redeker, Morgan Upton, Michael Lerner, Kenneth Tobey.

Fat City (July 26, 1972)
D: John Huston; W: Leonard Gardner; P: John Huston and Ray Stark; C: Conrad L. Hall; With: Stacy Keach, Jeff Bridges, Susan Tyrrell, Candy Clark, Nicholas Colasanto, Art Aragon, Curtis Cokes, Sixto Rodriguez, Billy Walker, Wayne Mahan, Ruben Navarro.

Deliverance (July 30, 1972)
D/P: John Boorman; W: James Dickey; C: Vilmos Zsigmond; With: Jon Voight, Burt Reynolds, Ned Beatty, Ronny Cox, Ed Ramey, Billy Redden, Bill McKinney, Herbert "Cowboy" Coward, James Dickey.

Hickey & Boggs (September 20, 1972)
D: Robert Culp; W: Walter Hill; P: Fouad Said; C: Bill Butler; M: Ted Ashford; With: Bill Cosby, Robert Culp, Ta-Ronce Allen, Rosalind Cash, Lou Frizzell, Isabel Sanford, Sheila Sullivan, Robert Mandan, Michael Moriarty, Vincent Gardenia, James Woods.

The King of Marvin Gardens (October 12, 1972)
D/P: Bob Rafelson; W: Jacob Brackman (screenplay), Bob Rafelson and Jacob Brackman (story); C: László Kovács; With: Jack Nicholson, Bruce Dern, Ellen Burstyn, Julia Anne Robinson, Scatman Crothers, Charles LaVine, Arnold Williams, John P. Ryan, Sully Boyar, Josh Mostel, William Pabst.

Last Tango in Paris (October 14, 1972)
D: Bernardo Bertolucci; W: Bernardo Bertolucci and Franco Arcalli; P: Alberto Grimaldi; C: Vittorio Storaro; M: Gato Barbieri; With: Marlon Brando, Maria Schneider, Maria Michi, Giovanna Galletti, Gitt Magrini, Catherine Allégret, Luce Marquand, Marie-Hélène Breillat, Catherine Breillat, Jean-Pierre Léaud

Ulzana's Raid (October 18, 1972)
D: Robert Aldrich; W: Alan Sharp; P: Carter DeHaven; C: Joseph F. Biroc; M: Frank De Vol; With: Burt Lancaster, Bruce Davison, Jorge Luke, Richard Jaeckel, Joaquín Martínez, Lloyd Bochner, Karl Swenson, Douglass Watson, Dran Hamilton, John Pearce, Gladys Holland, Margaret Fairchild.

The Heartbreak Kid (December 17, 1972)
D: Elaine May; W: Neil Simon; P: Edgar J. Scherick; C: Owen Roizman; M: Garry Sherman; With: Charles Grodin, Cybill Shepherd, Jeannie Berlin, Audra Lindley, Eddie Albert, Mitchell Jason, William Prince, Augusta Dabney, Doris Roberts.

Images (December 18, 1972)
D/W: Robert Altman; P: Tommy Thompson; C: Vilmos Zsigmond; M: John Williams; With: Susannah York, Rene Auberjonois, Marcel Bozzuffi, Hugh Millais, Cathryn Harrison, John Morley.

Payday (February 22, 1973)
D: Daryl Duke; W: Don Carpenter; P: Martin Fink; C: Richard C. Glouner; M: Ed Bogas, Tommy McKinney, Shel Silverstein, Ian Tyson, and Sylvia Tyson; With: Rip Torn, Ahna Capri, Elayne Heilveil, Michael C. Gwynne, Jeff Morris, Cliff Emmich, Henry O. Arnold, Bobby Smith, Dallas Smith, Richard Hoffman.

The Long Goodbye (March 7, 1973)
D: Robert Altman; W: Leigh Brackett; P: Jerry Bick; C: Vilmos Zsigmond; M: John Williams; With: Elliott Gould, Nina Van Pallandt, Sterling Hayden, Mark Rydell, Henry Gibson, David Arkin, Jim Bouton, Warren Berlinger, Jo Ann Brody, Stephen Coit, Jack Riley, David Carradine.

Scarecrow (April 11, 1973)
D: Jerry Schatzberg; W: Garry Michael White; P: Robert M. Sherman; C: Vilmos Zsigmond; M: Fred Myrow; With: Gene Hackman, Al Pacino, Dorothy Tristan, Ann Wedgeworth, Richard Lynch, Eileen Brennan, Penelope Allen, Richard Hackman, Al Cingolani, Rutanya Alda.

Pat Garrett and Billy the Kid (May 23, 1973)
D: Sam Peckinpah; W: Rudy Wurlitzer; P: Gordon Carroll; C: John Coquillon; M: Bob Dylan; With: James Coburn, Kris Kristofferson, Richard Jaeckel, Katy Jurado, Chill Wills, Barry Sullivan, Jason Robards, Bob Dylan, R. G. Armstrong, Rita Coolidge, Slim Pickens, Harry Dean Stanton, Elisha Cook Jr., Sam Peckinpah

Blume in Love (June 17, 1973)
D/W/P: Paul Mazursky; C: Bruce Surtees; M: Bill Conti; With: George Segal, Susan Anspach, Kris Kristofferson, Marsha Mason, Shelley Winters, Donald F. Muhich, Paul Mazursky, Erin O'Reilly, Annazette Chase, Shelley Morrison.

The Friends of Eddie Coyle (June 26, 1973)
D: Peter Yates; W/P: Paul Monash; C: Victor J. Kemper; M: Dave Grusin; With: Robert Mitchum, Peter Boyle, Richard Jordan, Steven Keats, Alex Rocco, Joe Santos, Mitch Ryan, Peter MacLean, Kevin O'Morrison, Marvin Lichterman, Carolyn Pickman, Helena Carroll.

American Graffiti (August 1, 1973)
D: George Lucas; W: George Lucas, Gloria Katz and Willard Huyck; P: Francis Ford Coppola; C: Jan D'Alquen and Ron Eveslage; With: Richard Dreyfuss, Ron Howard, Paul Le Mat, Charles Martin Smith, Cindy Williams, Candy Clark, Mackenzie Phillips, Wolfman Jack, Bo Hopkins, Manuel Padilla Jr., Beau Gentry, Harrison Ford, Suzanne Somers.

Mean Streets (October 2, 1973)
D: Martin Scorsese; W: Martin Scorsese and Mardik Martin; P: Jonathan T. Taplin; C: Kent L. Wakeford; With: Robert De Niro, Harvey Keitel, David Proval, Amy Robinson, Richard Romanus, Cesare Danova, George Memmoli, Lenny Scaletta, Jeannie Bell, Murray Moston, Martin Scorsese.

Badlands (October 13, 1973)
D/W/P: Terrence Malick; C: Tak Fujimoto, Stevan Larner, and Brian Probyn; M: George Aliceson Tipton; With: Martin Sheen, Sissy Spacek, Warren Oates, Ramon Bieri, Alan Vint, Gary Littlejohn, John Carter, Bryan Montgomery, Gail Threlkeld, Charles Fitzpatrick.

Charley Varrick (October 19, 1973)
D/P: Don Siegel; W: Howard Rodman and Dean Riesner; C: Michael C. Butler; M: Lalo Schifrin; With: Walter Matthau, Joe Don Baker, Felicia Farr, Andy Robinson, Sheree North, Norman Fell, Benson Fong, Woodrow Parfrey, William Schallert, Jacqueline Scott, Marjorie Bennett.

Breezy (November 18, 1973)
D: Clint Eastwood; W: Jo Heims; P: Robert Daley; C: Frank Stanley; M: Michel Legrand; With: William Holden, Kay Lenz, Roger C. Carmel, Marj Dusay, Joan Hotchkis, Jamie Smith-Jackson, Norman Bartold, Lynn Borden, Shelley Morrison, Dennis Olivieri.

Serpico (December 5, 1973)
D: Sidney Lumet; W: Waldo Salt and Norman Wexler; P: Martin Bregman; C: Arthur J. Ornitz; M: Mikis Theodorakis; With: Al Pacino, John Randolph, Jack Kehoe, Biff McGuire, Barbara Eda-Young, Cornelia Sharpe, Tony Roberts, John Medici, Allan Rich, Norman Ornellas.

Don't Look Now (December 9, 1973)
D: Nicolas Roeg; W: Allan Scott and Chris Bryant; P: Peter Katz; C: Anthony B. Richmond; M: Pino Donaggio; With: Julie Christie, Donald Sutherland, Hilary Mason, Clelia Matania, Massimo Serato, Renato Scarpa, Giorgio

Trestini, Leopoldo Trieste, David Tree, Ann Rye, Nicholas Salter, Sharon Williams, Bruno Cattaneo, Adelina Poerio.

The Last Detail (December 12, 1973)
D: Hal Ashby; W: Robert Towne; P: Gerald Ayres; C: Michael Chapman; M: Johnny Mandel; With: Jack Nicholson, Otis Young, Randy Quaid, Clifton James, Carol Kane, Michael Moriarty, Luana Anders, Kathleen Miller, Nancy Allen, Gerry Salsberg.

The Laughing Policeman (December 20, 1973)
D/P: Stuart Rosenberg; W: Thomas Rickman; C: David M. Walsh; M: Charles Fox; With: Walter Matthau, Bruce Dern, Louis Gossett Jr., Albert Paulsen, Anthony Zerbe, Val Avery, Cathy Lee Crosby, Mario Gallo, Joanna Cassidy, Shirley Ballard.

The Conversation (April 7, 1974)
D/W/P: Francis Ford Coppola; C: Bill Butler; M: David Shire; With: Gene Hackman, John Cazale, Allen Garfield, Frederic Forrest, Cindy Williams, Michael Higgins, Elizabeth MacRae, Teri Garr, Harrison Ford, Robert Duvall.

The Parallax View (June 14, 1974)
D/P: Alan J. Pakula; W: David Giler and Lorenzo Semple Jr.; C: Gordon Willis; M: Michael Small; With: Warren Beatty, Paula Prentiss, William Daniels, Walter McGinn, Hume Cronyn, Kelly Thordsen, Chuck Waters, Earl Hindman, William Joyce, Bettie Johnson.

Chinatown (June 20, 1974)
D: Roman Polanski; W: Robert Towne; P: Robert Evans; C: John A. Alonzo; M: Jerry Goldsmith; With: Jack Nicholson, Faye Dunaway, John Huston, Perry Lopez, John Hillerman, Darrell Zwerling, Diane Ladd, Roy Jenson, Roman Polanski, Richard Bakalyan, Joe Mantell, Bruce Glover, James Hong, Burt Young.

California Split (August 7, 1974)
D: Robert Altman; W: Joseph Walsh; P: Robert Altman and Joseph Walsh; C: Paul Lohmann; With: George Segal, Elliott Gould, Ann Prentiss, Gwen Welles, Edward Walsh, Joseph Walsh, Bert Remsen, Barbara London, Barbara Ruick, Jay Fletcher, Jeff Goldblum.

The Gambler (October 1974)
D: Karel Reisz; W: James Toback; P: Robert Chartoff and Irwin Winkler; C: Victor J. Kemper; M: Jerry Fielding; With: James Caan, Paul Sorvino, Lauren

Hutton, Morris Carnovsky, Jacqueline Brookes, Burt Young, Carmine Caridi, Vic Tayback, Steven Keats, London Lee, M. Emmet Walsh, James Woods.

The Taking of Pelham One Two Three (October 2, 1974)
D: Joseph Sargent; W: Peter Stone; P: Gabriel Katzka and Edgar J. Scherick; C: Owen Roizman; M: David Shire; With: Walter Matthau, Robert Shaw, Martin Balsam, Hector Elizondo, Earl Hindman, James Broderick, Dick O'Neill, Lee Wallace, Tom Pedi, Beatrice Winde, Jerry Stiller, Doris Roberts, Tony Roberts.

A Woman under the Influence (October 12, 1974)
D/W: John Cassavetes; P: Sam Shaw; C: Caleb Deschanel; M: Bo Harwood; With: Peter Falk, Gena Rowlands, Fred Draper, Lady Rowlands, Katherine Cassavetes, Matthew Labyorteaux, Matthew Cassel, Christina Grisanti, O. G. Dunn, Mario Gallo.

Lenny (November 10, 1974)
D: Bob Fosse; W: Julian Barry; P: Marvin Worth; C: Bruce Surtees; M: Ralph Burns; With: Dustin Hoffman, Valerie Perrine, Jan Miner, Stanley Beck, Frankie Man, Rashel Novikoff, Gary Morton, Guy Rennie, Michele Yonge, Kathryn Witt.

Alice Doesn't Live Here Anymore (December 9, 1974)
D: Martin Scorsese; W: Robert Getchell; P: Audrey Maas and David Susskind; C: Kent L. Wakeford; M: Richard LaSalle; With: Ellen Burstyn, Alfred Lutter III, Billy Green Bush, Harvey Keitel, Lane Bradbury, Diane Ladd, Vic Tayback, Valerie Curtin, Kris Kristofferson, Jodie Foster.

The Godfather, Part II (December 12, 1974)
D/P: Francis Ford Coppola; W: Francis Ford Coppola and Mario Puzo; C: Gordon Willis; M: Nino Rota; With: Al Pacino, Robert Duvall, Diane Keaton, Robert De Niro, John Cazale, Talia Shire, Lee Strasberg, Michael V. Gazzo, G. D. Spradlin, Richard Bright, Harry Dean Stanton, Danny Aiello, Roger Corman.

Shampoo (March 13, 1975)
D: Hal Ashby; W: Robert Towne and Warren Beatty; P: Warren Beatty; C: László Kovács; M: Paul Simon; With: Warren Beatty, Julie Christie, Goldie Hawn, Lee Grant, Jack Warden, Tony Bill, George Furth, Jay Robinson, Ann Weldon, Luana Anders, Carrie Fisher.

The Yakuza (March 19, 1975)
D/P: Sydney Pollack; W: Paul Schrader and Robert Towne; C: Kôzô Okazaki; M: Dave Grusin; With: Robert Mitchum, Ken Takakura, Brian Keith, Herb

Edelman, Richard Jordan, Keiko Kishi, Eiji Okada, James Shigeta, Kyôsuke Machida, Christina Kokubo, Eiji Gô.

The Passenger (April 9, 1975)
D: Michelangelo Antonioni; W: Mark Peploe, Peter Wollen, and Michelangelo Antonioni; P: Carlo Ponti; C: Luciano Tovoli; M: Ivan Vandor; With: Jack Nicholson, Maria Schneider, Jenny Runacre, Ian Hendry, Steven Berkoff, Ambroise Bia, José María Caffarel, James Campbell, Manfred Spies, Jean-Baptiste Tiemele, Angel del Pozo, Charles Mulvehill.

Posse (June 4, 1975)
D/P: Kirk Douglas; W: Christopher Knopf and William Roberts; C: Fred J. Koenekamp; M: Maurice Jarre; With: Kirk Douglas, Bruce Dern, Bo Hopkins, James Stacy, Luke Askew, David Canary, Alfonso Arau, Katherine Woodville, Mark Roberts, Beth Brickell, Dick O'Neill.

Nashville (June 11, 1975)
D/P: Robert Altman; W: Joan Tewkesbury; C: Paul Lohmann; With: David Arkin, Barbara Baxley, Ned Beatty, Karen Black, Ronee Blakley, Timothy Brown, Keith Carradine, Geraldine Chaplin, Robert DoQui, Shelley Duvall, Allen Garfield, Henry Gibson, Scott Glenn, Jeff Goldblum, Barbara Harris, David Hayward, Michael Murphy, Allan F. Nicholls, Dave Peel, Cristina Raines, Bert Remsen, Lily Tomlin, Gwen Welles, Keenan Wynn.

Night Moves (June 11, 1975)
D: Arthur Penn; W: Alan Sharp; P: Robert M. Sherman; C: Bruce Surtees; M: Michael Small; With: Gene Hackman, Jennifer Warren, Susan Clark, Edward Binns, Harris Yulin, Kenneth Mars, Janet Ward, James Woods, Melanie Griffith, Anthony Costello, John Crawford.

Dog Day Afternoon (September 21, 1975)
D: Sidney Lumet; W: Frank Pierson; P: Martin Bregman and Martin Elfand; C: Victor J. Kemper; With: Al Pacino, John Cazale, Charles Durning, Chris Sarandon, Sully Boyar, Penelope Allen, James Broderick, Carol Kane, Beulah Garrick, Sandra Kazan.

Three Days of the Condor (September 24, 1975)
D: Sydney Pollack; W: Lorenzo Semple Jr. and David Rayfiel; P: Stanley Schneider; C: Owen Roizman; M: Dave Grusin; With: Robert Redford, Faye Dunaway, Cliff Robertson, Max von Sydow, John Houseman, Addison Powell, Walter McGinn, Tina Chen, Michael Kane, Don McHenry.

Smile (October 9, 1975)
D/P: Michael Ritchie; W: Jerry Belson; C: Conrad L. Hall (as Conrad Hall); M: LeRoy Holmes; With: Bruce Dern, Barbara Feldon, Michael Kidd, Geoffrey Lewis, Eric Shea, Nicholas Pryor, Titos Vandis, Paul Benedict, William Traylor, Dennis Dugan.

Hustle (December 25, 1975)
D/P: Robert Aldrich; W: Steve Shagan; C: Joseph F. Biroc; M: Frank De Vol; With: Burt Reynolds, Catherine Deneuve, Ben Johnson, Paul Winfield, Eileen Brennan, Eddie Albert, Ernest Borgnine, Catherine Bach, Jack Carter, James Hampton.

Taxi Driver (February 8, 1976)
D: Martin Scorsese; W: Paul Schrader; P: Julia Phillips and Michael Phillips; C: Michael Chapman; M: Bernard Herrmann; With: Peter Boyle, Albert Brooks, Robert De Niro, Jodie Foster, Leonard Harris, Harvey Keitel, Steven Prince, Martin Scorsese, Cybill Shepherd.

All the President's Men (April 4, 1976)
D: Alan J. Pakula; W: William Goldman; P: Walter Coblenz; C: Gordon Willis; M: David Shire; With: Dustin Hoffman, Robert Redford, Jack Warden, Martin Balsam, Hal Holbrook, Jason Robards, Jane Alexander, Meredith Baxter, Ned Beatty, Stephen Collins, Penny Fuller, John McMartin, Robert Walden.

The Man Who Fell to Earth (May 28, 1976)
D: Nicolas Roeg; W: Paul Mayersberg; P: Michael Deeley and Barry Spikings; C: Anthony B. Richmond; M: John Phillips and Stomu Yamashta; With: David Bowie, Rip Torn, Candy Clark, Buck Henry, Bernie Casey, Jackson D. Kane, Rick Riccardo, Tony Mascia, Linda Hutton, Hilary Holland.

Network (November 14, 1976)
D: Sidney Lumet; W: Paddy Chayefsky; P: Howard Gottfried; C: Owen Roizman; M: Elliot Lawrence; With: Faye Dunaway, William Holden, Peter Finch, Robert Duvall, Wesley Addy, Ned Beatty, Beatrice Straight, Marlene Warfield, William Prince, Arthur Burghardt, John Carpenter, Kathy Cronkite.

Mikey and Nicky (December 12, 1976)
D/W: Elaine May; P: Michael Hausman; C: Bernie Abramson, Lucien Ballard, Jack Cooperman, Jerry File, and Victor J. Kemper; M: John Strauss; With: Peter Falk, John Cassavetes, Ned Beatty, Rose Arrick, Carol Grace, William Hickey, Sanford Meisner, Joyce Van Patten, M. Emmet Walsh, Sy Travers.

NOTES

1. Before the Flood

1. David Thomson, "The Decade When the Movies Mattered," *Movieline,* August 1993, 42–47, 80; Susan Sontag, "The Decay of Cinema," *New York Times,* February 25, 1996; Pauline Kael, *Reeling* (Boston: Little, Brown, 1976), xiii–xiv.

2. Orson Welles, "But Where Are We Going?" *Look,* November 3, 1970, 35.

3. Richard S. Randall, *Censorship of the Movies: The Social and Political Control of a Mass Medium* (Madison: University of Wisconsin Press, 1968), 18, 24–25, 29, 77; Garth S. Jowett, "A Capacity for Evil: The 1915 Supreme Court *Mutual* Decision"; Matthew Bernstein, "A Tale of Three Cities: The Banning of *Scarlet Street*"; and Ellen Draper, "'Controversy Has Probably Destroyed Forever the Context': The *Miracle* and Movie Censorship," all in *Controlling Hollywood: Censorship and Regulation in the Studio Era,* ed. Matthew Bernstein (New Brunswick: Rutgers University Press, 1999), 16–40, 157–85, 186–205.

4. Edward de Grazia and Roger K. Newman, *Banned Films: Movies, Censors, and the First Amendment* (New York: R. R. Bowker Company, 1982), 25–26; Garth Jowett, *Film: The Democratic Art* (Boston: Little, Brown, 1976), 166–67, 174, 238–39; Gregory D. Black, *Hollywood Censored: Morality Codes, Catholics, and the Movies* (Cambridge: Cambridge University Press, 1994), 30–32; Randall, *Censorship of the Movies,* 15–16.

5. John Izod, *Hollywood and the Box Office, 1895–1986* (New York: Columbia University Press, 1988), 105–6; Jack Vizzard, *See No Evil: Life inside a Hollywood Censor* (New York: Simon and Schuster, 1970), 38; Black, *Hollywood Censored,* 53–55, 72, 126; de Grazia and Newman, *Banned Films,* 35.

6. Black, *Hollywood Censored,* 39, 70, 165–66, 170; Gerald Gardner, *The Censorship Papers: Movie Censorship Letters from the Hays Office, 1934 to 1968* (New York: Dodd, Mead & Company, 1987), xviii–xix; Vizzard, *See No Evil,* 64, 67, 103; de Grazia and Newman, *Banned Films,* 41, 43. Thomas Doherty, *Hollywood's Censor: Joseph I. Breen and the Production Code Administration* (New York: Columbia University Press, 2007), offers a more sympathetic portrayal of Breen. (For those with a scorecard, note also that the Committee for Public Relations had in the interim been renamed the Studio Relations Department.)

7. Ruth Vasey, "Beyond Sex and Violence: 'Industry Policy' and the Regulation of Hollywood Movies, 1922–1939," in Bernstein, *Controlling Hollywood,* 102–29; Gardner, *The Censorship Papers,* xx–xxii. This is also a central theme in Doherty, *Hollywood's Censor,* esp. 89–92, 339.

8. Jowett, *Film,* 282; Gardner, *The Censorship Papers,* 110, 146 (Mae West); Black, *Hollywood Censored,* 56, 202, 238, 245–46, 295 (Legion quotes); Doherty, *Hollywood's Censor,* 77; Thomas Schatz, *Boom and Bust: American Cinema in the 1940s* (Berkeley: University of California Press, 1997), 266–67.

9. Larry Ceplair and Steven Englund, *The Inquisition in Hollywood: Politics in the Film Community, 1930–60* (1979; Urbana: University of Illinois Press, 2003), 275–79; A. M. Sperber and Eric Lax,

Bogart (New York: William Morrow and Co., 1997), 357 (Nixon), 359-60, 369, 386-87; Lawrence Grobel, *The Hustons* (New York: Macmillan, 1989), 300-304; Schatz, *Boom and* Bust, 308-9; Gordon Kahn, *Hollywood on Trial: The Story of the Ten Who Were Indicted* (New York: Boni & Gaer, 1948), 6 (Johnston).

10. Ceplair and Englund, *Inquisition in Hollywood,* 328, 330-31, 336; Schatz, *Boom and Bust,* 311-13; Kahn, *Hollywood on Trial,* 71, 115, 191, 195; Janet Wasko, *Movies and Money: Financing the American Film Industry* (Northwood, N.J.: Ablex Publishing, 1982), 109-11.

11. Rui Nogueira, *Melville on Melville* (New York: Viking, 1971), 149.

12. Truman's own program already required loyalty oaths of government employees and facilitated very aggressive and invasive investigations by the FBI into the private lives of government employees. See David McCullough, *Truman* (New York: Simon and Schuster, 1992), 551-53.

13. See, for example, Patrick McGilligan and Paul Buhle, *Tender Comrades: A Backstory of the Hollywood Blacklist* (New York: St. Martins, 1999); Victor S. Navasky, *Naming Names* (1980; New York: Hill and Wang, 2003); Bob Blauner, *Resisting McCarthyism: To Sign or Not to Sign California's Loyalty Oath* (Stanford: Stanford University Press, 2009).

14. Sterling Hayden, *Wanderer* (New York: Knopf, 1963), 386-89, 392 (quote); Izod, *Hollywood and the Box Office,* 133-34; Peter Lev, *The Fifties: Transforming the Screen, 1950-1959* (Berkeley: University of California Press, 2003), 11 (Kazan quote), 78, 81; see also Richard Schickel, *Elia Kazan: A Biography* (New York: HarperCollins, 2005), chap. 12 ("testimonies"). Schickel, an apologist, does not whitewash the facts; he is limited to arguing that Kazan's about-face cannot be "dismissed as *purely* opportunistic" (255; emphasis added).

15. *Times Film Corp v. Chicago* (1961), cited in the dissent by Justices Warren, Black, Douglas, and Brennan; Andrew Sarris, *The American Cinema: Directors and Directions, 1929-68* (1968; New York: DaCapo Press, 1996), 106-7; Dawn B. Sova and Marjorie Heins, *Forbidden Films: Censorship Histories of 125 Motion Pictures* (New York: Checkmark Books, 2001), 17-18, 106-8.

16. Lev, *The Fifties,* 3, 7, 9, 76-77; Jowett, *Film,* 348, 368, 378; Izod, *Hollywood and the Box Office,* 117, 120-22; de Grazia and Newman, *Banned Films,* 89; Shyon Baumann, *Hollywood Highbrow: From Entertainment to Art* (Princeton: Princeton University Press, 2007), 9-10, 15, 37-38. United Artists also withdrew from the MPAA at this time.

17. Lev, *The Fifties,* 89, 93; Doherty, *Hollywood's Censor,* 314, 322; Jonathan Kirshner, "Subverting the Cold War in the 1960s: *Dr. Strangelove, The Manchurian Candidate,* and *Planet of the Apes,*" *Film and History* 31.2 (2001): 40-44; Stephen Vaughn, *Freedom and Entertainment: Rating the Movies in an Age of New Media* (Cambridge: Cambridge University Press, 2006), 5.

18. The term refers to independent, usually urban movie houses that showed more sophisticated foreign films produced outside the Hollywood studio system and its Production Code.

19. Jowett, *Film,* 364, 419, 421, 428, 436; Baumann, *Hollywood Highbrow,* 107, 113; Thomas Schatz, *The Genius of the System: Hollywood Filmmaking in the Studio Era* (New York: Pantheon Books, 1988), 4, 299, 411-12, 435, 469, 481; Jack Valenti, *This Time, This Place: My Life in War, the White House, and Hollywood* (New York: Harmony Books, 2007), 270, 279-80. Valenti remained head of the MPAA for thirty-eight years, retiring in his eighties in 2004.

20. Paul Monaco, *The Sixties* (Berkeley: University of California Press, 2001), 58-62; Leonard Leff and Jerold Simmons, *The Dame in the Kimono: Hollywood Censorship and the Production Code from the 1920s to the 1960s* (New York: Grove Weidenfeld, 1990), 241-66; Valenti, *This Time, This Place,* 302-5; Vizzard, *See No Evil,* 318, 329, 353, 364; de Grazia and Newman, *Banned Films,* 115-16, 119, 135; Vaughn, *Freedom and Entertainment,* 12, 14.

21. See David Garrow, *Bearing the Cross: Martin Luther King Jr. and the Southern Christian Leadership Conference* (New York: William Morrow, 1986); Terry Pluto, *Tall Tales: The Glory Years of the NBA* (New York: Simon and Schuster, 1992), 70-72; see also Bill Russell and Taylor Branch, *Second Wind: The Memoirs of an Opinionated Man* (New York: Random House, 1979).

22. For a good concise history, see George C. Herring, *America's Longest War: The United States and Vietnam, 1950-1975,* 2nd ed. (New York: Alfred A Knopf, 1986).

23. Betty Friedan, *The Feminine Mystique* (New York: Norton, 1963); see also Ruth Rossen, *The World Split Open: How the Modern Women's Movement Changed America* (New York: Penguin, 2000), 43; Bruce J. Dierenfield, *Keeper of the Rules: Congressman Howard W. Smith of Virginia* (Charlottesville: University Press of Virginia 1987), 150-60, 193-96.

24. Leonard Quart and Albert Auster, *American Film and Society since 1945* (New York: Praeger, 1991), 78, 108-9; Justin Wyatt, "The Stigma of X: Adult Cinema and the Institution of the MPAA Rating System," in Bernstein, *Controlling Hollywood,* 239; Monaco, *The Sixties,* 37-38; Wasko, *Movies and Money,* 145; Izod, *Hollywood and the Box Office,* 171-74.

25. Teresa Grimes, "BBS: Auspicious Beginnings, Open Endings," *Movie* 31/32 (Winter 1986): 54–66; Mitchell S. Cohen, "7 Intricate Pieces: The Corporate Style of BBS," *Take One* 3.11 (September 1973): 19–22; Peter Biskind, *Easy Riders, Raging Bulls: How the Sex-Drugs-and-Rock'n'Roll Generation Saved Hollywood* (New York: Simon and Schuster, 1998), 76.

26. John Maynard Keynes, "My Early Beliefs," from *Two Memoirs* (1949), reprinted in *The Collected Writings of John Maynard Keynes,* ed. Donald Moggridge and Elizabeth Johnson, vol. 10 (London: Macmillan, 1971–1989),436. Looking back from the vantage point of middle age, Keynes, while sticking to his iconoclastic guns, nevertheless had come to understand both sides of the argument: "We were not aware that civilization was a thin and precarious crust . . . only maintained by rules and conventions" (446–47).

27. David Bowie, interview in the documentary *VH1: The Seventies* (1996).

28. Quoted in Michael Pye and Lynda Myles, *The Movie Brats: How the Film Generation Took Over Hollywood* (New York: Holt, Reinhart and Winston, 1979), 190.

29. Jules Feiffer, *Backing into Forward: A Memoir* (New York: Doubleday, 2010), 327; Maurice Isserman and Michael Kazin, *America Divided: The Civil War of the 1960s,* 2nd ed. (Oxford: Oxford University Press, 2003), 227 (Carmichael).

30. Joseph A. Palermo, *In His Own Right: The Political Odyssey of Senator Robert F. Kennedy* (New York: Columbia University Press, 2001), 179–81.

31. J. Hoberman, *The Dream Life: Movies, Media, and the Mythology of the Sixties* (New York: New Press, 2003), 205.

32. Paul Schrader, "Notes on Film Noir," *Film Comment* 8.1 (Spring 1972): 8; see also Lee Server, "Behind the Shadows: Film Noir's Dark Roots," *Scenario* 5.3 (Autumn 1999): 158–71.

33. Cameron Crowe, *Conversations with Wilder* (New York: Alfred A. Knopf, 1999), 225 (quote); see also 4, 20, 116, 198.

34. Patrick McGilligan, *Alfred Hitchcock: A Life in Darkness and Light* (New York: HarperCollins, 2003), 676–79, 681 (quote), 696; Dan Auiler, *Hitchcock's Notebooks* (New York: Avon Books, 1999), 278–79, 289, 443–44, 546.

2. Talkin' 'bout My Generation

1. Terry Anderson, *The Movement and the Sixties: Protest in America from Greensboro to Wounded Knee* (Oxford: Oxford University Press, 1995), 39; Peter Braunstein, "Forever Young: Insurgent Youth and the Sixties Culture of Rejuvination," in *Imagine Nation: The American Counterculture of the 1960s and 1970s,* ed. Peter Braunstein and Michael William Doyle (Routledge: New York, 2001), 244.

2. W. J. Rorabaugh, *Berkeley at War: The 1960s* (New York: Oxford University Press, 1989), 10, 19, 32, 35; Anderson, *The Movement and the Sixties,* 76, 102–5; Jo Freeman, "From Freedom Now! To Free Speech: The FSM's Roots in the Bay Area Civil Rights Movement," in *The Free Speech Movement: Reflections on Berkeley in the 1960s,* ed. Robert Cohen and Reginald Zelnik (Berkeley: University of California Press, 2002), 79.

3. Todd Gitlin, *The Sixties: Years of Hope, Days of Rage* (New York: Bantam, 1993), 343; Anderson, *The Movement and the Sixties,* 98. 101.

4. W. J. Rorabaugh, "The Free Speech Movement, Berkeley Politics, and Ronald Reagan," in Cohen and Zelnik, *The Free Speech Movement,* 515; Gerard De Groot, "Ronald Reagan and Student Unrest in California, 1966–1970," *Pacific Historical Review* 65.1 (February 1996): 107–29. See also the documentary *Berkeley in the Sixties* (dir. Mark Kitchell, 1990).

5. Jan Aghed and Bernard Cohen, "Interview with Arthur Penn," *Positif* (April 1971), reprinted in Michael Chaiken and Paul Cronin, *Arthur Penn Interviews* (Jackson: University Press of Mississippi, 2008), 61; David Newman and Robert Benton, "The New Sentimentality," *Esquire* 62.1 (July 1964): 25–31.

6. Phillip Lopate, "Anticipation of *La Notte:* The 'Heroic' Age of Moviegoing," reprinted in Phillip Lopate, *Totally, Tenderly, Tragically: Essays and Criticism from a Lifelong Love Affair with the Movies* (New York: Anchor, 1998), 3–26; "Cinema: A Religion of Film," *Time,* September 20, 1963, 82–90; Tino Balio, *The Foreign Film Renaissance on American Screens, 1946–1973* (Madison: University of Wisconsin Press, 2010), 227, 250–51.

7. Balio, *Foreign Film Renaissance,* 5–6, 79–90, 130, 135, 145; see also Tony Talbot, *The New Yorker Theater* (New York: Columbia University Press, 2009). On the critics, see Raymond J. Haberski Jr., *It's Only a Movie: Film and Critics in American Culture* (Lexington: University Press of Kentucky, 2001), 115–19, 123–25, 129–31, 144, 146, 188; see also Shyon Baumann, *Hollywood Highbrow: From Entertainment to Art* (Princeton: Princeton University Press, 2007), 10, 33, 53, 113.

8. Michel Marie, *The French New Wave: An Artistic School,* trans. Richard Neupert (1997; Malden Mass.: Blackwell, 2003),5; Geoffrey Nowell-Smith, *Making Waves: New Cinemas of the 1960s* (New York: Continuum, 2008), 138–40.

9. Richard Neupert, *A History of the French New Wave Cinema,* 2nd ed. (Madison: University of Wisconsin Press, 2007), 125, 128, 208, 252; Naomi Greene, *The French New Wave: A New Look* (New York: Wallflower, 2007), 7–8. See also James Monaco, *The New Wave: Truffaut, Godard, Chabrol, Rohmer, Rivette,* 30th Anniversary ed. (New York: Harbor Electronic Publishing, 2004).

10. Richard Round, *A Passion for Films: Henri Langlois and the Cinémathèque Française* (Baltimore: Johns Hopkins University Press, 1999), 58, 67 (quote), 68; Richard Brody, *Everything Is Cinema: The Working Life of Jean-Luc Godard* (New York: Metropolitan Books, 2008), 18; Dudley Andrew, *André Bazin* (1978; New York: Columbia University Press, 1990), 150, 154, 172, 181, 193; Antoine de Baecque and Serge Toubiana, *Truffaut: A Biography* (New York: Knopf, 1999), 61, 67–68, 118; Tom Milne, ed. and trans., *Godard on Godard* (1972; New York: Da Capo Press, 1986), 43, 47, 75–80.

11. Andrew, *André Bazin,* 124, 136, 138, 251; Genevieve Sellier, *Masculine Singular: French New Wave Cinema* (Durham: Duke University Press, 2008), 41; Neupert, *History of the French New Wave,* 46, 190; Greene, *French New Wave,* 27, 29, 89; Nowell-Smith, *Making Waves,* 32, 46, 48; Milne, *Godard on Godard,*146 (quote).

12. Jean Douchet, *French New Wave* (New York: Distributed Art Publishers, 1999), 78; Marie, *French New Wave,* 18–19, 44, 50; Nowell-Smith, *Making Waves,* 35; Milne, *Godard on Godard,* 163, 193. Melville and his cinematographer Henri Decae were enormous influences on the New Wave. Chabrol said, "We certainly would not have dreamed of making the films we all did without Melville." Green, *French New Wave,* 24. Godard gave Melville an extended cameo in *Breathless;* Decae shot the first films of Malle, Chabrol, and Truffaut.

13. Andrew, *André Bazin,* 172, 198; de Baecque and Toubiana, *Truffaut,* 72–77; Neupert, *History of the French New Wave,* 31; Marie, *French New Wave,* 33, 40, Douchet, *French New Wave,* 78, 90.

14. Marie, *French New Wave,* 70; Nowell-Smith, *Making Waves,* 68, 70, 74; Douchet, *French New Wave,* 213, 253.

15. Douchet, *French New Wave,* 93; Monaco, *The New Wave,* 21, 133; Nowell-Smith, *Making Waves,* 3, 106; Sellier, *Masculine Singular* 95–96, 98; Nowell-Smith, *Making Waves,* 75; Nestor Almendros, *A Man with a Movie Camera* (New York: Farrar, Straus and Giroux, 1984), 61, 59; Neupert, *History of the French New Wave,* 41, 211, 248.

16. When I was researching *Mickey One,* the movie was not available in video form. I had the opportunity to screen the film on a tabletop machine at the Harvard Film Archive. I thank Amy Sloper at the archive for her time and hospitality.

17. Penn, comments at the BFI National Film Theatre, August 30, 1981, published in Chaiken and Cronin, *Arthur Penn Interviews,* 140.

18. *Time,* October 8, 1965; 1963 interview with Penn, *Cahiers du Cinéma,* in Chaiken and Cronin, *Arthur Penn Interviews,* 6–7; American Film Institute Seminar with Penn, 1970, in Chaiken and Cronin, *Arthur Penn Interviews,* 35; Mark Harris, *Pictures at a Revolution: Five Movies and the Birth of the New Hollywood* (New York: Penguin, 2008), 38; Peter Biskind, *Star: How Warren Beatty Seduced America* (New York: Simon and Schuster, 2010), 68, 70.

19. Bosley Crowther, "Film Festival: Heroes, Old and New," *New York Times* September 9, 1965 (see also his follow up in the *Times,* "Mickey One," on September 28); Penn interviewed in *Positif,* April 1971, and by Jessica van Heller, August 30, 1976, both in Chaiken and Cronin, *Arthur Penn Interviews,* 65, 92–93.

20. Gerald Pratley, *The Films of John Frankenheimer* (Bethlehem: Lehigh University Press, 1998), 57, 59 (quote); Todd Rainsberger, *James Wong Howe, Cinematographer* (La Jolla: A. S. Barnes, 1981), 232–33; "Interview with James Wong Howe," *Take One* 3.10 (March–April 1972): 21; John Frankenheimer, commentary on *Seconds* DVD (Paramount, 2002). On the motivated visual style, note, for example, how the camera slows down for a six-minute take at the crucial early juncture when Hamilton assesses his life and its meaning.

21. Pratley, *The Films of John Frankenheimer,* 58; Frankenheimer, DVD commentary.

22. *Blow-Up* was released in December 1966, but its influence was felt in 1967. *Persona* opened in the United States in March, *Algiers* in September. See Stanley Kauffmann, "Some Notes on a Year with *Blow-Up,*" in *Film 67/68: An Anthology by the National Society of Film Critics,* ed. Richard Schickel and John Simon (New York: Simon and Schuster, 1968), 274–81.

23. Joseph Gelmis, *The Film Director as Superstar* (New York: Doubleday, 1970), 25, 29, 31 (quotes). *Hi Mom* (1970) something of a follow-up to *Greetings,* also featured De Niro and self-consciousness about

film. It includes the remarkable twenty-minute "Be Black Baby" sequence, in which white middle-class theatergoers are terrorized by black performance artists.

24. Stephen Farber, "Coppola and *The Godfather,*" *Sight and Sound* 41.4 (Autumn 1972): 217 (quote); Gene D. Phillips, *Godfather: The Intimate Francis Ford Coppola* (Lexington: University Press of Kentucky, 2004), 55–56, 64; Michael Schumacher, *Francis Ford Coppola: A Filmmaker's Life* (New York: Crown, 1999), 66. The motivating action in *The Rain People,* the protagonist's flight, is triggered by her panic as she struggles to understand her role as wife and, incipiently, a mother. "I used to wake up and begin my day and now it belongs to you," she tells her confused husband from the road.

25. David Thompson and Ian Christie, eds., *Scorsese on Scorsese* (London: Faber and Faber, 1989), 14, 151, 154. See also Vincent LoBrutto, *Martin Scorsese: A Biography* (Westport, Conn.: Praeger, 2008), 84, 91.

26. LoBrutto, *Martin Scorsese,* 105; Marshall Fine, *Accidental Genius: How John Cassavetes Invented Independent Film* (New York: Hyperion, 2005), 244.

27. Nick Bromwell, *Tomorrow Never Knows: Rock and Psychedelics in the 1960s* (Chicago: University of Chicago Press, 2000), 16.

28. James Miller, *Flowers in the Dustbin: The Rise of Rock and Roll* (New York: Simon and Schuster, 1999), 231 (quote), 19 (quote), 205; Bromwell, *Tomorrow Never Knows,* 17, 132; Charles Kaiser, *1968 in America: Music, Politics, Chaos, Counterculture, and the Shaping of a Generation* (New York: Grove Press, 1988), xxiii.

29. Ian MacDonald, *Revolution in the Head: The Beatles Records and the Sixties,* 3rd ed. (Chicago: Chicago Review Press, 2007), 10, 135; Miller, *Flowers in the Dustbin,* 207–8.

30. Joe Boyd, *White Bicycles: Making Music in the 1960s* (London: Serpent's Tale, 2006), 99, 105.

31. Bromwell, *Tomorrow Never Knows,* 17–18, 28, 34, 39; Miller, *Flowers in the Dustbin,* 218, 225 (quote); Kaiser, *1968 in America,* 199, 202–3.

32. Bromwell, *Tomorrow Never Knows,* 14, 25; Miller, *Flowers in the Dustbin,* 227, 239, 251, 154; Kaiser, *1968 in America,* 211.

33. Richard Poirier, "Learning from the Beatles," *Partisan Review* (1967), reprinted in *The Age of Rock: Sounds of an American Cultural Revolution,* ed. Jonathan Eisen (New York: Random House, 1969), 165, 171; Allen Beckett, "Stones," *New Left Review* 47 (1968): 24–29; Michael Parsons, "Rolling Stones" *New Left Review* 49 (1968): 85–86; Bromwell, *Tomorrow Never Knows,* 18 (Havel); James F. Pontuso, "Interview with Vaclav Havel," *Society* 45.1 (2008): 9–11.

34. Allan Bloom, *The Closing of the American Mind* (New York: Simon and Schuster, 1987), 79.

35. To name quickly twenty representing this astonishing cohort: The Band; The Byrds; Buffalo Springfield; Cream; Creedence Clearwater Revival; Crosby, Stills, and Nash; The Doors; Aretha Franklin; Marvin Gaye; Jimi Hendrix; Janis Joplin; Jefferson Airplane; The Kinks; Van Morrison; Simon and Garfunkel; Sly and the Family Stone; Traffic; The Velvet Underground; The Who; and Stevie Wonder.

36. Miller, *Flowers in the* Dustbin, 259, 260; Kaiser, *1968 in America,* xx; Braunstein, "Forever Young," 67; John Boorman, *Adventures of a Suburban Boy* (London: Faber and Faber, 2003), 143.

37. Pennebaker would go on to direct *Monterey Pop* (1968) and David Bowie's *Ziggy Stardust and the Spiders from Mars* (1973).

38. Andrew Sarris, "Digging Dylan," in Schickel and Simon, *Film 67/68,* 253.

39. That is, impossibly long takes, extended tracking shots, vibrant colors, striking compositions, and self-consciousness about filming, as well as Godard's Maoist-flavored politics, with the usual concerns about Vietnam, capitalism, and, here, black militancy.

40. Stephen Farber, "The Writer in American Films," *Film Quarterly* 21.4 (Summer 1968): 5.

41. Boorman, *Adventures of a Suburban Boy,*129; see also Boorman's commentary on the *Point Blank* DVD (Warner Home Video, 2005).

42. Boorman calls it "a possible interpretation"; Michel Ciment, *John Boorman* (London: Faber and Faber, 1986), 79; also Boorman, DVD commentary.

43. Farber, "The Writer in American Films," 6; Ciment, *John Boorman,* 78.

44. Boorman, *Adventures of a Suburban Boy,* 138 (quote, cell echo); Boorman, DVD commentary.

45. Boorman, *Adventures of a Suburban Boy,* 126 (quote), 135–36; Ciment, *John Boorman,* 66; Farber, "The Writer in American Films," 4. Boorman, DVD commentary ("it's about betrayal"). Marvin and Boorman forged a close personal bond, and Marvin recruited the director to shoot his next picture, *Hell in the Pacific,* which addressed some of these issues even more explicitly. Boorman, *Adventures,* 145, 151.

46. Farber, "The Writer in American Films," 6; also Boorman, DVD commentary.

47. Farber, "The Writer in American Films," 7 (quote); Ciment, *John Boorman,* 61 (Ciment); 76 (Boorman).

48. Boorman, *Adventures*, 129-31; 138-40; Ciment, *John Boorman*, 72-74; Farber, "The Writer in American Films," 5.

49. These debates became even more heated with the release of Sam Peckinpah's *The Wild Bunch* (1969) and have not been resolved to this day.

50. Bosley Crowther, "Point Blank," *New York Times*, September 19, 1967; see also Richard Schickel, "Point Blank," in Schickel and Simon, *Film 1967/68*, 58.

51. "Hollywood: The Shock of Freedom in Films," *Time*, December 8, 1967, 74-82; Bosley Crowther, "Bonnie and Clyde," *New York Times*, April 14, 1967; Lester Friedman, *Bonnie and Clyde* (London: BFI, 2000), 8, 15, 21.

52. David Newman and Robert Benton, "Lightning in a Bottle," in *The Bonnie and Clyde Book*, ed. Sandra Wake and Nicola Hayden (New York: Simon and Schuster, 1972), 13, 15, 23; Peter Biskind, *Easy Riders, Raging Bulls* (New York: Simon and Schuster, 1998), 27 (quote); Harris, *Pictures at a Revolution*, 14 (quote), 26, 38, 64-65, 67; Friedman, *Bonnie and Clyde*, 11, 70; Brody, *The Working Life of Jean-Luc Godard*, 220-21, 222 (quote); de Baecque and Toubiana, *Truffaut*, 210-12; Francois Truffaut, *Correspondence, 1945-1984* (New York: Noonday Press, 1990), 251-52.

53. Newman and Benton, "Lightning in a Bottle," 25, 27, 29-30; Harris, *Pictures at a Revolution*, 93, 214; Biskind, *Star*, 87, 95; Arthur Penn, "Making Waves: The Directing of Bonnie and Clyde," in *Arthur Penn's Bonnie and Clyde*, ed. Lester Friedman (Cambridge: Cambridge University Press, 2000), 12, 22.

54. All involved in conceiving the film were eager to have it feature some form of nontraditional sexuality that would also serve as a vehicle for the narrative. In Newman and Benton's original conception, Clyde was bisexual and the Barrow gang a ménage à trois. Penn ruled this out; the goal of the movie was to have the audience identify with outlaw killers, and in 1967 homosexuality would have irretrievably alienated Clyde from much of that audience. Dunaway (and a few critics) saw vestigial hints of a relationship between Clyde and C.W., which are also suggested in a few scenes that were shot but left out of the final version. David Newman, "What's It Really All About: Pictures at an Execution," in Friedman, *Bonnie and Clyde*, 37; Harris, *Pictures at a Revolution*, 95, 207, 209. Faye Dunaway, *Looking for Gatsby: My Life* (New York: Simon and Schuster, 1995), 129.

55. Dunaway, *Looking for Gatsby*, 127, 130 (quote); Friedman, *Bonnie and Clyde*, 52. Dunaway's observation holds true; when Bonnie and Clyde finally consummate their relationship, it does mark the end of their criminal adventures. As they make love, the events that will lead to their ambush by the police are unfolding.

56. It was an "unspoken rule" of the production code that the firing of a gun and the person being hit would be shown in separate shots. Stephen Prince, *Classical Film Violence* (New Brunswick: Rutgers University Press, 2003), 105.

57. Arthur Penn, "Bonnie and Clyde: Private Moralist and Public Violence," *Take One* 1.6 (1967): 21 (quote); Penn interviewed in *Le Monde* (1968), reprinted in Chaiken and Cronin, *Arthur Penn Interviews*, 13 (quote).

58. Farber, "The Writer in American Films,"12 (Benton); Friedman, *Bonnie and Clyde*, 70.

59. Newman, "What's It Really All About," 39 (quotes); Newman and Benton, "Lightning in a Bottle," 16; Friedman, *Bonnie and Clyde*, 67.

60. Raymond J. Haberski Jr., *Freedom to Offend: How New York Remade Movie Culture* (Lexington: University Press of Kentucky, 2007), offers a thoughtful, sympathetic treatment of Crowther's career and the *Bonnie and Clyde* affair; see esp. 9, 40, 42, 46, 52, 59-60, 177, 185, 187. See also Harris, *Pictures at a Revolution*, 338-39, 344.

61. Clifford Terry, "Bonnie and Clyde Are Glamorized Killers," *Chicago Tribune*, September 25, 1967; Simon's and Morgenstern's reviews are reprinted in Schickel and Simon, *Film 67/68*, 25-26, 29-30.

62. Morgenstern, "A Thin Red Line," reprinted in Schickel and Simon, *Film 67/68*, 26-29; Roger Ebert, "Bonnie and Clyde," *Chicago Sun-Times*, September 25, 1967; Pauline Kael, "Bonnie and Clyde," *New Yorker*, October 21, 1967, 154, 161, 162.

63. Balio, *Foreign Film Renaissance,*17; Haberski, *Freedom to Offend*, 169, 195; Bosley Crowther, *Reruns: Fifty Memorable Films* (New York: G. P. Putnam's Sons, 1978), 200, 203-4.

64. See, for example, Jonathan Rosenbaum, "Bridge over Troubled Water," *Chicago Reader*, March 28, 1997.

65. Richard Sylbert and Sylvia Townsend, *Designing Movies: Portrait of a Hollywood Artist* (Westport, Conn.: Praeger, 2006), 93; Robert L. Carringer, "Designing Los Angeles: An Interview with Richard Sylbert," *Wide Angle* 20.3 (1998): 111.

66. For an example of Hitchcock's symmetrical constructions that echoes this sequence, see Jessica Tandy approaching and retreating from the farm in *The Birds* (1963).

67. Marcia Seligson, "Hollywood's Hottest Writer, Buck Henry," *New York Times*, July 19, 1970.

68. At least one old Hollywood hand pitched in, however. All involved in the film credit sixty-year-old cinematographer Robert Surtees, who not only was open to every wild idea Nichols came up with but contributed some innovations of his own as well. The change in lighting tone before and after Mr. Robinson's arrival in the early sunroom scenes was his idea. Carringer, "Designing Los Angeles," 113; Harris, *Pictures at a Revolution*, 314-15; Mike Nichols, commentary, *The Graduate*, DVD (MGM, 2007).

69. Nichols, DVD commentary; Harris, *Pictures at a Revolution*, 313, 319.

70. Nichols, DVD commentary; see also H. Wayne Schuth, *Mike Nichols* (Boston: Twayne, 1978), 62.

71. Hollis Alpert, "The Graduate Makes Out," in *Film 68/69: An Anthology by the National Society of Film Critics*, ed. Hollis Alpert and Andrew Sarris (New York: Simon and Schuster, 1969), 235, 237; Richard Schickel, "Half a Loaf," in Schickel and Simon, *Film 67/68*, 116-18; Harris, *Pictures at a Revolution*, 380. The dividing lines were not cast in stone; Bosley Crowther praised the movie in his final review as chief critic of the *New York Times* ("Graduating with Honors," December 31, 1967).

72. Rosenbaum, "Bridge over Troubled Water"; Alpert, "The Graduate Makes Out," 238; Harris, *Pictures at a Revolution*, 122, 296. The only hint of politics comes with his landlord's (Norman Fell) concern than Benjamin might be an "outside agitator." Nichols reports that at screenings on college campuses, many students criticized the film's lack of engagement with political issues of the day, especially the Vietnam War. Nichols, DVD commentary.

73. Among many others, *Getting Straight* (1970) with Elliott Gould and Candice Bergen; Milos Forman's *Taking Off* (1971), which features Buck Henry; and even Jack Nicholson's often intriguing directorial debut, *Drive, He Said* (1971), with Karen Black, Bruce Dern, and Robert Towne, all today play much more like period pieces.

74. Charles Webb, *The Graduate* (New York: New American Library, 1963), 189; see also the interview with Webb in *Voices from the Set: The Film Heritage Interviews*, ed. Tony Macklin (Lanham, Md.: Scarecrow Press, 2000), 214; Alpert, "The Graduate Makes Out," 240.

75. Roger Ebert, "The Graduate," *Chicago Sun Times*, December 26, 1967; Roger Ebert, "The Graduate," *Chicago Sun Times*, March 28, 1997; Rosenbaum, "Bridge over Troubled Water"; Stephen Farber and Estelle Changas, "The Graduate," *Film Quarterly* 21.3 (Spring 1968): 37-41.

76. See Ebert's 1997 review, in which he reassesses Benjamin as "clueless" and "an insufferable creep"; also Farber and Changas, who really pile on ("The Graduate," 37, 38, 40).

77. Nichols says that the last shot captures "this terror that is about to happen to them" (DVD commentary); Richard Sylbert's guess is that Benjamin and Elaine "probably divorced six years later." Carringer, "Designing Los Angeles," 112.

78. This interpretation is most clearly supported early in the film, when Mr. Robinson says to Ben, "In many ways I feel as if you were my own son." This is a reasonable take on the film, although the payoff is not clear.

79. Webb, *The Graduate*, 109.

80. Sylbert, in his designs, was motivated to express the similarities between the two couples; it took some effort, for example, to find two very similar houses for the two families. Sylbert and Townsend, *Designing Movies*, 90-91.

81. This reading of the film is also much more progressive on gender issues than is suggested by a simple demonization of Mrs. Robinson. The importance of her narrative, and her character's complexity, speak to debates about the relationship between the seventies film and the women's movement, which are discussed in chapter 4.

82. Phillips, *Godfather*, 37, 41-43; Schumaker, *Francis Ford Coppola*, 47; Harris, *Pictures at a Revolution*, 270; Biskind, *Easy Riders, Raging Bulls*, 36.

83. Bogdanovich was credited as an "assistant to the director" and Monte Hellman as editor, but everybody did everything on a Corman picture. Corman backed Bogdanovich's attention-getting debut effort, *Targets* (1968).

84. Roger Corman, *How I Made a Hundred Movies in Hollywood and Never Lost a Dime* (New York: Delta, 1990), 143, 148, 153; Beverly Gray, *Roger Corman: An Unauthorized Biography of the Godfather of Indie Filmmaking* (Los Angeles: Renaissance Books, 2000), 85-89.

85. Kovács and fellow Hungarian refugee Vilmos Zsigmond would become leading cinematographers of the New Hollywood. Michael Goodwin, "Camera: Laszlo Kovacs," *Take One* 2.12 (July-August 1970): 12-14.

86. Peter Fonda, *Don't Tell Dad: A Memoir* (New York: Hyperion, 1998), 258–59; Biskind, *Easy Riders, Raging Bulls,* 74.

87. Fonda, *Don't Tell Dad,* 283–84, 285 (quote).

88. LoBrutto, *Martin Scorsese,* 110–14.

89. Of course, to some extent the "Woodstock Nation" was always, in Benedict Anderson's famous phrase, an "imagined community." Moreover, it is perhaps too easy to wax nostalgic about the concert itself, especially for people like me, who were not there, and who would not have fared well in the rain and the mud and the Port-o-Sans.

90. Within six months of Woodstock, the disastrous Altamont concert showed that unsupervised freedoms could have a dark, violent side; the Isle of Wight concert in the summer of 1970 pointed toward the commercial co-optation of rock. In April 1970 the Beatles broke up; in June, Dylan released the uninspired and heavily criticized album *Self Portrait;* within the next year Jimi Hendrix, Janis Joplin, and Jim Morrison all died in drug-related incidents, as had Rolling Stones guitarist Brian Jones in 1969.

91. Axel Madsen, "The Changing of the Guard," *Sight and Sound* 39.2 (Spring 1970): 63; Harris, *Pictures at a Revolution,* 266–67; Biskind, *Easy Riders, Raging Bulls,* 75–76, 77 (quote).

3. 1968, Nixon, and the Inward Turn

1. See Mark Kurlansky, *1968: The Year That Rocked the World* (New York: Ballantine, 2004); Jules Witcover, *1968: The Year the Dream Died* (New York: Warner Books, 1997); Charles Kaiser, *1968 in America: Music, Politics, Chaos, Counterculture, and the Shaping of a Generation* (New York: Grove Press, 1988); Todd Gitlin, *The Sixties: Years of Hope, Days of Rage,* rev. ed. (New York: Bantam, 1993).

2. To argue that the United States never "lost" the war on the battlefield is to miss the fundamental point that military force is applied to achieve political objectives and must be evaluated in that context. Not only did the war effort fail to achieve those objectives—the creation of an independent, legitimate, self-sustaining South Vietnam to hold the line against communism after the U.S. forces left—but also fighting the war was actually undermining broader U.S. political goals. It should be recalled that South Vietnam, a geopolitical backwater, mattered to the Americans only in its cold war context. Yet by the mid-1960s, Vietnam was a cold war liability for the United States. Its military had been hollowed out across the globe to fight in Vietnam, its economy was increasingly strained under the burdens of the war, and its international reputation was in tatters. Even if further escalation might have improved the military situation in Vietnam (and this was unlikely), it would not have brought the United States closer to attaining its political goals in Vietnam or globally. The war is discussed further in chapter 5.

3. Herbert Y. Schandler, *Lyndon Johnson and Vietnam: The Unmaking of a President* (Princeton: Princeton University Press, 1977), 62, 64–65, 74, 79–80; Don Oberdorfer, *Tet!* (New York: Doubleday, 1971).

4. Joseph A. Palermo, *In His Own Right: The Political Odyssey of Senator Robert F. Kennedy* (New York: Columbia University Press, 2001), 105, 107, 117–18; Thurston Clarke, *The Last Campaign: Robert F. Kennedy and the 82 Days That Inspired America* (New York: Henry Holt, 2008), 34; Schandler, *Lyndon Johnson and Vietnam,* 197–98.

5. Clark Clifford, "A Vietnam Reappraisal," *Foreign Affairs* 47.4 (July 1969): 601–22; Schandler, *Lyndon Johnson and Vietnam,* 98, 109, 119–20, 129, 140–41, 197–98, 258, 263–64.

6. Joseph A. Califano Jr., *The Triumph and Tragedy of Lyndon Johnson* (College Station: Texas A&M University Press, 200), 260–62; Hugh Davis Graham, "On Riots and Commissions: Civil Disorders in the 1960s," *Public Historian* 2.4 (Summer 1980): 16, 18–19; Clarke, *The Last Campaign,* 34; Palermo, *In His Own Right,* 161.

7. Kurlansky, *1968,* 201, 203, 206, 279, 283; Witcover, *The Year the Dream Died,* 320–21, 324, 327–28, 333–36; Gitlin, *The Sixties,* 323, 325, 327, 331–35. For an unsurpassed account of both 1968 national political conventions, see Norman Mailer, *Miami and the Siege of Chicago* (New York: Penguin, 1968).

8. Renata Adler, "Fracas at the Cannes Film Festival," *New York Times,* May 26, 1968; Kurlansky, *1968,* 220–21, 225–26, 230, 234; Richard Brody, *Everything Is Cinema: The Working Life of Jean-Luc Godard* (New York: Metropolitan Books, 2008), 328–30.

9. Adler, "Fracas at the Cannes Film Festival"; Geoffrey Nowell-Smith, *Making Waves: New Cinemas of the 1960s* (New York: Continuum, 2008), 149; Brody, *Everything Is Cinema,* 331–33; Antoine de Baecque and Serge Toubiana, *Truffaut: A Biography* (New York: Knopf, 1999), 242–45; editorial, *Cahiers du Cinéma* 202 (June–July 1968): 5.

10. Richard Roud, *A Passion for Films: Henri Langlois and the Cinémathèque Française* (Baltimore: Johns Hopkins University Press, 1999), viii, xxv, 150, 152–53, 155, 158–59. Roud also sees May as "a logical extension" of the Langlois affair (148). De Baecque and Toubiana, *Truffaut,* 235–40; Nowell-Smith, *Making Waves,* 148; editorial, *Cahiers du Cinéma* 200–201 (April–May 1968): 5; Jack Valenti, *This Time, This Place: My Life in War, the White House, and Hollywood* (New York: Harmony Books, 2007), 365–69.

11. All of Wexler's other directorial efforts were politically themed documentaries.

12. Dennis Schaefer and Larry Salvato, *Masters of Light: Conversations with Contemporary Cinematographers* (Berkeley: University of California Press, 1984), 259, 261. Paramount also insisted on specific changes regarding the footage involving police behavior. *Take One* 3.6 (July–August 1971): 15.

13. In an interview conducted before he made *Medium Cool,* Wexler observed, "I have very strong opinions about us and the world, and I don't know how in hell to put them all in one basket." *Film Quarterly* 21.3 (Spring 1968): 12.

14. Wexler repeatedly spoke of his desire to "find some wedding between features and *cinéma vérité,*" to break "some of the theatrical film convention," and "to make films, theatrical films, closer to what we think are real films." *Film Quarterly* 21.3 (Spring 1968): 12 (first quote); *Take One* 2.4 (March–April 1969): 5 (remaining quotes).

15. In another nod to Godard, after John and Eileen watch a TV special on Martin Luther King Jr., a careful listen will reveal the TV announcer plugging Godard's film *Contempt,* coming up next. Critics were divided as to whether this was also a nod toward the car crash that ends *Contempt* (and would end *Medium Cool*), and in turn whether this was clever or not. See Joseph Morgenstern and Stefan Kanfer, eds., *Film 69/70: An Anthology by the National Society of Film Critics* (New York: Simon and Schuster, 1970), 165–72.

16. In the radio announcement she is dead, but John is described as being "in critical condition."

17. On Robert Kennedy, see Palermo, *In His Own Right;* Clarke, *The Last Campaign;* Jeff Shesol, *Mutual Contempt: Lyndon Johnson, Robert Kennedy, and the Feud That Defined a Decade* (New York: Norton, 1997); Arthur M. Schlesinger Jr., *Robert Kennedy and His Times* (New York: Houghton Mifflin, 1978); Evan Thomas, *Robert Kennedy: His Life* (New York: Simon and Schuster, 2000).

18. Palermo, *In His Own Right,* 47–48, 54, 56; Clarke, *The Last Campaign,* 5, 19, 23, 45, 253.

19. Bernard Weintraub, "John Frankenheimer Is Dead at 72: Resilient Director of Feature Films and TV Movies," *New York Times,* July 7, 2002; Gerald Pratley, *The Films of John Frankenheimer* (Bethlehem, Pa.: Lehigh University Press, 1998), 127.

20. On this issue, see Mark Feeney, *Nixon at the Movies* (Chicago: University of Chicago Press, 2004), esp. 298–99.

21. Greg Mitchell, *Tricky Dick and the Pink Lady* (New York: Random House, 1998).

22. On the 1968 election and the early years of the Nixon presidency, see H. R. Haldeman, *The Haldeman Diaries: Inside the Nixon White House* (New York: Putnam, 1994); William Safire, *Before the Fall: An Inside View of the Pre-Watergate White House* (New York: Doubleday, 1975); John Ehrlichman, *Witness to Power: The Nixon Years* (New York: Simon and Schuster, 1982); Richard Nixon, *RN: The Memoirs of Richard Nixon* (New York: Grosset and Dunlap, 1978); Richard Reeves, *President Nixon: Alone in the White House* (New York: Simon and Schuster, 2001); Stephen E. Ambrose, *Nixon,* vol. 2, *The Triumph of a Politician, 1962–1972* (New York: Simon and Schuster, 1989); Jonathan Schell, *The Time of Illusion* (New York: Knopf, 1975). Nixon's memoirs are unreliable but offer insights into Nixon's thinking and especially how he wanted to speak to history; his versions of events also provide interesting contrasts with the accounts of others, and with the historical records as they continue to be released.

23. Schell, *Time of Illusion,* 21–23, 44, 62, 65; Ambrose, *Nixon,* 258, 272, 312.

24. On the importance of BBS Productions and the "no interference" deal it reached with Columbia, see chapter 1.

25. Tod Lippy, "Writing Five Easy Pieces: Interview with Carole Eastman," *Scenario* 1.2 (Spring 1995): 166, 188 (note that Eastman wrote under the pseudonym Adrian Joyce); Jay Boyer, *Bob Rafelson: Hollywood Maverick* (New York: Twayne Publishers, 1996), 36; Peter Biskind, *Easy Riders, Raging Bulls: How the Sex-Drugs-and-Rock 'n' Roll Generation Saved Hollywood* (New York: Simon and Schuster, 1998), 76, 119.

26. This contrast is emphasized in Stephen Farber, "Easy Pieces," *Sight and Sound* 40.3 (Summer 1971): 128–29. Farber considers *Five Easy Pieces* "a more mature and honest work."

27. John Russell Taylor, "Interview with Bob Rafelson," *Sight and Sound* 45.4 (Autumn 1976): 202; Michael Goodwin, "Camera: Laszlo Kovacs," *Take One* 2.12 (July–August 1970): 16; Boyer, *Bob Rafelson,* 40.

28. Eastman stresses the importance of "patriarchal expectations," and her early drafts indicated more of this; Rafelson, in revisions, put greater emphasis on Bobby's inability to make connections. Lippy, "Interview with Carole Eastman," 187; Boyer, *Bob Rafelson,* 38.

29. From a record playing "Stand by Your Man" by Tammy Wynette.

30. In an earlier version of the screenplay Catherine had been swimming; the decision to switch from swimming to riding changes the gender and power dynamics of the interaction.

31. Eastman originally wanted to kill Bobby off in a car crash (Rayette would survive), which Rafelson rejected as "too suicidal"; a number of possible endings were considered. Richard Coombs and John Pym, "Prodigal's Progress," *Sight and Sound* 50.4 (1981): 267; Lippy, "Interview with Eastman," 187; Dennis McDougal, *Five Easy Decades: How Jack Nicholson Became the Biggest Movie Star in Modern Times* (Hoboken, N.J.: John Wiley, 2008), 112.

32. Ambrose, *Nixon,* 224; Schell, *Time of Illusion,* 78; "Protest Season on the Campus," *Time,* May 11, 1970; Nixon, *RN,* 685.

33. Feeney, *Nixon at the Movies,* 66-73; J. Hoberman, *The Dream Life: Movies, Media, and the Mythology of the Sixties* (New York: New Press, 2003), 270-76.

34. Lou Cannon, *Governor Reagan: His Rise to Power* (New York: Public Affairs, 2003), 295; Safire, *Before the Fall,* 191; Schell, *Time of Illusion,* 96, 98; Ambrose, *Nixon,* 350-51; Reeves, *Alone in the White House,* 213; Haldeman, *Diaries,* 159-61.

35. Safire, *Before the Fall,* 204-11; Nixon, *RN,* 459-66; Reeves, *Alone in the White House,* 217-22; Ambrose, *Nixon,* 353-57; Haldeman, *Diaries,* 162-63.

36. Vincent J. Cannato, *The Ungovernable City: John Lindsay and His Struggle to Save New York* (New York: Basic Books, 2001), 448-51; Fred J. Cook, "Hard-Hats: The Rampaging Patriots," *The Nation,* June 15, 1970, 712-19; Schell, *Time of Illusion,* 101; Nixon, *RN,* 466-67.

37. These events, and especially the conduct of the Vietnam War, would also invite revisionism, which is considered in chapter 5.

38. John Russell Taylor, "Interview with Bob Rafelson," *Sight and Sound* 45.4 (Autumn 1976): 203; see also Mitchell S. Cohen, "The Corporate Style of BBS: 7 Intricate Pieces," *Take One* 3.12 (July-August 1972): 22.

39. Rafelson had hosted a free-form radio show in Japan during the Korean War, for example. David Thompson, in his essay on the film, emphasizes the personal connection at a deeper level as well and calls attention to two separate moments in the movie when each of the two brothers is referred to as an "artist." David Thomson, *Overexposures: The Crisis in American Filmmaking* (New York: William Morrow & Co., 1981), 234-35, 239; see also Boyer, *Bob Rafelson,* 2, 47, 53.

40. Ellen Burstyn, *Lessons in My Life* (New York: Penguin, 2006), 286-87.

41. Bryant Simon, *Boardwalk of Dreams: Atlantic City and the Fate of Urban America* (New York: Oxford University Press, 2004); American Film Institute, *Dialogue on Film* 4.1 (October 1974): 2-4.

42. This symmetry can be extended. Once in Atlantic City, Jason (Dern) has an initial conversation with his brother David, which sends him on his way for a meeting with the gangster Lewis; in the last two scenes there, David has a meeting with Lewis, which then motivates his final conversation with his brother.

43. David's trip home from work anticipates the lonely commute of another alienated one-roomer, Gene Hackman's Harry Caul in *The Conversation* (see chapter 6). On "black blacks," see American Film Institute, *Dialogue,* 11; for "one-roomer," see McDougal, *Five Easy Decades,* 140.

44. On camera movement and color schemes in the movie, see Boyer, *Bob Rafelson,* 5, 57; American Film Institute, *Dialogue,* 4, 7.

45. Near the end we learn that the story has unfolded over the course of about four weeks.

46. Nicholson also contributed to both monologues.

47. The combination of Antonioni's iconic status for the seventies filmmakers, Nicholson's position within the movement, and the fact that continental production was nevertheless mostly in English associates this film closely with the New Hollywood.

4. The Personal Is Political

1. For a short overview, see Beth Bailey, "Sexual Revolution(s)," in *The Sixties: From Memory to History,* ed. David Farber (Chapel Hill: University of North Carolina Press, 1994), 235-62.

2. Helen Gurley Brown, *Sex and the Single Girl* (1962; Fort Lee, N.J.: Barricade Books, 2003), 7, 24, 25, 28, 224, 226.

3. David Carter, *Stonewall: The Riots That Sparked the Gay Revolution* (New York: St. Martin's Press, 2004), 1, 15-16.

4. The Esalen Institute, located in Big Sur, California, was "dedicated to the continual exploration of human potential." Participants engaged in various encounters and activities designed to break down socially constructed roles, expectations, and barriers in order to understand themselves and others better. See Leo E. Litwak, "A Trip to Esalen Institute: Joy Is the Prize," *New York Times Magazine,* December 31, 1967, 8, 28–31.

5. Arthur Schlesinger offers a more specific comparison, finding Mazursky's direction "somewhat influenced…by the Cassavetes of *Faces.*" Arthur Schlesinger Jr., "Innocence Updated," in *Film 69/70: An Anthology by the National Film Critics,* ed. Joseph Morgenstern and Stefan Kanfer (New York: Simon and Schuster, 1970), 57.

6. American Film Institute, *Dialogue on Film* 4.2 (November 1974), 15; Paul Mazursky, *Show Me the Magic: My Adventures in Life and Hollywood* (New York: Simon and Schuster, 1999), 162–63.

7. DVD commentary, *Bob & Carol & Ted & Alice* (Columbia Pictures, 2004).

8. As Stephen Farber observed, many of the films of the period "tell the young, liberal intelligent audience what it already knows," but this film "implicates the educated audience more painfully." Stephen Farber, "Couples," *Hudson Review* 23.1 (Spring 1970): 106.

9. Gloria Steinem, "Words and Change," in *Outrageous Acts and Everyday Rebellions,* 2nd ed. (New York: Holt, 1995), 166. See also Ruth Rosen, *The World Split Open: How the Modern Women's Movement Changed America* (New York: Penguin, 2000), 143, 145, 151; and Beth Bailey, "She Can Bring Home the Bacon: Negotiating Gender in the 1970s," in *America in the 1970s,* ed. Beth Bailey and David Farber (Lawrence: University Press of Kansas, 2004), 116, 117.

10. Gurley Brown, *Sex and the Single Girl,* 4–5, 11, 65, 67; see also Rosen, *World Split Open,* 148, 175, 176.

11. Claudia Goldin and Lawrence F. Katz, "The Power of the Pill: Oral Contraceptives and Women's Career and Marriage Decisions," *Journal of Political Economy* 110.4 (August 2002): 730–32, 734, 738, 744–45, 749, 767; Gail Collins, *When Everything Changed: The Amazing Journey of American Women from 1960 to the Present* (New York: Little, Brown, 2009), 102, 158–59, 161.

12. It is of course an oversimplification to talk about the "women's movement" as a monolithic force. Three main strands of the movement can be identified: an economic-legalistic approach, which emphasized institutional reform; a liberal-cultural approach, which was more individualistic and stressed "the personal is political" (the power structures embedded in private relations); and a radical approach that featured more fundamental challenges to patriarchy and capitalism. There were numerous and often virulent rifts within and especially between these approaches. On these issues, see Jo Freeman, *The Politics of Women's Liberation* (New York: McKay, 1975), esp. 134–42; Rosen, *World Split Open,* 77, 81, 166, 217, 232, 234, 238; Alice Echols, *Daring to Be Bad: Radical Feminism in America, 1967–1975* (Minneapolis: University of Minnesota Press, 1989), 101, 199, 212, 240, 265; Patricia Bradley, *Mass Media and the Shaping of American Feminism, 1963–1975* (Jackson: University Press of Mississippi, 2003), 48, 253.

13. Claudia Goldin, *Understanding the Gender Gap: An Economic History of American Women* (New York: Oxford University Press, 1990), 206–7; Freeman, *Politics of Women's Liberation,* 33.

14. Betty Friedan, *The Feminine Mystique* (1963; New York: Norton, 2001), 15, 18–20, 30–31, 71, 77, 162, 174, 233, 242, 249; Rosen, *World Split Open,* 3, 37, 40–43, 51. As noted earlier, there is no single "voice" of the women's movement, and there were many internal debates and (often sharp) contestations. Friedan, for example, was criticized for focusing on the concerns of middle-class white women and thus marginalizing the distinct issues and problems many women faced that were associated with their race and class.

15. Goldin, *Understanding the Gender Gap,* 200; Bradley, *Mass Media and the Shaping of American Feminism,* 4, 7–8, 11; Rosen, *World Split Open,* 64.

16. Goldin, *Understanding the Gender Gap,* 201; Freeman, *Politics of Women's Liberation,* 53–54; Rosen, *World Split Open,* 70–72; Collins, *When Everything Changed,* 75–76, 78, 81–82; Carl M. Bruer, "Women Activists, Southern Conservatives, and the Prohibition of Sex Discrimination in Title VII of the 1964 Civil Rights Act," *Journal of Southern History* 49.1 (1983): 37, 43–45, 48.

17. Freeman, *Politics of Women's Liberation,* 55; Collins, *When Everything Changed,* 84; Bradley, *Mass Media and the Shaping of American Feminism,* 31, 33; Echols, *Daring to Be Bad,* 25–26, 117. On the break with the left, see Ellen Willis, "Letter to the Left" (1969), in *Dear Sisters: Dispatches from the Women's Liberation Movement,* ed. Rosalyn Baxandall and Linda Gordon (New York: Basic Books, 2000), 51; and Robin Morgan "Goodbye to All That" (1970), also in Baxandall and Gordon, *Dear Sisters,* 54.

18. Collins, *When Everything Changed,* 193; Bradley, *Mass Media and the Shaping of American Feminism,* 60, 104; Echols, *Daring to Be Bad,* 93, 198.

19. Steinem, "Life Between the Lines," in *Outrageous Acts,* 21; "I Was a Playboy Bunny," ibid., 32–75; Freeman, *Politics of Women's Liberation,* 148, 154, 160–61; Bradley, *Mass Media and the Shaping*

of American Feminism, 114, 152, 167, 182; Echols, *Daring to Be Bad,* 141, 198; Suzanne Levine and Harriet Lyons, eds., *The Decade of Women: A Ms. History of the Seventies in Words and Pictures* (New York: Paragon, 1980).

20. Kate Millet, *Sexual Politics* (1970; Urbana: University of Illinois Press, 2000), 91–92, 164, 167–69, 180–99 (Freud), 294–95, 296, 204. Friedan had also taken on Freud (and the sociologist Talcott Parsons); see *The Feminine Mystique,* chap. 5, "The Sexual Solipsism of Sigmund Freud." On *Ms.,* see Rosen, *World Split Open,* 208–17. See also Norman Mailer, *The Prisoner of Sex* (Boston: Little, Brown, 1971), in response to Millet.

21. Molly Haskell, *From Reverence to Rape: The Treatment of Women in the Movies,* 2nd ed. (1973; Chicago: University of Chicago Press, 1987), 31, 323, 39; Joan Mellon, *Women and Their Sexuality in the New Film* (New York: Dell, 1973), 22, 23, 25.

22. See Jacques Siclier, "Misogyny in Film Noir," in *Perspectives on Film Noir,* trans. and ed. R. Barton Palmer (1956; New York: G. K. Hall, 1996), 66–75; see also Elizabeth Cowie, "Film Noir and Women," in *Shades of Noir,* ed. Joan Copjec (London: Verso, 1993), 121–66.

23. Geneviève Sellier, *Masculine Singular: French New Wave Cinema,* trans. Kristin Ross (Durham: Duke University Press, 2008), 99, 102, 109, 116, 124, 218–19, 220.

24. Haskell seems to favor pre-code Hollywood, which was more permissive about depicting independent, sexually confident women, but which nevertheless placed limits on their objectification. See Haskell, *From Reverence to Rape,* 7, 38, 91–92.

25. Ibid., 30, 31, 93, 118, 324–25; Mellon, *Women and Their Sexuality in the New Film,* 17, 18, 24.

26. David Denby, "Men without Women, Women without Men," *Harper's* (September 1973): 51–54; "Profile of Monte Hellman," *Take One* 4.2 (November–December 1972): 30; Stephen Farber, "The Vanishing Heroine," *Hudson Review* 27.4 (Winter 1974–75): 576. See also Arthur Noletti Jr., "Male Companionship Movies and the Great American Cool," *Jump Cut,* no. 12–13 (1976): 35: "Male companionship film has emerged as one of the most durable and important screen modes of the 1970s." Prominent examples of New Hollywood male companionship films include *Mean Streets, The Last Detail, Easy Rider, M*A*S*H, The Wild Bunch, Scarecrow, Midnight Cowboy, The Godfather,* and *The French Connection.*

27. John Simon, "Rape upon Rape," in Morgenstern and Kanfer, *Film 69/70,* 75; John Hess, "The Glamour of Individualism in *Cockfighter* (Born to Kill)," *Jump Cut,* nos. 10–11 (1976): 19; Michael Ryan and Douglas Kellner, *Camera Politica: The Politics and Ideology of Contemporary Hollywood Film* (Bloomington: Indiana University Press, 1988), 28, also 58, 66; Marjorie Rosen, *Popcorn Venus: Women, Movies, and the American Dream* (New York: Coward, McCann and Geoghegan, 1973), 363–64; Vincent Canby, "Straw Dogs," *New York Times,* January 20, 1972. Peckinpah more generally invites an antifeminist (at best) interpretation of many of his films (for example, *The Wild Bunch* and *The Getaway*) with comments like these: "Well, there are two kinds of women. There are women and then there's pussy." William Murray, "Playboy Interview: Sam Peckinpah," *Playboy* (August 1972), reprinted in *Sam Peckinpah: Interviews,* ed. Kevin J. Haynes (Jackson: University Press of Mississippi, 2008), 104. Barbara Halpern Martineau, "Chinatown's Sexism," *Jump Cut,* no. 4 (1974): 24.

28. See Scorsese's commentary on the 2000 DVD release. For what it's worth, the extra scene, shot in two days and cut to the music of The Doors' song "The End," is more or less equally exploitative of its male and female actors.

29. Haskell, *From Reverence to Rape,* 118, 235.

30. For example, personally I consider *The Rain People* to be sensitive to women's issues and point of view (especially in context, as discussed in this chapter); others might have different readings of the "positive" films on my list. And some films defy easy categorization. *The Hired Hand,* for example, is a certainly a "male companionship" film, but it also prominently features a strong, independent female character.

31. Haskell, *From Reverence to Rape,* 93, 118, 324–25.

32. Ibid., 327; Denby, "Men without Women," 51–54; Schrader, "Notes on Film Noir," *Film Comment* 8.1 (Spring 1972): 8; Farber, "Vanishing Heroine," 572.

33. Pauline Kael, *Reeling* (Boston: Little, Brown, 1976), xiii–xiv.

34. Bailey, "She Can Bring Home the Bacon," 108, 111; Debra Michals, "From Consciousness Expansion to Consciousness Raising: Feminism and the Countercultural Politics of the Self," in *Imagine Nation: The American Counterculture of the 1960s and '70s,* ed. Peter Braunstein and Michael Doyle (New York: Routledge, 2002), 47; Collins, *When Everything Changed,* 24, 245; Levine and Lyons, *Decade of Women,* 88; Vivian Berger, "Men's Trial, Woman's Tribulation: Rape Cases in the Courtroom," *Columbia Law Review* 77.1 (January 1977): 1–103.

35. Jo Freeman, "The Legal Basis of the Sexual Caste System," *Valparaiso University Law Review* 5.2 (1971), 212, 218–29; "Women Move toward Credit Equity," *Time,* October 27, 1975, 77; Collins, *When Everything Changed,* 7, 20, 250, 351; Mailer, *Prisoner of Sex,* 51; Freeman, *Politics of Women's Liberation,* ix; Levine and Lyons, *Decade of Women,* 8.

36. Freeman, *Politics of Women's Liberation,* 57, 59, 61, 206; Steinem, *Outrageous Acts,* 111; Bradley, *Mass Media and the Shaping of American Feminism,* 111, 119; Bailey, "She Can Bring Home the Bacon," 111; Rosen, *World Split Open,* 95, 108, 110, 117, 133–34.

37. Mellon, *Women and Their Sexuality,* 61, 65.

38. Jules Feiffer, *Backing into Forward: A Memoir* (New York: Doubleday, 2010), 398, 400–401. Jules Feiffer, *Carnal Knowledge* (New York: Farrar, Straus and Giroux, 1971), is the shooting script.

39. Mellon, *Women and Their Sexuality,* 66; Haskell, *From Reverence to Rape,* 360; Janice Law Trecker, "Sex, Marriage, and the Movies... More of the Same," *Take One* 3.5 (May–June 1971): 12.

40. Roger Ebert, "Carnal Knowledge," *Chicago Sun Times,* July 6, 1971; Pauline Kael, "Carnal Knowledge," *New Yorker* July 3, 1971, 43–44; Vincent Canby, "Carnal Knowledge," *New York Times,* July 1, 1971; see also Vincent Canby, "I Was Sorry to See It End," *New York Times,* July 4, 1971.

41. Herb Lightman, "On Location with Carnal Knowledge," *American Cinematographer* 52 (January 1971): 34–37, 86–87.

42. Kael, "Carnal Knowledge"; Jacob Brackman, "Carnal Knowledge" ("pathetic"); Gary Arnold, "Carnal Knowledge" ("bastard," "dubious message"); Richard Schickel, "The View from Mr. Nichols' Bridge," all in *Film 71/72: An Anthology by the National Society of Film Critics,* ed. David Denby (New York: Simon and Schuster, 1972), 38, 41, 42, 43.

43. For Bergen's reflection on the production, see Candice Bergen, *Knock Wood* (New York: Linden Press, 1984), 219, 221, 224.

44. Haskell, *From Reverence to Rape,* 360.

45. The water motif is emphasized in H. Wayne Schuth, *Mike Nichols* (Boston: Twayne, 1978), 85, 106.

46. Christine Gledhill, "*Klute* 2: Feminism and *Klute,*" in *Women in Film Noir,* ed. E. Ann Kaplan (London: British Film Institute, 1978), 113, 121; Mellon, *Women and Their Sexuality,* 26, 55, 56; Haskell, *From Reverence to Rape,* 31.

47. Jared Brown, *Alan J. Pakula: His Films and Life* (New York: Back Stage Books, 2005), 104.

48. Tom Milne, "Not a Garbo or a Gilbert in the Bunch: An Interview with Alan J. Pakula," *Sight and Sound* 41.2 (Spring 1972): 90–91.

49. Diane Giddis, "The Divided Woman: Bree Daniels in *Klute,*" in *Movies and Methods: An Anthology,* ed. Bill Nichols (Berkeley: University of California Press, 1976), 195, 199. Marjorie Rosen also is positively inclined toward the film; see *Popcorn Venus,* 360.

50. To be clear, this is a cinematic parallel, not a moral equivalence. Klute is good, Cable is bad.

51. Giddis, "The Divided Woman," 196–97, 199; Milne, "Interview with Pakula," 92. Christine Gledhill also noted parallels between Klute and Cable in "*Klute* 2: Feminism and *Klute,*" 117, 121.

52. Milne, "Interview with Pakula," 92.

53. Mellon, *Women and Their Sexuality,* 56; Gledhill, "*Klute* 2: Feminism and *Klute,*" 125; Milne, "Interview with Pakula," 92; Brown, *Pakula: His Films and Life,* 110.

54. Teena Webb and Betsy Martens, "*Alice Doesn't Live Here Anymore:* A Hollywood Liberation," *Jump Cut,* no. 7 (1975): 4–5; Karyn Kay and Gerald Perry, "*Alice Doesn't Live Here Anymore:* Waitressing for Warners," *Jump Cut,* no. 7 (1975): 5–7; Robin Wood, *Hollywood from Vietnam to Reagan* (New York: Columbia University Press, 1986), 203–4.

55. See Ellen Burstyn, *Lessons in Becoming Myself* (New York: Riverhead Books, 2006), 287–90.

56. And there is no confusion about what has happened. Her version to Elmo is "He raped me," which Blume acknowledges with a nod. Later Blume tells his business partner (played by Mazursky), "I raped my ex-wife."

57. Howard Movshovitz, "The Delusion of Hollywood's Women's Films," *Frontiers: A Journal of Women Studies* (Spring 1979): 12.

58. American Film Institute, *Dialogue on Film* 4.2 (November 1974): 8, 12; Paul Mazursky, *Show Me the Magic: My Adventures in Life and Hollywood* (New York: Simon and Schuster, 1999), 212, 215. (Mazursky's comment that the ending was central and planned from the start was a surprise to this viewer at least; my original notes include "Really awful ending—were other endings considered?")

59. Molly Haskell, "A Women's Movement," *New York Magazine,* March 6, 1978, 72–73; see also Molly Haskell, "Movies 1973," *Massachusetts Review* 14.4 (Autumn 1973): 817, 828, 829, for additional, if here slightly more qualified, praise; Richard Corliss, "Paul Mazursky: The Horace with a Heart of Gold," *Film Comment* 11.2 (March–April 1975): 40; Denby, "Men without Women," 51.

5. Crumbling Cities and Revisionist History

1. The literature on the Vietnam War is obviously vast; five sources were particularly important for this brief overview: George McT. Kahin, *Intervention: How America Became Involved in Vietnam* (New York: Anchor Books, 1987); Fredrik Logevall, *Choosing War: The Lost Chance for Peace and the Escalation of War in Vietnam* (Berkeley: University of California Press, 1999); George C. Herring, *America's Longest War: The United States and Vietnam, 1950–1975*, 2nd ed. (New York: Knopf, 1986); Jeffrey Kimball, *Nixon's Vietnam War* (Lawrence: University Press of Kansas, 1998); and Larry Berman, *No Peace, No Honor: Nixon, Kissinger, and Betrayal in Vietnam* (New York: Free Press, 2001). For more on Johnson's conduct of the war, see chapter 3.

2. Kahin, *Intervention*, 3, 27 (quote), 30, 66, 87–89; Herring, *America's Longest War*, 6–7, 11–12, 14–15.

3. Eisenhower thought that in 1954, Ho would have carried the election with 80 percent of the vote; the CIA estimated that it was a "virtual certainty" that Ho would win an all-Vietnam election. Dwight Eisenhower, *The White House Years: Mandate for Change* (New York: Doubleday, 1963), 372; Lloyd C. Gardner, *Approaching Vietnam: From World War II through Dienbienphu* (New York: Norton, 1988), 316–17, 318 (quote).

4. John Lewis Gaddis, *Strategies of Containment* (Oxford: Oxford University Press, 1982), 179; Fred Greenstein and Richard Immerman, "What Did Eisenhower Tell Kennedy about Indochina?" *Journal of American History* 79.2 (September 1992): 579 (quote), 581; Kahin, *Intervention*, 93, 101, 126, 129; Herring, *America's Longest War*, 29, 55, 65, 75; Logevall, *Choosing War*, xviii–xix, 51–52, 69.

5. Kahin, *Intervention*, 181, 202–3, 208; Herring, *America's Longest War*, 98–99, 103, 106.

6. Logevall, *Choosing War*, 73–74, 78, 145, 298, 314, 388, 393; Kahin, *Intervention*, 260, 262, 286, 306, 366, 393, 399, 423, 426, 432; Herring, *America's Longest War*, 144–45, 146, 151, 161. On the Tet Offensive and its aftermath, see chapter 3.

7. Stephen E. Ambrose, *Nixon*, vol. 2, *The Triumph of a Politician, 1962–1972* (New York: Simon and Schuster, 1989), 43–44, 61, 64, 68, 81; Richard Nixon, *RN: The Memoirs of Richard Nixon* (New York: Grosset and Dunlap, 1978), 269–71; Logevall, *Choosing War*, 135 (quote).

8. Richard Nixon, "Asia after Vietnam," *Foreign Affairs* 46.1 (October 1967): 111, 114–15, 121; Ambrose, *Nixon*, 2:142–44, 147, 260; Berman, *No Peace, No Honor*, 45.

9. Henry Kissinger, "The Vietnam Negotiations," *Foreign Affairs* 47.2 (January 1969): 213–14, 216–17; Ambrose, *Nixon*, 2:167; Kimball, *Nixon's Vietnam War*, 29–31, 39–40, 101.

10. Kimball, *Nixon's Vietnam War*, 73, 90–91, 139, 182; Herring, *America's Longest War*, 221, 224.

11. Kimball, *Nixon's Vietnam War*, 125, 131, 135; Herring, *America's Longest War*, 225; Ambrose, *Nixon*, 2:224; Nixon, *RN*, 382.

12. Kimball, *Nixon's Vietnam War*, 137, 193, Richard Reeves, *President Nixon: Alone in the White House* (New York: Simon and Schuster, 2001), 177–78; Kahin, *Intervention*, 404; Herring, *America's Longest War*, 151.

13. Seymour Hersh, *Cover-Up: The Army's Secret Investigation of the Massacre at My Lai 4* (New York: Random House, 1972); William R. Peers, *Report of the Department of the Army Review of the Preliminary Investigations into the My Lai Incident* (Washington, D.C.: U.S. Government Printing Office, 1974); Reeves, *Alone in the White House*, 146, 177–78; Kimball, *Nixon's Vietnam War*, 204, 210, 216; Ambrose, *Nixon*, 2:312, 498.

14. Berman, *No Peace, No Honor*, 108, 111; Reeves, *Alone in the White House*, 303; Herring, *America's Longest War*, 240.

15. Kimball, *Nixon's Vietnam War*, 240, 260, 272; Berman, *No Peace, No Honor*, 50; Jeffrey Kimball, *The Vietnam War Files* (Lawrence: University Press of Kansas, 2004), 163, 165 (quotes). Kissinger wrote "We want a decent interval" in the margin of his notes for his trip to China in July 1971. Kimball, *Vietnam War Files*, 187.

16. Mark Clodfelter, *The Limits of Air Power: The American Bombing of North Vietnam* (Lincoln: University of Nebraska Press, 2006), 156, 167–68, 173–74; Berman, *No Peace, No Honor*, 123, 126, 132 (quote).

17. Kimball, *Nixon's Vietnam War*, 341–42; Berman, *No Peace, No Honor*, 142, 158, 161, 180; Clodfelter, *The Limits of Air Power*, 175; Nixon, *RN*, 693 (quote).

18. Kimball, *Vietnam War Files*, 262; Berman, *No Peace, No Honor*, 153, 190, 197, 215 (quote), 218; Kimball, *Nixon's Vietnam War*, 348–49, 364 (quote).

19. Clodfelter, *The Limits of Air Power*, 186, 188, 194, 196; Kimball, *Nixon's Vietnam War*, 363–64; Herring, *America's Longest War*, 253–54.

20. Berman, *No Peace, No Honor*, 219, 225, 227, 233, 244–46, 251; Herring, *America's Longest War*, 255, 260, 264; Kimball, *Nixon's Vietnam War*, 365.

21. David Thompson, ed., *Altman on Altman* (London: Faber and Faber, 2006), 25, 46.

22. Beatty was not alone in his dissatisfaction with the sound, and even Altman expressed concern about some early prints of the film. Mitchell Zuckoff, *Robert Altman: The Oral Biography* (New York: Knopf, 2009), 226, 229–30; Peter Biskind, *Star: How Warren Beatty Seduced America* (New York: Simon and Schuster, 2010), 163–64.

23. Thompson, *Altman on Altman*, 59; Zuckoff, *Altman: The Oral Biography*, 215–16, 219, 229; American Film Institute, *Dialogue on Film* 4.1 (October 1974): 18–19; Robert Altman, DVD commentary, *McCabe & Mrs. Miller* (Warner Bros., 2002).

24. On this theme, see Robert T. Self, *Robert Altman's McCabe & Mrs. Miller: Reframing the American West* (Lawrence: University of Kansas Press, 2007), 5, 9, 23, 34, 55, 112.

25. The tendency of the seventies film to blur the distinction between capitalism and organized crime, which would reach its apogee in *The Godfather* (1972), is discussed in chapter 8.

26. Sandra Wake and Nicola Heyden, eds., *The Bonnie and Clyde Book* (New York: Simon and Schuster, 1972), 172–73. Penn also made *The Missouri Breaks* (1976) with Marlon Brando and Jack Nicholson, an offbeat film about the arbitrary nature of violence and justice in the "civilizing" West.

27. Peter Fonda, *Don't Tell Dad: A Memoir* (New York: Hyperion, 1998), 297, 314–15; Molly Haskell, "Narcissism in Visual Violets," *Village Voice*, August 26, 1971.

28. Fonda, *Don't Tell Dad*, 300; for more on Oates, see Susan Compo, *Warren Oates: A Wild Life* (Lexington: University Press of Kentucky, 2009).

29. On Peckinpah, see David Weddle, *"If They Move... Kill 'Em!" The Life and Times of Sam Peckinpah* (New York: Grove Press, 1994); Paul Seydor, *Peckinpah: The Western Films, A Reconsideration* (1980; Urbana: University of Illinois Press, 1999); Garner Simmons, *Peckinpah: A Portrait in Montage* (New York: Limelight, 1998).

30. "Of all the projects I have ever worked on," Peckinpah wrote at the time, "this is the closest to me." Seydor, *Peckinpah*, 170.

31. William Murray, "Interview with Sam Peckinpah," *Playboy*, August 1972, reprinted in *Sam Peckinpah Interviews*, ed. Kevin J. Hayes (Jackson: University Press of Mississippi, 2008), 109; Paul Schrader, "Sam Peckinpah Going to Mexico," *Cinema* 5.3 (1969): 22.

32. The machine gun, and its capacity for slaughter, is the most obvious of these.

33. Weddle, *"If They Move... Kill 'Em!"*, 6, 7 (Ebert quotes), 271, 334, 364; Richard Schickel, "Mastery of the 'Dirty Western,'" in *Film 69/70*, ed. Joseph Morgenstern and Stefan Kanfer (New York: Simon and Schuster, 1970), 150; Stephen Farber, "Peckinpah's Return," *Film Quarterly* 23.1 (Fall 1969): 2.

34. "Interview with Sam Peckinpah," *Take One* 2.3 (1969): 20; Farber, "Peckinpah's Return," 8, 9.

35. The year 1971 saw a cluster of bloody, high-profile controversial films: Stanley Kubrick's *A Clockwork Orange*, Roman Polanski's *Macbeth*, as well as the violent policers *Dirty Harry* and *The French Connection*.

36. Farber, "Peckinpah's Return," 8; Murray, "Interview with Sam Peckinpah," 103.

37. David Denby, "Violence, Once Again," in *Film 72/73*, ed. David Denby (New York: Simon and Schuster, 1973), 118. Peckinpah's comments on *Straw Dogs*, especially regarding its controversial rape scene, make the film even harder to defend; see esp. Murray, "Interview with Sam Peckinpah, 100, 105–6.

38. Even *Garcia* is not without defenders. Roger Ebert called it "some kind of bizarre masterpiece" (*Chicago Sun Times*, August 1, 1974); see also Mark Crispin Miller, "In Defense of Sam Peckinpah," *Film Quarterly* 28.3 (Spring 1975): esp. 2, 6, 13–14. But the more common reaction was that of actor Robert Culp, who had praised *The Wild Bunch* as a film "more quintessentially and bitterly American than any since World War II" but thought there was "no excuse" for the "lousy" *Garcia*. Compo, *Warren Oates*, 316.

39. Kimball, *Nixon's Vietnam War*, 249, 251; Hayes, *Peckinpah Interviews*, 143, 153; Stephen Prince, *Savage Cinema: Sam Peckinpah and the Rise of Ultraviolent Movies* (Austin: University of Texas Press, 1998), 35–36.

40. The version cut and released by the studio is inferior to two other existing versions, assembled posthumously in 1988 and 2005, which come much closer to Peckinpah's vision. On the studio's hatchet job, see "Interview with James Coburn," *Take One* 4.12 (July–August 1974): 7. Martin Scorsese saw an early cut, before the studio took over the film, and "thought it was a masterpiece" (Weddle, *"If They Move... Kill 'Em!"* 483).

41. For more on the production history, see Seydor, *Peckinpah*, 256, 262; Weddle, *"If They Move... Kill 'Em!"* 453, 456, 460.

42. Richard Brodie, *Everything Is Cinema: The Working Life of Jean-Luc Godard* (New York: Metropolitan Books, 2008), 350; Jules Feiffer, *Backing into Forward: A Memoir* (New York: Doubleday, 2010), 343, 379.

43. Feiffer, *Backing into Forward,* 352; see also Juan José Cruz, "'One of those little things you learn to live with': On the Politics of Violence in Jules Feiffer's *Little Murders,*" *Americana* 2.1 (Spring 2003).

44. On New York City in this period, see Martin Shefter, *Political Crisis/Fiscal Crisis: The Collapse and Revival of New York City* (New York: Basic Books, 1985); Joshua Freeman, *Working-Class New York: Life and Labor since World War II* (New York: New Press, 2000); and Vincent Cannato, *The Ungovernable City: John Lindsay's New York and the Crisis of Liberalism* (New York: Basic Books, 2001).

45. Freeman, *Working-Class New York,* 164, 167–68, 172; Shefter, *Political Crisis/Fiscal Crisis,* 61; Paul Peterson, *City Limits* (Chicago: University of Chicago Press, 1981), 188–89, 203–5.

46. Sam Roberts, introduction to *America's Mayor: John V. Lindsay and the Reinvention of New York,* ed. Sam Roberts (New York: Columbia University Press, 2010), 12, 16, 21, 24; Freeman, *Working-Class New York,* 99, 210–13; Cannato, *The Ungovernable City,* 76–78, 82, 90, 196–97, 199.

47. Schatzberg also directed *Puzzle of a Downfall Child* (1970), written by Carol Eastman and starring Faye Dunaway, and *Scarecrow* (1973), a male companion–road picture with Pacino and Gene Hackman. Didion and Dunne also co-scripted *Play It as It Lays* (1972), based on Didion's novel, starring Tuesday Weld and Anthony Perkins.

48. Roberts, introduction, 13.

49. For more on police corruption, see chapter 6; also Cannato, *The Ungovernable City,* 466–78.

50. Shefter, *Political Crisis/Fiscal Crisis,* 43, 67, 70–71, 93; Cannato, *The Ungovernable City,* 120, 123–24, 132–33, 140, 183, 210, 301, 353, 447; Sam Roberts, "The Legacy," in Roberts, *America's Mayor,* 237.

51. Shefter, *Political Crisis/Fiscal Crisis,* 66, 196; Cannato, *The Ungovernable City,* 100–101, 104, 107; Theodore Lowi, "Dear Mayor Lindsay," *The Nation,* December 8, 1969, 626.

52. Freeman, *Working-Class New York,* 171, 209; Keith T. Jackson, "The Mayoral Matchup," in Roberts, *America's Mayor,* 216, 219, 223; Peterson, *City Limits,* 189, 191, 194, 198–99, 207–8; Cannato, *The Ungovernable City,* 461–62, 550; Shefter, *Political Crisis/Fiscal Crisis,* 82, 86, 92, 105.

53. Steven R. Weisman, "City in Crisis II," in Roberts, *America's Mayor,* 194, 198, 201; Freeman, *Working-Class New York,* 197, 256, 272–73.

54. Shefter, *Political Crisis/Fiscal Crisis,* 106–7, 109, 127, 132, 134–35; Freeman, *Working-Class New York,* 356 (quote), 257–58, 260, 262, 267, 270.

55. Roberts, introduction, 86; Vincent Canby, "New York's Woes Are Good Box Office," *New York Times,* November 10, 1974.

56. In later years, both films would be reclassified R.

57. William J. Mann, *Edge of Midnight: The Life of John Schlesinger* (New York: Billboard Books, 2005), 5.

58. Anne Nocenti, "Producing Midnight Cowboy: A Talk with Jerome Hellman," *Scenario* 3.4 (Winter 1997): 94 (quote); Mann, *Edge of Midnight,* 318–19, 331, 335. Schlesinger's next film, *Sunday Bloody Sunday* (1971), written by Penelope Gilliatt, was overt about the homosexuality of its lead male characters.

59. "Waldo Salt," *Scenario* 3.4 (Winter 1997): 88, 92; Nocenti, "Directing Midnight Cowboy," 101, 206; Mann, *Edge of Midnight,* 268, 295, 315–16.

60. Salt's interpretation is that when he returns from his triumph, the initial motivation for the scene was that "Joe is going to leave Ratso." Mann, *Edge of Midnight,* 317.

61. Judith McNally, "Filming in the Dark: An Interview with Owen Roizman," *Filmmakers Newsletter* 8.1 (November 1974): 27, 28.

62. Pauline Kael, "Urban Gothic," *New Yorker,* October 30, 1971, 113.

63. Friedkin also had a hit with *The Exorcist* (1973). As his career progressed, he would distance himself from "arty" or "cerebral" films in favor of movies designed to be mass entertainments.

64. American Film Institute, *Dialogue on Film* 3.4 (February–March 1974): 3, 20, 27–28; Michael Sheldon, "Police Oscar: The French Connection," *Film Quarterly* 25.4 (Summer 1972): 3, 4 (quote), 5, 6, 7 (quotes).

65. Including *Cool Hand Luke* (1967), the politically ambitious *WUSA* (1970), and the revisionist detective film *The Drowning Pool* (1975).

66. Vincent Canby, "Taxi Driver," *New York Times,* February 8, 1976; Richard Thompson, "Interview with Paul Schrader," *Film Comment* 12.2 (March–April 1976): 9, 13; Kevin Jackson, ed., *Schrader on Schrader* (London: Farber and Farber, 2004), 117.

67. Marshall Fine, *Accidental Genius: How John Cassavetes Invented American Independent Film* (New York: Hyperion, 2005), 270; David Thompson and Ian Christie, *Scorsese on Scorsese* (London: Faber and Faber, 1989), 38, 45, 48; American Film Institute, "Interview with Martin Scorsese," *Dialogue on Film* 4.7 (April 1975): 4, 5, 7, 9, 11, 21; "Interview with Martin Scorsese," *Filmmakers Newsletter* 7.3 (January 1974): 28, 30–31.

68. Dennis Schaefer and Larry Salvato, *Masters of Light: Conversations with Contemporary Cinematographers* (Berkeley: University of California Press, 1984), 105; Peter Biskind, *Easy Riders, Raging Bulls* (New York: Simon and Schuster, 1998), 299.

69. Thompson, "Interview with Schrader," 11; Thompson and Christie, *Scorsese on Scorsese,* 63, 66. Many critics have emphasized the numerous thematic similarities with *The Searchers,* another film about a racist war veteran on an obsessive, violent quest to reclaim an innocent young woman from defilement.

70. Thompson, "Interview with Schrader," 11, 17, 19.

71. For a highly critical essay on *Taxi Driver*'s "immoral posture" on race, gender, violence, and guns, see Patricia Patterson and Manny Farber, "The Power and the Gory," *Film Comment* 12.3 (May–June 1976): 26–30. Also critically exploring these themes, although from a perspective more favorable to the movie, is Amy Taubin, *Taxi Driver* (London: British Film Institute, 2000).

72. On the dolly shot, see Thompson and Christie, *Scorsese on Scorsese,* 54; Jackson, *Schrader on Schrader,* 211.

73. Coincidentally, Scorsese also played a psychopath in the backseat of a car in *Mean Streets.*

74. Thompson, "Interview with Schrader," 18.

75. Thompson and Christie, *Scorsese on Scorsese,* 54 (New York), 62; Jackson, *Schrader on Schrader,* 126.

76. Norman Mailer, *Miami and the Siege of Chicago* (New York: Penguin, 1968), 15 (Updike).

6. Privacy, Paranoia, Disillusion, and Betrayal

1. Mark Feeney, *Nixon at the Movies* (Chicago: University of Chicago Press, 2004), 298; see also 299–300, 315–17.

2. The literature on Nixon is, of course, enormous. Highly recommended are Richard Reeves, *President Nixon: Alone in the White House* (New York: Simon and Schuster, 2001), 40 (quote), which draws heavily on the voluminous notes Nixon wrote to himself on yellow legal pads; and Stanley I. Kutler, *Abuse of Power: The New Nixon Tapes* (New York: Free Press, 1997), for transcriptions of many of the key tapes, and commentary. Reading Nixon's massive *RN: The Memoirs of Richard Nixon* (New York: Grosset and Dunlap, 1978) is a mind-bending experience that leaves the reader staggering like Orson Welles trying to escape the funhouse in *The Lady from Shanghai:* a version of events told by a smart, enigmatic man, a pathological liar who nevertheless knows that many of the facts are in the public domain, and thus wants to include enough truths to lend plausibility to the version of history he hopes will be recorded. This description extends to almost all the memoirs of the president's men, although the spectrum ranges from the history- and image-obsessed Kissinger to Nixon speechwriter William Safire, with his more detached journalistic instincts, but even Safire, with his Madison Avenue background, knew something about image making. See H. R. Haldeman, *The Haldeman Diaries: Inside the Nixon White House* (New York: Putnam, 1994); John Ehrlichman, *Witness to Power: The Nixon Years* (New York: Simon and Schuster, 1982); Henry Kissinger, *White House Years* (Boston: Little, Brown, 1979), and *Years of Upheaval* (Boston: Little, Brown, 1982); John Dean, *Blind Ambition* (New York: Simon and Schuster, 1976); and William Safire, *Before the Fall* (New York: Doubleday, 1975). Also helpful in sorting through the loose ends and triangulating competing versions of events are Steven E. Ambrose, *Nixon,* vol. 2, *The Triumph of a Politician* (New York: Simon and Schuster, 1989), and vol. 3, *Ruin and Recovery* (New York: Simon and Schuster, 1991); and Fred Emery: *Watergate: The Corruption of American Politics and the Fall of Richard Nixon* (New York: Touchstone, 1994).

3. Reeves, *Alone in the White House,* 26 (quote), 30–31, 57, 583; Nixon, *RN,* 279, 337, 340, 629, 648; Kissinger, *Years of Upheaval,* 95; Ehrlichman, *Witness to Power,* 75, 78, 317.

4. Pauline Kael, "The Businessman-Pimp as Hero," *New Yorker* February 17, 1973, 94; Vincent Canby "Save the Tiger," *New York Times* February 15, 1973. Roger Ebert gave up a three-star review, even as he recognized that the movie "apologizes for actions that are corrupt no matter how you view them" ("Save the Tiger," *Chicago Sun Times,* March 2, 1973).

5. Nixon, *RN,* 149, 248, 1013 (quotes); see also Bob Woodward and Carl Bernstein, *The Final Days* (New York: Simon and Schuster, 1976), 165; Ehrlichman, *Witness to Power,* 74.

6. Feeney, *Nixon at the Movies*, 86; Kutler, *Abuse of Power*, 639.

7. Nixon, *RN*, 357, 496, 543; Emery, *Watergate*, 7–8, 36; Ambrose, *Nixon*, 2:499.

8. Reeves, *Alone in the White House*, 273; Emery, *Watergate*, 88; Nixon, *RN*, 497; Safire, *Before the Fall*, 509, 527–28.

9. Haldeman, *Diaries*, 134; Nixon, *RN*, 677; Ambrose, *Nixon*, 2:561, 588, 3:78.

10. Stanley Kutler, *Watergate: A Brief History with Documents*, 2nd ed. (Oxford: Wiley-Blackwell, 2010), 19, 34, 36, 47; Reeves, *Alone in the White House*, 501; Kutler, *Abuse of Power*, xiii, xv, 43; Emery, *Watergate*, 148, 161; Ambrose, *Nixon*, 2:566, 571, 576, 661; Bob Woodward, *The Secret Man: The Story of Watergate's Deep Throat* (New York: Simon and Schuster, 2005), 91, 93.

11. Kutler, *Abuse of Power*, 38 ("snake out"), 47 ("other things"), 65–66 ("can't trace"), 72; Emery, *Watergate*, 174, 176; Nixon, *RN*, 496 ("point man"), 640 ("find some way"), 711 ("acting in my name").

12. Kutler, *Abuse of Power*, 67–68; Haldeman, *Diaries*, 476–77; Dean, *Blind Ambition*, 121–25; Ambrose, *Nixon*, 3:72; Emery, *Watergate*, 195.

13. Reeves, *Alone in the White House*, 511; Dean, *Blind Ambition*, 128–29; Kutler, *Abuse of Power*, 45, 92, 99, 111 (keeping Hunt happy); Haldeman, *Diaries*, 483; Ehrlichman, *Witness to Power*, 359, 397–98; Ambrose, *Nixon*, 2:603, 607, 3:28.

14. Kutler, *Watergate*, 48, 212–14; Emery, *Watergate*, 6; Kutler, *Abuse of Power*, 217–18.

15. Reeves, *Alone in the White House*, 40, 462–63; Emery, *Watergate*, 109–11, 200; Nixon, *RN*, 711; Haldeman, *Diaries*, 74.

16. Reeves, *Alone in the White House*, 64, 101, 279; Haldeman, *Diaries*, 148, 215; Nixon, *RN*, 543; Kutler, *Abuse of Power*, 25, 40, 132.

17. Reeves, *Alone in the White House*, 367; Emery, *Watergate*, 173, 197; Dean, *Blind Ambition*, 114–15, 121–22; Woodward, *Secret Man*, 96.

18. Emery, *Watergate*, 10, 13; Ambrose, *Nixon*, 2:272–73, 250; Woodward, *Secret Man*, 21–22; Reeves, *Alone in the White House*, 74–75.

19. Reeves, *Alone in the White House*, 235–36; Ambrose, *Nixon*, 2:660; Jonathan Schell, *The Time of Illusion* (New York: Knopf, 1972), 33, 111–12; Nixon, *RN*, 471, 474–75, 476.

20. Kutler, *Abuse of Power*, 3, 7–8; Reeves, *Alone in the White House*, 332, 338–39, 348, 353; Kutler, *Watergate*, 23–24; Nixon, *RN*, 512.

21. Kutler, *Abuse of Power*, 8, 28; Ambrose, *Nixon*, 2:449, 465; Ehrlichman, *Witness to Power*, 342; Nixon, *RN*, 514.

22. Kutler, *Abuse of Power*, 38; Reeves, *Alone in the White House*, 228–29, 480; Schell, *Time of Illusion*, 125; Woodward, *Secret Man*, 49.

23. Schell, *Time of Illusion*, 145, 205, 218, 220; Woodward, *Secret Man*, 77; Ambrose, *Nixon*, 2:82, 477; Kutler, *Abuse of Power*, 158; Emery, *Watergate*, 74, 77, 89, 91, 94–96, 107, 114–15; Haldeman, *Diaries*, 449; Reeves, *Alone in the White House*, 279, 413, 424, 430.

24. Nixon, *RN*, 717; Kutler, *Abuse of Power*, 193–94, 230; Ambrose, *Nixon*, 3:66; Bob Woodward and Carl Bernstein, *All the President's Men* (New York: Simon and Schuster, 1974).

25. Kutler, *Abuse of Power*, xxi, 388–89, 411, 532; Reeves, *Alone in the White House*, 604–5; Ambrose, *Nixon*, 3:137–38.

26. Kutler, *Abuse of Power*, 247, 251, 252–54, 256; Emery, *Watergate*, 261, 263–64, Ambrose, *Nixon*, 3:81, 84–87.

27. Kutler, *Abuse of Power*, 257, 549–50, 580–81, 593, 600–601; Reeves, *Alone in the White House*, 578.

28. Reeves, *Alone in the White House*, 579, 587; Kutler, *Watergate*, 64, 65, 77, 79; Emery, *Watergate*, 269, 274, 276, 282, 286–89, 318; Ambrose, *Nixon*, 3:97, 104, 104, 118, 120, 123–25.

29. Nixon, *RN*, 846, 847, 849; Kissinger, *Years of Upheaval*, 102; Ehrlichman, *Witness to Power*, 389–90; Haldeman, *Diaries*, 672; Reeves, *Alone in the White House*, 599, 601; Ambrose, *Nixon*, 3:126.

30. Nixon, *RN*, 848, 849; Woodward and Bernstein, *The Final Days*, 32.

31. Kutler, *Watergate*, 118; Emery, *Watergate*, 359, 363, 365, 368, 373; Ambrose, *Nixon*, 3:147–48, 179–81, 193; Kutler, *Abuse of Power*, 407, 415.

32. Ambrose, *Nixon*, 3:211, 215, 229, 250; Kissinger, *Years of Upheaval*, 431; Nixon, *RN*, 893; Emery, *Watergate*, 397; Kutler, *Watergate*, 134, 155–56.

33. Woodward and Bernstein, *The Final Days*, 27; Kutler, *Watergate*, 162–63; Emery, *Watergate*, 409, 419–20, 425; Ambrose, *Nixon*, 3:285.

34. Woodward and Bernstein, *The Final Days*, 235; Ambrose, *Nixon*, 3:327–28, 334–35; Kutler, *Watergate*, 7, 167.

35. Reeves, *Alone in the White House*, 608–9; Woodward and Bernstein, *The Final Days*, 270–71, 325, 350, 391; Ambrose, *Nixon*, 3:394–95, 399, 401, 403, 414, 416; Emery, *Watergate*, 446, 449, 466–67.

36. Brian De Palma, "The Making of *The Conversation:* An Interview with Francis Ford Coppola," *Filmmakers Newsletter* 7.7 (May 1974): 30, 31, 33 (quote); Gene D. Phillips, *Godfather: The Intimate Francis Ford Coppola* (Lexington: University Press of Kentucky, 2004), 73–74.

37. Feeney, *Nixon at the Movies,* 319; Michael Schumacher, *Francis Ford Coppola: A Filmmaker's Life* (New York: Crown, 1999), 134, 136, 140.

38. Michael Ondaatje, *The Conversations: Walter Murch and the Art of Film Editing* (New York: Knopf, 2004), 53, 152, 164, 166. Coppola went so far as to insist that he did not want to know too much about the murder, so that he would not "be infected with that knowledge" (164). Claude Chabrol, "Little Themes," *Cahiers du Cinéma* 100 (October 1959): 39–41.

39. De Palma, "Interview with Coppola," 33; Francis Ford Coppola, DVD commentary, *The Conversation* (Paramount, 2000); Walter Murch, DVD commentary, *The Conversation.*

40. The surveillance camera allusion was purposeful; see Annie Nocenti, "Writing and Directing *The Conversation:* A Talk with Francis Ford Coppola," *Scenario* 5.1 (Spring 1999): 64; De Palma, "Interview with Coppola," 32; and Coppola's DVD commentary.

41. On the influence of *Blow-Up,* see Nocenti, "A Talk with Francis Ford Coppola," 62; Coppola, DVD commentary; Murch, DVD commentary.

42. Ondaatje, *The Conversations,* 34 (quote), 36; Nocenti, "A Talk with Coppola," 64 (quote); Phillips, *Godfather,* 79; Coppola, DVD commentary.

43. From the girls unknowingly being photographed through one-way mirrors to remote control security cameras at the convention to the "rolling 10–28" of the joy ride–car chase and beyond, Coppola takes every opportunity to fill the frame with allusions to surveillance. De Palma, "Interview with Coppola," 31; Coppola, DVD commentary; Murch, DVD commentary.

44. It bears repeating that although the movie was written and directed by Coppola, Murch had an important hand in the finished product. Left mostly to his own devices for almost a year, with an enormous amount of footage (and a first assembly of over four hours), Murch created many of the plot points in the editing room, as Coppola readily acknowledges. De Palma, "Interview with Coppola," 32; Ondaatje, *The Conversations,* 157, 160, 163, 166; Murch, DVD commentary; Phillips, *Godfather,* 80; Michael Pye and Lynda Myles, *The Movie Brats: How the Film Generation Took Over Hollywood* (New York: Holt, Rinehart and Winston, 1979), 99.

45. Nocenti, "A Talk with Coppola," 67; Murch, DVD commentary; Coppola, DVD commentary.

46. Ondaatje, *The Conversations,* 175; Schumaker, *Francis Ford Coppola,* 136; Coppola, DVD commentary.

47. De Palma, "Interview with Coppola," 34; Nocenti, "A Talk with Coppola," 63; Coppola, DVD commentary; Seth Cagan and Philip Dray, *Hollywood Films of the Seventies: Sex, Drugs, Violence, Rock 'n' Roll, and Politics* (New York: Harper and Row, 1984), 228 ("made a film").

48. Seymour Martin Lipset and William Schneider, *The Confidence Gap: Business, Labor, and Government in the Public Mind* (New York: Free Press, 1983), 17, 48–49, 183.

49. Nick Dawson, *Being Hal Ashby: The Life of a Hollywood Rebel* (Lexington: University Press of Kentucky, 2009), 140.

50. Reeves, *Alone in the White House,* 308, 309 (quote), 458; Ambrose, *Nixon,* 3:203–4; Schell, *Time of Illusion,* 146, 192; Emery, *Watergate,* 423.

51. Ambrose, *Nixon,* 3:205, 220, 323; Jules Witcover, *Very Strange Bedfellows: The Short and Unhappy Marriage of Richard Nixon and Spiro Agnew* (New York: Public Affairs, 2007), 300, 302, 319, 328; Nixon, *RN,* 823 (quote), 912, 914–17; Kutler, *Watergate,* 149–51; David Rosenbaum, "Rebozo Reportedly Tells Watergate Aide He Got $100,000 Hughes Gift for Nixon," *New York Times,* October 10, 1973.

52. Kutler, *Watergate,* 176; Emery, *Watergate,* 430; Ambrose, *Nixon,* 3:341.

53. Reeves, *Alone in the White House,* 551; Kutler, *Abuse of Power,* 180 (quote); Kutler, *Watergate,* 48, 51–52.

54. Robert Dallek, *Nixon and Kissinger: Partners in Power* (New York: HarperCollins, 2007), 239 (quote), 240–41, 509–10; Kissinger to Helms, TELCON (transcription of telephone conversation), 9/12/70, posted on the George Washington University National Security Archive; see also Kissinger to Secretary of State Rogers, TELCON, 9/14/70; Reeves, *Alone in the White House,* 249–50, 259–60 (CIA cable, 10/18/70).

55. Kissinger, *Years of Upheaval,* 374, 413 (Chile), 103, 1198 (Nixon); Nixon-Kissinger TELCON, 9/16/73; Nixon, *RN,* 489; Dallek, *Nixon and Kissinger,* 511, 515.

56. Faye Dunaway, *Looking for Gatsby: My Life* (New York: Simon and Schuster, 1995), 278.

57. Also as with Hitchcock, a reluctant woman is caught up in the effort, and the first safe haven approached is in reality an enemy harbor. And wonderful Hitchcock touches abound: the momentarily terrifying woman tending to her baby; the excruciating elevator ride with stops on every floor.

58. Telephone interview with Lorenzo Semple Jr., February 16, 2010; Patricia Erens, "Sydney Pollack: The Way We Are," *Film Comment* 11.5 (September–October 1975): 25. The source material, James Grady's *Six Days of the Condor* (New York: Norton, 1974), later retitled to match the film, is a rather undistinguished novel. In the film, only a handful of elements survive, principally the initial hit, the kidnapping, and the murderous mailman.

59. Erens, "Sydney Pollack," 25. Compare especially the final, thoughtful exchange between Turner and Joubert near the end of the movie with their unpleasant interactions in the book (Grady, *Six Days of the Condor,* e.g., 177–78, 188). Patrick McGilligan, "Hollywood Uncovers the CIA," *Jump Cut* 10–11 (1976): 11–12.

60. McGilligan, "Hollywood Uncovers the CIA," 12.

61. Prominent shots of and location work within the World Trade Center are even more likely to catch the eye now, post 9/11, than when the film was released, but the shots and the location work were always important visual signatures for the film.

62. Jennifer Wood, "Owen Roizman Looks Back," *Moviemaker,* February 3, 2007; International Cinematographers Guild, "A Conversation with Owen Roizman about the Art of Filmmaking," http://www.cameraguild.com.

63. Jared Brown, *Alan J. Pakula: His Films and Life* (New York: Back Stage Books, 2005), 148, 151–53, 157–60; William Goldman, *Adventures in the Screen Trade* (New York: Warner Books, 1983), 215–16, 220, 227; *Take One* 4.8 (November–December 1973): 5.

64. Rick Lyman, "Watching Movies with Steven Soderbergh," *New York Times,* February 16, 2001; Richard Thompson, "Mr. Pakula Goes to Washington," *Film Comment* 12.5 (September–October 1976): 18; Brown, *Alan J. Pakula,* 165; Paul Ramaeker, "Notes on the Split-Field Diopter," *Film History* 19 (2007): 179–81, 187–88.

65. Thompson, "Mr. Pakula Goes to Washington," 14 (quote), 15; Brown, *Alan J. Pakula,* 183, 192–93, 194.

66. Phillip French, "The Parallax View," *Sight and Sound* 44.1 (Winter 1974–75): 55; Thompson, "Mr. Pakula Goes to Washington," 13 (quote); Peter Biskind, *Star: How Warren Beatty Seduced America* (New York: Simon and Schuster, 2010), 175.

67. Brown, *Alan J. Pakula,* 127.

68. Author's conversation with Lorenzo Semple Jr.; Andrew C. Bobrow, "The Parallax View: Interview with Alan Pakula," *Filmmaker's Newsletter* 7.11 (September 1974): 22; French, "The Parallax View," 54; Brown, *Alan J. Pakula,* 127, 133; Biskind, *Star,* 134, 176–77.

69. Loren Singer, *The Parallax View* (New York: Doubleday, 1970), e.g., 65–66, 76–77. When Tucker's bodyguard first approaches Frady, he puts his hand on his shoulder and tells Frady he is going to subject him to a "skin search." When Frady objects, he is told, "If I don't see you, you don't see him [Tucker]." The only actual scene from the book that makes it into the film is the confrontation at the dam, including the fishing-rod-as-weapon bit (24–28).

70. This includes taking the much-appreciated Parallax visual test, a five-minute montage of sound and image starting with benign themes that devolve into unsettling juxtapositions of family, country, violence, and fascism. A provocative aspect of the montage is that the moviegoing audience is essentially subject to the same "test" as Frady. For its entire length, the Parallax test fills the screen, and we in the audience experience it as Frady does, our point of view having converged with his. The camera returns to the protagonist only after the full five minutes have elapsed. (I thank Dana Polan for stressing this point with me.) More subtle, but equally chilling, is the earlier moment when the camera pans across the questions of the "written test" that probes for antisocial tendencies and proclivities toward violence. Brown, *Alan J. Pakula,* 132; author's conversation with Lorenzo Semple Jr.; see also Kyle Renick, "The Poet of Paranoia: An Appreciation of the Late, Great Michael Small," *Film Score Monthly* 10.5 (September–October 2005): 31.

71. Bobrow, "Interview with Alan Pakula," 21 (quote), 24; Richard T. Jameson, "The Pakula Parallax," *Film Comment* 12.5 (September–October 1976): 10, 12; Thompson, "Mr. Pakula Goes to Washington," 17. Willis did go too far in one scene, relying on the light from one naked bulb in Frady's apartment; seeing the rushes, Pakula complained that it looked like he was directing the shadows, not the actors. Biskind, *Star,* 175, 178.

72. Brown, *Alan J. Pakula,* 126; Erens, "Sydney Pollack," 25; McGilligan, "Hollywood Uncovers the CIA," 12.

73. Nixon's instruction concludes, "Could we please investigate some of the cocksuckers?" Kutler, *Abuse of Power,* 31. On Nixon and his mistrust of "the Jews"—he once asked (and was told) how many Jews worked at the Bureau of Labor Statistics when he did not like some of the economic data being reported— see, for example, ibid., 32, 172, 191; Reeves, *Alone in the White House,* 42, 340, 343–44. On "us versus

them," see, for example, Safire, *Before the Fall*, 308–15. On the enemies list, see Emery, *Watergate*, 27; Ambrose, *Nixon*, 3:183–84; Christopher Lydon, "Ex-Council Says White House Kept 'Enemy List' That It Used for Harassment," *New York Times*, June 27, 1973; Jack Anderson, "Nixon Enemy List Reveals Paranoia," *Washington Post*, July 4, 1973.

74. Kissinger, *White House Years*, 1406; Nixon, *RN*, 769; Reeves, *Alone in the White House*, 15–16, 244, 542; Ambrose, *Nixon*, 2:228, 239; Kissinger, *Years of Upheaval*, 75, 104; Ehrlichman, *Witness to Power*, 85, 137; Safire, *Before the Fall*, 615.

75. Reeves, *Alone in the White House*, 178; Haldeman, *Diaries*, 99, 103, 139, 182, 186, 189, 362, 369, 372, 444 (quote); Ehrlichman, *Witness to Power*, 288, 296, 311; Woodward and Bernstein, *The Final Days*, 196; Kissinger, *Years of Upheaval*, 97–98, 104, 108.

76. Emery, *Watergate*, 12, 423; Safire, *Before the Fall*, 166–68; Woodward and Bernstein, *The Final Days*, 190; Kutler, *Abuse of Power*, 191, 202; Ambrose, *Nixon*, 3:43.

77. Nixon, *RN*, 711; Ambrose, *Nixon*, 3:106; Emery, *Watergate*, 339.

78. Ehrlichman, *Witness to Power*, 344, 348; Kutler, *Abuse of Power*, 50, 194–96, 229, 291, 501; Nixon, *RN*, 777, 815, 828; Schell, *Time of Illusion*, 325; Ambrose, *Nixon*, 3:84, 106.

79. Nixon, *RN*, 902–3.

80. See, for example, the reviews by Vincent Canby, *New York Times*, June 27, 1973; Roger Ebert, *Chicago Sun Times*, June 27, 1973; and Richard Schickel, *Time*, July 2, 1973.

81. Andrew C. Bobrow, "The Making of *Friends of Eddie Coyle*," *Filmmakers Newsletter* 6.12 (October 1973): 20, 23; George V. Higgins, *The Friends of Eddie Coyle* (New York: Knopf, 1972). Yates also discusses the locations, and offers repeated high praise for the book, in his "Director's Commentary" on the DVD (Criterion Collection, 2009). Another link between *Condor* and *Coyle* is Dave Grusin, who did the music for both films; the similarities are noticeable, especially over the opening credits.

82. Vernon Young, "The Friends of Graham Greene," *Hudson Review* 27.2 (Summer 1974): 250 (quote); see also 251 on Yates's "neutrality"; Yates, "Director's Commentary."

83. Bobrow, "The Making of *Friends of Eddie Coyle*," 21; Yates, "Director's Commentary."

84. A sharp piece of dialogue actually not in the novel, where Foley manages just two ironic "Merry Christmases." Higgins, *Friends of Eddie Coyle*, 16, 42.

85. Janet Coleman, *The Compass: The Improvisational Theatre That Revolutionized American Comedy* (Chicago: University of Chicago Press, 1990), 295; interview with Michael Hausman (producer) and Jonathan Rosenbaum, liner notes, *Mikey and Nicky* (DVD, Home Vision Entertainment, 2004); Marshall Fine, *Accidental Genius: How John Cassavetes Invented the American Independent Film* (New York: Hyperion, 2005), 314–17.

86. Stanley Kauffmann, *Before My Eyes: Film Criticism and Comment* (New York: Harper and Row, 1980), 275. Along with Rosenbaum and Kauffmann, another booster is Dave Kehr, for whom the movie "offers an almost Shakespearean appreciation of human complexity." "New DVDs," *New York Times*, December 21, 2004.

87. Peter Falk, *Just One More Thing: Stories from My Life* (New York: Carroll and Graf, 2006), 226–28; DVD interview with Hausman.

88. Kauffmann, *Before My Eyes*, 273; Barbara Koenig Quart, *Women Directors: The Emergence of a New Cinema* (New York: Praeger, 1998), 48 (quote), 44, 46.

7. White Knights in Existential Despair

1. For the iconic rooftop evacuation photo, see the *New York Times*, April 30, 1975, under the headline "Minh Surrenders, Vietcong in Saigon; 1,000 Americans and 5,500 Vietnamese Evacuated by Copter to U.S. Carriers." On abuses of power, see, for example, Commission on CIA Activities within the United States (Rockefeller Commission), *Report to the President* (Washington, D.C., June 1975), 10 ("plainly unlawful"); Select Committee to Study Governmental Operations (Church Committee) "Alleged Assassination Plots Involving Foreign Leaders: Interim Report" (Washington, D.C., November 1975), 255; Church Committee, *Intelligence Activities and the Rights of Americans: 1976 U.S. Senate Report on Illegal Wiretaps and Domestic Spying by the FBI, CIA, and NSA* (St. Petersburg, Fla.: Red and Black Publishers, 2007), 98–99, 116, 149.

2. In February 1975 Lennon released *Rock 'n' Roll*, an album of covers that had been in various stages of production since 1973. In October 1975 the compilation album *Shaved Fish* fulfilled a contractual obligation to Capitol Records.

3. For a critical assessment of this trend, see David Denby, "Law and Disorder," *Harper's*, March 1974, 82–84.

4. "The Commission found that corruption within the police department was so pervasive that honest rookies joining the police force were subject to strong pressures to conform to patterns of behavior

which . . . ultimately led many of them into the most serious kinds of corruption." *The Knapp Commission Report on Police Corruption* (New York: George Braziller, 1973), 260.

5. In 1966 Dylan would improve on this phrasing: "To live outside the law, you must be honest" (from the song "Absolutely Sweet Marie" on the album *Blonde on Blonde*).

6. Don Siegel, *A Siegel Film: An Autobiography* (London: Faber and Faber, 1993), 376, 382–83.

7. Vincent Canby, "Charley Varrick," *New York Times,* October 20, 1973; "Nixon Discharges Cox for Defiance; Abolishes Watergate Task Force; Richardson and Ruckelshaus Out," *New York Times,* October 21, 1973.

8. This image is also seen over the introductory titles. "In using the title 'Last of the Independents,' it had been my intention to burn 'Last of the Independents,' as the first and last title of the picture." Siegel, *A Siegel Film,* 383; Andrew Sarris, "Charley Varrick," *Village Voice,* November 1, 1973, 67.

9. Hickey's wife matter-of-factly refers to Boggs as his "fag partner"; there is an elliptical scene in which an introspective, downcast Boggs pays off a largely unseen prostitute who is probably but not necessarily female; his stripper ex-wife, only seen performing in the distance, has a very boyish figure.

10. Hill, who would become a director, also wrote *The Getaway* (1972), *The Mackintosh Man* (1973), and *The Drowning Pool* (1975). *Hickey and Boggs* was shot by Bill Butler, who was also the cinematographer on *The Rain People* (1969), *Drive, He Said* (1971), and *The Conversation* (1974).

11. On the significance of the cat, see John Zelazny, "The Long Goodbye: Elliott Gould Remembers Robert Altman," *EightMillionStories.com,* November 14, 2008; Jan Dawson, "Robert Altman Speaking," *Film Comment* 10.2 (March–April 1974): 40; David Thompson, ed., *Altman on Altman* (London: Faber and Faber, 2006), 76.

12. This need not have been so. Originally Howard Hawks and then Peter Bogdanovich were considered to direct the picture from Brackett's script, which she and Altman revised; Robert Mitchum was eyed for the lead. That version of *The Long Goodbye* would have been more traditional, probably along the lines of the adaptation of Chandler's *Farewell, My Lovely* that starred Mitchum in 1975.

13. American Film Institute, "Laszlo Kovacs/Vilmos Zsigmond," *Dialogue on Film* 4.1 (October 1974): 20; Edward Lipnick, "Creative Post-Flashing Technique for 'The Long Goodbye,'" *American Cinematographer* (March 1973): 278–81, 328–29, 334–35; "Vilmos Zsigmond Flashes *The Long Goodbye*," interview with Zsigmond on the DVD of *The Long Goodbye* (MGM, 2002); Thompson, *Altman on Altman,* 77; see also Michael Tarantino, "Movement as Metaphor: *The Long Goodbye," Sight and Sound* 4.2 (Spring 1975): 98–102.

14. Pauline Kael, "Movieland—the Bums' Paradise," *New Yorker,* October 22, 1973, 137.

15. Vincent Canby, "The Long Goodbye," *New York Times,* October 29, 1973; Roger Ebert, "The Long Goodbye," *Chicago Sun Times,* March 7, 1973; Kael, "Movieland—the Bums' Paradise," 133–39.

16. Charles Champlin, "The Long Goodbye," *Los Angeles Times,* March 8, 1973; Charles Gregory, "Knight without Meaning?" *Sight and Sound* 42.3 (Summer 1973): 159; Philip French, "The Long Goodbye," *Sight and Sound* 43.1 (Winter 1973-74): 52; see also Charles Gregory, "The Long Goodbye," *Film Quarterly* 26.4 (Summer 1973): 46–48; and the review by William S. Pechter, who sniffed, "A stiff is a stiff, even when propped up by Pauline Kael," in *Commentary* (January 1974): 54–58.

17. Leigh Brackett, "From 'The Big Sleep' to 'The Long Goodbye,' and More or Less How We Got There," *Take One* 4.1 (September–October 1972 [published in 1974]): 27, 28; see also Brackett interviewed in Jon Tuska, *In Manors and Alleys: A Casebook of the American Detective Film* (New York: Greenwood Press, 1988), 387–88; also Zelazny, "The Long Goodbye."

18. Dawson, "Robert Altman Speaking," 41 (quote); Harry Kloman and Lloyd Michaels with Virginia Wright Wexman, "A Foolish Optimist," *Film Criticism* 7.3 (Spring 1983), reprinted in *Robert Altman Interviews,* ed. David Sterritt (Jackson: University of Mississippi Press, 2000), 111 (quote); see also Altman's comments in Tuska, *In Manors and Alleys,* 389; Michael Wilmington, "Robert Altman and *The Long Goodbye*," in *Movie Talk from the Front Lines: Filmmakers Discuss Their Works with the Los Angeles Film Critics Association,* ed. Jerry Roberts and Steven Gaydos (Jefferson, N.C.: McFarland & Company, 1995), reprinted in Sterritt, *Interviews,* 137; and Thompson, *Altman on Altman,* 75.

19. Zelazny, "The Long Goodbye."

20. Patricia Erens, "Sydney Pollack: The Way We Are," *Film Comment* 11.5 (September–October 1975): 28, 29.

21. There is no universally agreed-upon definition of film noir. In addition, the approach, labeled by French critics after the fact, is not a proper genre, like "the Western." Nevertheless, there are some common characteristics, themes, and visual styles that are generally understood to represent film noir. Two key touchstones for these definitions are Paul Schrader, "Notes on Film Noir," *Film Comment* 8.1 (Spring 1972): 8–13; and Janey Place and Lowell Peterson, "Some Visual Motifs in *Film Noir," Film Comment* 10.1

(January–February 1974): 30–35. There is a vast literature on film noir; for the themes discussed here, see James Naremore, *More Than Night: Film Noir in Its Contexts* (Berkeley: University of California Press, 1998); Raymond Borde and Étienne Chaumeton, *A Panorama of American Film Noir, 1941–1963,* trans. Paul Hammond (1955; San Francisco: City Lights, 2002); and Alain Silver and Elizabeth Ward, eds., *Film Noir: An Encyclopedic Reference to the American Style,* 3rd ed. (New York: Overlook Press, 1992).

22. As noted, film noir's commitment to "realism"—showing the hard truths of the world and avoiding the pristine, artificial lighting and settings of classical studio productions—was at the same time associated with expressionistic, highly stylized visual compositions.

23. Schrader, "Notes on Film Noir," 11; Place and Peterson, "Some Visual Motifs," 30–31; Alain Silver and James Ursini, *The Noir Style* (New York: Overlook Press, 1999); Foster Hirsch, *Film Noir: The Dark Side of the Screen* (New York: Da Capo, 1981).

24. Lee Server, "Behind the Shadows: Film Noir's Dark Roots," *Scenario* 5.3 (2000): 156–71; Paul Jensen, "Film Noir: The Writer Raymond Chandler; The World You Live In," *Film Comment* 10.6 (November–December 1974): 18, 19; Sheri Chinen Biesen, *Blackout: World War II and the Origins of Film Noir* (Baltimore: Johns Hopkins University Press, 2005); Nicholas Christopher, *Somewhere in the Night: Film Noir and the American City* (New York: Free Press, 1997); Andrew Dickos, *Street with No Name: A History of the Classic American Film Noir* (Lexington: University Press of Kentucky, 2002).

25. Server, "Behind the Shadows," 158, 162, 168 (Polonsky quote); Schrader "Notes on Film Noir," 9, 10 (quote).

26. Or if not death, final ruin. Sterling Hayden dies at the end of John Huston's *The Asphalt Jungle* but survives in Stanley Kubrick's later caper picture *The Killing.* The money lost, cops approaching, "Run, Steve!" his girlfriend urges. "What's the point?" he exhales. They are the last words in the movie.

27. John Houseman, "Today's Hero: A Review," *Hollywood Quarterly* 2.2 (January 1947): 163.

28. Brackett, "From 'The Big Sleep' to 'The Long Goodbye,'" 28.

29. Paul Jensen describes Marlowe as "a disillusioned idealist" who "knows that society in general cannot be changed, although a few people might be helped." Jensen, "Film Noir," 19.

30. Much has been written about this celebrated film. A good starting point is Michael Eaton, *Chinatown* (London: BFI Publishing, 1997).

31. Robert Towne, *Two Screenplays: Chinatown, The Last Detail* (New York: Grove Press, 1997); see, for example, 45–46, 62–63, 72–75, 86–87; see also Roman Polanski, *Roman by Polanski* (New York: William Morrow and Company, 1984), 346–47.

32. Polanski, *Roman by Polanski,* 349; John Alonzo, "Behind the Scenes of Chinatown," *American Cinematographer* 56.5 (May 1975): 564, 565, 572. Alonzo and Polanski also note (as have others) the important contributions to the look of the film by production designer Richard Sylbert, who was also the production designer on *The Graduate, Carnal Knowledge, Fat City,* and *Shampoo.* See Robert Carringer, "Designing Los Angeles: An Interview with Richard Silbert," *Wide Angle* 30.3 (1998), 97–131.

33. Paul Cronin, ed., *Roman Polanski: Interviews* (Jackson: University of Mississippi Press, 2005), 60; Wayne Warga, "Writer Towne: Under the Smog, a Feel for the City," *Los Angeles Times,* August 18, 1974 ("I've read all of [Hammett] and all of Chandler and they have influenced me a lot").

34. Polanski, *Roman by Polanski,* 348; Cronin, *Roman Polanski,* 61.

35. Mulwray was unwilling to support the building of a new dam because it was similar to one that was constructed, under his reluctant supervision, and which gave way, leading to the death of five hundred people. "It won't hold," he insists, "and I'm not going to make the same mistake twice."

36. Cronin, *Roman Polanski,* 62; Joel Engel, ed., "Interview with Robert Towne," *Screenwriters on Screenwriting* (New York: Hyperion, 1995), 201; see also 202.

37. Engel, "Interview with Robert Towne," 216; see also Aljean Harmetz, "The Two Jacks," *New York Times,* September 10, 1989.

38. Towne, *Two Screenplays,* 5.

39. Jeff Greenfield, "Columbo Knows the Butler Didn't Do It," *New York Times,* April 1, 1973. (The episode, "A Friend in Deed," was broadcast May 5, 1974.)

40. Faye Dunaway with Betsy Sharkey, *Looking for Gatsby: My Life* (New York: Simon and Schuster, 1995), 253; see also 262, and 263 for her endorsement of the ending.

41. Near the end of *The Maltese Falcon,* Spade, as Brigid watches in confusion and concern, calls the police and summons them to their location. Hanging up, he then turns to Brigid and manhandles her until he finally shakes out the confession that confirms his solution to the mystery. Near the end of *Chinatown,* exactly the same events unfold. But in a reversal of Spade's savvy and insight, Jake is completely blindsided by the truth that comes tumbling out of Evelyn. His theory was exactly wrong. He has not unmasked the culprit and brought her to justice; he has sealed the fate of the innocent, someone he was trying to help.

42. *Chinatown* is Jake's story (and Nicholson's); only twice, briefly, do we see things that he does not.

43. *Farewell, My Lovely* (1975) is a remake of *Murder My Sweet,* Edward Dmytryk's celebrated 1944 noir adoption of the Chandler novel. A straightforward and faithful period piece, *Farewell, My Lovely* is less ambitious than *Chinatown,* but it earns its seventies stripes by lingering authentically on seamy locations forbidden to the cinema of the forties, and by reestablishing the racial elements that were so important to the novel but were whitewashed in the original film.

44. For particularly positive and insightful reviews, see Richard Cooms, "Night Moves," *Sight and Sound* 44.3 (Summer 1975): 189–90; David Bartholomew, "Night Moves," *Film Quarterly* 29.2 (Winter 1975-76): 52-55; Roger Ebert, "Night Moves," *Chicago Sun Times,* June 11, 1975; and Penelope Gilliatt, "Night Watch," *New Yorker,* June 23, 1975, 98–99. Penn has singled out Gilliatt's reading of the film for praise. Writer-director Robert Benton is also an enthusiastic fan of *Night Moves*—"a great film"—and he named the detective in his movie *Twilight* (1998) Harry, for Harry Moseby. Alex Simon, "Robert Benton: Adventures in the Twilight Zone," *Venice* (March 1998).

45. Bruce Surtees also shot *Play Misty for Me* (1971), *Blume in Love* (1973), and *Lenny* (1974); Small's credits include *Klute* (1971), *The Parallax View* (1974), and *The Drowning Pool* (1975). Dede Allen's fifty-year career (she cut *Odds Against Tomorrow,* 1959) includes a number of important collaborations with Penn, dating back to *Bonnie and Clyde* (1967). Penn routinely emphasizes his "very close collaboration" with Allen; see, for example, his interviews in *Cinema* (May 1977), and *24 Images* (June 1983), both reprinted in *Arthur Penn Interviews,* ed. Michael Chaiken and Paul Cronin (Jackson: University Press of Mississippi, 2008), 128 (quote), 129, 170.

46. Penn interview, *Cinema,* reprinted in Chaiken and Cronin, *Arthur Penn Interviews,* 116; Vincent Canby, "Night Moves," *New York Times,* June 12, 1975; Raymond Chandler, *The Big Sleep* (1939; New York: Vantage, 1988), 154.

47. Thanks again to Amy Sloper at the Harvard Film Archive for her time and hospitality in making it possible for me to view *Mickey One* when it was otherwise unavailable.

48. Harry, of course, was a fan of the art house. "I saw a Rohmer film once," he says, turning down an invitation to see the film. "It was like watching paint dry." In the novelization, Sharp switches the movie back to his original suggestion, a Chabrol film (*Le Boucher*), which works less well both for the themes evoked and for Harry's line. Alan Sharp, *Night Moves* (New York: Warner Books, 1975), 14.

49. Penn interview in Chaiken and Cronin, *Arthur Penn Interviews,* 113, 114 (compared to other possibilities, "the Rohmer reference does add something thematically"); also Penn interviewed in Tag Gallagher, "Arthur Penn's Night Moves," *Sight and Sound* 4.2 (Spring 1975): 88; Antoine de Baeque and Serge Toubiana, *Truffaut: A Biography,* trans. Catherine Temerson (New York: Alfred A. Knopf, 1999), 249. Truffaut took a room in town and that night found a movie house playing Chaplin's *Gold Rush.*

50. Bruce Horsfield, "Night Moves Revisited: Scriptwriter Alan Sharp Interviewed by Bruce Horsfield, December 1979," *Literature Film Quarterly* 11.2 (1983): 88; Penn interview in Chaiken and Cronin, *Arthur Penn Interviews,* 112; Penn interview in Gallagher, "Arthur Penn's Night Moves," 87. No wonder Penn thought that Gilliatt "got it." Her review opens with the story of Harry's search for his father, then quickly makes a transition into a discussion of his marriage. The essay is half over before she even mentions the "plot" of the mystery story.

51. Middle age, in particular its implied limitations and foreclosures of promise, is a recurrent theme in the movie. Harry twice rather sheepishly identifies his age (a subject that never comes up, for example, in *The Long Goodbye* and *Chinatown*). As an ex-football star, his glory days (like America's) are long behind him. The same could be said for Arlene Iverson, who hires Moseby and who is also repeatedly associated with her lost youth. Harry's conversations with stunt director Joey Ziegler ("guys like him make me feel old," Joey laments), and Joey's later barroom confrontation with a young man, also emphasize this theme.

52. Sharp, *Night Moves* (note the tone throughout); Penn interviewed in *Écran* (December 1976), reprinted in Chaiken and Cronin, *Arthur Penn Interviews,* 102. For some additional background on Sharp, see Brian Pandreigh, "Sharp Shooter," *iofilm,* n.d. On the Penn-Sharp collaboration, see Horsfield, "Night Moves Revisited," 89, 94; Penn interview in Gallagher, "Arthur Penn's Night Moves," 88-89; seminar with Penn at the BFI National Film Theater, August 30, 1981, published in Chaiken and Cronin, *Arthur Penn Interviews,* 139.

53. "The theme of the Kennedys is so central to the film." Penn interview in Chaiken and Cronin, *Arthur Penn Interviews,* 112; see also Penn interviewed by Richard Schickel, May 22, 1990, reprinted ibid., 186; and Horsfield, "Night Moves Revisited," 89.

54. Paula's story, and the story of Arlene Iverson (who has a small role but about whom we know much), add yet another dimension to *Night Moves,* that of gender politics. Paula, a drifter and a survivor,

describes her past: "I taught school, I kept house, I waited tables, I did a little stripping, I did a little hooking"—in sum, she experienced the full range of options society had to offer her. Arlene, whose very despairing life story and trajectory are told mostly secondhand, paints another none-too-pretty picture of a runaway who slept her way to modest Hollywood success (and, as she observes, "there were a lot of girls like me"). Sharp thinks she "comes off better" in her final, hostile exchange with Moseby; Penn thinks she "had something to say" and "holds her own." Horsfield, "Night Moves Revisited," 99; author's interview with Arthur Penn, New York City, January 25, 2010. Ellen, a professional woman and a character meant to be respected, offers some hope, but the fact that her lover is noticeably well-off could possibly be read to suggest a third if more subtle form of prostitution, although Penn didn't "think of her as wanting money" (author's interview with Penn).

55. Ric Gentry, "Dede Allen: An Interview," *Post Script: Essays in Film and the Humanities* 19.3 (Summer 2000): 26; Horsfield, "Night Moves Revisited," 90.

56. Penn interview in Gallagher, "Arthur Penn's Night Moves," 87; Gentry, "Dede Allen," 26; Horsfield, "Night Moves Revisited," 97.

57. Horsfield, "Night Moves Revisited," 96, 97; Gentry, "Dede Allen," 26; author's interview with Arthur Penn.

58. Author's interview with Arthur Penn; author's telephone interview with Jennifer Warren, February 19, 2010; Horsfield, "Night Moves Revisited," 90, 93. Both Penn and Warren found the "balance of emotional power" interpretation plausible but did not suggest it on their own (author's interviews).

59. Warren "made a choice that it wasn't about that." That is, when Paula seduces Harry, although she is diverting his attention, this is "not her main interest"; she has real feelings for Harry. Penn says he was not thinking along these lines when deciding about the cut. Author's interviews.

60. Penn interview with Schickel, in Chaiken and Cronin, *Arthur Penn Interviews,* 186; Horsfield, "Night Moves Revisited," 90, see also 103; Sharp, *Night Moves,* 102.

61. Penn interview in Gallagher, "Arthur Penn's Night Moves," 87, 88; Penn interview in Chaiken and Cronin, *Arthur Penn Interviews,* 114; author's interview with Penn. Compare Sharp's contradictory statements on his preferences regarding Harry's fate in Horsfield, "Night Moves Revisited," 93, 100; in his view the film itself "aimed at the dead center of ambiguity" on this point. See also his own uncertainties about Delly's accident (98).

8. Businessmen Drink My Wine

1. See, for example, Anthony Lewis, "For Gerald Ford," *New York Times,* August 5, 2000.

2. For a good short overview of the Ford presidency, see Douglas Brinkley, *Gerald R. Ford* (New York: Times Books, 2007).

3. "The Nation: The Ridicule Problem," *Time,* January 5, 1976, 37; Yanek Mieczkowski, *Gerald Ford and the Challenges of the 1970s* (Lexington: University Press of Kentucky, 2005), 54, 327. It bears repeating that these are the descriptions of those coming to Ford's defense: a sympathetic weekly magazine and his most supportive biographer. See also Brinkley, *Gerald R. Ford,* 5–6, 135.

4. Edward D. Berkowitz, *Something Happened: A Political and Cultural Overview of the Seventies* (New York: Columbia University Press, 2006), 83, 107, 109; Brinkley, *Gerald R. Ford,* 134, 137–38, 142; Jefferson Cowie, *Stayin' Alive: The 1970s and the Last Days of the Working Class* (New York: New Press, 2010), 14, 219, 264–65.

5. Larry Sturhahn, "The Making of 'Smile': An Interview with Michael Ritchie," *Filmmakers Newsletter* 8.12 (October 1975): 18. *The Man Who Fell to Earth* and *Smile* leave it to the viewer to draw these conclusions; in Robert Aldrich's despairing neo-noir *Hustle* (1975), characters occasionally pause to give short speeches on the dismal state of values, morals, justice, and clawing ambition in mid-seventies America.

6. David Thompson, ed., *Altman on Altman* (London: Faber and Faber, 2006), 87.

7. Tom Wicker, "Nashville: Dark Perceptions in a Country Music Comedy," *New York Times,* June 15, 1975.

8. Jan Stuart, *Nashville Chronicles: The Making of Robert Altman's Masterpiece* (New York: Simon and Schuster, 2000), 276; Connie Byrne and William O. Lopez, "Nashville," *Film Quarterly* 29.2 (Winter 1975–76): 21.

9. Mitchell Zuckoff, *Robert Altman: The Oral Biography* (New York: Knopf, 2009). Altman describes his aim to "push the actor into contributing to the part" (81); see also 248 (on Altman's permissive style). For this reason, *Nashville's* static frame compositions and color schemes are not rigid or uniformly

systematic. That sort of precision would inhibit the feeling of spontaneity that Altman was trying to capture on film. Nevertheless, as discussed in this chapter, *Nashville*'s compositions are not haphazard.

10. Walker's speeches, broadcast from a roving van that Altman instructed to stalk the production, were written and performed by the novelist Thomas Hal Phillips.

11. Byrne and Lopez, "Nashville," 18–19; Stuart, *Nashville Chronicles,* 45, 69, 80, 206, 252, 267; Zuckoff, *Robert Altman,* 273, 284–85; Thompson, *Altman on Altman,* 88, 91–92. Altman welcomed input but was no pushover; he and Blakley fought endlessly over the breakdown scene before the director ultimately agreed to shoot it. As he eventually recognized, the result is "dynamite material" which he "almost missed out on." American Film Institute, *Dialogue on Film* 4.5 (February 1975): 18, 19.

12. Connie White (Karen Black) is at the airport only in spirit, represented by a photograph.

13. Stuart, *Nashville Chronicles,* 22, 66; Zuckoff, *Robert Altman,* 276; Thompson, *Altman on Altman,* 93–94.

14. Byrne and Lopez, "Nashville," 25.

15. M. A. Adelman, *The Genie Out of the Bottle: World Oil since 1970* (Cambridge: MIT Press, 1995), 1–3, 42, 43, 99, 107, 112–13, 327.

16. Natasha Zaretsky, *No Direction Home: The American Family and the Fear of National Decline, 1968–1980* (Chapel Hill: University of North Carolina Press, 2007), 78, 81, 84; Berkowitz, *Something Happened,* 2, 53.

17. Cowie, *Stayin' Alive,* 222–23, 276–77; Zaretsky, *No Direction Home,* 86–87; Berkowitz, *Something Happened,* 54, 66–67, 81.

18. Sidney Lumet, *Making Movies* (New York: Vintage Books, 1995), 36, 85, 178.

19. Ibid., 41; Faye Dunaway, *Looking for Gatsby: My Life* (New York: Simon and Schuster, 1995), 294.

20. Shaun Considine, *Mad as Hell: The Life and Work of Paddy Chayefsky* (New York: Random House, 1994), 274–75, 276, 277, 285, 286, 305, 310.

21. Michel Ciment, "A Conversation with Sidney Lumet," *Positif* (February 1982), reprinted in *Sidney Lumet: Interviews,* ed. Joanna E. Rapf (Jackson: University Press of Mississippi, 2006), 86; Lumet, *Making Movies,* 57, 100; see also John Wojtowicz, "Real Dog Day Hero Tells His Story," *Jump Cut* 15 (1977): 31–32. Lumet, it should be noted, thought that ideally movies should be reducible to one theme; in *Dog Day,* in his view, that theme is that the "freaks" are just like us, and thus the "entire point" of the picture is exemplified when Pacino makes out his will. With similar efficiency, he distills the theme of *Network* to "the machines are winning" (*Making Movies,* 14, 163).

22. Gavin Smith, "Sidney Lumet: The Lion of the Left," *Film Comment* (1988), reprinted in Rapf, *Sidney Lumet: Interviews,* 144; Considine, *Mad as Hell,* 304, 305 (quote), 307 (quote), 312–13, 324–25, 326; Dunaway, *Looking for Gatsby,* 293, 302.

23. Dunaway, *Looking for Gatsby,* 298, 300.

24. The same could be (and is) said of corporate "golden boy" Hackett, who has no life outside of his work.

25. Lumet (and Chayefsky) are important figures in the New Hollywood, but they are part of its older cohort; clearly of the political left but not associated with the counterculture or rock music, both men were over fifty when *Network* was made, old enough to have vivid memories of the depression and World War II, and, perhaps, quicker to perceive the slippery path from sixties idealism to seventies hedonism. On Lumet's ambivalence about the sixties, see Smith, "Sidney Lumet," 139.

26. Interestingly, Holden had previously acted in a film about intergenerational romance, Clint Eastwood's *Breezy* (1973). That film emphasizes the hypocrisy of the values of its older generation, with Holden's character trapped by the rigid social norms of his cohort and class in contrast with the genuine sincerity of the younger generation.

27. Stephen Farber, "Coppola and the Godfather," *Sight and Sound* 41.4 (Autumn 1972): 223. More than one reviewer noticed this connection; see, for example, John Kane, "The Godfather," *Take One* 3.4 (June 1972): "This hellish vision of the American dream is at the heart of *The Godfather* and, in the midst of the Nixon-America of the seventies, it carries disturbing weight" (27).

28. The theme of evil against a backdrop of iconic Americana is very Hitchcockian, as is the film's climactic chase through tall wheat fields, à la *North by Northwest.* But instead of a crop-duster, Marvin is pursued by a ravenous harvester, the tension enhanced by the use of a space-compressing telephoto lens.

29. Again, it is crucial to distinguish between the market and the encroachment of the market sphere. Selling a movie for money is capitalism; changing the end of a movie in the hopes of increasing its audience is encroachment, whereby the market rather than the artist determines the content of expression.

30. For a discussion of these issues, see Marshall Berman, "Sympathy for the Devil: Faust, the '60s, and the Tragedy of Development," *American Review* 19 (January 1974): esp. 33–35.

31. Nick Bromwell, *Tomorrow Never Knows: Rock and Psychedelics in the 1960s* (Chicago: University of Chicago Press, 2000), 161.

32. *Message to Love: The Isle of Wight Festival* (1997), directed by Murray Lerner.

33. See, for example, the various depictions of drugs and money overtaking the music in Barney Hoskins, *Hotel California* (Hoboken, N.J.: Wiley, 2006), 118–20, 150, 192, 201–5, 217–21, 231, 235, 238–39, 251–53, 256–57.

34. On the emergence of rock as nostalgia, see James Miller, *Flowers in the Dustbin: The Rise of Rock and Roll, 1947–1977* (New York: Simon and Schuster, 1999), 311, 352.

35. Lester Bangs, "State of the Art: Bland on Bland," *Creem*, July 1976, reprinted in *Mainlines, Blood Feasts, and Bad Taste: A Lester Bangs Reader*, ed. John Morthland (New York: Anchor Books, 2003), 159. For a brilliant essay on the difference between rock music before and after it "mattered," see Nick Hornby, "Pop Quiz," *New Yorker*, September 4, 2001, 166–68.

36. Seth Cagin and Philip Dray, *Hollywood Films of the Seventies: Sex, Drugs, Violence, Rock 'n' Roll, and Politics* (New York: Harper and Row, 1984), 239 (quote); Robert L. Carringer, "Designing Los Angeles: An Interview with Richard Sylbert," *Wide Angle* 20.3 (1998): 117.

37. Peter Biskind, *Star: How Warren Beatty Seduced America* (New York: Simon and Schuster, 2010), 182, 191, 193–94, 202; "Interview with Robert Towne," in Joel Engel, *Screenwriters on Screenwriting* (New York: Hyperion, 1995), 209, 218; Nick Dawson, *Being Hal Ashby: Life of a Hollywood Rebel* (Lexington: University Press of Kentucky, 2009), 152–53, 155, 157, 161–62, 164.

38. Biskind, *Star*, 134, 136, 143 (quote), 166, 169–71, 174 (McGovern); Dawson, *Being Hal Ashby*, 70, 100–101.

39. Biskind, *Star*, 213; Carringer, "Designing Los Angeles," 116; Roger Ebert, "Interview with Warren Beatty," *Chicago Sun Times*, June 29, 1975.

40. Carringer, "Designing Los Angeles," 117; Biskind, *Star*, 207 (quote).

41. Of course, Jackie is no innocent in these matters. Having previously abandoned her relationship with the irresponsible George, she is now a kept woman—Lester's mistress. "It's so great to wake up in the morning with your rent paid," she says to Jill (Goldie Hawn), George's current girlfriend. *Shampoo* is a seventies film, and so its characters are flawed and compromised and don't always make the choices we would wish for them. And George had earlier confronted Jackie with his own plainspoken words, also expressing the truth: "I don't fuck anyone for money, I do it for fun."

42. Ebert, "Interview with Warren Beatty."

43. There are no credits or copyright acknowledgments for the music other than for Simon's soundtrack.

44. Joel Engel, ed., "Interview with Robert Towne," *Screenwriters on Screenwriting* (New York: Hyperion, 1995), 219; Biskind, *Star*, 195.

45. "Grow up, grow up, grow up!" Jill shouts at one point. Jackie's critique is more subtle; she tells George that his most irritating quality is that he is "always so happy," which she finds "unrealistic" (or perhaps childlike).

46. Peter Biskind, *Easy Riders, Raging Bulls: How the Sex-Drugs-and-Rock 'n' Roll Generation Saved Hollywood* (New York: Simon and Schuster, 1998), 314.

47. Tom Wolfe, "The Me Decade and the Third Great Awakening," *New York*, August 23, 1976, reprinted in Tom Wolfe, *Mauve Gloves & Madmen, Clutter & Vine* (New York: Bantam Books, 1977), 117–54.

48. Bert Cardullo, "Over Forty: An Interview with Stanley Kauffmann," *Bright Lights Film Journal* 43 (February 2004); see also Stanley Kauffmann, *A World on Film: Criticism and Comment* (New York: Harper and Row, 1966), and "After the Film Generation," *New Republic*, December 15, 1985, 22–23.

49. Pauline Kael, "Why Are Movies So Bad? Or, the Numbers," *New Yorker*, June 23, 1980, 82–93.

50. Altman's films from 1976 to 1980 were not as impressive, collectively, as his output of 1970–1975 (but what could be?); Penn made no films from 1977 to 1980. Mike Nichols and Peter Bogdanovich were saddled with flops, Sidney Lumet and Sydney Pollack hit soft patches, Sam Peckinpah was finally overtaken by alcohol and drug abuse. BBS Productions shuttered, and Bob Rafelson made only one more film in the 1970s after *The King of Marvin Gardens*. Frankenheimer and Cassavetes slowed down, as did the self-exiled Stanley Kubrick.

51. John Pym, "Rocky," *Sight and Sound* 46.3 (Summer 1997): 192.

52. Also contributing to the backlash were members of the liberal intelligentsia who were cultural conservatives; Harvard sociologist Daniel Bell, for example, favored the "literary sensibility" of the 1950s to the "sexually perverse," "shrill," and "anti-intellectual" 1960s. See Daniel Bell, *The Cultural Contradictions of Capitalism* (New York: Basic Books, 1976), 121–22. On the political backlash, see Cowie, *Stayin' Alive;* and Bruce J. Schulman, *The Seventies* (New York: Free Press, 2001).

53. Stephen Farber, "George Lucas: The Skinny Kid Hits the Big Time," *Film Quarterly* 27.3 (Spring 1974): 8, 9 (Lucas quotes); Jonathan Rosenbaum, "The Solitary Pleasures of Star Wars," *Sight and Sound* 46.4 (Autumn 1977): 208, 209.

54. "Letterboxing," that is, preserving a film's original wider aspect ratio, was initially rare and unpopular with home audiences. As a result, movies on video either showed the middle two-thirds of the image or, disastrously, "panned and scanned" back and forth across the frame.

55. Zuckoff, *Robert Altman,* 369; Aljean Harmetz, "Robert Altman Sells Studio for $2.3 Million," *New York Times,* July 11, 1981.

56. I would even argue that *Prince of the City* was more of a seventies film than 1973's *Serpico,* a movie that mined similar terrain.

INDEX

Numbers in italics refer to film images.

Adler, Renata, 44
"After the Film Generation" (Kauffmann), 213–214
After the Gold Rush (Young), 207
Agnew, Spiro, 69, 152, 189
Aldrich, Robert, 114, 185, 257n5
Alex in Wonderland (1970), 32
Alice Doesn't Live Here Anymore (1974), 99
Alice's Restaurant (1969), 208
Allen, Dede, 182, 186, 187, 256n45
Allen, Woody, 9, 216
Allende, Salvador, 152–153
All the President's Men (1976), 138, 155–157, 215
All Things Must Pass (Harrison), 207
Alonzo, John, 179
Alpert, Hollis, 46
Altamont festival, 207, 240n90
Altman, Robert, 111, 112, 151, 191, 214–215, 216, 259n50
 The Long Goodbye, 170, 171–172, 174, 177–178
 Nashville, 191, 192–193, 194, 195–196, 257–258nn
Ambrose, Steven, 137
American Graffiti (1973), 208
American New Wave. *See* seventies film
Anatomy of a Murder (1959), 11
The Anderson Tapes (1971), 135–136, 200–201
Anka, Paul, 76
Another Side of Bob Dylan (Dylan), 34–35
antiwar movement, 69–70, 76
Antonioni, Michelangelo, 13, 25, 74
Arbuckle, Fatty, 6

Arkin, Alan, 110, 119
art houses, 12, 25
Ashby, Hal, 151, 209, 210–211, 215
"Asia after Vietnam" (Nixon), 105
The Asphalt Jungle (1950), 11, 84, 176
Associated Milk Producers, 151
Atlantic City, 71
L'Avventura (1960), 25–26
Aykroyd, Dan, 166

baby boomers, 23
Bad Company (1972), 113–114
Baker, Howard, 135
Bangs, Lester, 208–209
Bao Dai, 103
Baskin, Richard, 192
Baxley, Barbara, 192
Bazin, André, 27, 28
BBS Productions, 16, 51, 64, 71, 259n50
Beame, Abe, 122, 123
Beatles, 24, 33, 34, 35, 37, 207, 240n90
Beatty, Warren, 42, 112, 210, 213
 The Parallax View, 157, 158
 Shampoo, 209, 211
Beggars Banquet (Rolling Stones), 167
Bell, Daniel, 259n52
Benton, Robert, 25, 42, 43, 113–114, 256n44
Bergman, Ingmar, 25, 32, 32, 213
Bernstein, Carl, 142, 155, 156
Berry, Chuck, 17, 34
The Best Years of Our Lives (1946), 9
The Big Sleep (1946), 177–178

birth control pill, 17, 80
Black and Blue (Rolling Stones), 208–209
Blauner, Steve, 16
blockbusters, rise of, 214, 215–216
Blonde on Blonde (Dylan), 34
Blood on the Tracks (Dylan), 167
Bloom, Allan, 36
Bloomfield, Mike, 56
Blow-Up (1966), 13, 32, 41
Blume in Love (1973), 99–101
Bob & Carol & Ted & Alice (1969), 32, 77–80, 79, 86
Body and Soul (1947), 9
Bogart, Humphrey, 9, 176, 177, 178, 183
Bogdanovich, Peter, 50, 51, 71, 239n83, 259n50
Bonnie and Clyde (1967), 32, 41–44, 238nn54–55
Boorman, John, 36, 37–41
Bork, Robert, 144
Bound for Glory (1976), 215
Bowie, David, 17, 191
The Boys in the Band (1970), 126–127
Brackett, Leigh, 171, 173, 178
Brackman, Jacob, 70
Brandeis University, 24
Breathless (1960), 20, 25, 26
Brecht, Bertolt, 10
Breen, Joseph, 7, 8, 12
Breezy (1973), 258n26
Bremer, Arthur, 141
Bring It All Back Home (Dylan), 34
Bring Me the Head of Alfredo Garcia (1974), 116
Brinkley, David, 61–62
Brookings Institution, 140–141
Bullitt (1968), 127
Bunker, Ellsworth, 52
"bunny rule," 82
Burstyn, Ellen, 70–71, 99
Burstyn v. Wilson (1952), 6
business, public trust in, 151–152
Butterfield, Alexander, 139, 144

Cahiers du Cinéma (journal), 27–28, 55
California Split (1974), 191
Calley, William, 116
Cambodia, 63, 69, 102, 104, 106–107
Canby, Vincent, 90, 123, 128, 168, 184
The Candidate (1972), 167
Cannes Film Festival (1968), 55
Carmichael, Stokely, 18
Carnal Knowledge (1971), 90–94, 93
Carter, Jimmy, 190, 213
Cassavetes, John, 3, 33, 78, 128, 164, 259n50
Catch-22 (1970), 110–111
Catholic Church, 7
censorship, 5–8
"A Certain Tendency of the French Cinema" (Truffaut), 28
Chabrol, Claude, 20, 25, 26, 27, 84, 146, 236n12

Champlin, Charles, 173
Chandler, Raymond, 175, 184
Chaplin, Geraldine, 192
Chapman, Michael, 95, 129, 151, 213
Charley Varrick (1973), 168–169
Chayefsky, Paddy, 200, 201, 202, 258n25
Chicago Tribune, 152
Chile, 152–153
Chinatown (1974), 85, 171, 178–182, 179, 255n41
Christie, Julie, 37, 112, 124, 211
Chrysler Corporation, 152
Church Committee, 166
CIA, 137, 138, 153
Ciment, Michel, 41
Cinémathèque Française, 27, 55
Cisco Pike (1972), 206
Civil Rights Act (1964), 13, 82
civil rights movement, 13–14, 34, 76
Cloquet, Ghislain, 30
Close Encounters of the Third Kind (1977), 215
cocaine, 208
Cockfighter (1974), 85
Cohen, Leonard, 112, 113
Colson, Charles, 133, 134, 160
 Watergate and, 135, 138, 139, 140, 141, 142, 161
Columbia Pictures, 16
Columbia University, 54
Columbo (TV show), 181
Commission on the Status of Women (1963), 15, 81–82
Committee for Public Relations, 7
Committee for the First Amendment, 9
Committee of Bishops, 7
Committee to Re-Elect the President (CREEP), 137, 139, 141
The Conversation (1974), 146–150, 148
Coppola, Francis Ford, 29, 32–33, 49–50, 85, 204–205, 214
 The Conversation, 146, 147, 148, 150, 251n38, 251n43
Corey, Jeff, 30–31
Corliss, Richard, 101
Corman, Roger, 50, 239n83
Cosby, Bill, 169
Le Coup du Berger (1956), 26–27
Criss Cross (1949), 84, 176
Cronkite, Walter, 53
Cronyn, Hume, 157
Crowe, Cameron, 20
Crowther, Bosley, 30, 41, 42, 43–44
Cuban Missile Crisis (1962), 17, 23
Culp, Robert, 77, 169, 247n38

Daily News, 123
Daley, Richard J., 54
Davis, Miles, 26

Dean, John, 138, 139, 142-143, 143, 144, 152, 160, 161, 162
Decae, Henri, 236n12
Deep Throat, 138
Democratic National Convention (1968), 54
Denby, David, 85, 87-88, 101, 116
De Niro, Robert, 32, 128, 129
De Palma, Brian, 29, 32
Dern, Bruce, 50, 70, 71, 128, 191
Diary of a Mad Housewife (1970), 86
Didion, Joan, 121
Diem, Ngo Dinh, 103, 104
The Dirty Dozen (1967), 44
Dirty Harry (1971), 127
disco, 213
D.O.A. (1950), 176
Dog Day Afternoon (1975), 200-201
domino theory, 103
Don't Look Back (1967), 36
Double Indemnity (1944), 19, 84, 176
Douchet, Jean, 29
Douglas, Kirk, 12, 134
Dr. Strangelove (1963), 12
drug use, 17, 35, 208
Dunaway, Faye, 42, 113, 153, 181, 199, 201, 238n54
Dunne, John Gregory, 121
Dylan, Bob, 16, 17, 33, 34-35, 36, 50, 114, 117, 124, 167, 213, 214, 240n90

Eastman, Carole, 64, 242n28, 242n31
Eastwood, Clint, 258n26
Easy Rider (1969), 50, 51
Ebert, Roger, 44, 47, 90, 115, 173, 247n38
Ehrlichman, John, 133, 134, 160, 161
 Watergate and, 135, 137, 138, 139, 140, 141, 142, 143
Eisenhower, Dwight D., 63, 102, 104, 246n3
Elevator to the Gallows (1958), 26
Ellsberg, Daniel, 141
energy crisis (1970s), 197
Equal Employment Opportunity Commission, 82
Equal Opportunity Credit Act (1975), 89
Esalen Institute, 77, 243n4
An Evening with Mike Nichols and Elaine May, 45
Exile on Main Street (Rolling Stones), 167
existential insecurity, 17-18
Exodus (1960), 12
L'Express, 26

Fairbanks, Douglas, 6
Falk, Peter, 164, 165
Farber, Stephen, 85, 88, 115, 243n8
Farewell My Lovely (1975), 256n43
FBI, 137, 138, 140
Feeney, Mark, 146
Feiffer, Jules, 18, 90, 119
The Feminine Mystique (Friedan), 15, 81

film industry
 market encroachment and, 205-206, 258n29
 rating system, establishment of, 13
films noir, 19-20, 84, 170, 254-255nn21-22
 seventies film, affinities with, 174-177
Five Easy Pieces (1970), 16, 51, 63-68, *67,* 86
Fonda, Jane, 94, 98
Fonda, Peter, 50, 114
Ford, Gerald, 142, 166, 189-190
Forman, Milos, 55
The 400 Blows (1959), 20, 25, 26, 27
France, 54-56, 102-103
 See also French New Wave
Frankenheimer, John, 12, 30-32, 62, 259n50
Freeman, Jo, 89
Free Speech Movement, 24
The French Connection (1971), 126-127
French New Wave, 20, 25, 26-29, 84
 influence on seventies film, 29-30, 42
Friedan, Betty, 15, 81, 82-83, 88-89, 243n14
Friedkin, William, 126-127, 248n63
The Friends of Eddie Coyle (1973), 162-163

de Gaulle, Charles, 55
Geer, Will, 30
Geneva Accords of 1954, 103
Genovese, Kitty, 121
Gentleman's Agreement (1947), 9
Getz, Stan, 30
Giddis, Diane, 96
Giler, David, 157
Gimme Shelter (1970), 207
Gledhill, Christine, 94
Godard, Jean-Luc, 27, 28, 30, 36, 42, 55, 119
 Breathless, 20, 25, 26
The Godfather, Part II (1974), 134-135
The Godfather (1972), 204-205
Goldman, William, 138, 155-156
Goldwater, Barry, 145
Gould, Elliot, 77, 111, 119, 170, 174, 191, 193
government, public trust in, 151-152
The Graduate (1967), 32, 37, 44-49, *48,* 86
The Grapes of Wrath (1940), 8
Grateful Dead, 37, 80
Gray, L. Patrick, 138, 139, 143-144
Great Depression, 7
Greenfield, Jeff, 181
Greetings (1968), 32
Gulf Oil, 16
Gurley-Brown, Helen, 76, 80

Hackman, Gene, 43, 64, 126, 146, 182, 205, 206
Haig, Alexander, 140, 142, 160-161, 166
Haldeman, H. R., 70, 133, 134, 152, 160, 161
 Watergate and, 135, 137, 138, 139, 141, 142, 143
A Hard Day's Night (1964), 37
"hardhats," 70

Harrison, George, 34, 35, 207
Haskell, Molly, 86, 87, 90, 92, 94, 99, 100–101, 114
 claim of seventies film's misogyny, 83, 84–85
Hausman, Michael, 165
Havel, Vaclav, 35–36
Hayden, Sterling, 11, 172
Hays, Will, 6–7
The Heartbreak Kid (1972), 85, 88
Heller, Joseph, 110
Hellman, Jerome, 124
Hellman, Monte, 50, 64, 85, 117
Hells Angels, 207
Hells Angels on Wheels (1967), 50
Helms, Richard, 153
Help! (1965), 37
Help! (Beatles), 34
Hendrix, Jimi, 50, 240n90
Henry, Buck, 45, 49, 110, 191
Hermann, Bernard, 129
Hersh, Seymour, 107
Hickey and Boggs (1972), 169–170, 254n9
Higgins, George, 162
Highway 61 Revisited (Dylan), 34
Hill, Walter, 169
Hi Mom (1970), 236–237n23
The Hired Hand (1971), 114
Hiroshima, Mon Amour (1959), 26
Hitchcock, Alfred, 9, 11, 20–21, 25, 27, 45, 127, 131, 141, 150, 53, 158
Ho Chi Minh, 102–103, 246n3
Hoffman, Dustin, 45, 64, 113, 116, 124, 156
Holden, William, 114, 115, 199, 258n26
Hollywood blacklist, 10, 11, 12
Hollywood Ten, 10
Hoover, J. Edgar, 140
Hope, Bob, 123–124
Hopper, Dennis, 50
The Hospital (1971), 151, 200
House Impeachment Committee, 145
Houseman, John, 154, 177
House Un-American Activities Committee, 9–10, 11, 30
"housewife fatigue," 81
Howe, James Wong, 31
Hughes, Howard, 137, 152
Humphrey, Hubert, 19, 54, 62
Hunt, Dorothy, 152
Hunt, Howard, 137, 138, 139, 141, 143
Husbands (1970), 164
Hustle (1975), 257n5
Huston, John, 9, 11, 20, 134, 176, 180, 181, 183
"Huston Plan," 140

Indochina, 102
inflation, 197–198
Internal Security Act (1950), 10
IRS, 137, 152

Isle of Wight festival, 207–208, 240n90
Isley Brothers, 34
I Spy (TV show), 169
It's Only Rock and Roll (Rolling Stones), 167
ITT Corporation, 152
"I Was a Playboy Bunny" (Steinem), 83

"Jack Straw" (Grateful Dead), 80
Jacobs, Alex, 40
Jagger, Mick, 36–37
Jaglom, Henry, 51
Jaworski, Leon, 145
Jaws (1975), 214
Jensen, Paul, 255n29
Johnson, Lyndon B., 52, 53–54, 62, 102, 104–105
Johnston, Eric, 9, 10, 12
Jones, Brian, 240n90
Joplin, Janis, 37, 240n90

Kael, Pauline, 26, 44, 88, 90, 126, 134, 171, 173, 214
Kaleidoscope (1968), 21
Kalmbach, Herbert, 138, 139, 141, 142
Kauffmann, Stanley, 164, 165, 213–214
Kay, Karyn, 99
Kazan, Elia, 11, 55
Kennedy, John F., 17, 18, 23, 24, 139
 Commission on the Status of Women, 15, 81–82
 Vietnam War, 102, 104
Kennedy, Robert, 18, 19, 53, 54, 61–62, 166, 210
Kennedy, Ted, 54, 61, 131, 136
Kent State University, 69
Kerner Commission, 53
Kerr, Clark, 23
Key Largo (1948), 20, 176
Keynes, John Maynard, 17, 235n26
The Killer Elite (1975), 174
King, Martin Luther, Jr., 13, 23, 54
The King of Marvin Gardens (1972), 16, 70–74, 72
Kinney National, 16
Kissinger, Henry, 105–106, 108–109, 133, 134, 152–153, 160–161, 166
 Watergate and, 140, 143, 144
Kleindienst, Richard, 143
Klute (1971), 94–98, 97
Knapp Commission, 168
"Knocking on Heaven's Door" (Dylan), 117
Kovács, László, 50, 64–65, 70, 71, 209, 213, 239n85
Kraft, Joseph, 140
Kristofferson, Kris, 99, 100, 117, 206, 207
Kubrick, Stanley, 9, 12, 259n50
Kutler, Stanley, 142

The Lady from Shanghai (1947), 84, 176
Lang, Fritz, 6, 9, 27, 175
Langhorne, Bruce, 114
Langlois, Henri, 27, 55–56

Laos, 104, 107, 108
The Last Detail (1973), 151
The Last Picture Show (1971), 16, 51, 86
The Last Waltz (1978), 213
The Laughing Policeman (1973), 127–128, 167
Legion of Decency, 7, 8
Lennon, John, 34, 35, 167, 207, 253n3
Lester, Richard, 37
Let It Be (1970), 37, 207
Let It Bleed (Rolling Stones), 167
letterboxing, 260n54
Liddy, G. Gordon, 137, 139, 141
Lindsay, John, 70, 120, 121–122, 123
The Lineup (1958), 168
Little Big Man (1970), 113
Little Murders (1971), 118–119
Little Richard, 34
Loman, Alan, 35
The Long Goodbye (1973), 111, 170–174, *171,* 177–178
Lopate, Phillip, 25
The Lovers (1958), 25, 26
Lowi, Ted, 122
LSD, 35
Lucas, George, 208, 215
Lumet, Sidney, 135, 199, 200–201, 202, 203, 215, 216, 258nn, 259n50

The Mackintosh Man (1973), 134
Malle, Louis, 25, 26, 30, 55, 129
The Maltese Falcon (1941), 19, 84, 176, 255n41
The Manchurian Candidate (1962), 12, 31
Manhattan (1979), 216
The Man Who Fell to Earth (1976), 190–191, 257n5
Martens, Betsy, 99
Martin, Mardik, 129
Martineau, Barbara Halpern, 85
Marty (1955), 200
Marvin, Lee, 37, 38, 40, 41, 205
*M*A*S*H* (1970), 111
May, Elaine, 85, 164, 165
May uprisings (Paris, 1968), 54–56
Mazursky, Paul, 29, 32, 99–100
McCabe & Mrs. Miller (1971), 112–113
McCarthy, Eugene, 19, 54
McCarthy, Joseph, 10
McCarthyism, 10, 11, 12
McCartney, Paul, 34, 207
McGovern, George, 89, 136, 142, 210
McGuinn, Roger, 50
Mean Streets (1973), *33,* 128–129
"Me Decade" (Wolfe), 213
Medium Cool (1969), 56–61, *58*
Mellon, Joan, 83–84, 85, 90, 94
Melville, Jean-Pierre, 10, 27–28, 129, 236n12
Meredith, James, 23
Metro-Goldwyn-Mayer, 41
Mickey One (1965), 29–30, 184
Midnight Cowboy (1969), 85, 123–126, *125*

Mikey and Nicky (1976), 164–165
Miller, James, 35
Millett, Kate, 83
Miss America Pageant protest (1968), 82–83
Mitchell, John, 63, *133,* 134, 160, 161
 Watergate and, 135, 137, 138, 140, 141, 142
Mitchell, Joni, 207–208
The Moon is Blue (1953), 11–12
moral ambiguity, 5, 21, 87
Moreau, Jeanne, 26, 32, 42, 45
Morgenstern, Joseph, 44
Morrison, Jim, 240n90
Motion Pictures Producers and Distributors of America, 6–7, 12–13
Movshovitz, Howard, 100
Ms. magazine, 83
Murch, Walter, 146, 148, 150, 251n44
Muskie, Ed, 136, 137
Mutual Film Corporation v. Industrial Commission of Ohio (1915), 6
My Lai massacre (1968), 107, 116
My Night at Maud's (1969), 184

Nashville (1975), 191–196, *195,* 257–258nn
National Organization for Women, 82
National Security Council, 161
Network (1976), 198–204, *204,* 215
New Hollywood. See seventies film
New Left Review, 35
Newman, David, 25, 42, 43, 113–114
Newman, Paul, 128, 134, 200
New Republic, 82
"New Sentimentality" (Newman and Benton), 25
New York City, 119–121, 121–123
New York Film Festival, 25
New York Times, 63, 82, 121, 140, 152
Nichols, Mike, 13, 44–45, 48, 49, 90, 110, 239n72, 259n50
Nicholson, Jack, 31, 50, 64, 70, 71–72, 74, 75, 90, 151, 180, 187
Night Moves (1975), 171, 182–188, *183,* 256–257nn
Nixon, Richard, 54, 68, 133–135, 166, 197
 anticommunism, 9, 12, 19
 antisemitism, 133, 140, 160, 252n73
 campaign tactics, 18–19, 62–63, 136–137, 139, 141, 151–152
 dirty tricks, 135–141
 management style, 160–162
 Pinochet, support for, 152–153
 Vietnam War and, 62, 63, 69–70, 102, 105–107, 116
 women's liberation movement and, 82, 89
 See also Watergate
North Vietnam, 104

Oates, Warren, 114, 116
O'Brien, Larry, 137
Out of the Past (1947), 19, 84, 176

Pakula, Alan J., 94, 95, 96, 98, 215
 All the President's Men, 155, 156, 157
 The Parallax View, 157, 158, 159
The Parallax View (1974), 157–159, *158*,
 252nn69–70
Paramount, 16
Paramount decision (1948), 12
Partisan Review, 35
The Passenger (1975), 74–75
Passer, Ivan, 121
Pat Garrett and Billy the Kid (1973), 117–118, *118*
Payday (1973), 206
Peckinpah, Sam, 85, 114–116, 117–118, 174,
 244n27, 259n50
Penn, Arthur, 25, 29–30, 45, 113, 208, 214–215,
 256n45, 259n50
 Bonnie & Clyde, 41, 43, 238n54
 Night Moves, 182, 184, 185, 186–187, 187–188
Pennebaker, D. A., 36
Pentagon Papers, 140–141
Performance (1970), 37
Perry, Gerald, 99
Persona (1967), 32
Petulia (1968), 37, 86
Phillips, Thomas Hal, 258n10
Pickford, Mary, 6
Pinochet, Augusto, 153
Platt, Polly, 195
Point Blank (1967), 37–41, *39*
Poirier, Richard, 35
Poland, 54
Polanski, Roman, 55, 178, 179, 180
Pollack, Sydney, 71, 153, 154, 155, 159, 174, 259n50
Polonsky, Abraham, 176
Posse (1975), 134
pot, 35
"Prague Spring" (1968), 54
Preminger, Otto, 11, 12
Prime Cut (1972), 205
Prince of the City (1981), 216
private investigator, appeal of, 169
production code, 7–8, 13, 84
Production Code Administration, 7, 11
psychedelics, 208
"Puppy Love" (Anka), 76

Rafelson, Bob, 16, 51, 64–65, 70, 71, 242n39,
 259n50
Raging Bull (1980), 216
Raiders of the Lost Ark (1981), 215
The Rain People (1969), 33, 85, 237n24
Randolph, John, 30
Raybert (production company), 51
Rayfiel, David, 154
Reagan, Ronald, 8, 24–25, 69, 190
Redford, Robert, 154, 155, 156, 167
Resnais, Alain, 26, 28–29
Reston, James, 109

revisionism, 110–111
Revolver (Beatles), 34
Ribicoff, Abraham, 54, 89
Richardson, Elliot, 144
Ritchie, Michael, 71, 191, 205
Rivette, Jacques, 26, 27
Robertson, Robbie, 213
Robozo, Bebe, 152
Rockefeller, Nelson, 120
Rockefeller Commission, 166
rock journalism, 35
rock music, 17, 33–37, 167, 206–209, 240n90
Rocky (1976), 215
Roeg, Nicholas, 37, 190
Rogers, William, 160
Rohmer, Eric, 20, 26, 27, 29, 84, 184
Roizman, Owen, 126, 155, 199
Rolling Stones, 34, 35, 167, 208–209, 240n90
Roosevelt, Eleanor, 15, 81
Roosevelt, Franklin Delano, 175
Rosen, Marjorie, 85
Rosenbaum, Jonathan, 164, 215
Rosenberg, Stuart, 127–128, 200
Rotunno, Giuseppe, 90
Rubber Soul (Beatles), 34
Ruckelshaus, William, 144
Russell, Bill, 14

Safire, William, 161, 249n2
Salt, Waldo, 124
Sanchez, Manolo, 63, 69
Sarris, Andrew, 11, 26, 36, 168
Save the Tiger (1973), 134
Savio, Mario, 24
Scarlett Letter (1945), 6
Schatzberg, Jerry, 121
Schell, Jonathan, 161–162
Schickel, Richard, 46, 91, 115, 234n14
Schlesinger, John, 124
Schneider, Bert, 16, 51
Schrader, Paul, 20, 88, 115, 128, 129, 131, 174
Scorsese, Martin, 17, 29, 33, 50, 71, 85, 99,
 213, 214, 215, 216
 Mean Streets, 128–129
 Taxi Driver, 128, 129, 130–131
Scott, George C., 37, 200
Seconds (1966), 30–32
Seeger, Pete, 35
Segretti, Donald, 141
self-censorship, 6–7, 7–8, 11
Self Portrait (Dylan), 240n90
Sellier, Geneviève, 84
Semple, Lorenzo, Jr., 154, 157
Sergeant Pepper (Beatles), 36
Serpico (1973), 167–168
Serpico, Frank, 168
seventies, economic difficulties of, 196–198
seventies film, 1–3, 4–5, 21–22

artistic agenda, 87–88
 end of era, 213–216
 films noir, affinities with, 174–177
 French New Wave influence, 29–30, 42
 misogyny, criticism of, 83–84, 84–85
 rock music, synergy with, 36–37
The Seven Ups (1973), 167
Sex and the Single Girl (Gurley-Brown), 76, 80
sex discrimination, 82
Sexual Politics (Millett), 83
sexual revolution, 17, 76–77, 80
Shadows (1959), 33
Shampoo (1975), 209–212, *210*, 259n41, 259n45
Sharp, Alan, 114, 182, 184, 185, 186, 187, 188,
 256n48
The Shooting (1967), 64
Shurlock, Geoffrey, 12, 13
Siegel, Don, 168
Sight and Sound, 173
The Silence of the Sea (1949), 28
Simon, John, 44, 85
Simon, Paul, 209
Simon and Garfunkel, 45
Singer, Loren, 157
Sirica, "Maximum John," 142, 143, 144
Small, Michael, 95, 182, 256n45
Smile (1975), 191, 257n5
Smith, Howard K., 89
Smith, Howard W., 15
social experimentation, 17
Soderbergh, Steven, 156
South Vietnam, 103–110, 240n2
Spartacus (1960), 12
speed, 35
Spielberg, Steven, 215
Star Wars (1977), 215
Steinem, Gloria, 80, 83, 89
Steppenwolf, 50
Stewart, Jimmy, 11
Sticky Fingers (Rolling Stones), 167
Stills, Stephen, 76
"Stranger Song" (Cohen), 112
Straw Dogs (1971), 85, 116
studio system, 84, 86
Sunday Bloody Sunday (1971), 86, 248n58
Supreme Court, U.S., 6, 12, 90, 145
Supreme Court of Georgia, 90
Surtees, Bruce, 182, 256n45
Surtees, Robert, 239n68
Sutherland, Donald, 32, 94, 98, 111, 119, 174
Sylbert, Richard, 45, 255n32
Sympathy for the Devil (1968), 36

The Taking of Pelham One Two Three (1974), 126
Tavernier, Bertrand, 55
Taxi Driver (1976), 128, 129–131, *130,* 215
Taylor, William Desmond, 6
Temple, Shirley, 8

Tet Offensive, 14, 52
Tewkesbury, Joan, 192, 193, 195
The Band, 50, 213
The Byrds, 50
The Pill, 17, 80
Thieu, Nguyen Van, 108, 109
Thieves Like Us (1974), 151
Thomas, J. Parnell, 9–10
Thomson, David, 242n39
Three Days of the Condor (1975), 153–155, *156,*
 159–160, 162
THX-1138 (1971), 208
Time magazine, 25
Tlatelolco Massacre (Mexico City, 1968), 54
Tombs prison (New York City), 122
Tomlin, Lily, 192
Towne, Robert, 31, 42, 50, 151, 157, 174, 209
 Chinatown, 178, 179, 180
Transamerica, 16
Trecker, Janice Law, 90
The Trip (1967), 50
Truffaut, François, 20, 21, 25, 26, 27, 28, 30,
 32, 42, 45, 55, 56, 84, 184
 May uprisings, 55, 56
Truman, Harry S, 10, 102, 234n12
Trumbo, Dalton, 12
TV programming, 15
Twelve Angry Men (1957), 200

Ulzana's Raid (1972), 114
United Artists, 16
university administrators, paternalism of, 24
University of California at Berkeley, 24–25
An Unmarried Woman (1978), 99, 100
Updike, John, 132

Valenti, Jack, 12–13
Varda, Agnès, 26, 84
Vietcong, 104
Vietnam, 102–103
Vietnam War, 13, 14–15, 52–53, 102, 166
 under Johnson, 104–105
 under Nixon, 62, 63, 69–70, 102, 105–107,
 116
Voight, Jon, 124
Voting Rights Act (1965), 13

Wagner, Robert (NYC mayor), 120
Wallace, George, 136, 141
Walls and Bridges (Lennon), 167
Wall Street Journal, 53
Warner, Jack, 42
Warner Brothers, 16
Warren, Jennifer, 182, 183, 187, 257n59
Watergate, 135–139, 142–145
Wayne, John, 136
Webb, Charles, 46
Webb, Teena, 99

Welles, Orson, 5, 11, 27, 55, 127, 163, 176, 215
West, Mae, 7, 8
Westmoreland, William, 52, 53
Wexler, Haskell, 56, 57, 60, 61, 241nn13–14
Who's Afraid of Virginia Woolf? (1966), 13, 45
Who's That Knocking at My Door (1967), 33, 85
Wicker, Tom, 191
The Wild Angels (1966), 50
The Wild Bunch (1969), 114–116
Wilder, Billy, 9, 20, 175
Willis, Gordon, 95, 134, 156, 159
Wolfe, Tom, 213
women's liberation movement, 13, 15–16, 76–77, 80–83, 88–89, 243n12
Wood, Robin, 99

Woods, Rose Mary, 63, 133, 143, 160
Woodstock festival, 50, 206–207
Woodward, Bob, 138, 142, 155, 156
Wurlitzer, Rudy, 117
WUSA (1970), 200

The Yakuza (1975), 174
Yarrow, Peter, 35
Yates, Peter, 127, 162, 163
Young, Neil, 4, 19, 207
Young Turks, 27–28
You're a Big Boy Now (1966), 49

Ziegler, Ron, 70, 142, 143, 144
Zsigmond, Vilmos, 112, 114, 172, 213, 239n85